Watteau and His World

Lenders to the Exhibition

The Art Institute of Chicago

Sterling and Francine Clark Art Institute,
Williamstown, Massachusetts

Cooper-Hewitt, National Design Museum,
Smithsonian Institution

Berger Collection at The Denver Art Museum

The Fine Arts Museums of San Francisco, Achenbach
Foundation for Graphic Arts

The J. Paul Getty Museum, Los Angeles

Harvard University Art Museums

Indianapolis Museum of Art

The Minneapolis Institute of Arts

The Metropolitan Museum of Art, New York

Museum of Fine Arts, Boston

National Gallery of Art, Washington, D.C.

National Gallery of Canada, Ottawa

The Pierpont Morgan Library, New York

San Francisco Museum of Modern Art

The Snite Museum of Art, University of Notre Dame

The Art Museum, Princeton University

Yale University Art Gallery, New Haven

University of California, Berkeley Art Museum

Mr. and Mrs. Russell B. Aitken, New York

Kate de Rothschild and Yvonne Tan Bunzl, London

Mr. and Mrs. Eugene Thaw

Andrea Woodner and Dian Woodner, New York

and several lenders who wish to remain anonymous

Watteau and His World

FRENCH DRAWING

FROM 1700 TO 1750

Alan Wintermute

With essays by
Colin B. Bailey,
Margaret Morgan Grasselli,
Pierre Rosenberg,
and Alan Wintermute

MERRELL HOLBERTON
PUBLISHERS LONDON

AND

THE AMERICAN FEDERATION OF ARTS

This catalogue has been published in conjunction with *Watteau and His World: French Drawing from 1700 to 1750*, an exhibition organized by The American Federation of Arts. It is made possible in part by The Florence Gould Foundation. The catalogue is supported in part by the Samuel H. Kress Foundation.

The American Federation of Arts is a nonprofit art museum service organization that provides traveling art exhibitions and educational, professional, and technical support programs developed in collaboration with the museum community. Through these programs, the AFA seeks to strengthen the ability of museums to enrich the public's experience and understanding of art.

EXHIBITION ITINERARY

The Frick Collection
New York
October 19, 1999 – January 9, 2000

National Gallery of Canada
Ottawa
February 11 – May 8, 2000

ISBN 1 85894 079 6 hardback
ISBN 1 885444 12 5 paperback

First published in 1999 by
Merrell Holberton Publishers Limited
42 Southwark Street, London SE1 1UN
and The American Federation of Arts
41 East 65th Street, New York, New York 10021

Hardback edition distributed in the USA and Canada by
Rizzoli International Publications, Inc.
through St Martin's Press, 175 Fifth Avenue, New York,
New York 10010

Publication Coordinator, AFA: Michaelyn Mitchell
Produced by Merrell Holberton Publishers Limited
Designed by Roger Davies
Printed in Italy

Note to the reader: Not all works reproduced in the catalogue section will be on view at all venues on the exhibition tour.

Front cover: Antoine Watteau, *Young Woman Wearing a Chemise*, *ca.* 1718 (detail; cat. no. 37)
Back cover: Jacques-André Portail, *Young Man Sharpening His Pencil*, *ca.* 1740 (detail; cat. no. 77)

LIBRARY OF CONGRESS CATALOGING-IN-PUBLICATION DATA

Wintermute, Alan
Watteau and his world : French drawing from 1700 to 1750 /
Alan P. Wintermute : essays by Colin B. Bailey … [et al.];
catalogue entries by Alan P. Wintermute
p. cm
Catalog of an exhibition organized by the American Federation of Arts and held at the Frick Collection, New York, N.Y., Oct. 19, 1999–Jan. 9, 2000 and the National Gallery of Canada, Ottawa, Feb. 11–May 8, 2000.
Includes bibliographical references and index.
ISBN 1-85894-079-6 (hardcover). — ISBN 1-885444-12-5 (paperback)
1. Watteau, Antoine, 1684-1721 Exhibitions. 2. Watteau, Antoine, 1684-1721—Friends and associates Exhibitions. 3. Drawing, French Exhibitions. 4. Drawing—18th century—France Exhibitions.
I. Bailey, Colin B. II. American Federation of Arts. III. Frick Collection. IV. National Gallery of Canada. V. Title.
NC248.W35A4 1999
741.944—dc21

99-16700
CIP

BRITISH LIBRARY CATALOGUING-IN-PUBLICATION DATA

Wintermute, Alan
Watteau and his world : French drawing from 1700 to 1750
1.Watteau, Antoine, 1684–1721 – Criticism and interpretation 2.Drawing – 18th century – France 3.Drawing, French
I.Title
741'.092
ISBN 1 85894 079 6

Contents

Acknowledgments

This selection of extraordinary works exploring both the brilliance of Watteau and the rich matrix of influences connecting him to the artists who were his mentors, contemporaries, and pupils is sure to be enjoyed as much by the uninitiated as it is anticipated by connoisseurs of drawing. I am delighted that its opening venue coincides with the celebration of the AFA's ninetieth anniversary.

I want to acknowledge guest curator Alan Wintermute, senior specialist of old master paintings at Christie's, for the intelligence and insight he has brought to both exhibition and book, and, for their important contributions to the book, Colin B. Bailey, deputy director and chief curator at the National Gallery of Canada, Margaret Morgan Grasselli, curator of old master drawings at the National Gallery of Art, and Pierre Rosenberg, director of the Musée du Louvre, Paris. All their essays represent new scholarship relating to the issues of connoisseurship, attribution, artistic influence, patronage, and the collecting of drawings in the eighteenth century.

At the AFA, this project has been brought to fruition by numerous dedicated staff members. First among these are Donna Gustafson, chief curator of exhibitions, who expertly oversaw the complex organization of the exhibition, and Michaelyn Mitchell, head of publications, who skillfully coordinated the publication of this beautiful book. Ms. Gustafson and Ms. Mitchell benefited from the able assistance of Amy Cooper and Beth Huseman, respectively. Diane Rosenblum, registrar, meticulously coordinated the logistics of traveling the exhibition; Lisbeth Mark, director of communications, energetically guided the promotion and publicity efforts for the project; and Katey Brown, head of education, and Brian Boucher, assistant curator of education, planned the absorbing symposium on Watteau that accompanied the exhibition in New York. Doris Palca and Christina Ferando kindly volunteered their time to help us meet the demands of the publication. I also want to recognize with thanks the director of exhibitions, Thomas Padon, for his keen oversight of the project.

Thanks also go to Paul Holberton and Hugh Merrell at Merrell Holberton, the copublisher of this book, for their patience and graciousness.

The many private and institutional lenders without whose generosity the exhibition could not have been organized are acknowledged with deep gratitude.

I wish to recognize the two presenting museums: the Frick Collection, New York, and the National Gallery of Canada, Ottawa.

Lastly, I wish to acknowledge the Florence Gould Foundation for its support of the exhibition and the Samuel H. Kress Foundation for its support of the catalogue.

SERENA RATTAZZI
Director, *The American Federation of Arts*

Watteau and His World: French Drawing from 1700 to 1750, organized by the American Federation of Arts, provides yet another opportunity for the National Gallery of Canada and the Frick Collection to work together in a happy "series" of exhibitions shared solely by the two institutions. The most recent occasion was the exhibition *French and English Drawings of the Eighteenth and Nineteenth Centuries from the National Gallery of Canada*, seen at the Frick from February 9 through April 25 of this year. The present collaboration takes us into the new millennium.

Watteau and His World is somewhat poignant for the Frick Collection, as Watteau long figured in its acquisitions goals, which first failed in 1947 in an attempt to acquire *The Embarkation for the Island of Cythera* (now in Berlin). Success came in 1991, with the acquisition of *The Portal of Valenciennes*, which added Watteau to the company of such other French artists of the eighteenth century represented at the Frick as Boucher, Chardin, David, Drouais, Fragonard, Greuze, Lajoüe, and Pater.

Sadly, there is not a single painting by Watteau in Canada, but the National Gallery acquired in 1939 the resonant *Two Men Standing*, owned in the eighteenth century by the scholar, collector, and art historian Dezallier d'Argenville. The opportunity to collaborate with the Frick Collection and the AFA in bringing over seventy superb sheets by Watteau and his contemporaries to Ottawa allows us, temporarily at least, to address this lack. Thanks to the generosity of the Frick Collection in lending Watteau's *Portal of Valenciennes* to the National Gallery of Canada for the Ottawa venue of the exhibition, our public will also be able to appreciate how Watteau's enchanting and life-affirming studies assisted in creating the poetic and nostalgic universe to which he gave form in his paintings.

The presentation of *Watteau and His World* at the Frick has been made possible in part by the generosity of the Fellows of the Frick Collection.

Edgar Munhall, curator, and William Stout, registrar, coordinated arrangements at the Frick Collection for the presentation of the exhibition. In Ottawa, *Watteau and His World* has been overseen by Colin B. Bailey, deputy director and chief curator, who also contributed an important essay to the catalogue. David G. Franklin, curator, Prints and Drawings; Daniel Amadei, director, Exhibitions and Installations; Karen Colby-Stothart, chief, Exhibitions; and Kate Laing, head, Art Loans and Exhibitions, have been responsible for the presentation of the exhibition at the National Gallery of Canada.

SAMUEL SACHS II
Director, *The Frick Collection*
PIERRE THÉBERGE C.Q.
Director, *National Gallery of Canada*

Fifteen years after the tercentenary exhibition of Watteau's paintings, drawings, and prints, it seemed a good moment to reexamine his art in light of the new scholarship that accompanied and followed that great event. For reasons both practical and aesthetic the decision was made to focus exclusively on Watteau's drawings—often regarded as his most perfectly realized creations—and to gather the sheets from the rich holdings of North American public and private collections, whose collective resources in this field are surpassed only in France. More than a few of the Watteau drawings included in this exhibition have never been seen in public before.

Thanks to the scholarship of Marianne Roland Michel, Margaret Morgan Grasselli, Martin Eidelberg, Donald Posner, Pierre Rosenberg, and Louis-Antoine Prat, it is now possible to consider Watteau's achievements as a draftsman and comment on his development with far greater confidence. What remains to be done, however, is more thoroughly to situate Watteau's practice within the broader artistic milieu of his times. To that end, *Watteau and His World* also looks at those artists who influenced Watteau's development as a draftsman, and at younger practitioners who turned to his drawings for inspiration. The latter category is vast: can we imagine the drawings of Fragonard or Gabriel de Saint-Aubin without Watteau, to name but two artists from later in the century? The selection has been confined to the most talented draftsmen of the generation immediately following Watteau's own: young artists for whom Watteau was a living presence or at least a vivid memory, who would have had direct access to the master's drawings, and who found in them liberating stylistic novelty rather than nostalgic grace. Several of these "followers"—notably François Boucher—went on to have long and distinguished careers and developed pictorial languages of their own. Yet while it is our view that to a man Watteau provided an essential lesson, whose consequences were lifelong, we have nonetheless focused on those drawings made when Watteau's inspiration flared most brightly.

The realization of this exhibition and its accompanying publication has required the assistance of many people. At the AFA, Thomas Padon, director of exhibitions, embraced the idea of the show from the moment I first proposed it and helped usher it through each stage of its development. Donna Gustafson, chief curator of exhibitions, oversaw and guided every aspect of its organization—always with intelligence, unshakable calm, and astonishing good cheer—and must be acknowledged, in many ways, as the exhibition's co-curator. Michaelyn Mitchell, head of publications, strove valiantly, if not always successfully, to keep me working to deadline and still managed to coordinate and edit meticulously this handsome book in record time.

I have had the good fortune to collaborate closely in the planning of the exhibition with Edgar Munhall, curator at the Frick Collection and a formidable expert on the art of Watteau. A great debt is also owed to the staff of the Frick Art Reference Library, which for more than two years allowed me and my assistant free access to their unsurpassed research facilities.

I am very grateful to Pierre Rosenberg and Margaret Morgan Grasselli, who have contributed elegant and highly informative essays to this catalogue, adding to their many publications that are the basis of Watteau studies today.

Christie's, for whom I am privileged to work, has been unwaveringly generous and open-minded in supporting me while I was engaged on this project. I must thank, in particular, Patricia G. Hambrecht, president, Christie's North and South America; Stephen S. Lash, vice chairman; Christopher Hartop, executive vice president; Anthony Crichton-Stuart, head, Old Master Paintings Department; and Maria Ludkin, former business manager, Old Master Paintings Department. The catalogue could not have been produced without the sterling efforts of Anne Hargrave, research assistant.

My greatest debt, as always, is to Colin B. Bailey, who encouraged and supported this exhibition from its inception, and is responsible for bringing it to Ottawa. He has proven to be as devoted a collaborator as he is a companion, and in addition to the superb and original essay he has written for the catalogue, his close reading and scrupulous editing of my contributions have spared the reader from many errors of fact and infelicities of language. My gratitude to him for this, and so many things, is beyond measure.

For their help in many ways, I thank the following: Noël Annesley, Joseph Baillio, William and Bernadette Berger, Jean-Luc Bordeaux, François Borne, Mark Brady, David J. Burke, Arline Burwash, Richard J. Campbell, Alvin L. Clark, Jr., Allen W. Clowes, John B. Collins, Patrick J. Cooney, Cara Dufour Denison, Douglas W. Druick, Martin Eidelberg, Richard S. Field, Carter Foster, David Franklin, James Ganz, Michel Gierzod, George Goldner, John Goodman, William Griswold, Susan Hapgood, Jo Hedley, Richard Hemphill, Lee Hendrix, John Herring, Paul Herring, Mrs. Eliot Hodgkin, Mary Tavener Holmes, Jeffrey E. Horvitz, Valerie Hoyt, Robert Flynn Johnson, Jennifer Jones, Laurence Kanter, Ronda Kasl, Heidi Kucker, Pauline Labelle, Alastair Laing, Thomas LeClaire, Michael and Linda McCann, Suzanne Folds McCullagh, Shira Nichman, Stephen Ongpin, Tash Perrin, Ann Percy, Louis-Antoine Prat, Charles and Jessie Price, Bronwyn Maloney Quillen, Richard Rand, John D. Reilly, Joseph J. Rishel, William T. Robinson, Andrew Robison, Marianne Roland Michel, Barbara Ross, Kate de Rothschild, Sybille Russell, Guy Sainty, Alan Salz, Danny Santow, Scott Schaefer, George T. M. Shackelford, Innis Shoemaker, Regina Shoolman Slatkin, Mason Snyder, Stephen B. Spiro, Perrin Stein, James Steward, Judy Sund, Marilyn Symmes, Yvonne Tan Bunzl, Patricia Tang, Mr. and Mrs. Eugene Victor Thaw, Carol Togneri, Jessica Varner, Bret Waller, Paul Weis, Daniel Wildenstein, Eunice Williams, Thomas Williams, Linda Wolk-Simon, Andrea Woodner, Dian Woodner, Franco Zangrilli, and the lenders who wish to remain anonymous.

ALAN WINTERMUTE

Le Pèlerinage à Watteau

An Introduction to the Drawings of Watteau and His Circle

by Alan Wintermute

When Antoine Watteau died on July 18, 1721, not yet thirty-seven years old, he was a successful, admired, and well known artist, whose paintings were sought after and collected in France and throughout much of Europe. His most characteristic creations, the *fêtes galantes*—small, romantic landscapes with wistful lovers in fancy dress—were fashionable across the Continent and widely imitated. Yet the nature of Watteau's art, his personal character, and the times in which he worked have conspired to leave almost no secure documentation of his life or career. Although he was a member of the Royal Academy of Painting and Sculpture (Académie Royale), he did not receive his training there, nor did he gain public exposure through the Academy's biennial exhibitions—the famous Salons—which had been suspended in 1704 by the financially ailing Crown and were not resumed until well after his death. He did not receive royal or Church commissions, which, while poorly paid, nevertheless generated press commentary and left behind a trail of dated contracts and paid invoices. Watteau painted small easel pictures that he made in private and sold directly to collectors or through several dealers who were also his friends. He seems to have had no workshop assistants and only one acknowledged pupil. He did not sign or date a single known work; he left no correspondence; he appears never to have had a fixed abode and instead moved restlessly every few months from the home of one generous friend to another; he never married, had children, or brushed with the law, any of which would have resulted in a certificate or record in the archives; he may not even have had a regular studio.

Virtually everything we know about the life, career, and working methods of Watteau comes from a half dozen short obituaries, memoirs, and discourses written after his death by his friends or contemporaries.[1] The essential biographical sketches are by Antoine de La Roque (1672–1744), publisher of the *Mercure de France,* whose portrait was painted by Watteau[2]; Jean de Jullienne (1686–1766), a textile manufacturer who became the artist's greatest champion[3]; Edme-François Gersaint (1694–1750), the art dealer for whom Watteau painted the eponymous *Shopsign* (*L'Enseigne de Gersaint;* fig. 2) that is one of his masterpieces[4]; Pierre-Jean Mariette (1694–1774), the print dealer, collector, and art historian who may have become acquainted with Watteau through the collector Pierre Crozat[5]; Antoine-Joseph Dezallier d'Argenville (1680–1765), the connoisseur and art historian famous for his multi-volume *Abrégé de la vie des fameux peintres*[6]; and Anne-Claude-Philippe de Tubières de Grimoard de Pestels de Lévis, the comte de Caylus (1692–1765), court noble, libertine author, and amateur printmaker who provided rooms where he and Watteau

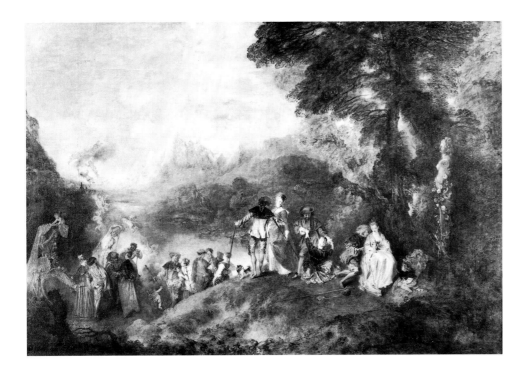

went to sketch from the live model.[7] Watteau's friends provide few firm dates and are occasionally contradictory, but taken together their anecdotal accounts establish the framework for our understanding of his career.

Watteau was baptized on October 10, 1684, in Valenciennes, a city in Flanders that had been ceded to France only six years earlier. He was the second of four sons born to Jean-Philippe Watteau, a roofer, and his wife, Michèle Lardenois. Watteau's father seems to have been hot-tempered and violent and was brought up on assault charges on several occasions; the family moved house repeatedly. When the boy was "only ten or eleven years old," he was apprenticed to an unnamed local artist of little talent, possibly the forgotten religious painter Jacques-Albert Gérin (1640–1702).[8]

In 1702, the year Gérin died, Watteau moved to Paris to "cultivate the Muse that he cherished."[9] Noting that the young artist "desired nothing more than to perfect himself,"

Jullienne pointed out "that only residence in this great city could procure [Watteau] the means of improving himself." He added that the boy was brought to Paris by an unnamed scene-painter from Valenciennes who had been called to work at the Paris Opéra; when the painter failed and was forced to return home, Watteau stayed behind and supported himself making copies of religious paintings for a dealer on the Pont Notre-Dame.[10] Although this was production-line work of the lowest order, where he was compelled to replicate pictures "copied for the hundredth time," it provided him with room and board.[11] Tiring of such work, which was "as repugnant as it was fruitless," Watteau parted company with his employer and, according to Jullienne, made the acquaintance of Claude Gillot (1673–1722), a painter recently accepted by the Academy.[12]

As Gillot was admitted into the Academy only in July 1710, Jullienne must have been mistaken about the timing of his first meeting with Watteau, which might have taken place

as much as five years earlier.[13] However, all the biographers agree that the encounter was decisive for both artists. A witty, inventive draftsman and an elegant painter, Gillot was early recognized for his "unique manner, completely his own," which was the "fruit of his studies after subjects from the French and Italian theatre."[14] Gillot's innovative repertory of theatre scenes soon became Watteau's as well. Gillot experienced "joy in finding a young painter whose work resembled his own," and he invited Watteau to live with him: "[Watteau] profited from the wisdom of this skilled man in such a way that in a short time he had taken on much of his style, and one may say that even in the beginning he invented and drew in the style of Gillot, treating more or less the same subjects as he."[15] As Gersaint stated without hesitation, "In truth, Gillot was the only Master whom Watteau could be said to have had."[16]

After an unknown period of time and for reasons that are unclear—but may have had to do with growing jealousy on Gillot's part toward a student whose talents would soon eclipse his own—Gillot and his pupil parted company and Watteau entered the workshop of Claude III Audran (1658–1734), a prominent decorative painter and designer who headed a team of gilders, sculptors, and painters who ornamented the interiors of private and royal residences.[17] Watteau was employed to paint figures that filled the arabesques and other decorative compositions that were executed by painters specializing in ornamental tracery. Audran was also painter in ordinary to the king and had been appointed *concierge* (or curator) of the Luxembourg Palace in 1704. At the time, the Luxembourg housed Rubens's monumental cycle of paintings commemorating the life of Marie de Médicis (now in the Musée du Louvre), motifs from which Watteau would repeatedly copy in drawings. "Watteau, inclined more and more to study, and excited by the beauties of the gallery of this palace painted by Rubens, often went to study the color and the composition of this great master. This in a short time gave

him a taste much more natural and very different from that which he had acquired with Gillot."[18]

"It was about this time that he created [a painting] for the prize which the Royal Academy of Painting offers every year and in which he came second."[19] The official minutes of the Academy indicate that Watteau's participation in the competition for the Prix de Rome was approved on April 6, 1709. The results were announced on August 31, when Watteau was awarded second prize for a submission depicting *Abigail Who Brings Food to David* (lost), one of the two biblical subjects that were assigned to the competitors. The winner, Antoine Grison, is today remembered for this victory alone.[20]

Despite having placed well in his first competition, Watteau's hopes of studying in Italy were dashed: "After such an honor one would have thought that Watteau would have resolved to stay in Paris to make himself better known and to perfect the talent he had for painting. However, as his income had been less than mediocre and as he saw his works were not gaining in favor because of the little understanding people had of his new style of painting, he became disgusted with Paris and resolved to return to his homeland."[21] Watteau does not seem to have had the money to finance the trip to Valenciennes, and, according to Gersaint, his sole possession was a painting of a military subject that he had executed in his spare time, the *Return from the Campaign* (*Retour de campagne*; lost), which he showed to Audran. "A clever man and able to recognize a thing of beauty," Audran was "astounded at the merit he discerned in this painting."[22] Watteau then turned to his more worldly friend the painter Jean-Jacques Spoede (1680–1757), who, like him, was of Flemish origin, and Spoede took the painting to the dealer Pierre Sirois, future father-in-law of Gersaint. The price was set at 60 *livres* (the equivalent of many weeks' pay in Audran's shop), "and the deal was made on the spot. Watteau came to get his money; he merrily left for Valenciennes."[23]

Watteau's return trip was brief, however. It is uncertain

that relations with his family were especially warm, and his freedom to paint would have been restricted because he was not a member of the local guild. However, since Valanciennes was a garrison town during the later years of the ruinous War of Spanish Succession (1701–13), Watteau would have had many opportunities to make studies of the soldiers stationed there. We do know that he fulfilled a commission from Sirois to make a pendant to the military scene that had underwritten his trip, and he produced *The Bivouac* (*Camp volant*; Moscow, Pushkin Museum) for his patron, for which he now charged 200 *livres*.[24] Sirois was soon showing Watteau's two paintings to collectors in Paris who were eager to acquire them, and Watteau's talents "became well known amongst all the connoisseurs."[25] Henceforth, he would always have the support of dealers, who guaranteed the commercial success of his work.

Although it seems evident that he returned to Paris with a promising future and a developing market for his art—as Mariette observed, "his way of painting had found favor"—it is at this point that the details of his life and career become frustratingly murky.[26] It was probably around 1710 that Watteau made the series of seven etched fashion plates known as *Les Figures de modes*. He may have gone to live with Sirois or returned to work for Audran, but there is no documented event until July 30, 1712, when he was received as an associate member of the Academy.[27] Jullienne tells us that Watteau once again presented himself for the Prix de Rome (presumably at a session of the Academy that took place several weeks earlier, on July 11, 1712), submitting "like the others, drawings and paintings to the gentlemen of the Academy."[28] Gersaint said that he presented the two military paintings that were still the property of his future father-in-law, and Mariette identified one of the submissions as the *commedia dell'arte* scene *Jealousy* (*Les Jaloux*; lost).[29] What is clear is that the Academicians—if somewhat mystified by these paintings, which in style and subject matter were unclassifiable within the hierarchy of the genres—were

nonetheless dazzled by their originality and accomplishment. Charles de La Fosse (1636–1716), former director of the Academy, was particularly impressed by what he saw, and advised Watteau to abandon his plans to study in Rome, inviting him instead to join the Academy. More than thirty-five years later, in an address before the Academy, Caylus would recount to its members the attitude of their predecessors: "For such an accomplished and outstanding artist, the voyage to Rome that he asked to be allowed to undertake would have been of no use; and so the Academy decided to receive him as a full member. This was done with all the more distinction since M. de La Fosse ... spoke up for his merits, and knowing him only by his works, took a great interest in him."[30] Encouraged to present his candidacy at the July 30 session, Watteau was accepted then and there and invited to paint a reception piece. Exceptionally, he was allowed to determine the subject of his *morçeau de reception* himself.[31]

"A testimonial so glorious and so authentic as that which the Academy paid Watteau's merit considerably increased the number of his admirers," Jullienne observed, and Watteau presumably was gainfully employed fulfilling their requests for pictures; certainly, he made little effort to provide the Academy with the required reception piece.[32] On January 5, 1714, both he and Gillot were called to account for their delay in submitting the promised paintings, and they were warned again exactly one year later; on January 25, 1716, Watteau was granted another postponement (Gillot having by this time submitted his painting and been formally received into the Academy); on January 9, 1717, he was granted a six-month extension. Finally, on August 28, 1717—five years after his provisional admission—he was formally received as an academician on submitting his masterpiece *The Embarkation to Cythera* (*Le Pèlerinage à l'isle de Cithère*; fig. 1); in the minutes of the Academy recording the event, the title of the painting was crossed out and replaced with the words "*feste galante*."[33]

These years are the period of Watteau's greatest productivity and achievement, yet it is the very time for which we have the least knowledge of his movements and activities. In his diary for June 13, 1715, the young Swedish collector Carl Gustaf Tessin (1695–1770) recorded a visit to Watteau on the quai Conti, where the artist was then living. It is the earliest reference to Watteau written by a collector, and it gives a sense of how the artist and the kinds of work he was then producing were perceived by contemporaries: "Watho [sic], a pupil of Gillot, Flemish by birth, succeeds very well in grotesques, landscapes, fashions."[34]

It was most likely around this time—and probably through the good offices of Charles de La Fosse—that Watteau met Pierre Crozat (1665–1740), the fabulously wealthy banker who surrounded himself with an illustrious circle of artists, musicians, and collectors, and whose friendship would greatly influence the direction of Watteau's art.[35] Crozat introduced Watteau to the Venetian painters Sebastiano Ricci (1659–1734) and Rosalba Carriera (1657–1757) when they visited France, and commissioned from him a series of four oval paintings representing the seasons for his dining room—only one of which, *Summer* (*L'Eté*; Washington, D.C., National Gallery of Art), survives—but Crozat's most significant contribution to Watteau's development as an artist came through the generous access he gave to his celebrated collection of old master drawings.[36] All of the early biographers stress the tremendous impact that hours of study in this vast *cabinet* had on his art: "Most exciting to his taste was the large collection of drawings by the great masters. He was affected by those of Jacopo Bassano; and still more so by the studies of Rubens and Van Dyck. He was charmed by the fine inventions, the exquisite landscape backgrounds, and the foliage, revealing so much taste and understanding, of Titian and Campagnola, whose secrets he was able to explore in these drawings."[37] Crozat offered him room and board, and at the end of 1717 Watteau was recorded in the

Almanach Royal as living in Crozat's house; however, it is possible that the artist moved in with his patron more than once.[38]

According to Gersaint, "it was the love of liberty and independence that induced [Watteau] to leave M. Crozat; he wished to live as he liked, and he even preferred an obscure existence; he retired to small lodgings at my father-in-law's house and gave orders that his address was not to be revealed to those who might ask for it."[39] Caylus and Jullienne have Watteau leaving Crozat and moving in with his friend, the painter Nicolas Vleughels (1668–1737), who subsequently was appointed director of the French Academy in Rome.[40] Whatever the precise sequence, Watteau reappears in the *Almanach Royal* for 1718 as sharing the home of "M. LeBrun on the Fossez S. Victor" with Vleughels. Watteau may have lived for up to a year with the older painter, who was also of Flemish heritage and who shared his enthusiasm for the art of Rubens and Veronese.[41]

By 1719 Watteau was well established in the Parisian art world. Nicolas Lancret (1690–1743), who had known Watteau more than a decade earlier when they were both assistants in Gillot's shop, was making a name for himself as a successful painter in the new genre that Watteau had created: he was received in the Academy in March of that year as a painter of "*festes galantes*"—only the second time the title had been employed.[42] Sirois published two popular engravings after recent paintings by Watteau; and the first biography of the artist appeared, probably written by Dubois de Saint-Gelais (1669–1737), as an entry in Père Orlandi's biographical dictionary *Abécédario pittorico*, published in Bologna.[43]

"Watteau's reputation was then among the greatest. It acquired for him the friendship of several influential persons and he could flatter himself that he could make a profitable business for himself in a short time had he wanted to stay in Paris. But again he showed a trait of his instability in leaving for a second time all his hopes in order to go to England."[44]

The exact date of Watteau's departure for London is unknown: Caylus recalled that "he set off in 1719," and a letter from Vleughels to Rosalba Carriera dated September 20, 1719, makes it clear that Watteau was still living with him at the time, so the artist must have sailed across the Channel in the final months of that year.[45] Although his natural restlessness surely played a role in his departure, he might also have expected the move to provide further business opportunities. Gersaint confirmed that Watteau was kept busy in England but was well recompensed for his efforts; in fact, it was only then that he developed "a taste for money of which he had hitherto made light, despising it to the point of indifference and always considering that his works sold at much higher prices than they were worth."[46] Caylus observed that he was "tolerably well received and he did not neglect such business advantages as presented themselves," and Jullienne added that "he did not fail to do there several paintings which drew to him the admiration of the connoisseurs."[47] One of these admirers was Dr. Richard Mead (1673–1754), an art collector and physician to the British Royal Family, who was a respected specialist in the treatment of infectious diseases.[48] Horace Walpole, writing half a century after Watteau's death, claimed that the sole purpose of the artist's visit to London was to see Mead, for whom he painted two pictures, and it is certainly possible that Watteau, who was already suffering the effects of tuberculosis, would have sought consultation with the eminent doctor.[49] The paintings made for Mead in 1719–20—*Peaceful Love* (*L'Amour paisible*; lost; see fig. 51a, p. 55) and *The Italian Comedians* (*Comédiens italiens*; fig. 92, p. 174)—are among the few paintings by Watteau that can be dated with confidence.[50]

Isolated by his inability to communicate in English, and his health further weakened by "the fogs and coal dust in the air," Watteau returned to France after an absence of almost a year, more ill than when he had departed.[51] Rosalba Carriera noted in a diary entry written in Paris on August 20, 1720,

that she finally "saw M. Vato [*sic*] and An Englishman"; he had probably only recently arrived back in the city.[52] By the end of 1720 Watteau was living with Gersaint above the dealer's shop on the Pont Notre-Dame, and it was then—during the first months of the new year—that Watteau painted the famous *Shopsign* (*L'Enseigne de Gersaint*; fig. 2) to hang outside Gersaint's gallery. It was an exercise that allowed him "to stretch his fingers," and he completed the large canvas in eight sessions, painting only in the mornings as his weak constitution no longer permitted him to work all day.[53]

On February 11, 1721, Watteau sat to Rosalba, who had been commissioned by Crozat to make a portrait of the artist in pastel; in that same month *Le Mercure* announced that Watteau was one of the artists commissioned to copy paintings in the collections of the king and the regent for an engraving project organized by Crozat.[54] By then, as Jullienne remarked, Watteau "scarcely had a day of good health, but although his continual infirmities gave him not a moment's respite, nevertheless he worked from time to time."[55] After having lived for about six months with Gersaint, and perhaps fearing that he had become a burden, Watteau asked his friend to find him new lodgings. According to Gersaint, he stayed at his new address only briefly; increasingly agitated, he determined to return to Valenciennes, where he hoped he might recover his health, but he was finally dissuaded from attempting the arduous journey when his friend, the abbé Pierre-Maurice Haranger (*ca.* 1660–1735), canon of Saint-Germain l'Auxerrois, arranged for a certain "M. Le Febvre," an *intendant des menus plaisirs,* to lend the dying artist his country house in Nogent-sur-Marne, near Vincennes.[56]

According to Gersaint, in Watteau's final weeks, he determined to reconcile with the young painter Jean-Baptiste Pater (1695–1736), who had apparently studied with him some years earlier.[57] Like Watteau, Pater was a native of Valenciennes, whose father, Antoine Pater, was a local

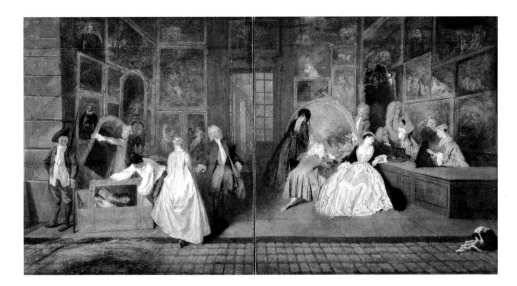

Figure 2
Antoine Watteau, *Gersaint's Shopsign* (*L'Enseigne de Gersaint*), 1721. Oil on canvas, 65¼ × 120 in. (166 × 306 cm). Charlottenburg Palace, Berlin (Stiftung Preußische Schlösser and Gärten Berlin-Brandenburg)

sculptor. He may have accompanied Watteau to Paris when the artist returned to the capital in 1710. Reproaching himself for the ill treatment he had offered his pupil at the time, Watteau urged Gersaint to call Pater to Nogent, "that he might somehow repair the wrong he had done him by his previous neglect, and that [Pater] might at least profit from such instruction as he might still be in a condition to give him." He devoted much of the final month of his life to training the young painter.[58]

Shortly before his death, Watteau asked Gersaint to arrange the sale of his effects, which apparently realized 3000 *livres*, a not inconsiderable sum.[59] The money was sent to his family after his death, together with the 6000 *livres* Jullienne had salvaged from Watteau's investment in the Compagnie des Indes, following its financial collapse in May, 1720.[60] On July 18, 1721, Watteau died in Nogent, cradled in Gersaint's arms. On July 26 his death was announced to the Academy. Two weeks later Crozat wrote Rosalba, "We have lost poor Vateau [*sic*], who died with a brush in his hand. His friends are to give a public discourse on his life and on his rare talents."[61]

No record exists of the "public discourse" that Crozat promised, but, in the three decades that followed Watteau's death, his friends offered ample testimonials to his talents in the affectionate and revealing biographical sketches that preserve almost everything that is known about his life. All modern historians bemoan the dearth of archival evidence concerning Watteau's career, yet, in truth, there are few artists who worked in France in the first decades of the eighteenth century about whom the pool of knowledge is significantly deeper. Although the scholar who looks for a detailed account of the artist's activities on which to devise a month-by-month chronology of his development will inevitably be disappointed, the sheer number of contemporary memoirs of Watteau, and the intimacy of these remembrances, is exceptional. Something in the character of the man and his work seems to have compelled his closest friends to commit his story to paper.

All the early biographers allude to Watteau's eccentric behavior and changeable personality. He moved house continually and for no good reason; he was independent, restless, and "dominated by a certain spirit of instability."[62] He was moody, "caustic but also timid," "cold and indifferent to people he did not know," and could be alternately shy or

aggressive with the curious strangers who sought him out after his initial success.[63] Yet he "had an upright heart" and could be childlike in his enthusiasms; he had a quick intelligence, was widely read, and was "an acute, even fastidious, judge of music and the arts."[64] He is everywhere described as melancholic and morose, qualities that may have been exacerbated by his declining health. Gersaint said that Watteau "had a wanton, truant wit" but that his "conduct was virtuous."[65] Caylus mentioned the artist's fondness for women and "his taste for love," but struck this line from the final draft of his text.[66] Watteau's friends were quick to contrast his troubled and contradictory personality with the gentle and pastoral entertainments that he painted. He worked ceaselessly, and Caylus, who had rented rooms where he and Watteau would go to draw from the model, observed that it was only there—"in these retreats, consecrated exclusively to art, free from all importunities"—that the artist, "so morose, so splenetic, so timid, so caustic everywhere else," was "purely the Watteau of his pictures, an artist, that is to say, such as they evoke: tender, agreeable, faintly bucolic [*un peu berger*]."[67]

These writers assume universal consensus on two matters: the absolute originality of Watteau's genius and the greatness of his drawings. Although praise was lavished on the artist's early military scenes, and on his depictions of characters from the French theater and the *commedia dell'arte*—which were found to be so true to nature, finely composed and lively in color—it was necessary to concede that his efforts in the latter genre were inspired by the example of Claude Gillot. Clearly Watteau's claim to originality lay principally in his having invented the *fête galante*, and it would appear that, to his contemporaries, the novelty of the genre was so evident as to require no further explanation. Modern historians regularly cite prints by Bernard Picart (1673–1733) and Claude Simpol (1666–1716) that depict the manners and costumes of contemporary society in the first decade of the eighteenth century as precedents for Watteau's modish

creation, but the names of those artists are never mentioned by Watteau's contemporaries; to the friends who chronicled his career, Watteau's genre was thoroughly his own.[68]

Watteau's first biographers take obvious delight in the finest of his paintings and recognize his singular achievement, yet it is evident that several of them have difficulty in reconciling the subject matter and manner of his paintings with their own expectations of the requirements of "high" or serious art. Caylus was himself a member of the Academy and, as he grew older, increasingly a proponent of history painting in the grand manner; thus it comes as little surprise that, in the prefatory remarks to the "Life of Watteau" that he delivered to the Academy on February 3, 1748, he would reassure his audience that "aware as I am how great an effort is required of nature for the production of a great historical painter, I shall certainly not imitate the enthusiasm of those who compare the authors of a few Spanish *nouvelles*, a few little plays given at the Italian Comedy, with M. de Thou or Pierre Corneille."[69] Later in his lecture he observed, famously, that Watteau's compositions are compromised by having no proper subject: "They do not express the activity of any passion, and are thus deprived of one of the most affecting aspects of painting, that is, of action."[70] Even Gersaint did not resist entirely the grip of anti-Rococo sentiment, apologizing in his 1744 biography that, "with regard to his works, we must regret that his early studies were not devoted to history painting, and that he did not enjoy a longer life; we may presume that he might have become one of the great French Painters."[71] And Jullienne, as early as 1726, noted defensively that Watteau "left a few historical pieces, whose excellent taste shows well enough that he would have been equally successful in this genre if he had made it his principal objective."[72]

If they were not entirely at ease in welcoming the artistic revolution introduced by Watteau's little pastoral paintings, his contemporaries had no such reservations about the

lasting value of his drawings: "In the drawings of his best period, that is to say, after he had left M. Crozat, there is nothing superior to them in their kind; subtlety, grace, lightness, correctness, facility, expression, there is no quality that one might wish for which they lack, and he will always be considered as one of the greatest and best draftsmen that France has ever produced."[73] According to Gersaint, Watteau himself was more satisfied with his drawings than his paintings. "It was, for him, a greater pleasure to draw than to paint. I have often seen him out of temper with himself because he was unable to convey in Painting the truth and brilliance that he could express with his Pencil."[74]

As with Watteau's paintings—and indeed his life—there are few secure dates to guide us in an assessment of his development as a draftsman. We are told that Watteau drew relentlessly from his earliest youth in Valenciennes, "and he took advantage, at this period, of his free time to go and sketch, in the main square of the town, the various comic scenes with which quack doctors and other itinerant charlatans would regale the public. Perhaps that occasioned his long-held taste for pleasant and comic subjects, despite the sad character that was dominant in him."[75] Not a single drawing (or painting) has been dated to the period before he left Valenciennes, but a rapid sketch made in red chalk (fig. 3), now in the Ashmolean Museum, Oxford, represents the sort of subject that first captured the boy's imagination. A self-confident quack, standing on a plank, pitches his wares to the small audience that has gathered; behind him, two monkeys sit atop a roughly improvised stage curtain. The drawing of the figures in the crowd is clumsy, and the sketch must be from very early in Watteau's career.[76] This and the several dozen drawings that most closely mimic Gillot's style are probably Watteau's earliest surviving drawings, dating from the period 1705–08, when he was working in Gillot's shop and strongly under his influence.[77]

Gillot was eleven years older than Watteau and arrived in Paris from his native Burgundy in the early 1690s to

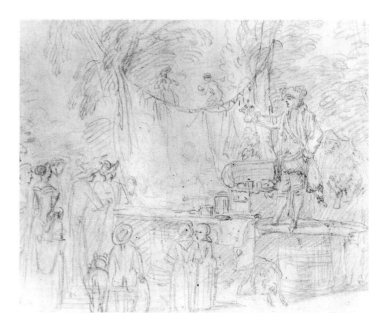

Figure 3. Antoine Watteau, *The Mountebank, ca.* 1705–08. Red chalk, 7 × 9 in. (17.7 × 22.8 cm). Ashmolean Museum, Oxford

complete his artistic education in the studio of the history painter Jean-Baptiste Corneille (1649–1695). He seems to have absorbed nothing of his master's taste for heroic, Bolognese-inspired melodrama, although Gillot's career is undocumented from 1695, when he must have struck out on his own following Corneille's death, until 1710, when he was accepted as an associate member in the Academy. Gillot's known works, which include drawings, paintings, and prints, treat popular *bamboccianti* subjects, costume pieces, bacchanals, and fantastic and grotesque decorations.[78] However, by the time Watteau was working with him, according to Caylus, he confined himself principally "to the representation of themes from the *commedia dell'arte*."[79] As was the case with Watteau, the Academy appears to have recognized and admired Gillot for the theater scenes at which he excelled, despite the fact that they did not fit easily into its hierarchy of genres. *Christ at the Time He was about to be Nailed to the Cross* (Corrèze, Eglise de Noailles), the

reception piece he submitted to the institution in 1715, is his only known religious painting; however, it was as a "painter of modern subjects" that he was granted full membership.[80]

All the early biographers acknowledge the importance of Gillot's influence on the development of the young Watteau's style and choice of subject matter. As Watteau may have launched his career in Paris working for a scene-painter, it was natural that he would have been drawn to the art of Gillot, who himself designed sets and costumes for the Paris Opéra. While Watteau certainly arrived in Gillot's shop already harboring an affection for the rough-and-tumble traveling theater of the day—as the Oxford drawing of a charletan confirms—it was probably his encounter with Gillot that convinced him it would be possible to build a successful career on depictions of characters from the Italian Comedy. After 1697, when the Italian Comedy, or *commedia dell'arte*, was banished from Paris by royal decree, Gillot regularly attended their performances held at the popular fairs of Saint-Laurent and Saint-Germain, on the edges of the city; although passed over in silence by his biographers—the popular theater still having a slightly unsavory flavor—we can presume that Watteau did as well.[81]

A delightful ink-and-wash drawing by Gillot (fig. 4) records one of these performances and testifies to his distinctive manner of drawing. The subject was inspired by a three-act pantomime by Fuzelier called *Jupiter, curieux impertinent,* which was performed at the Foire Saint-Germain in the summer of 1711. Ironically, the nervous pen-work and strong contrasts of light and shade created by the virtuoso handling of sanguine wash may reveal his sole debt to his master, Corneille, whose Baroque history drawings evince similar characteristics. Typical of Gillot's style are the elongated, almost weightless figures with tiny, pinched faces and tapering arms and legs—reflecting the French Mannerist tradition of Jacques Callot—placed in shallow stage settings that emphasize the figural frieze.[82]

Unlike his mentor, Watteau drew only in chalks and, until

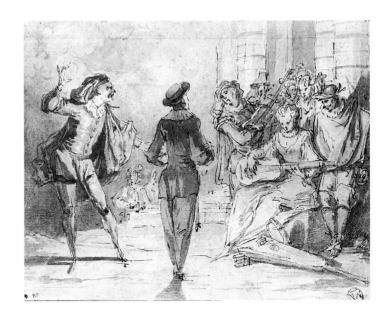

Figure 4. Claude Gillot, *Actors Performing the Play "Jupiter, curieux impertinent,"* ca. 1711–20. Ink and wash, 6⅝ × 8½ in. (16.8 × 21.5 cm). Musée du Louvre, Paris

at least 1712, seems to have drawn in red chalk exclusively. Gillot also worked in red chalk (see cat. no. 56), but he was more experimental in the media he employed, and a great number of his drawings are in ink, brown and black washes, and even gouache. While none of those drawings is ever attributed to Watteau—for obvious reasons—a number of the red-chalk drawings from this period have had their attributions vigorously debated for many years; in some cases, a conclusive attribution to Gillot, Watteau, or some other member of Gillot's studio may never be possible.[83] A small red-chalk study of an actor (fig. 5) in the Louvre would almost certainly be regarded as the work of Gillot if a counterproof of the drawing, acquired by Count Tessin when he visited Watteau in 1715 and inscribed on the bottom with Watteau's name, were not in the Nationalmuseum, Stockholm; the drawing bears an uncanny similarity to sketches of actors in the *commedia dell'arte* by Gillot, presumably made at the same time (see fig. 6).[84] Likewise, *Children Imitating a Triumphal Procession* (cat. no. 1)

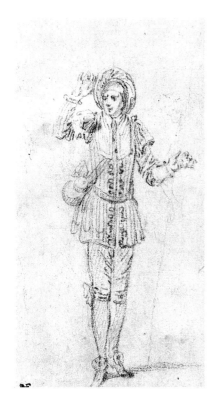

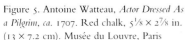

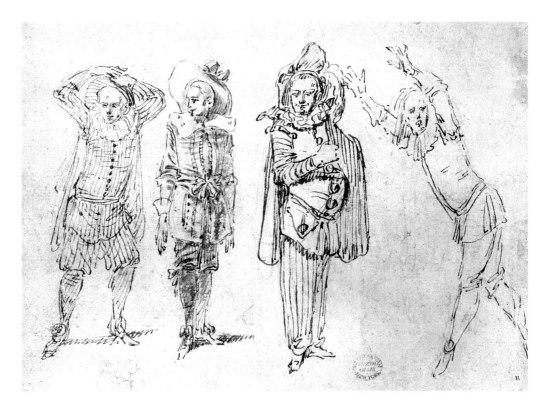

Figure 5. Antoine Watteau, *Actor Dressed As a Pilgrim*, ca. 1707. Red chalk, 5⅛ × 2⅞ in. (13 × 7.2 cm). Musée du Louvre, Paris

Figure 6. Claude Gillot, *Four Figures in Theatrical Costume* ca. 1705–10. Pen and brown ink, red chalk, 5½ × 7⅞ in. (13.8 × 20.1 cm). The Metropolitan Museum of Art, New York; Rodgers Fund, 1909

and *Allegory of Spring* (Art Institute of Chicago) would be hard to recognize as from Watteau's hand if they had not both been engraved as his work in the early eighteenth century. The flattened figures with their button noses, pinched features, and weightless, attenuated forms, the even handling of the chalk, and the rapid, repetitive notations that evoke the foliage make these drawings almost indistinguishable from some of Gillot's bacchanals in red chalk.[85]

Although early on Watteau would pattern his figure types on Gillot's, they would rarely reach the same heightened level of Mannerist stylization, and both Jullienne and Dezallier d'Argenville praised Watteau's "more natural manner," which they attributed to the assiduousness with which he drew from nature and the live model, and copied the old masters. In his maturity, Watteau rarely drew anything except individual figure sketches from the live model, virtually abandoning compositional studies and any sort of drawing inspired by the imagination, rather than direct study from life. In this he differed fundamentally from Gillot, whose airy comedies seem rarely to have depended on posed models. Traces of Gillot's figure style reappear with some regularity in Watteau's drawings into his early maturity, but after about 1712 it is only in his extremely rare compositional drawings, when Watteau was forced to work from his imagination alone, that Gillot's manner would fully reassert itself (see fig. 7).[86]

A famous drawing in the Pierpont Morgan Library

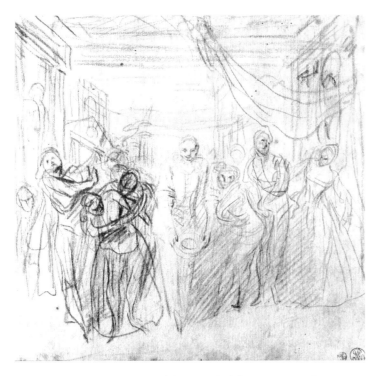

Figure 7. Antoine Watteau, *Actors of the Commedia dell'arte Bowing on a Stage, ca. 1719–20.* Red chalk and graphite on cream paper, 7 × 7¼ in. (17.8 × 18.5 cm). Private collection

(cat. no. 2), made when Watteau was still strongly influenced by Gillot, seems to demonstrate the differences in Watteau's style when he worked from memory and when he drew from the model. In the upper register of the drawing are four theatrical characters in amusing costumes rendered in a manner reminiscent of Gillot's slender figure types, and they can be assumed to have been made near the end of Watteau's time with the artist. The lower register shows two men—or, more properly, one man posed twice—seated on the ground. The slightly larger scale of the latter sketches lends the impression that all of the figures on the sheet occupy the same space, and that the seated men are simply closer to the foreground; but it is likely that the lower register was drawn sometime after the other figures—perhaps as long as two or three years later. The

figures at the bottom of the page are more animated than those at the top, their poses more complex but also more natural, their foreshortening more sophisticated, and their faces more individualized. While this reflects the artistic maturation to be expected after the passage of several years, it is almost certainly the result as well of a greater level of engagement on the part of the artist when he was drawing from a live model: it has long been surmised, correctly in my view, that the upper figures were drawn from Watteau's memories of stock theatrical types, while the lower figures were studied from life.[87]

The pilgrim with a flowering staff on the upper left of the Morgan Library sheet, and the preening Bacchus on the upper right, are closely associated with one of Watteau's few surviving decorative paintings, *The Faun (Le Faun*; fig. 8). It was one of a series of eight arabesques, later engraved by Pierre Aveline, that decorated a room in the Hôtel de Nointel, a residence on the rue de Poitiers acquired by the marquis de Nointel in 1705, and presumably decorated shortly thereafter. *The Faun* and *The Cajoler (L'Enjoleur)*, another panel from the same room, almost certainly date from around 1707–08, the period when Watteau worked in the studio of Claude III Audran.[88] Little is known of the workings of Audran's shop, although it was a large firm and employed a team of painters and artisans. Nothing of Audran's production—which included commissions at the royal châteaux at Versailles and Marly—long survived the changing fashions in interior decor. Although Watteau probably first learned ornamental design from Gillot, it was while he was in Audran's shop, according to Caylus, that his "taste for decoration was formed and that he developed the lightness of brushwork required by the white or gilded backgrounds on which Audran's designs were carried out."[89] Jullienne remarked that Audran was a master who kept Watteau "busy making figures in his works and whose good taste served not a little to give him new inspiration."[90] Watteau was responsible for painting the graceful figures in

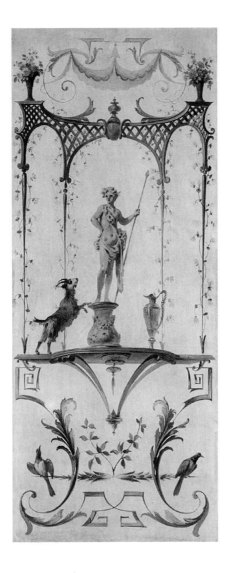

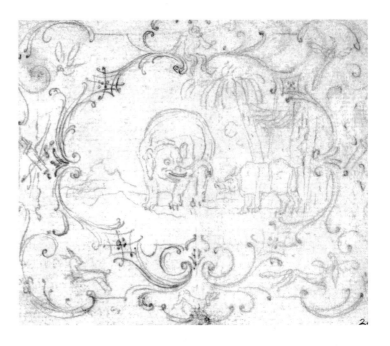

the Hôtel de Nointel decorations, but the tightly painted arabesque enframements were probably executed by another painter trained in that specialty, as Jullienne's comment would indicate.

While all of Audran's decorative schemes have been destroyed, several thousand preparatory studies by the artist and the members of his studio were saved after his death and are today in Stockholm.[91] Even though Audran's own drawings are inventive and sometimes witty (see fig. 9),

Watteau would have had nothing to learn from his dry and mechanical technique. There have been attempts, of course, to find Watteau's hand in some of the Stockholm sketches, but none of these exhibits the fluency and freedom we expect from Watteau, even at this early point in his career.[92] Surely, however, an artist and businessman as astute as Audran would have encouraged a draftsman of Watteau's inventiveness to develop his own designs. Several ornamental drawings that can be securely attributed to Watteau are known, but they appear, based on their advanced style and accomplished handling, to postdate his period with Audran.[93]

One red-chalk arabesque that probably reflects Watteau's manner when he worked with Audran is *The Gallant Gardener* (fig. 10). Etched by François Boucher for *Les Figures de différents caractères*, Jullienne's compendium of prints made after drawings by Watteau and published between 1726 and 1728, the drawing probably dates from around 1711 or 1712, immediately after the artist's return from Valenciennes— approximately the time, according to the abbé Leclerc, when he was finishing a brief second term of employment with

Figure 10. Antoine Watteau, *The Gallant Gardener*, ca. 1711–12. Red chalk on laid paper, 9 × 7⅛ in. (22.9 × 18.1 cm). National Gallery of Art, Washington, D.C.; Ailsa Mellon Bruce Fund

Audran. Although the sheet has been cut on all four sides, enough of the decorative surround remains to make clear how much more pictorially integrated Watteau's ornamental designs had become since his earliest exercises in the genre.[94] Now the central motif is a complete landscape setting in which a gardener and his lady love play subsidiary roles to a great sinuous tree, its curving branches creating a natural arabesque, while the acanthus leaf surround that Audran popularized—itself a revival of ancient Roman design favored by Renaissance artists such as Giulio Romano—is

replaced with a completely organic enframement in the form of a gently arching trellis of vines. Many of the elements central to Watteau's *fêtes galantes* can be seen to coalesce in these ornamental works.

Few of Watteau's decorative drawings have come down to us, though more than forty are known from engravings, and it is clear from the extraordinary ease and ambition of the two greatest surviving examples—*The Bower* (cat. no. 9) and *The Temple of Diana* (cat. no. 10)—that he continued to make them well into his maturity, developing as an ornamental draftsman years after he left Audran's employ.[95] Is it possible that Watteau continued to supply designs for Audran or other ornamental painters throughout his career, and that the fact went unrecorded by his contemporaries? The general disregard in which this sort of work was held might have prompted his biographers to pass over it in silence: Caylus confessed that it was only "with some regret" that he spoke "with a kind of admiration of [Audran's] work," for its popularity deprived serious painters from exercising their "talents in a branch of art that encourages the expression of what is noble and heroic."[96] Or did Watteau make these complex and carefully realized sheets primarily "to stretch his fingers"? Perhaps he continued to find in them a wellspring of ideas that stimulated his imagination and fed the *fêtes galantes*, paintings he almost always worked out directly on the canvas, without recourse to compositional designs.

Watteau's admission into the Academy as an associate member in July 1712 proved something of a watershed in his career. With the honor came acclaim and the concomitant attentions of collectors, dealers, and established painters. It legitimized his ambitions to produce easel paintings for the Parisian market and introduced him to new artistic circles. The precise timing and sequence of events is uncertain, but soon after his acceptance he met and was befriended by the comte de Caylus; Charles de La Fosse took an interest in him, becoming a mentor and champion; and he was

introduced to Pierre Crozat, probably through La Fosse, who himself enjoyed Crozat's protection and had lived under his roof since 1708.[97] The consequences for Watteau's draftsmanship were no less momentous. Exposure to connoisseurs and collectors of the stamp of Caylus and Crozat—and to the treasury of old master drawings that were being assembled in these very years—inspired Watteau to begin drawing with the new amplitude and monumentality that characterize what Gersaint later referred to as his "best period."

Watteau's experiences of the previous few years had laid the groundwork for his evolution in style. He had had ample opportunities while working with Audran to study the vast, magisterial canvases of his Flemish predecessor Peter Paul Rubens, and was by all accounts dazzled by their rich colors and complex but natural compositions. He tried his hand at history painting, as is evident from his recently rediscovered oil sketch of *Louis XIV Bestowing the Cordon Bleu on Monsieur de Bourgogne* (Warsaw, Muzeum Narodowe), which was based on a drawing by Antoine Dieu (*ca.* 1662–1727); and his brief return to Valenciennes, away from the orbit of Gillot and Audran, seems to have elicited a new naturalism in his drawings.[98] This trip coincided with the devastating famine of the winter of 1709–10, and the studies that he made of exhausted and bored soldiers resting between skirmishes (cat. no. 4) or on sentry duty, and of the loyal wives and mothers who followed their encampments (cat. no. 3), demanded his most careful attention. These quick sketches—many of which are used in his earliest military paintings such as *The Portal of Valenciennes* (New York, Frick Collection) and *The Bivouac*—are intensely empathetic and Watteau was careful to record the precise movements, postures, and expressions of the subjects he had captured, perhaps unawares.[99]

Paradoxically, the naturalism of Watteau's mature style would depend on more than simply direct confrontation with quotidian subject matter, as Pierre Rosenberg demonstrates in his essay in this book; essential here was his experience of Crozat's collection of old master drawings, one of the largest and most celebrated in Europe. Crozat had begun collecting towards the end of the seventeenth century, and by the time of his death in 1740 he had amassed more than nineteen thousand sheets, mostly of the Italian school, with many acquired through the wholesale purchase of collections such as that of the theorist and connoisseur Roger de Piles. Ironically, Crozat owned only nine drawings by Watteau, all of them bequeathed by the artist at the time of his death, "in grateful recognition of all the kindness he had received from him."[100] One of the reasons that Watteau took up residence with Crozat, according to Gersaint, "was his knowledge of the priceless collection of drawings in the possession of the connoisseur; he took advantage of it with avidity, and his only pleasure was in studying continually, and even copying, all the fragments of the greatest masters which it contained."[101]

According to Mariette, Watteau systematically copied the 122 landscape drawings by Domenico Campagnola that were in Crozat's collection; approximately twenty of Watteau's copies of landscape drawings by Campagnola and other followers of Titian are known today (see cat. no. 15).[102] A drawing in Princeton (cat. no. 16) and another in the Metropolitan Museum of Art are based on extant drawings by Campagnola, and allow for a closer consideration of Watteau's methods as a copyist. Whereas the original Venetian drawings, such as *Landscape with an Old Woman Holding a Spindle* (also in the Metropolitan Museum of Art) were, in the main, executed in pen and brown ink, Watteau's copies are all in his preferred medium of red chalk. Although he generally reproduced the originals quite faithfully, he did not attempt to copy every pen stroke: he eliminated mistakes, stray lines, and pentimenti; he also left out inconsequential figures on occasion, or elements of staffage, focusing his attention instead on reproducing the structural organization of buildings and the shaping of land, attempting to learn the characteristic ways in which Titian,

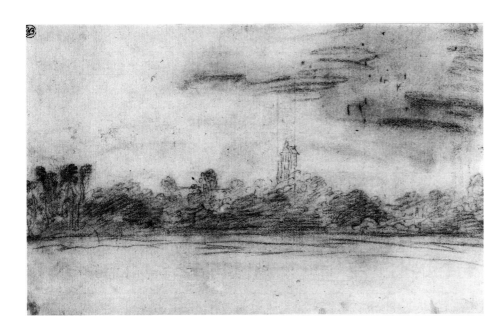

Figure 11
Antoine Watteau, *Landscape with a Tower*, ca. 1718–19. Red chalk, 6⅞ × 11¼ in. (17.3 × 28.4 cm). Städelsches Kunstinstitut und Städtische Galerie, Frankfurt am Main

Campagnola, and other Venetian draftsmen built up their compositions. One can see in his copy how Watteau imitated Campagnola's curving, parallel pen strokes in red chalk, thereby softening their effect and intensifying the atmospheric quality of his drawing. These firm, discrete strokes differ appreciably from the diaphanous technique he employed in his few known landscape studies from nature (see cat. no. 44b; and fig. 11).[103]

Watteau's careful copying taught him how the masters of the pastoral tradition created landscapes with hills that rose and fell in gentle rhythms, and how they gave mass and weight to buildings and devised spatial relationships that were fluent yet almost measurable. The landscape settings of his *fêtes galantes* are dominated by airy mountains, the inspiration for which was found in their works. Occasionally, motifs from his copies would be transplanted directly into a painting, as when a castle and a watermill from a copy of Campagnola in the Art Institute of Chicago reappear in the background of *The Love Lesson* (*Leçon d'amour*) in the Nationalmuseum, Stockholm; such transpositions, however,

are exceptional.[104] In general, the copies seemed to provide Watteau with indirect inspiration, perhaps as his ornamental drawings did, serving as substitutes for the compositional drawings he abjured: they became a means of penetrating art and nature and uncovering their secrets, which, once learned, provided the foundations for the *fêtes galantes*.

Clearly, Watteau's copies of Venetian landscapes, like his copies of figure drawings by Jacopo Bassano, Federico Zuccaro, Domenico Fetti, and Paolo Veronese (see cat. no. 19), substituted for the Italian education denied him by the Academy. Crozat, Caylus, and La Fosse would all have encouraged his interest in such exalted models, as would the writings of Roger de Piles, the ardent Rubéniste who, until his death in 1709, had been the leading advocate of colorism and *chiaroscuro* within academic practice. In the debate that raged within the Academy about the relative importance of color and design, de Piles advanced Rubens as the ideal: an artist possessed of every academic skill, who was also an unsurpassed colorist.[105] Watteau's campaign to copy the Rubens drawings in Crozat's collection (including some of

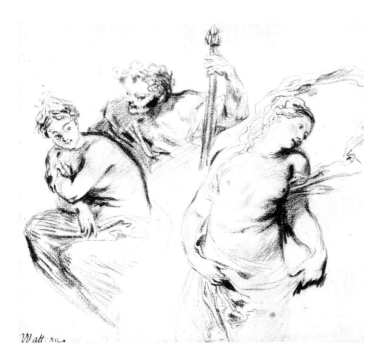

Figure 12. Antoine Watteau, after Rubens, *Three Mythological Figures (Ariadne, Bacchus, and Venus)*, 1710–12. Red chalk, 6⅜ × 7¼ in. (16.3 × 18.3 cm). The British Museum, London

the ninety-four sheets by Rubens and his assistants contained in an album acquired from the collection of de Piles) might have renewed his interest in studying Rubens's paintings as well, in particular the *Marie de Médicis* cycle that had first captivated him during his time with Audran.[106] Although he must have made drawings of it then, none of his early copies of the cycle survives; those that do must date, on the basis of style, from his early maturity. Thus, a drawing such as *Three Mythological Figures (Ariadne, Bacchus, and Venus*; fig. 12), which reproduces, with some variation, three figures from the twelfth painting in the cycle, *The Government of the Queen*, may have been made around the time Watteau began to copy Crozat's drawings.[107] The figures in Watteau's sketch are flatter and less robust than those of Rubens's painting, as well as younger and more playful, yet the study displays a greater sense of monumental form than had thus been

encountered in his work.

That Watteau selected for reproduction the only three seductive characters from a vast Baroque canvas, peopled by nearly thirty figures, is typical of his method. Just as his mature drawings consist almost exclusively of individual figure studies, drawn in isolation and devoid of surroundings or context, so do the drawings that are the copies made from old master paintings. With regard to Watteau's copying, Caylus observed that "since it is natural to consider things in relation to their possible usefulness," he gave his attention to "fine inventions rather than to those other qualities of arrangement, composition, and expression in the works of the great history painters whose talents and purposes were so remote from his own. These he was content to admire without seeking to adapt himself to them by any special course of study, from which, indeed, he would have derived scant advantage."[108] The same selectivity and economy is found in one of Watteau's first drawings in *trois crayons*, which—and this is not without significance—is also a copy: the *Sheet of Studies: Four Faces and Three Figures, after Rubens's "Marie de Médicis" Cycle* (cat. no. 17). Here, Watteau brought together on one sheet studies from two different canvases in the Luxembourg cycle: a group of three standing figures taken from *The Disembarkation of Marie de Médicis* and four studies of heads from *The Coronation of Marie de Médicis*. The standing queen and two members of her entourage are rendered in Watteau's usual red chalk. The fawning urgency of the courtier who takes her arm is captured with particular subtlety, and Watteau maximizes the effect by contrasting it expertly with the regal and self-contained pose of the queen. Watteau's primary concern, however, was to imitate the shimmering folds of their costumes, and he no doubt eliminated the outstretched arm of a subject who curtsies before the queen in Rubens's painting because it interfered with the elegant lines of the drapery. The study of Rubens's manner of re-creating silk was especially applicable to Watteau's own art; as Caylus noted, Watteau "hardly ever

painted other stuffs than silk, which always falls in small folds."[109]

What is remarkable about Watteau's drawing, however, is the inclusion below the standing figures of four head studies in *trois crayons*, the first example we have seen of the artist working in a medium with which his name is synonymous. This was certainly not Watteau's first exercise in using two and three colors of chalk—as we will see, there were earlier experiments of lesser subtlety—but it probably dates from soon after his breakthrough. One can sense how naturally Watteau took to the medium and how effortless he made its complicated demands appear. The heads of the two women were first lightly sketched in with red chalk, then black chalk was firmly overlaid to elaborate their hair and jewelry and to stress the accent points on their faces: pupils, eyebrows, nostrils. The delicate flesh of the woman who leans forward was evoked with warm tones of red chalk only, whereas the recessed position of the woman beside her is made immediately clear by the application of very gentle strokes of black chalk over red, which indicate that she is in shadow. White-chalk highlights were applied very sparingly, and the glow of the women's flesh was obtained principally by employing the bare paper to provide the lightest values. In his development of a three-chalk technique, Watteau seems to have embraced black chalk with particular enthusiasm while initially employing white chalk with some hesitancy.

The two male heads are handled more roughly. The head on the left was laid in with red chalk, while black was used to strengthen his beard and fringe of hair; Watteau completed the study by going over the facial features again entirely in red. The gruff face on the right was barely indicated in preliminary red-chalk outlines, then worked up principally in black; only the glow of his ruddy skin is rendered in red, while the sharp hollow of his cheekbone is set off with a few vigorous strokes of white. The head studies were thoughtfully arranged around the standing figures, and it is probable that Watteau added them some time after

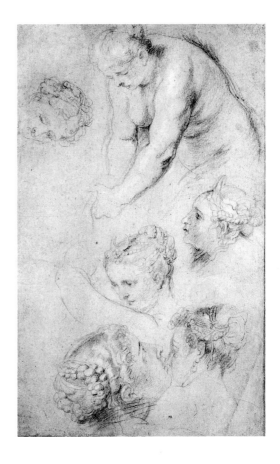

Figure 13
Peter Paul Rubens, *Studies of Women*, 1628. Black, red, and white chalks, lower right-hand corner replaced, 17¹¹⁄₁₆ × 11³⁄₈ in. (44.9 × 28.9 cm). The J. Paul Getty Museum, Los Angeles

completing the initial red-chalk sketch. In isolating motifs from larger compositions, Watteau transformed Rubens's Baroque opera into a more personal, introspective poetry, though without sacrificing the painting's grace or nobility. In the process, he unconsciously emulated Rubens's own practice, as displayed in the Flemish artist's ravishing *trois crayons* sheet of figure studies copied from three of Titian's celebrated mythological paintings in the Spanish royal collections (fig. 13).[110]

Watteau was by no means the first artist of the eighteenth century to draw in *trois crayons*. The drawings by La Fosse in this technique are also deeply indebted to his study of Rubens as well as to the five years he had spent working in Venice (1658–63). With La Fosse's ascendancy to the highest

ranks of the Academy—accompanied by his fellow Rubéniste Antoine Coypel (1661–1722)—the three-color technique was legitimized for history painters.[111] But it seems that it was primarily Watteau's intense study of Rubens's drawings in red, black, and white chalks in the Crozat collection, and only secondly the example provided by La Fosse and Coypel, that inspired Watteau around 1715 to pick up a second, then a third color of chalk. The first time he expanded on his usual red-chalk technique seems to have been in a group of drawings of Persians that, with good reason, can be dated to the early part of that year. Nine of these drawings are known, each depicting a standing or seated male dressed in Persian costume, one of them in red chalk only, seven in red and black chalks, and one in *trois crayons* (cat. no. 12). The group is stylistically coherent, and several of the drawings give the appearance of having been made as portraits. One of the sheets (fig. 14) bears on its verso an inscription in an old hand that identifies the sitter as the Persian ambassador Mehemet Riza Bey, intendant of the province of Erivan; Bey headed an embassy that arrived in Paris, to much fanfare, on February 7, 1715. Unfortunately, as the ambassador was fully bearded—a fact confirmed in contemporary prints—the identification of the drawing is unlikely. However, it has been generally assumed that the sitter, like all of the other subjects of this series of drawings, was a member of this same delegation. It is not known how Watteau gained access to the visitors, but this could have been arranged through Coypel, who was commissioned to make a painting recording the ambassador's audience with Louis XIV.[112]

In the Louvre drawing, Watteau conveyed his sitter's imposing form and self-certain posture with complete authority, but he did not fail to capture something gentle and even diffident in his expression. As in comparable red- and black-chalk studies of exotic models by Rubens—for example, the portrait of a man in Korean costume (fig. 15)—Watteau's Persian studies linger with curiosity over each aspect of the model's foreign appearance and colorful attire. With his lifelong love of costume, Watteau could hardly fail to have been fascinated by the Persian's extravagant dress, and he took obvious delight in exploiting its full decorative potential. Yet, as in Rubens's drawing, there is no hint of mockery or condescension in the attitude taken to his sitter, whose humanity and individuality are respected.

The Louvre sheet, like several of the Persian drawings (see cat. no. 13), was obviously first brought up to a state of near completion in red chalk alone, before Watteau went back to add accents in black chalk, almost as an afterthought. Although the Persian drawings are both decorative and powerful, and stand among the artist's most appealing works, they make it evident that Watteau was at first uncertain how to integrate fully the different chalks that he used. By including strokes of black chalk in faces and red chalk in drapery, he was already moving beyond his mentors, who had attributed to each color a distinct purpose: La Fosse, for example, used colors to underscore content, as painters did, reserving his red chalk for flesh tones almost exclusively.[113] But Watteau was still not capable of making the sort of continuous, flickering shifts among the three chalks that would become the hallmark of his mature style.

A second group of drawings, also datable to 1715, offers points of comparison to the Persians. These fourteen studies of Savoyards and other lowlife—or "popular"—figures were made in the same technique as the Persians, with Watteau having overlaid black-chalk accents on essentially complete red-chalk studies. Several of the drawings, notably *The Old Savoyard* in Chicago (cat. no. 14), are large-scale and monumental in presentation. Beyond their technique, the Savoyard drawings seem to be linked to the Persian series by the "exoticism" of their subject and the compassion with which they are presented. Savoyards appeared often in French art of the seventeenth and eighteenth centuries, as thousands of poor and ragged natives of Italian Savoy made annual migrations to the capitals of Europe to seek

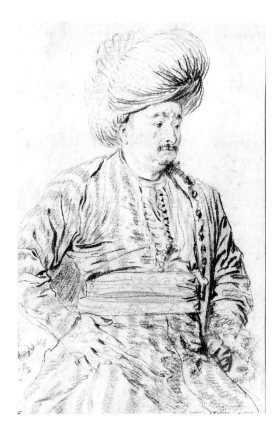

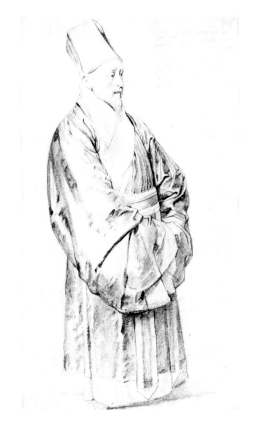

employment as chimney-sweeps, blade-sharpeners or—like Watteau's old man, with his marmot case and curiosity box—street entertainers.[114] Watteau's affection for performers, no matter how humble, permeates the drawing, which follows in the long tradition of depicting popular types traceable back to Callot. The quiet dignity with which the model was portrayed almost certainly reflected Watteau's admiration for the art of the Le Nain brothers, whose paintings he is known to have copied around this time.[115] As with the Persian series, these drawings do not seem to have been intended as preparations for paintings; rather, as exercises in intense observation, dedicated to achieving a rigorous naturalism, they were an essential requirement for Watteau's graduation to the next and most glorious phase of his development.

The year 1715 was to be Watteau's *annus mirabilus*, when, in Donald Posner's words, "Watteau crossed the boundary that in art separates men of high professional competence, and even originality, from those geniuses who are able to create new worlds of vision."[116] He had labored in Paris for more than a decade, worked as a journeyman painter and ornamental designer, studied the old masters, drawn from nature, apprenticed with one of the most unconventional artists of the day, and received counsel from the grand old men of the Academy. The moment had arrived when his new technical prowess enabled him to give perfect form to the ideas he had been nurturing throughout his career. The elegant *tableaux de mode* he had been fashioning for several years, such as *La Conversation* (fig. 16)—with its relatively accurate and straightforward depiction of the manners, dress,

and contemporary amusements of a certain Parisian elite, around 1714—soon evolved into the timeless comedies of romantic love that came to be called *fêtes galantes*.[117] In *La Perspective* (fig. 17), probably painted in 1715 and set in the gardens of Crozat's château at Montmorency, couples stroll along the grounds, slip into the woods, and make music. Two solitary women gaze across a reflecting pool to Crozat's open-air *maison de plaisance*. The revelers wear "fancy dress," or costumes inspired by the theater. Cunningly, Watteau transformed carefully observed reality into fantasy. A house, a pool, and some overgrown trees emerge from Watteau's brush imaginatively reconfigured into an enchanted palace, a symbol of romantic longing, shimmering in the distance beyond a mythic isle of love.[118] "Caresses are dreamily exchanged, words lull the spirits," wrote the Goncourts of the mood of languorous nostalgia that is the atmosphere of the *fête galante*. "In the recesses of Watteau's art, beneath the laughter of its utterance, there murmurs an indefinable harmony, slow and ambiguous."[119]

Although Watteau did not as a rule make drawings as studies with particular paintings in mind, the predominant place that *fêtes galantes* would occupy in his artistic production would necessitate having at his disposal a body of sketches suited to this new genre. He would surely have devoted much time and energy to drawing in his new three-color medium the cavaliers, clowns, and graceful ladies who are the cast members of his pictorial theater. In a famous account, Caylus described Watteau's method of drawing and composing his paintings:

> The exercise of drawing had infinite charms for him and although sometimes the figure on which he happened to be at work was not a study undertaken with any particular purpose in view, he had the greatest imaginable difficulty in tearing himself away from it. I must insist that in general he drew without a purpose. For he never made an oil sketch or noted down the idea, in however slight or

Figure 16. Antoine Watteau, *La Conversation*, ca. 1714. Oil on canvas, 19¾ × 24 in. (50.2 × 61 cm). The Toledo Museum of Art; Purchased with funds from the Libbey Endowment, Gift of Edward Drummond Libbey

Figure 17. Antoine Watteau, *La Perspective*, ca. 1715. Oil on canvas, 18⅜ × 21¹³⁄₁₆ in. (46.7 × 55.3 cm). Museum of Fine Arts, Boston; Maria Antoinette Evans Fund

summary a form, for any of his pictures. It was his habit to do his drawings in a bound book, so that he always had a large number of them that were readily available. He possessed cavalier's and comedian's costumes in which he dressed up such persons as he could find, of either sex, who were capable of posing adequately, and whom he drew in such attitudes as nature dictated and with a ready preference for those that were the most simple. When he took his fancy to paint a picture, he resorted to his collection of studies, choosing such figures as suited him for the moment. These he usually grouped so as to accord with a landscape background that he had already conceived or prepared. He rarely used them in any other way.[120]

The idea of posing models and drawing them without a particular composition in mind was entirely different from the method of La Fosse, Coypel, or any classically trained painter of the period and flew in the face of academic convention. For Watteau, drawing was like note-taking, to be filed away for future reference, but his way of working would have been possible only in an essentially subjectless genre like the *fête galante*. Caylus's criticism that Watteau's paintings were devoid of "action" must be understood to mean that they are without legible narrative. It is worth considering here whether Watteau's improvisational method of composing the *fêtes galantes* grew out of his experience in Audran's shop, where his role was to develop appropriate figures to be inserted harmoniously into decorative settings designed by other painters.

A sketch of one of the models whom Watteau dressed from his trunk of costumes (fig. 18) was adapted without change to a small panel painting in Chantilly called *The Guitarist* (*Le Donneur de sérénade*; fig. 19), but this guitarist would also appear in *Gathering in the Open Air* (*La Réunion en plein air*), the large *fête galante* in Dresden, and again in *La Surprise*, a lost painting known from an engraving (fig. 50,

p. 53).[121] Although Caylus complained that Watteau "repeated, on many occasions, the same figure without being aware of it," the practice was surely not the result of carelessness; rather, the artist was happy to exploit, in new contexts, figures that he found especially expressive.[122] The *Seated Guitarist* (fig. 18) is not far removed from the two-color method he had explored in the Persian and Savoyard drawings, but it is executed with more obvious speed. Although it was sketched principally in red chalk, with black chalk added afterward with careful deliberation, we can now sense that Watteau was working with both chalks at once and that the black touches, though few, are integral to the drawing. The same is true in *Two Studies of a Seated Guitarist* (fig. 20), where the touches of black and white are interwoven so seamlessly as to be inconspicuous.[123]

The figure on the right of *Two Studies of a Seated Guitarist* may have served as the model—minus beret—for the seated guitarist in the painting *La Perspective*. A splendid sheet of studies of a couple seated on the ground, in the National Gallery (fig. 21), is also associated with *La Perspective*, although neither figure appears in the final version: radiography of the painting reveals that the man in the National Gallery study originally reclined to the right of the music-making couple, only to be replaced by a seated woman with her back to us in the final composition; why Watteau chose to replace him is unknown.[124] However, the reclining man of the study eventually found his way into *The Family* (*La Famille*; fig. 22); curiously, his partner recurs in no known painting by Watteau, a fact that seems especially odd considering that the harmoniously arranged figures appear to have been conceived in tandem.[125] A sketch of a woman turning to her left and withdrawing from an unseen presence was obviously conceived as a study of two figures as well, but later cut down: the ghostly foot of the man to whom she reacts is still visible (cat. no. 26). She, likewise, turns up in several paintings with different male partners, none of whom positions his foot in a

Figure 18
Antoine Watteau, *Seated
Guitarist Turning Toward
the Left*, ca. 1716.
Red and black chalks on
paper, 10½ × 8⅛ in.
(26.7 × 20.5 cm). Musée
du Louvre, Paris

Figure 20. Antoine Watteau, *Two Studies of a Seated Guitarist, ca.* 1716.
Red, black, and white chalks on brown paper, 9½ × 14⅞ in. (24.2 × 37.9 cm).
The British Museum, London

Figure 19
Antoine Watteau,
*The Guitarist (Le Donneur
de sérénade), ca.* 1716–17.
Oil on wood panel,
9½ × 6¾ in.
(24 × 17 cm).
Musée Condé, Chantilly

Figure 21. Antoine Watteau, *Couple Seated on a Bank, ca.* 1716.
Red, black, and white chalks, 9½ × 14⅛ in. (24.1 × 35.9 cm). National Gallery of
Art, Washington, D.C.; The Armand Hammer Collection

Figure 22
Antoine Watteau, *The Family (La Famille)*, *ca.* 1716–17. Oil on canvas, 16³⁄₁₆ × 12³⁄₄ in. (41.2 × 32.4 cm). Ortiz Collection, Switzerland

corresponding way.[126] Regardless of how Watteau conceived of his figures when drawing them, he judged each individually when determining their appropriateness for inclusion in a particular painting.

Watteau now had an easy facility with all three chalks and was capable of wielding them with unmatched dexterity and versatility: he could make rapid notations, with great freedom, in bold, staccato strokes of thick chalk, as in the sketch of a seated man in the Thaw collection (cat. no. 28); or, using sharp-pointed crayons, he could render the graceful profile of the famous *Seated Young Woman* in the Morgan Library (cat. no. 27) in long, sinuous lines of the utmost delicacy. The dress of the seated woman in the National Gallery drawing (fig. 21) seems almost luminescent, the result of Watteau's ingenuity in calibrating the density of white chalk to be applied over a structure of black underdrawing.

This remarkable drawing also demonstrates the originality of the artist's response to his models, an originality that sometimes disconcerted his contemporaries. The models' hands are too small, their heads too big, their feet doll-like;

moreover, the figures are viewed from an unusual perspective and foreshortened in a way that defies convention but is, somehow, visually convincing. Caylus, in recollecting his days of drawing from the model with Watteau, declared that, as the artist "had no knowledge of anatomy and had never drawn from the nude, he was unable either to comprehend or express it; so much so that the complete rendering of an academy study was for him an exacting and consequently disagreeable exercise. The female body, requiring less articulation, was somewhat easier for him."[127] It is difficult to fathom the meaning of Caylus's remark when we look at the *Standing Male Nude* studied in preparation for one of the Crozat *Seasons,* or the magnificent and highly finished female nude of *The Remedy* (cat. no. 24), one of the few erotic works that managed to escape destruction at Watteau's own hand. But if we consider some of the rough sketches of female nudes possibly made during the very modeling sessions in which Caylus participated, we can recognize, in the awkward foreshortening and uncertainly defined relationship of the model's arms to her torso, the peculiarities that would have disturbed Caylus.[128] Watteau's drawings do not adhere to that official system, refined by years of academic pedagogy, for reproducing the ideal appearance of the human form through the articulation of the structure and mechanics of bone and muscle. In his female nudes he aimed to express the soft sensuality of the female body, its fleshiness and feline flexibility. An ingenious and instinctive anti-classicist, Watteau created for himself what we might call an art of romantic naturalism that was virtually without rules, in which he intuited artistic solutions in response to the demands of fresh observation and the problems posed by the living model.

The rare sheets in which Watteau compiled multiple studies of heads are of breathtaking beauty and accomplishment (see fig. 23). They are the most immediately recognizable of his drawings, and they elicited from him a sensitivity to human expression, delicacy of spirit, and

mastery of technique without equal in the history of European art. Yet they were not entirely *sui generis*. The history painter Michel II Corneille (1642–1708), who trained in the studio of the founder of the Academy, Charles Lebrun, was also known for his highly finished multiple head studies executed in *trois crayons* (see fig. 24). Finding his inspiration in Le Brun's own sheets of expression studies, Corneille drew pages of heads that were almost always preparatory for specific religious or mythological paintings. They display all the traits of his classical training, yet the elegant *mise-en-page* that characterizes Corneille's best sheets almost certainly offered Watteau a striking visual precedent for the organization of his own multiple head studies. Although Watteau probably never met Corneille, he would have been introduced to the artist's works by Claude Gillot, who had trained in the studio of Corneille's brother.[129]

Close examinations of certain of Watteau's more populous drawings reveal that the artist—who, as Caylus notes, kept his studies bound in books "so as to have a large number of them to hand at any one time"[130]—revisited them, adding additional sketches to the sheets over extended periods, sometimes as long as several years. Sometimes the stylistic variations on a sheet are slight, indicating that little time elapsed between one campaign and the next: although the studies of children on the left side of an early *trois crayons* drawing (cat. no. 21) are somewhat more supple and luminous than the heads of women on the same sheet, the affinities of handling among the sketches suggest that the children were added soon afterward.[131] On other occasions the shift in style from one study to the next is stark: in a drawing in the Metropolitan Museum (cat. no. 6), the poetic rendering of a beautiful woman's profile—clearly made when the artist was at the height of his powers—contrasts sharply with a less intimately observed and much earlier study of a standing peasant girl holding a spindle and distaff; however, it is thanks to Watteau's use of red chalks of different hue for each sketch—as much as the obvious

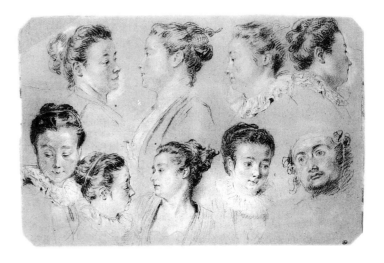

Figure 23. Antoine Watteau, *Sheet of Eight Heads*, ca. 1716. Black, red, and white chalks on grey-brown paper, 9⅞ × 15 in. (25.1 × 38 cm). Musée du Louvre, Paris

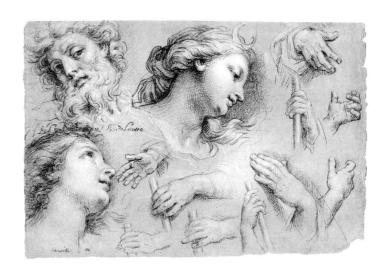

Figure 24. Michel II Corneille, *Sheet of Studies*, ca. 1690. Black and red chalks heightened with white on brownish paper, 12 × 17½ in. (30.5 × 44.6 cm). Musée du Louvre, Paris

disparities of style and subject—that we are alerted to the independence of the studies and their considerable divergence in date. The apparent randomness with which Watteau compiled studies on a page may account for Jullienne's decision to extract individual sketches from larger sheets when having them etched for his two-volume compendium of Watteau's drawings; as a close friend of the artist, he would have known that Watteau did not necessarily regard the various sketches that he assembled on any particular sheet as constituting one drawing, but as many drawings made on a single page for the sake of economy and his own convenience.[132]

There is little sense in speaking of the "late style" of an artist who died in his thirty-seventh year; and yet, the drawings produced in the final three years of Watteau's life do offer an identifiable evolution in style. During the innovative period of the early *fêtes galantes*, Watteau was busy building a repertory of suitable figures that were increasingly monumental in form, extrovert in handling, and audacious in their mix of colored chalks. His most ambitious painting to date, *The Embarkation to Cythera* was to be the fullest realization of the poetic vision that inspired the *fête galante,* and not long after he submitted it to the Academy in August 1717, there seemed to begin a subtle shift in the direction of his art. His drawings take on a quieter and more introspective presence, as in the celebrated *Three Studies of the Head of a Young Negro* in the Louvre (fig. 25). The drawing is in every way more subdued and more deeply meditated than the extravagant *trois crayons* sheets of only a year or two earlier: the slashing strokes of black, flickering dashes of red, and luxurious applications of white chalk that were so spectacular in such drawings as the National Gallery *Seated Couple* (fig. 21) and the *Seated Man Seen from Behind* in the Thaw collection (cat. no. 28), are supplanted by a more controlled line and a richer, but more sedate mixture of colored chalks. The use of white is sparing and is applied gently; touches of gray wash are introduced; and the black

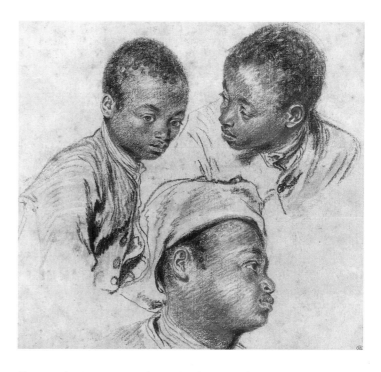

Figure 25. Antoine Watteau, *Three Studies of the Head of a Young Negro*, 1717–18. Black and red chalks, sanguine brûlée, stumping and touches of white chalk and gray wash on cream paper, 9⅝ × 10⅝ in. (24.3 × 27 cm). Musée du Louvre, Paris

crayon—especially in the hair and mahogany-colored flesh of the model—is stumped and softly blended with two different hues of red chalk that convey remarkable luminescence. Highlights were created by the unworked cream paper itself, and the texture of the boy's hair and structure of his face are carefully articulated.[133]

Moreover, the drawing reveals a psychological acuity and interest in individual character that goes beyond the studies of Persians and Savoyards of a few years earlier. Even at this relatively advanced stage in his career, Watteau was looking to his beloved old masters: we can speculate that the arrangement of the studies on the Louvre sheet might have been inspired by a copy of Rubens's oil sketch *Four studies of the Head of a Negro* (Brussels, Musées Royaux des Beaux-Arts); more certainly, Watteau was thinking of Veronese's sensitive *trois crayons Study of a Young Negro* (fig. 26) that was

Figure 26
Paolo Veronese,
Study of a Young Negro,
ca. 1570.
Black and red chalks on buff
paper, 11 × 8 in.
(27.8 × 20.5 cm).
Musée du Louvre, Paris

Figure 27
Charles de La Fosse
(formerly attributed to
Watteau),
Study of the Head of a Young
Negro Page Boy, 1715.
Red and black chalks,
heightened with white, on
buff paper, 7⅛ × 5¾ in.
(18 × 14.5 cm).
The British Museum,
London

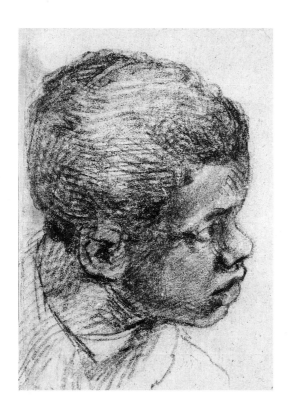

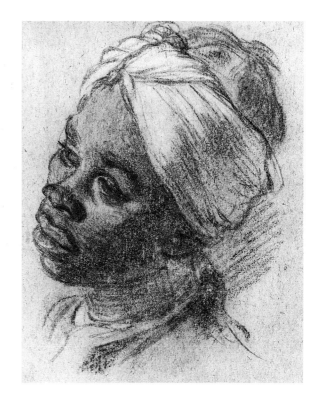

in Crozat's collection.[134] He would have known as well the studies of a black page made in *trois crayons* by Charles de La Fosse for his last major commission, *The Adoration of the Magi* (1715; Paris, Musée du Louvre); these drawings (see fig. 27), which were attributed to Watteau until 1981, display a greater integration of red and black chalks than was typically found in La Fosse's work and might indicate the impact that Watteau's increasingly sophisticated crayon technique had on the older artist.[135] In the event, Watteau's drawing surpasses even the study by Veronese in the complexity of its technique and the tenderness of its characterization.

Watteau's media expanded somewhat in his final years. Dezallier d'Argenville mentioned the new materials Watteau added to his repertoire in an often quoted description of the artist's techniques: "on white paper he most often drew in red chalk so as to be able to make counterproofs, which gave him the subject in both directions; he rarely heightened his drawings in white, leaving the paper to create this effect; there are many drawings in black and red chalk or pencil and red chalk which he used for heads, hands, and flesh; sometimes *trois crayons* was used, at other times he employed pastel, oil colors, gouache; indeed all were acceptable to him except pen, provided they achieved the effect he wanted; the hatchings of his drawings were almost perpendicular, sometimes leaning a little from right to left, while others were stumped with some light washes and accented strokes."[136]

Three Studies of a Woman's Head (cat. no. 44a) ideally demonstrates this rich new mixture of media. Although accented throughout in black chalk, the drawing is sketched in with graphite and red chalk; even the dark shadows along the women's necks are executed principally in graphite. The

least finished of the busts, in the lower right corner of the sheet, is also enriched with sanguine wash in the hair and gray wash along the shoulder; the washes, in addition to the overall gray tone of the pencil lead, create softer atmospheric effects than were found in the crisply drawn studies of Watteau's earlier years. A famous drawing, said to depict the painter Nicolas Vleughels (fig. 28), and generally thought to have been executed while the two Flemish painters lived together, in 1718–19, includes extensive use of graphite. In what is essentially a drapery study, Vleughels's cape and stockings were executed almost entirely in a soft, orangey-red chalk, while his tunic and head were drawn in pencil, with light touches in red to indicate flesh. Enveloped in soft effects of light, Vleughels's figure seems to glow with the iridescent sheen of graphite. Even here, where the model is dressed in one of Watteau's extravagant cavalier's costumes, his mood is more subdued and inward-looking than we would have expected in a comparable study of only two years earlier.[137]

The technique of stumping—the softening of the chalk's effect achieved by rubbing or smudging it with a wetted paper or piece of leather—which Watteau had almost never used in his earlier drawings, was now employed with regularity to create new, atmospheric, and textural effects, as in the drawings of a nude model on a chaise longue (for example, see cat. no. 36), probably dating from 1718, and the *Bust of a Young Woman* (fig. 29). If the nudes project an almost aggressive sensuality, the model in the latter drawing appears in quiet contemplation, as if seated by a window, perhaps reading, and bathed in warm afternoon light; only the smallest strokes of greasy red crayon pick out the shadows below the gentle woman's eyes, nose, and earring. The model in *Woman in Black* (cat. no. 41) is more direct in her gaze, but just as psychologically detached.

The translucent treatment of shadows in the face of the model in *Woman in Black*, created through the heavy stumping of delicate strokes of sooty black chalk applied

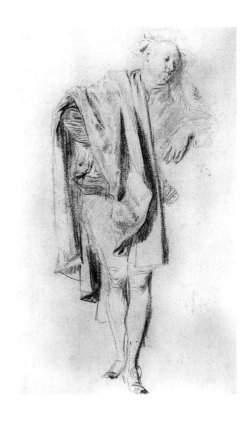

Figure 28
Antoine Watteau,
*Portrait of a Man
(Nicolas Vleughels?)*,
ca. 1718–19.
Red chalk and
graphite, 11⅛ × 6¾ in.
(28.4 × 17.3 cm).
Städelsches
Kunstinstitut und
Städtische Galerie,
Frankfurt am Main

over slighter touches of a warm, brick-colored red chalk, are found again—to even subtler effect—in *Two Studies of a Boy's Head* in Rotterdam (fig. 30). The head on the left, and the hands tying a knot, appear in *The Italian Comedians* (fig. 92, p. 174), a painting known to have been painted while Watteau was in England in 1719–20; although Watteau did not generally make drawings with a particular composition in mind, it seems likely that he deviated from his regular practice here, and that the sheet dates from the time of his London sojourn. Watteau rarely equaled the delicacy of the modeling in the faces that he achieved in these studies, and the sense that they are surrounded by a sparkling, light-filled atmosphere is palpable. The emotional reserve conveyed in the study on the right—enigmatic, though perhaps ironic—is found often in the drawings made in the year or so before Watteau's death. The models give away few of their

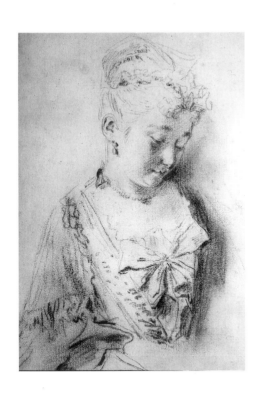

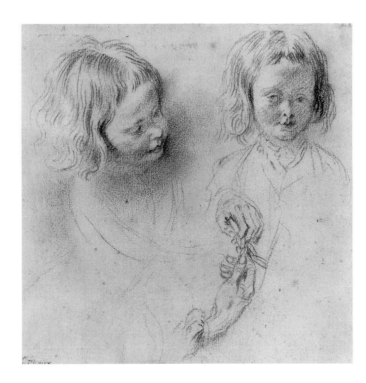

Figure 29
Antoine Watteau,
Bust of a Young Woman,
ca. 1720.
Red and black chalks
on laid paper,
8¼ × 5¾ in.
(21 × 14.7 cm).
National Gallery of Art,
Washington, D.C.;
Armand Hammer
Collection

Figure 30
Antoine Watteau, *Two
Studies of a Boy's Head*,
1719–20. Black and red
chalks and stumping on
cream paper,
6⅞ × 6¾ in.
(17.5 × 17.1 cm).
Museum Boymans-Van
Beuningen, Rotterdam

secrets, but their faces are not vacant—they project an intense undercurrent of contained emotion, a rich but ambiguous inner life that makes Watteau's last studies among his most powerful and memorable.[138]

The disposition of Watteau's drawings immediately after his death—an issue more fully addressed in the first half of Colin Bailey's essay in this book—remains something of a mystery because of conflicting testimonials from the early biographers. Gersaint, writing in 1744, stated that Watteau left a great number of drawings on his death, and that he carried out the artist's instructions to divide them equally among four friends: Jean de Jullienne, the abbé Haranger, Nicolas Hénin (1691–1724), and himself. However, obituaries written immediately after his death and published in *Le Mercure* and the *Gazette d'Utrecht* both record that his drawings were bequeathed to Haranger alone; the recent discovery of the inventory of Haranger's estate, which contained more than a thousand drawings by Watteau, argues

forcefully for the accuracy of the obituarists. Nevertheless, the question may never be fully resolved.[139]

Watteau prized his drawings and kept them in bound volumes that enabled him to refer to them easily when composing his paintings; they were the essential sources of inspiration for the figure poses in his *fêtes galantes*, and he seems to have parted with few of them during his lifetime. Until the breaking up of Watteau's sketchbooks, which presumably occurred when the drawings were parceled out to etchers around 1725, only a few artists in Watteau's immediate circle would have seen them or have been able to study them closely. It is no surprise, therefore, that the draftsmen who most closely emulated his style in the decade following his death were Jean-Baptiste Pater, his only documented pupil; Nicolas Lancret, who had known Watteau when they were both apprentices in Gillot's workshop; and Pierre-Antoine Quillard (?1704–1733), a shadowy figure who may have trained as a boy with the artist.

Both Pater and Lancret followed Watteau in the Academy as painters of *fêtes galantes*. Pater would later admit to Gersaint that "he owed all he knew" to his brief apprenticeship with the master[140]; the biographer Ballot de Savot attributed Lancret's work habits to the advice that Watteau had given the younger painter: "He urged him to go sketching landscapes on the outskirts of Paris, then to draw some figures, and to combine them to form a painting of his own choice and imagination."[141] Although, in the past, many drawings by Pater and Lancret have been attributed wrongly to Watteau, their styles, in truth, are generally easy to distinguish from his and from each other, as Margaret Grasselli demonstrates in her essay in this book.[142] However distinctive their personal styles became, both Pater and Lancret remained deeply indebted to Watteau for providing the model of how to make art, and it was their adoption of his methods of working, as much as their manner, that made them Watteau's disciples. Throughout his life Pater remained a painter of *fêtes galantes*, military subjects, and ornament; his single personal innovation to Watteau's genre seems to have come with the introduction of mildly erotic bathing scenes. He drew almost exclusively in red chalk and his graphic oeuvre consists almost entirely of figure sketches to which he could turn when selecting studies to incorporate in his paintings. Although most of his surviving drawings have been cut down into smaller, single-figure fragments (which he may have affixed directly to his canvas as he painted), he followed Watteau's improvisational way of composing pictures, and no full compositional studies from his hand are known.

Lancret lived longer than Pater and was an artist of greater talent and ambition. He, too, always drew in chalk; though following Watteau's example, he often added black and white chalks into the mix. More delicate and graceful as an artist than Pater, Lancret at his best achieved something of the dreamy nostalgia that infused Watteau's work, particularly in his drawings—which are generally lighter and more deft

Figure 31. Nicolas Lancret, *Study of Two Small Girls*, ca. 1720–25. Red chalk on ivory laid paper, 7⅞ × 9⅝ in. (20.1 × 24.4 cm). Art Institute of Chicago; Helen Regenstein Collection

than his paintings (see fig. 31). Lancret worked almost exclusively as a painter of *fêtes galantes* throughout the 1720s, as both he and Pater quite naturally stepped in to fill the void left in the market after Watteau's untimely death; it is during this period that his manner as both a painter and draftsman is closest to that of Watteau. A sheet such as *Four Studies of a Young Woman* (fig. 32), probably from the collection of Count Tessin, shows just how successfully—and consciously—Lancret imitated Watteau's *trois crayons* manner in the 1720s, but it also displays the limit of Lancret's ability to understand and replicate the master's style. Although his manipulation of the chalks could be airy and delicate, and he skillfully stumped and smudged his chalks for atmospheric effect, he never attempted the full integration of three chalks with the lightning-quick shifts from one color to the next that had been the hallmark of Watteau's *trois crayons* technique.[143] Likewise, the characterization of his models

Figure 32. Nicolas Lancret, *Four Studies of a Young Woman*, 1720s. Black, white, and red chalks on brownish paper, 8¾ × 8⅝ in. (22.3 × 22 cm). Nationalmuseum, Stockholm

Figure 33. Pierre-Antoine Quillard, *Fête galante*, late 1720s. Red chalk on paper, 5⅞ × 8½ in. (14.8 × 21.6 cm). Musée du Louvre, Paris

would always be cheerfully superficial—albeit charming—and without any of the emotional weight or darker psychological shadings to be found in Watteau's later studies. One of his finest and most sensitive *trois crayons* drawings is the *Three Studies of a Turbaned Black Man* (cat. no. 60), which is obviously indebted to Watteau's drawing of a young Negro in the Louvre. Even here, the flesh tones are evoked almost exclusively in red chalk alone, while the other chalks were reserved for the rendering of the model's hair and costume. The sheet lacks the effortless rhythm of Watteau's *mise-en-page*, and the faces are studied sympathetically but with a doll-like sweetness Lancret would never outgrow. In the 1730s, however, Lancret seems to have broadened his field of endeavor, perhaps because the fashion

for *fêtes galantes* was waning, and he turned his attention increasingly to historiated portraits, *tableaux de mode,* and genre scenes. He retreated somewhat to his early academic training, and developed at least some of his pictures more conventionally; in fact, complete compositional drawings executed in black and white chalks on blue paper are known for several paintings dating from the 1730s and early 1740s.[144]

The case for Quillard's direct involvement with Watteau remains somewhat elusive. His career is largely undocumented, and the little that is known about his brief life comes from a short biography published by Père Orlandi in his *Abécédario pitterico* in 1753, where we are told that Quillard was a disciple of Watteau and worked in his style. There is no firm evidence that he was ever Watteau's pupil as such, but a group of multifigural red-chalk studies—four of which are in the collection of the Duke of Devonshire at Chatsworth—that have been confidently attributed to the artist, make it clear that he had direct access to Watteau's drawings at an early date. All of these sheets copy single figures and groups of figures from early studies by Watteau

Figure 34. Pierre-Antoine Quillard, *Fête galante, ca.* 1720–25. Red chalk on paper, 6¼ × 8⅜ in. (16 × 21.2 cm). Private collection

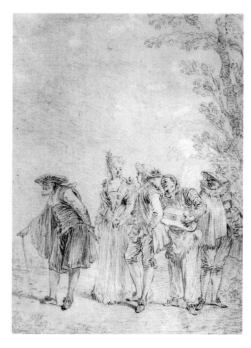

Figure 35
Antoine Watteau,
*The Ill-matched
Couple* (*Les Epoux
mal assortis*), *ca.* 1708.
Red chalk over
counterproof,
8⅞ × 6¾ in.
(22.5 × 17.2 cm).
Private collection

that, in the main, had never been reproduced in prints. They are stiff and awkward, but show the nervous, flickering accents and pointed, angular facial features that are also found in a more fluent—and presumably later—drawing of a *Fête galante* (fig. 33) that was inscribed in the eighteenth century with Quillard's name.[145]

To judge from the small number of drawings now attributed to Quillard, his graphic style seems to have been inspired almost entirely by Watteau's early Gillotesque red-chalk drawings. A *Fête galante* in a private collection (fig. 34) was closely modeled on Watteau's *Ill-matched Couple* (*Les Epoux mal assortis*; fig. 35), but its central figure group was reconfigured and relocated in an entirely different landscape setting.[146] Although a few single-figure studies by Quillard are known, including one sketch of a reclining girl in *trois crayons* in Stockholm, most of his surviving drawings are complete *fête galante* compositions in red chalk with figures set in landscapes. His more accomplished, and presumably more mature, drawings (see cat. no. 78) have formally

complex compositions that are comparable to Watteau's painted *fêtes galantes*, and may indicate that Quillard's contact with Watteau continued over a longer period of time than is generally assumed. There remained a certain pinched quality to the draftsmanship, but Quillard's line became freer and more confident, his handling of chalk softer and more blended. Although Watteau's later drawings consist overwhelmingly of figure studies, it is possible that Quillard was familiar with the master's rare compositional drawings for his later *fêtes galantes*, such as *The Pleasures of Love* (*Plaisirs d'amour*; fig. 36), in which Watteau himself returned briefly to the figural attenuation of his earliest drawings.

Jean de Jullienne's extraordinary and unprecedented publications of 351 etchings made of Watteau's drawings (*Les Figures de différents caractères*, 2 vols., 1726–28) and 271 engravings of his paintings (*Recueil Jullienne*, 2 vols., 1735) comprise what were perhaps the first *catalogue complet* of a contemporary artist's works. These prints spread not only Watteau's fame, but also his visual language, to every corner

of the continent. Regardless of Jullienne's intentions in publishing his *de luxe* volumes, they quickly came to serve as pattern books for painters, draftsmen, decorators, and artisans throughout Europe. Many of the artists who are regularly categorized as followers or satellites of Watteau had little firsthand knowledge of his art, and came to it by way of Jullienne's publications.[147] Jacques de Lajoüe (1686–1761), the painter of fantastical ruins and ornamental designs who was one of the progenitors of the *genre pittoresque*, was one of Watteau's most devoted followers, and regularly incorporated motifs inspired by Watteau's art into his paintings, drawings, and ornamental designs. Lajoüe's deliriously improbable homage to Watteau, *The Swing* (*La Balançoire*; fig. 37), is a sophisticated Rococo reinterpretation of Watteau's ornamental painting *The Swing* (*L'Escarpolette*; Helsinki, Ateneumin Taidemuseo), in which Lajoüe has cleverly interwoven elements from the original painting's decorative surround—a basket, cornemeuse, and hat—into the composition itself. However, Lajoüe based his painting on Crépy's engraving of Watteau's picture (fig. 38), which reverses the direction of Watteau's original. In fact, few if any of Lajoüe's paintings and drawings can be shown to derive from the direct study of Watteau's works; for all that Lajoüe took from Watteau, it came in the form of designs and motifs, not handling or technique, as is especially evident in his drawings, which were carried out principally in pen, ink, and wash—media that were foreign to Watteau's own practice.[148] The widespread dissemination of Watteau's visual repertoire through prints made after his drawings and paintings falls outside the scope of this essay; our purpose is to consider the direct impact of Watteau's drawings on some of the artists who knew them intimately.

It should come as no surprise that the greatest French painter of the middle of the eighteenth century, François Boucher, was also the most inventive and original student of Watteau's drawings, since he was the largest single contributor to *Les Figures de différents caractères*. Of the 351

Figure 36. Antoine Watteau, *Study for "The Pleasures of Love"* (*Plaisirs d'amour*), *ca.* 1717–18. Red chalk and graphite on buff laid paper, 7¾ × 10⅜ in. (19.6 × 26.5 cm). Art Institute of Chicago; Gift of the Helen Regenstein Collection, and the Mrs. Henry C. Woods; Wirt D. Walker Fund

plates etched, Boucher was responsible for between 105 and 119, and he can be presumed to have devoted a considerable portion of his time to the project from around 1723 to 1727.[149] Although Boucher worked quickly by all accounts—Mariette wrote that "his light and spirited needle seemed made for this work. M. Jullienne paid him 24 *écus* a day and they were both content for Boucher was very quick and engraving was play for him"[150]—the sheer number of etchings he undertook to produce meant that at a time when he had not yet fully evolved his own distinctive style he spent several years anatomizing and translating Watteau's intricately crafted drawings into prints. For a brilliant young artist of impressionable age the experience could hardly have failed to be seminal.[151]

There is some evidence that Jullienne also employed Boucher to make copies of drawings by Watteau that belonged to other collectors; if this is true, the copies have gone untraced.[152] Only one drawing by Boucher that

Figure 37. Jacques de Lajoüe, *The Swing (La Balançoire)*, after 1727. Oil on canvas, 34¼ × 54 in. (87 × 137 cm). Private collection

Figure 38. Louis Crépy, after Antoine Watteau, *The Swing (L'Escarpolette)*, 1727. Engraving, 6¼ × 8⅜ in. (16 × 21.2 cm). Private collection

directly reproduces a study by Watteau has been identified, the *Head of a Woman* (fig. 39), a *trois crayons* sheet from Tessin's collection based on an original by Watteau that has been untraced since the eighteenth century; the Goncourts, however, owned a counterproof of Watteau's sketch and Jules de Goncourt reproduced it in an etching.[153] Unlike Pater, Lancret, Quillard, and other artists who knew Watteau and were in his immediate circle, Boucher—who probably never met the artist and who was a generation younger—rarely aimed to copy or imitate Watteau in his original work. Instead, he resolved to understand Watteau's manner and integrate its lessons into his own, personal idiom.

The drawings Boucher etched for Jullienne spanned the full spectrum of Watteau's output: early, mature, and later studies; drawings in red chalk, two chalks, and three chalks;

studies of children, musicians, elegant women, elderly men, clowns, priests, Savoyards, and Persians. In the process he learned to emulate Watteau's technique, but one has to look closely to find direct evidence of its influence in his drawings; it is most immediately apparent, predictably, in the drawings he made in the late 1720s and early 1730s, shortly after he completed his work for Jullienne. The *Seated Woman with a Fan* (fig. 40), executed in red chalk and graphite, is a meticulously finished drawing from around 1730 that exhibits the grace, but also the exuberance and alert energy, of Watteau's figure studies for the *fêtes galantes*, and bears comparison with a lost drawing by Watteau that had been etched by Boucher for *Les Figures de différents caractères*.[154] Similar in character was a whole series of studies made by Boucher around the same time in preparation for a luxury edition of the works of Molière that was published in 1734.

These sketches in red chalk were almost certainly studied from posed models, and they exhibit the amplitude, self-confidence, and worldly good humor of Watteau's studies of actors and actresses from the French theatre (see fig. 41). The ruffs and pantaloons that his characters wear would have evoked for Boucher—as they do for us—memories of Watteau's cavaliers, and they seem to have inspired him to turn the Molière illustrations into a discreet homage to the master.[155] Another figure in fancy dress, from the J. Paul Getty Museum (cat. no. 50), apparently elicited thoughts of Watteau as well. Drawn in Watteau's three chalks (but on uncharacteristic blue paper), the reclining man—who was at one time attributed to Watteau—was made in preparation for a tapestry in the *Fêtes italiennes* suite that was first woven at Beauvais in 1736. Both the pose of the figure, which is close to that of a seated jester with a guitar in *Pleasures of the Dance* (*Les Plaisirs du bal*; London, Dulwich Picture Gallery), and his mood of quiet introspection, are redolent of Watteau's reticent poetry.[156]

Boucher found not only elegance and theatrical *élan* in Watteau's drawings, but a more threatening sensuality as well. Watteau's celebrated *trois crayons* male nude in the Louvre (fig. 42) was made as a study for his painting *Jupiter and Antiope* (Paris, Musée du Louvre). When Boucher came to paint his own version of the subject in the early 1730s, he naturally looked to Watteau's drawing—which, at the time, probably belonged to his friend the engraver Gabriel Huquier (1695–1772). His own satyr (fig. 43), fully equiped with horns, is drawn in red and white chalks with the same assured but brutal vigor.[157]

In addition to the etchings he contributed to *Les Figures de différents caractères*, Boucher also engraved more than twenty of Watteau's paintings for the *Recueil Jullienne*, including twelve of the thirty *chinoiseries* from Watteau's decorations at the Château de la Muette.[158] The paintings, and the prints after them, were largely responsible for launching the European craze for decor *à la chinoise*, and

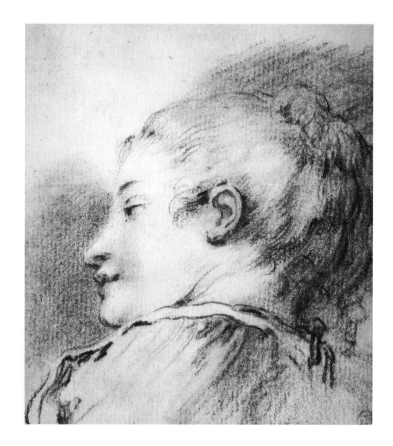

Figure 39. François Boucher, after Watteau, *Head of a Woman*, ca. 1725–30. Black, red, and white chalks on brownish paper, 3⅝ × 3½ in. (9.3 × 9 cm). Nationalmuseum, Stockholm

they inspired Boucher's lifelong taste for the genre.[159] He himself produced several series of paintings, tapestries, and prints of Chinese subjects, and his lovely three-chalk drawing of *A Seated Chinese Girl in Profile* (cat. no. 53), drawn in the late 1730s or early 1740s, is associated with one of these projects. The drawing also reflects Boucher's experience of having etched other exotic figure drawings by Watteau, including several of the Savoyards and Persians.

Even in Boucher's maturity, memories of Watteau's art would find their way into his work. In the last decade of his life Boucher would look to Watteau for a final time in the drawing of a veiled woman, now lost but reproduced in a

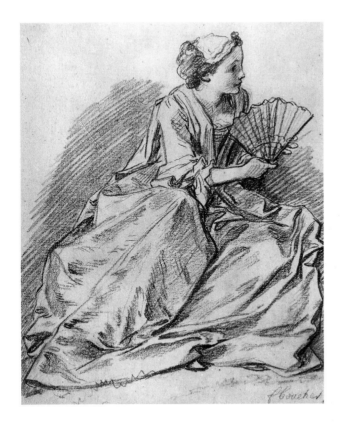

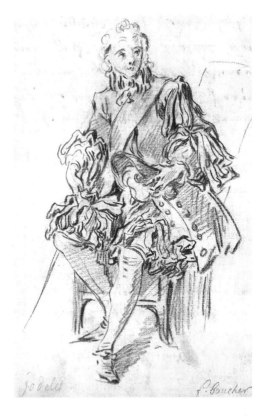

Figure 40
François Boucher,
Seated Woman with a Fan, ca.
1730.
Red chalk and graphite,
10⅝ × 8⅜ in.
(27 × 21.3 cm).
Nationalmuseum, Stockholm

Figure 41
François Boucher,
Jodelet (Les Précieuses Ridicules),
1733–34.
Red chalk on cream laid
paper, 10⅛ × 6⅝ in.
(25.6 × 16.8 cm).
Rijksprentenkabinet,
Rijksmuseum, Amsterdam

beautiful crayon-manner engraving (fig. 45) by Gilles Demarteau (1722–1776). It reinterprets in Boucher's own idiom his etchings (fig. 44) made after drawings by Watteau that depict a woman in a black mantilla (Amsterdam, Rijksmuseum, and Williamstown, Sterling and Francine Clark Institute; see cat. no. 41); Boucher had etched Watteau's studies for Jullienne's corpus nearly forty years earlier. [160]

Like his first teacher, François Lemoyne (1688–1737), Boucher was a product of academic training, and he would never adopt Watteau's practice of drawing "without purpose" since he would never compose paintings in Watteau's fluid, improvisational way. Boucher and Lemoyne were first and foremost history painters, who nevertheless had a talent for the "gallant" genre and were drawn to Watteau's art for its gracefulness, subtle eroticism, and lightness of touch. Each

could make sketches that closely emulated the spirit and technique of Watteau's drawings when the painting he was preparing called for them, whether it was a *scène galante*, such as Lemoyne's *Hunting Breakfast* (1723; São Paolo, Museu de Arte), for which the artist made numerous red-chalk figure studies of balletic grace (fig. 46), or a history subject with an erotic or comic undercurrent, such as Lemoyne's piquant mythology *Hercules and Omphale* (1724; Paris, Musée du Louvre; see cat. nos. 64 and 65). [161] But their figure drawings in the 1720s and 1730s were always posed and rendered with a particular narrative function in mind. Despite the easy bonhomie of Boucher's Molière sketches, which purposefully recall Watteau's elegant figure studies, they were carefully tailored to fit into larger—in this case engraved—compositions and to enact specific stories.

43

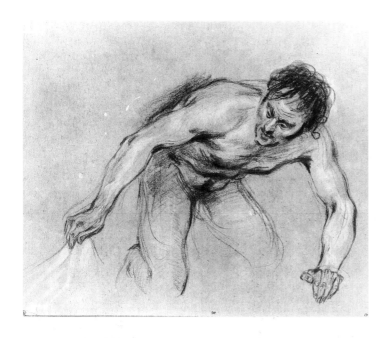

Figure 42. Antoine Watteau, *Nude Man Turning to the Right* (study for *Jupiter and Antiope*), *ca.* 1715–16. Black, red, and white chalks on beige paper, 9⅝ × 11¾ in. (24.4 × 29.7 cm). Musée du Louvre, Paris

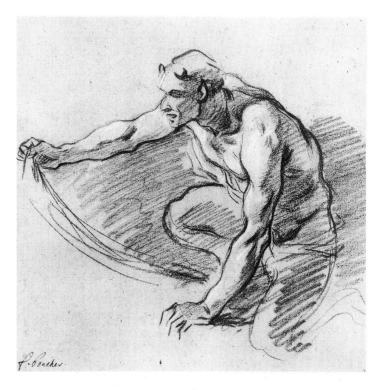

Figure 43. François Boucher, *Satyr Lifting a Drapery, Half-kneeling, ca.* 1730. Red chalk heightened with white on cream paper, 10⅜ × 10⅝ in. (26.5 × 26.9 cm). Prat Collection, Paris

It was only in their early landscape drawings that Boucher and Lemoyne sometimes sketched to no greater end. Lemoyne almost certainly knew Watteau through Jullienne, Crozat, and other mutual friends, and he was influenced by Watteau's treatment of landscape. A drawing such as *River Landscape with a Castle* (fig. 47), which probably dates from the early 1720s, has short, softly smudged, loosely applied strokes of red chalk that recall Watteau's atmospheric handling of nature studies (see cat. no. 44b). But its elements derive from the two separate strands of Watteau's landscape drawing: the rustic shack on the left side of Lemoyne's drawing looked to Watteau's *plein air* sketches made in the Porcherons and the environs of Paris, while the right side, with its looming medieval castle, evokes Watteau's copies from Campagnola.[162] It was Boucher who etched the Washington drawing, as he did all of Watteau's landscapes that appear in *Les Figures de différents caractères*, and his own

style of landscape drawing was, early in his career, almost entirely dependent on Watteau's example: every element of Boucher's large, red-chalk *Landscape with Figures* (cat. no. 47)—the thatch-roofed *fabrique*, country church and spire, winding road, densely massed trees—can be found in the landscapes by Watteau that Boucher copied.[163]

In some ways the most significant impact of Watteau's drawings on the development of Boucher's career as a draftsman was indirect and came not in the immediate wake of his work on *Les Figures de différents caractères*, but almost a decade and a half later, when he began to make highly finished, autonomous drawings that, glazed and framed, were sold as independent works of art. Jullienne's project had recognized the intrinsic artistic worth of Watteau's drawings:

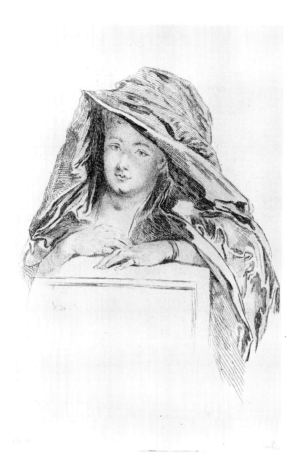

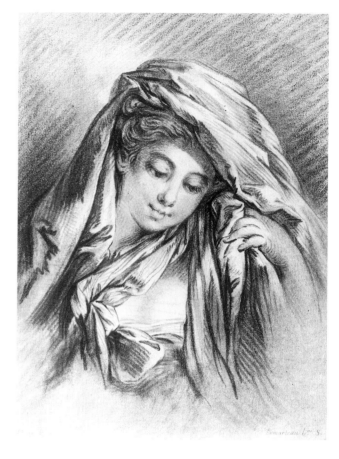

"Each figure from the hand of this excellent man has a character that is so true and natural that all by itself it can hold and satisfy one's attention, seeming to have no need for a supporting composition on a greater subject."[164] This novel estimation of the independent value of drawings carried obvious implications for the future art market, and it may have planted a seed in Boucher's mind that came to fruition only in the mid-1740s. In reproducing Watteau's drawings, Boucher and the other printmakers employed by Jullienne had edited the sheets, enlarging or reducing the scale of each sketch, interpreting and occasionally completing motifs that were unclear or unfinished, placing them on the page for maximum effect; in short, they took an artist's private studies and transformed them into self-sufficient works of art. The idea of creating drawings specifically to be sold on the open market would have been alien to the refined and uncommercial sensibilities of Watteau, who coveted his drawings, regarded them as superior to the most perfect of his paintings, and would not be parted from them. But it was those very drawings—intense and intimate sketches that "seem to possess the faculty of thought"[165]—that sparked in Boucher and artists of his generation the recognition that drawing is truly the sister art to painting and not merely its handmaiden; it was a sentiment with which the greatest of all French draftsmen would have silently concurred.

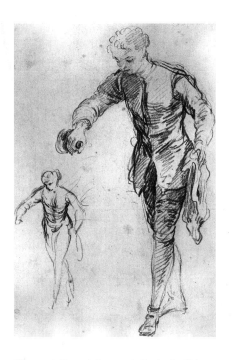

Figure 46. François Lemoyne, *Study of a Valet*,
1723. Red chalk, 10⅛ × 6⅝ in. (25.6 × 16.7 cm).
The Metropolitan Museum of Art, New York;
Gift of Ann Payne Blumenthal, 1943

Figure 47. François Lemoyne, *River Landscape with a Castle*, early 1720s. Red chalk on cream antique laid paper,
9 × 15⅛ in. (23 × 38.5 cm). Fogg Art Museum, Harvard University Art Museums;
Loan from the Collection of Jeffrey E. Horvitz

Notes

1. The essential contemporary biographies and obituaries are most easily found in
Rosenberg 1984a.

2. La Roque, *Le Mercure*, August 1721, pp. 81–83; Rosenberg 1984a, pp. 5–7.

3. Jullienne, "*Abrégé de la vie d'Antoine Watteau, Peintre du Roy en son Académie Royale de
Peinture et de Sculpture*," introduction to *Les Figures de différents caractères*, Paris 1726;
Rosenberg 1984a, pp. 11–17.

4. Gersaint, "*Abrégé de la vie d'Antoine Watteau*," in the *Catalogue raisonné des diverses
curiosités du Cabinet de Feu M. Quentin de Lorangère*, March 2, 1744, pp. 172–88;
Rosenberg 1984a, pp. 29–44.

5. Mariette, manuscript notes recorded in the margins of a copy of Orlandi's *Abécédario
Pittorico* (in the Cabinet des Estampes de la Bibliothèque nationale, Paris, Ya26 and
Ya24), probably around 1745; Rosenberg 1984a, pp. 3–4.

6. Dezallier d'Argenville 1745, II, pp. 420–24; Rosenberg 1984a, pp. 46–52.

7. Caylus, "*La vie d'Antoine Watteau, Peintre de figures et de paysages, Sujets galants et
modernes*," an address delivered to the Academy on February 3, 1748; the original
manuscript in Caylus's hand is in the Bibliothèque de la Sorbonne, Paris, Ms. 1152, fol.
17–27; a second copy by Caylus's secretary, with modifications to the original, is in the
Bibliothèque de la Sorbonne, Paris, Ms. 1152, fol. 28–41; a third text, the original of
which is today unknown, was published by the Goncourts in 1860; Rosenberg 1984a,
pp. 53–91.

8. Jullienne [1726] in Rosenberg 1984a, p. 11; the best and most authoritative
chronology of the known facts of Watteau's life is found in Rosenberg and Grasselli
1984, pp. 15–30.

9. Caylus [1748] in Rosenberg 1984a, p. 57.

10. Jullienne [1726] in Rosenberg 1984a, p. 12. Only Jullienne and Dezallier
d'Argenville mention this unnamed scene painter from Valenciennes.

11. Caylus [1748] in Rosenberg 1984a, p. 57.

12. Jullienne [1726] in Rosenberg 1984a, p. 12.

13. On Gillot's provisional admission to the Academy, see Emile Dacier in Dimier 1928,
p. 163; Grasselli 1987a, pp. 22–23, usefully summarizes the range of scholarly
suppositions as to when Watteau and Gillot first met.

14. Père P.-A. Orlandi [1719] in Rosenberg 1984a, p. 2.

15. Dezallier d'Argenville [1745] in Rosenberg 1984a, p. 47; Jullienne [1726] in
Rosenberg 1984a, pp. 12–13 (translated in Holt 1957, p. 307).

16. Gersaint [1744] in Rosenberg 1984a, p. 32.

17. The best source for an outline of Audran's life and career can be found in Weigert
1950, pp. xxvii–xxxi; Grasselli 1987a, pp 56–87, provides an excellent, in-depth
examination of the influence of Audran on Watteau, as does Roland Michel 1984a, pp.
23–28.

18. Jullienne [1726] in Rosenberg 1984a, p. 13 (translated in Holt 1957, p. 307).

19. Jullienne [1726] in Rosenberg 1984a, p. 13.

20. See the *procès-verbaux* of the Academy (4th register) for April 6, 1709.

21. Jullienne [1726] in Rosenberg 1984a, pp. 13–14 (translated in Holt 1957, pp.
307–08).

22. Gersaint [1744] in Rosenberg 1984a, p. 33.

23. Gersaint [1744] in Rosenberg 1984a, p. 33.

24. Munhall 1992 provides an excellent and elegant discussion of Watteau's early military

paintings and of the artist's return trip to Valenciennes; on *The Bivouac* in particular, see Rosenberg and Grasselli 1984, no. P6.

25. Gersaint [1744] in Rosenberg 1984a, p. 34.

26. Mariette [*ca.* 1745] in Rosenberg 1984a, p. 3.

27. Only the abbé Leclerc (1677–1736), in his note on Watteau for the *Grand dictionnaire historique de Moreri*, published in 1725, mentions that Watteau returned to work with Audran when he arrived back in Paris after his Valenciennes sojourn, in Rosenberg 1984a, p. 9; for Watteau's admission into the Academy as an associate member, see Roland Michel 1984a, pp. 34–37.

28. Jullienne [1726] in Rosenberg 1984a, p. 14.

29. Gersaint [1744] in Rosenberg 1984a, p. 35, and Mariette 1741, IX, fol. 193 [51]; G. Scotin's engraving of *Jealousy* for the *Recueil Jullienne* is reproduced in Dacier and Vuaflart 1921–29, III, no. 127.

30. Caylus [1748] in Rosenberg 1984a, pp. 64–65.

31. Recorded in the *procès-verbaux* of the Academy (4th register) for July 30, 1712.

32. Jullienne [1726] in Rosenberg 1984a, p. 15 (translated in Holt 1957, p. 308).

33. Recorded in the *procès-verbaux* of the Academy (5th register) for August 28, 1717.

34. Tessin's diary entry, quoted in Rosenberg and Grasselli 1984, p. 22.

35. For Crozat and his circle, and his impact on Watteau, see Stuffmann 1968; and Crow 1985b, pp. 39–44.

36. On Watteau and the commission for the Crozat *Seasons*, see Levey 1964; for the Washington *Summer*, see Rosenberg and Grasselli 1984, no. 35.

37. Caylus [1748] in Rosenberg 1984a, pp. 74–75 (translated in Goncourt 1948, p. 23).

38. *Almanach Royal*, 1718, p. 252.

39. Gersaint [1744] in Rosenberg 1984a, pp. 34–35 (translated in Goncourt 1948, p. 27, note 26).

40. Caylus [1748] in Rosenberg 1984a, p. 80, and Jullienne [1726] in Rosenberg 1984a, p. 15; for the most thorough analysis of the life and career of Vleughels, see Hercenberg 1975.

41. *Almanach Royal*, 1719, p. 253.

42. Recorded in the *procès-verbaux* of the Academy, March 24, 1719; see Wildenstein 1924, pp. 45–46.

43. Orlandi 1719, pp. 83 and 119; Rosenberg 1984a, pp. 1–2. The notice in Orlandi (1660–1727) appears in the 1719 edition, which was dedicated to Pierre Crozat; Hérold and Vuaflart first identified its author as Dubois de Saint-Gelais (1669–1737); see Dacier and Vuaflart 1921–29, I, pp. 89–90.

44. Jullienne [1726] in Rosenberg 1984a, pp. 15–16 (translated in Holt 1957, p. 309).

45. Caylus [1748] in Rosenberg 1984a, p. 83; Vleughels's letter to Rosalba is contained in the Ashburnham Codex (Ashb. 1781.4) and quoted in Rosenberg and Grasselli 1984, p. 24.

46. Gersaint [1744] in Rosenberg 1984a, p. 36 (translated in Goncourt 1948, p. 47).

47. Caylus [1748] in Rosenberg 1984a, p. 83 (translated in Goncourt 1948, p. 29); Jullienne [1726] in Rosenberg 1984a, p. 16 (translated in Holt 1957, p. 309).

48. For a brief discussion of Dr. Mead's life, see Dacier and Vuaflart, I, pp. 97–100, III, under no. 204.

49. Walpole 1771, IV, pp. 35–36; Rosenberg 1984a, p. 101.

50. For *The Italian Comedians* see Rosenberg and Grasselli 1984, no. 71.

51. Caylus [1748] in Rosenberg 1984a, p. 83.

52. Rosalba's diary entry (Ashb. 1781.5) is quoted in Rosenberg and Grasselli 1984, p. 25.

53. Gersaint [1744] in Rosenberg 1984a, p. 37; the bibliography on the *Shopsign* is vast, but well summarized in Rosenberg and Grasselli 1984, no. 73.

54. Rosalba's diary entry (Ashb. 1781.5); *Le Nouveau Mercure*, February 1721, p. 152; both cited in Rosenberg and Grasselli 1984, p. 26.

55. Jullienne [1726] in Rosenberg 1984a, p. 16 (translated in Holt 1957, p. 309).

56. Gersaint [1744] in Rosenberg 1984a, p. 38.

57. Gersaint [1744], "Abrégé de la vie de Pater," pp. 193–219 (translated in Goncourt 1948, p. 49); republished in Ingersoll-Smouse 1928, p. 19.

58. Gersaint [1744] in Ingersoll-Smouse 1928, p. 19 (translated in Goncourt 1948, p. 49).

59. Gersaint [1744] in Rosenberg 1984a, p. 38.

60. Both Gersaint and Caylus (in Rosenberg 1984a, pp. 38 and 82, respectively) allude a sale of Watteau's effects, although no record of such a sale exists.

61. Gersaint [1744] in Rosenberg 1984a, p. 39; July 26, 1721, *procès-verbaux* of the Academy (5th register), cited in Rosenberg and Grasselli 1984, p. 27; August 11, 1721, letter from Crozat to Rosalba (Ashb. 1781.2), cited in Rosenberg and Grasselli 1984, p. 27.

62. Caylus [1748] in Rosenberg 1984a, p. 71.

63. Caylus [1748] in Rosenberg 1984a, p. 68; Gersaint [1744] in Rosenberg 1984a, p. 39.

64. Caylus [1748] in Rosenberg 1984a, p. 68 (translated in Goncourt 1948, p. 20).

65. Gersaint [1744] in Rosenberg 1984a, p. 39 (translated in Goncourt 1948, p. 32).

66. Posner 1984, p. 252.

67. Caylus [1748] in Rosenberg 1984a, pp. 71–72 (translated in Goncourt 1948, p. 22).

68. De Vallée 1939, pp. 67–74; Posner 1984, p. 148.

69. Caylus [1748] in Rosenberg 1984a, pp. 55–56 (translated in Goncourt 1948, p. 11). Caylus awaits a comprehensive modern study and the most substantial one remains Samuel Rocheblave's in 1889; a fascinating recent study of Caylus and his relationship with Watteau is found in Fumaroli 1996, pp. 34–47.

70. Caylus [1748] in Rosenberg 1984a, p. 80 (translated in Goncourt 1948, p. 26).

71. Gersaint [1744] in Rosenberg 1984a, pp. 39–40.

72. Jullienne [1726] in Rosenberg 1984a, p. 17 (translated in Holt 1957, p. 310).

73. Gersaint [1744] in Rosenberg 1984a, p. 40 (translated in Goncourt 1948, p. 43).

74. Gersaint [1747] in Rosenberg 1984a, p. 44 (translated in Goncourt 1948, p. 43).

75. Gersaint [1744] in Rosenberg 1984a, pp. 29–30 (translated in Goncourt 1948, p. 12, note 13).

76. Rosenberg and Prat 1996, I, no. 19.

77. See as examples Rosenberg and Prat 1996, I, nos. 1, 4, 6, 7, 10, 11, 12, 14, 111, 112, 113 and 114.

78. The standard study of Gillot remains Populus 1930; also useful are Dacier in Dimier 1928; Eidelberg 1973, 1974, and 1987; and Grasselli 1987a, pp. 22–55.

79. Caylus [1748] in Rosenberg 1984a, p. 59.

80. Gillot was granted full membership in the Academy on April 27, 1715; see Dacier in Dimier 1928, p. 164.

81. On Gillot, Watteau, and the popular Fairs, see Crow 1985b, pp. 44–45, Tomlinson 1987, pp 203–211.

82. See, for example, Callot's drawing *L'Amiral Inghirami presente des prisonniers barbaresques à Ferdinand Ier*, in *Jacques Callot, 1592–1635*, exhib. cat., Nancy, Musée Historique Lorrain, 1992, cat. no. 76.

83. Rosenberg and Prat (1996, III) attribute catalogue numbers 2, 3, 111, 112, 113, 114 to Watteau, but all are given to Gillot by Grasselli, while several other Gillotesque sheets that Rosenberg and Prat have rejected from the corpus of Watteaus works—R2, R311, R373, R374, R516, among others—are accepted as Watteau's work, with some hesitation, by Grasselli; see Grasselli 1987a, pp. 41–45.

84. For Tessin's inscribed counterproof of Watteau's drawing, see Bjurström 1982, no. 1271; it is worth noting that Grasselli has rejected the attribution of this drawing to Watteau despite the inscription on Tessin's counterproof: she maintains that both the Louvre and Stockholm sheets are, in fact, the work of Gillot; see Grasselli 1987a.

85. Jean Audran's etching of the San Francisco *Children Imitating a Triumphal Procession* is no. 58 in *Les Figures de différents caractères*, reproduced in Rosenberg and Prat 1996, I, no. 13. The Chicago *Allegory of Spring* was etched by Caylus for *Les Figures de différents caractères*, although the plate was rejected before publication and can be found inserted into the copy preserved in the Bibliothèque de l'Arsenal; it is reproduced in Rosenberg and Prat 1996, I, no. 11, fig a. Gillot's drawing in the Morgan Library (inv. III.88) was attributed to Watteau by Parker and Mathey (1957, I, no. 153) and was correctly returned to Gillot by Eidelberg (1973, p. 239), a reattribution subsequently endorsed by Grasselli (1987a, pp. 35, 46) and Rosenberg and Prat, 1996, II, no. R394.

86. Rosenberg and Prat 1996, II no. 622; see also Grasselli 1982, no. 24.

87. Parker and Mathey first made the suggestion; see Parker and Mathey 1957, I, no 25.

88. For the Nointel commission, see Cailleux 1961; for *The Faun* and *The Cajoler* see Rosenberg and Grasselli 1984, nos. P3 and P2, and Wintermute 1993, pp. 42–45.

89. Caylus [1748] in Rosenberg 1984a, p. 61 (translated in Goncourt 1948, p. 15).

90. Jullienne [1726] in Rosenberg 1984a, p. 13 (translated in Holt 1957, p. 307).

91. The standard account of the thousands of Audran sheets in Stockholm is found in Moselius 1950 and Weigert 1950.

92. Bjurström 1982, nos. 1252–64; Grasselli 1987a, no. 15.

93. The two outstanding examples are cat. nos. 9 and 10 in this exhibition; see also Rosenberg and Prat 1996, I, nos. 190, 191, 192, 193, 231, 232.

94. Grasselli 1993, no. 5, fig. 7.

95. On Watteau as an ornamental artist, see in particular Eidelberg 1984, and Roland Michel 1984b, pp. 279–91.

96. Caylus [1748] in Rosenberg 1984a, p. 61 (translated in Goncourt 1948, p. 15).

97. For discussions of Watteau's *agrégation*, see Roland Michel 1984a, pp. 34–38, and Posner 1984, pp. 64–67.

98. Eidelberg 1997, pp. 25–29.

99. For especially insightful analyses of the military pictures and drawings, see Munhall 1992; and Grasselli 1987a, pp. 87–100.

100. Mariette [1741], p. 294.

101. Gersaint [1744] in Rosenberg 1984a, p. 34 (translated in Goncourt 1948, pp. 42–43).

102. Mariette [ca. 1745] in Rosenberg 1984a, p. 3.

103. On Watteau's copies after Campagnola, see Eidelberg 1967 and 1977, pp. 173–82 and 67–68, respectively.

104. Eidelberg 1977, pp. 67–68.

105. On Roger de Piles and his theory of art, see Puttfarken 1985.

106. For a reconstruction of de Piles's album of drawings from Rubens's Studio, see Eidelberg 1997a, pp. 234–66.

107. Rosenberg and Prat 1996, I, no. 175.

108. Caylus [1748] in Rosenberg 1984a, p. 75 (translated in Goncourt 1948, p. 24).

109. Caylus [1748] in Rosenberg 1984a, p. 74 (translated in Goncourt 1948, p. 23).

110. Rubens's copy of Titian is discussed in Haverkamp-Begemann and Logan 1988, no. 22, and Goldner and Hendrix 1988, no. 94.

111. For the most recent bibliography on La Fosse see Stuffman 1964, and Bailey 1991, pp. 115–41; we eagerly await Jo Hedley's forthcoming catalogue raisonné of La Fosse's drawings. For Coypel, see Garnier 1989.

112. Grasselli 1987a, p. 166; Garnier 1989, cat. 125, p. 169.

113. See Clark 1996, pp. 97–98, on the *Studies for the Arms and Legs of Bacchus and Ariadne* by La Fosse.

114. The standard study on Savoyards in eighteenth-century French art is Munhall 1968, pp. 86–94.

115. Rosenberg and Prat 1996, II, no. 425, represents *Six Heads, after Le Nain* copied by Watteau from a painting attributed to Antoine Le Nain, *La Danse des enfants*, in a Swiss private collection.

116. Posner 1984, p. 116.

117. For the most thorough discussions of *La Conversation*, see Rosenberg and Grasselli 1984, no. P23, and Rand 1997, no. 2.

118. For *La Perspective*, see Rosenberg and Grasselli 1984, no. P25; Wintermute 1990, pp. 129–38; Rand 1997, no. 3; Zafran 1998, no. 30.

119. Goncourt 1948, pp. 7–8.

120. Caylus [1748] in Rosenberg 1984a, pp. 78–79 (translated in Goncourt 1948, p. 25).

121. Rosenberg and Prat 1996, II, no. 459. The Chantilly painting is discussed in Rosenberg and Prat 1996, I, no. 3; the Dresden painting is found in Rosenberg and Camesasca 1970, no. 182; Audran's engraving of the lost *La Surprise* is published in Dacier and Vuaflart 1921–29, III, no. 31.

122. Caylus [1748] in Rosenberg 1984a, p. 79.

123. Rosenberg and Prat 1996, II, no. 479.

124. The infrared reflectography of *La Perspective* is published in Zafran 1998, p. 85, fig. 30c.

125. For *La Famille*, see Rosenberg and Grasselli 1984, no. P54.

126. For the *Assembly in a Park*, see Rosenberg and Grasselli 1984, no. P56.

127. Caylus [1748] in Rosenberg 1984a, p. 72 (translated in Goncourt 1948, pp. 22–23).

128. For a spectacular series of nude studies made of the same female model reclining on a *lit de repos*, see Rosenberg and Prat 1996, II, nos. 578–85; for Posner's elegant analysis of the series, which might have been drawn in a single session, see Posner 1973, pp. 54–65.

129. There is no serious study of the works of Michel II Corneille, though a brief biography by Nicole Parmantier-Lallement can be found in *The Dictionary of Art*, London 1996, VII, pp. 863–64.

130. Caylus [1748] in Rosenberg 1984a, p. 78.

131. Rosenberg and Prat 1996, II, no. 413.

132. On Watteau's drawings and the subsequent etchings in *Les Figures de différents caractères*, see Roland Michel 1987b, pp. 117–27.

133. Rosenberg and Prat 1996, II, no. 608.

134. For Rubens's oil sketch see Held 1980, I, no. 441, pl. 428; for Veronese's three chalk studies, see Cocke 1984, no. 54. My thanks to Colin B. Bailey for bringing Crozat's Veronese drawing to my attention.

135. Cuzin 1981, pp. 19–21.

136. Dezallier d'Argenville [1745] in Rosenberg 1984a, pp. 51–52.

137. Rosenberg and Prat 1996, I, no. 338 (verso). Rosenberg and Prat have challenged the generally accepted late dating of this drawing, instead moving it forward to around 1715; this is a rare instance where I find their carefully considered dating less than fully convincing. I concur with Grasselli 1987a, pp. 325–26, that the remarkable combination of red chalk and graphite and Watteau's soft, atmospheric handling of the media seems entirely in keeping with his drawing style around 1718–19.

138. Rosenberg and Prat 1996, II, no. 649.

139. For an in-depth examination of this issue, see Colin B. Bailey in the present catalogue, pp. 71–72.

140. Gersaint [1744] in Ingersoll-Smouse 1928, p. 19.

141. Ballot de Savot n.d., p. 16.

142. See Margaret Morgan Grasselli in the present catalogue, pp. 56–64.

143. For Lancret's *Four Studies of a Young Woman*, see Bjurström 1982, no. 1001.

144. For the most recent and most thorough examination of Lancret's career as both a draftsman and painter, see Holmes 1991. The remarkable group of six compositional sketches by Lancret—all those that have as yet come to light—appeared at Sotheby's London, July 5, 1993, lots 84–89; the study for *La Chasse au tigre* was acquired for the Musée de Picardie, Amiens, and is published in Salmon 1996, no. 11.

145. Quillard's life and career is much better known today following Martin Eidelberg's two groundbreaking articles on the artist: Eidelberg 1970, Eidelberg 1981. Earlier studies of Quillard include the brief article by Jean Messelet in Dimier 1930, II, pp. 341–46, and the study of Watteau's "satellites" by Rey 1931.

146. Quillard's *Fête Galante* was until recently accepted as a work by Watteau himself: see Roland Michel 1985, no. 43; Eidelberg 1981 (p. 31, fig. 31b) first proposed the reattribution of the drawing to Quillard, followed by Rosenberg and Prat 1996, III, no. R608.

147. Donald Posner's remarkable assertion that Watteau's influence on the development of French art "was relatively limited, and one may well question whether the history of French eighteenth-century painting would have been significantly different without him" was no doubt intended as a corrective to the insupportable view of Watteau's influence that prevailed in the later nineteenth and earlier twentieth centuries, and was best expressed by the Goncourts, who claimed that "Watteau was the dominant master who subjected all eighteenth-century painting to his manner, his taste, his vision." It seems to me an over correction, however, with which I find it impossible to concur.

148. The definitive study of Lajoüe's life and career as a painter, draftsman, and printmaker is by Marianne Roland Michel 1982. The author carefully elucidates the

impact of Watteau's art on Lajoüe's career, and was the first to recognize the dependence of Lajoüe's painting *La Balançoire* on Crépy's engraving of *L'Escarpolete*; see cat. no. P245, figs. 19, 21.

149. The precise number of plates etched by Boucher for the project is not entirely certain, and estimates range from 105 to 119; Pierrette Jean-Richard, who has made the most extensive study of Boucher's work as a printmaker puts the number of his contributions to *Les Figures de différents caractères* at 119, the figure we have adopted. For a thorough consideration of Watteau and *Les Figures de différents caractères*, see Roland Michel 1987b.

150. Mariette [*ca.* 1770–1775] in Montaiglon and Chennevières 1860, I, p. 166.

151. For Boucher's early career and the influence of Watteau, see Voss 1953; Pierre Rosenberg "The Mysterious Beginnings of the Young Boucher," in *François Boucher*, exhib. cat., New York, 1986, pp. 41–55; and Schreiber Jacoby 1986, pp. 81–100, 164–78.

152. Schreiber Jacoby 1986, pp. 4–5, cites a passage by Restout published in the *Galerie Françoise* (1771), which implies that Jullienne engaged Boucher to make drawn copies, as well as etched copies, of Watteau's drawings; Restout's remarks are reproduced in full in Ananoff 1976, I, pp. 133–34.

153. Boucher's drawing has long been recognized as a copy after Watteau, but its source has only recently been identified by Rosenberg and Prat 1996, III, no. G216.

154. For the Stockholm drawing, see Bjurström 1982, no. 837, and Schreiber Jacoby 1986, no. III.B.30; for Boucher's etching after Watteau's lost drawing, see Rosenberg and Prat 1996, III, no. G94

155. For Boucher's study of "Jodelet" in Amsterdam, see Schreiber Jacoby 1986, no. III.D.6; for a comprehensive study of Boucher's Molière drawings, see Bjurström 1959.

156. Schreiber Jacoby first drew the connection between Boucher's drawing and *Les Plaisirs du bal*. For the Dulwich painting, see Rosenberg and Grasselli 1984, no. P51; Boucher's drawing is published in Schreiber Jacoby 1986, no. III.B.26, and Goldner and Hendrix 1988, no. 60.

157. For Watteau's drawing, see Rosenberg and Prat 1996, II, no. 375; Boucher's *Satyr* is studied in Schreiber Jacoby 1986, no. III.B.22, and Rosenberg 1990, no. 38.

158. Eidelberg and Gopin 1997, have recently examined the surviving evidence of Watteau's chinoiserie decorations for La Muette with great thoroughness; although their analysis is comprehensive and convincing, I must disagree with their rejection of the attribution to Watteau (p. 24, fig. 14, notes 20 and 21) of the single surviving painted fragment from the decorative scheme: on the contrary, *A Chinese Musician Playing a Hurdy-gurdy with a Companion in a Landscape* (sold, Sotheby's New York, January 11, 1996, lot 151; now in a private collection, New York) seems to me absolutely characteristic of Watteau's autograph works, and constitutes a significant addition to the very small group of extant ornamental paintings by the artist.

159. Perrin Stein, "Boucher's Chinoiseries: Some New Sources," *The Burlington Magazine*, 138 (September 1996), pp. 598–604.

160. For Demarteau's engraving, see Jean-Richard 1978, no. 724; for Boucher's etching after Watteau's drawing in Amsterdam, see Rosenberg and Prat 1996, II, no. 568, fig. A (*Figures de différents caractères*, no. 286); Watteau's original drawing in the Rijksmuseum, Amsterdam is in Rosenberg and Prat 1996, II, no. 568. For the Williamstown sheet, see cat. no. 41.

161. For Lemoyne's *Hunt Breakfast*, see Bordeaux 1984, no. P38; for the Metropolitan Museum study, see Bordeaux 1984, D55; for *Hercules and Omphale*, see Bailey 1991, no. 23.

162. Ongpin in Wintermute 1990, no. 21.

163. Boucher's landscape etchings for *Les Figures de différents caractères* are reproduced in Jean-Richard 1978, nos. 40, 43, 51, 66, 73, 76, 89, 96, 101, 112, 116, 122, 130, 132, 135.

164. Jullienne [1726] in Rosenberg 1984a, p. 17.

165. Goncourt 1948, p. 44.

Watteau's Copies After the Old Masters

by Pierre Rosenberg

Why do some artists feel they need to copy the old masters? This question prompts others that are rather more complex. Which old masters in particular do they choose to copy? Is the temptation stronger at some moments of their careers than others? How do they copy? For whom? Clearly these questions are interesting ones, rich in lines of inquiry, even though these have not hitherto been pursued by art historians as far as they deserve to be.

Let us consider, for comparative purposes, a few other great French artists. Nicolas Poussin (1594–1665) copied rarely and only for himself—almost exclusively engravings after the antique, which he copied in pen, wash, and bistre. He used these drawings to ensure the historical accuracy of his paintings; the Palestrina mosaic, for example, provided him with the sacred Egyptian ibises that give his *Rest on the Flight into Egypt* (St. Petersburg, State Hermitage) its Egyptian character, the "local color" that he held so dear.

The practice of Jean-Honoré Fragonard (1732–1806) was quite different. In 1760–61, he copied, mostly in black chalk but sometimes in red chalk, the paintings of Italian masters in the churches and palaces of the cities he visited in the company of the abbé de Saint-Non. Who, the abbé or Fragonard himself, chose what to copy? Did Fragonard undertake these exercises for his own artistic benefit, or did they merely provide him with an agreeable means of earning his way back to France?

Gabriel de Saint-Aubin (1724–1780) illustrated the catalogues of some of the most important Parisian sales from the second half of the eighteenth century. With remarkable skill, he made tiny copies of the paintings and drawings that passed before his eyes and in tiny writing annotated the catalogue. We owe much to his precision. Was he motivated by the curiosity of an *amateur* (or enthusiast), or by a concern to keep a visual record of some of the great private collections of the day, or by his desire to affirm his exceptional virtuosity in the light of his contemporaries' failure to recognize his genius? We do not know.

Jacques-Louis David (1748–1825) copied in a gray ink that is already a declaration of his intentions. He copied mostly in Rome and mostly ancient sculpture, thereby creating for himself a visual "larder" from which he drew tirelessly throughout his career. He permitted his many students to consult and make use of his copies.

As for Jean-Auguste-Dominique Ingres (1780–1867), the most gluttonous of copyists, the voracity of his gaze and his insatiable curiosity are amazing. He copied everything that passed through his hands or before his eyes. This man of discipline apparently had none when it came to copying. His choices reveal no favorites. Was it a mere exercise, like a pianist doing his scales? Not at all. With Ingres, nothing is wanton, everything is used, digested, used again. But under his brush the source or loan recedes as it is subsumed into his style.

If now we return to Watteau, we may better isolate the originality of his practice and his aims. One proviso: in the eighteenth century all aspirant artists learned to draw by copying. It is not, however, work of this kind that is in question here. Unlike most French eighteenth-century

painters, Watteau did not receive the traditional training dispensed by the Royal Academy.[1] The names of his first masters—here Claude Gillot (1673–1722) and Claude III Audran (1658–1734) do not count—do not tell us much, nor do the few surviving anecdotes of his life. And there is no point in entering into the nature of the best training, essential for most French artists of the day, or into the role of copying in traditional apprenticeship. An admirable remark by Chardin (who also was not trained by the Academy), quoted by Denis Diderot in 1765, makes it clear why:

> The chalk holder is placed in our hands, [Chardin] said, at the age of seven or eight. We begin to draw eyes, mouths, noses, and ears after patterns, then feet and hands. After crouching over our portfolios for a long time, we are set in front of the *Hercules* or the *Torso*, and you have never seen such tears as those shed over the *Satyr*, the *Gladiator*, the Medici *Venus*, and the *Antinous*. You can be sure that these masterpieces by Greek artists would no longer excite the jealousy of the masters if they were placed at the students' mercy. Then, after having spent entire days and even nights, by lamplight, in front of a still, inanimate nature, we are presented with living nature, and suddenly the work of all the previous years seems reduced to nothing: it is as if one were taking up the chalk for the first time. The eye must be taught to look at nature; and many are those who have never seen it and never will! It is the bane of our existence. Having spent five or six years in front of the model, we are left with the resources of our own genius, if we have any. Talent is not revealed in a moment.[2]

We can be quite sure that Watteau's training was very different.

In a text published four years after the artist's death, the abbé Leclerc informs us that Watteau "came to terms with a wretched painter who gave him work, and from whom he earned so little that he dared say how much only in confidence; and to compound his misfortune, he was obliged to copy the miserable productions of his master."[3] Further on, Leclerc adds that "he spent part of his time copying for dealers on the pont Notre-Dame four prints after Albani, which he painted and colored according to his fancy (all themes scarcely consistent with the kind of painting he has since chosen)." Gersaint (1744) is more specific:

> At that time, many small portraits and devotional subjects were sold to provincial dealers who bought them by the dozen or the gross. The painter who had just hired [Watteau] had the greatest stock of such pictures, of which his turnover was considerable; he sometimes had a dozen destitute students whom he kept busy like laborers; the only thing that he required of his workers was delivery on time: each had his task. Some did skies, others did heads; some did drapery, others applied the whites; once it had come into the hands of these last the picture was finished. At the time, Watteau had no other employ than to turn out these mediocre works; but he stood out from the others because he could do everything, and quickly: he often repeated the same subjects; above all, he was so talented at rendering *Saint Nicholas*, a saint in great demand, that Saint Nicholas was reserved especially for him; "I knew," he told me one day, "my Saint Nicholas by heart, and I no longer needed the original."

We are indebted to the comte de Caylus (1748) for the most detailed account (whether it is the most accurate is another matter):

> [Watteau] had been working some time for a dealer in such pictures, to whom chance had directed him, when painting, which makes adversities more bearable owing to imagination, and consequently by the *gaiety* with which it sometimes manages to season them, had him make a joke that consoled him, at least momentarily, for the boredom of forever making the same figure. He worked by day, and

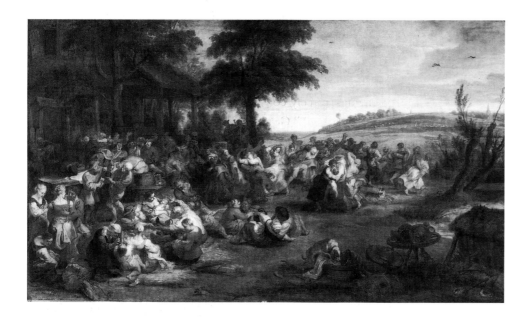

Figure 48
Peter Paul Rubens,
The Kermesse, or Country Wedding,
ca. 1635.
Oil on wood, 102¾ × 58¾ in
(261 × 149 cm).
Musée du Louvre, Paris

by noon he had still not come to ask for what was *called* the original. For the mistress took great care to lock it up every night. She noticed his neglect and called him. She cried out several times, but to no avail, in order to make him come down from the attic, where, since morning, he had been working and where, indeed, he had completed the original in question from memory. After she had been calling for some time, he came down and, with great composure accompanied by an air of affability that was natural to him, he asked her for it, he said, in order to place the spectacles: for it was, I think, an old woman consulting her registers, after Gerrit Dou; this composition was then all the rage in merchandise of this kind.

These anecdotes, which contradict one another on certain points, are precious, not simply because they provide humorous descriptions of the picture market in Paris in the early years of the eighteenth century. They also show Watteau earning a hard living by copying popular works for clients who had limited resources but who wanted to acquire paintings rather than prints. Above all, they tell us

that, if Watteau copied in his early life, he copied paintings, and did so in oil. And that he occasionally did so from memory. No resemblance here, obviously, to the training offered by the Academy.

The Watteau-as-copyist in question here was approaching his thirtieth year, by which time he had acquired a certain notoriety. Some intelligent collectors had recognized his genius and were vying with one another for his drawings (as well as his paintings). He copied works that pleased him, that inspired him, that appealed to his taste and predilections, works that revealed to him an Italy he would never visit and familiarized him with artists he admired and loved.

Eighteenth-century biographers of Watteau agree on two points.[4] First, that Watteau copied—"avidly"—Rubens's Marie de Médicis cycle in the Luxembourg Palace. To quote Jullienne (1726), one of the most reliable of his biographers, Watteau, "excited by the beauties of the gallery in this palace ... often went to study the coloring and composition of this great master." There was also the immense collection of Pierre Crozat, who "offered him an apartment in his home ... made it possible for him to imbibe new knowledge

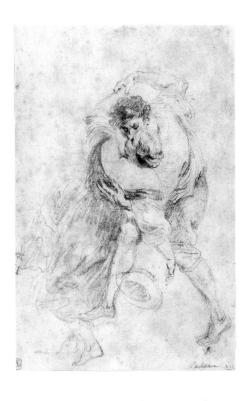

Figure 49
Antoine Watteau, after Rubens, *Entwined Couple*, ca. 1716.
Red chalk on laid paper,
8¾ × 5⅞ in. (22.3 × 14.7 cm)
Musée des Arts Décoratifs, Paris

Figure 50
Benoît Audran, after Watteau, *La Surprise*, ca. 1731.
Engraving, 11½ × 14½ in.
(29.3 × 36.7 cm).
Bibliothèque Nationale de France

from the drawings and paintings by great masters with which this house was filled." One can never read too attentively the account by Caylus:

However, M. Crozat, who loved artists, offered [Watteau] food and lodgings in his home. He accepted. This beautiful house, which then boasted the largest number of treasures in the way of paintings and objects of curiosity ever assembled by a private individual, provided Watteau with a thousand new promptings. But what most excited his taste was the beautiful and numerous collection of drawings by the great masters that figured among these treasures. He was responsive to those by Jacopo Bassano, but still more to the studies by Rubens and Van Dyck. The handsome rustic buildings, the beautiful sites, the lovely, the tasteful, and spirited foliage of the trees by Titian and Campagnola [Domenico Campagnola (*ca.* 1500–1564)], which he saw, so to speak, newly revealed, charmed him. And, as it is natural

to see things in relation to the use one can derive from them, so it was natural that he preferred these to the composition and expression of the great history painters whose aims and talents were so distant from his own. He was satisfied with admiring them, without applying them to himself by any special study, from which, in any case, he would have been unable to derive any benefit.

Louis-Antoine Prat and I have catalogued just over seventy copies by Watteau after the old masters (original drawings and/or counter proofs).[5] Such drawings were once much more numerous. The estate inventory of the abbé Haranger, compiled on May 17, 1735, and succeeding days, mentions "fifty landscapes of which the largest portion by Watteau after Titian and Campagnola" (valued at 5 *livres*!), and lot 107 in the Gravelle sale (Paris, April 17, 1752) was described as "a fifth portfolio ... of drawings of landscapes made by Watteau after originals by Titian and Campagnola."[6]

Figure 51
A.P. Van de Venne,
The Celebration of the Truce of 1609, 1616.
Oil on wood, 24½ × 44⅛ in.
(62 × 112 cm).
Musée du Louvre, Paris

Finally, lots 792–97 in the estate sale of Jean de Julienne in 1767 include no fewer than thirty-seven copies, described briefly, much too briefly to suit us.[7] Of interest here are the artists whose works were copied: Rubens,[8] Jordaens, Veronese, Van Dyck.[9] Add the "Venetians" mentioned by Gersaint (and Caylus), Titian, Campagnola, Zuccaro, and a few "northern" and French "accidents" (Van de Venne, Mellan, Le Nain, Louis de Boullogne, *etc.*), and we have a revealing list of the artist's preferences. His contemporaries were not mistaken: Watteau copied those he liked. He did so in his usual technique, generally employing red chalk, sometimes black chalk, never pen. As was his custom, he sometimes combined red and black chalk, with exceptional visual intelligence. From paintings, he would isolate motifs, groups of figures, single figures. When it came to drawings, he often copied the whole sheet, especially if they were landscapes. What is interesting in the first place is his selection, which reveals his taste, and, in the second, the way he used his copies.

Consider two examples. It is not surprising that Watteau should have copied *The Kermesse, or Country Wedding* by Rubens (fig. 48) in the royal collection, a painting which could not fail to have seduced him. He made a very faithful copy of an especially famous group from it, the pair of dancers in the foreground passionately embracing each other (fig. 49). Watteau used it in a work that is unfortunately lost but known to us in print form, *La Surprise* (fig. 50). In his painting, Watteau scarcely altered the upper portion of Rubens's picture, which he instilled with the same energy and dynamism. But he made the figures sit on the ground and stressed their precarious balance, the giddiness of love.

Another work from the royal collection interested Watteau: *The Celebration of the Truce of 1609* (fig. 51) by A.P. Van de Venne (1589–1662). Watteau incorporated its guitarist, which he had faithfully copied, into *Peaceful Love* (*L'Amour paisible*; fig. 51a). That Watteau was charmed by the figure of a musician is not surprising. But he also managed to make this guitarist his own!

This is not the place to dwell on the difficult problem of the dating of these copies (the author, with Louis-Antoine Prat, tackled this problem in 1996, primarily on the basis of the artist's stylistic evolution as we understood it). The complex question of the chronology of Watteau's graphic output—exacerbated by the scarcity of firm points of

Figure 51a. Bernard Barón, after Watteau, *Peaceful Love* (*L'Amour paisible*), early 1730s. Engraving, 13⅛ × 15¾ in. (33.2 × 39.9 cm). Bibliothèque Nationale de France

anchorage in the artist's brief career—is well known. And there is no need to discuss further the procedure special to Watteau of using "bound books" that never left him and in which he drew day after day, haphazardly and on whatever page happened to fall open. "Broken up" and shared by the artist's four heirs after his death, these notebooks were indispensable to him when he was working on a painting. But it is essential to insist on a point that distinguishes Watteau—radically, in my view—from the artists I mentioned at the beginning.

Copies by Poussin, Fragonard, David, and Ingres are fascinating objects of study that hold considerable interest for art lovers and collectors but they often prefer a study by Poussin for *The Seven Sacraments*, a view by Fragonard of the Villa d'Este, a study by David for *The Sabine Women*, or a portrait by Ingres of a pale English lady visiting Rome, to their copies after old masters or antiquity. With Watteau

things are different. His copies after the old masters are independent works of art that owe little to the models that inspired them. Rubens and Campagnola are not forgotten, nor are Domenico Fetti (1589–1623) or Bartolomeo Schedone (*ca.* 1570–1615), but they are *transfigured* by Watteau, like the "persons of one and the other sex" whom the artist "clothed in gallant dress" before drawing them.

True, Caylus observed that Watteau copied those artists who were useful to him, and in this respect Watteau is no different from Poussin or David. But this utility, the importance of which is undeniable, is subsumed into the sheer pleasure of drawing. Watteau may be regarded as the greatest draftsman after the old masters, because, breaking free of his models, he effectively effaces them, happily transforming them into so many admirable Watteaus.

Translated from the French by John Goodman

Notes

1. Drawing after the male nude played an essential role in academic education. One learned to draw male nudes, called *académies*, by first copying prints and other drawings. Watteau did not receive such training. In the words of Caylus: "Having almost never drawn the nude, he knew neither how to read it nor how to express it; to such an extent that [drawing] a full *académie* tired and displeased him. Women's bodies, requiring less articulation, were somewhat easier for him."
2. Denis Diderot, "The Salon of 1765," in *Diderot on Art*, edited and translated by John Goodman, 2 vols., London and New Haven, 1993, I, pp. 4–5.
3. This text, as well as those that follow, can be found in a small collection edited by the present author: *Vies anciennes de Watteau*, Paris: Hermann, 1984; Italian edition, revised and expanded, 1991.
4. See preceding note.
5. Rosenberg and Prat 1996.
6. Rosenberg and Prat 1996, pp. 1420 and 1426.
7. The catalogue of the Julienne sale indicates that these drawings were "in the style of Rubens" or "in the manner of Rubens," but a note scribbled in the margin of the copy in the Victoria and Albert Museum specifies: "or rather copies of drawings by Rubens."
8. Some copies by Watteau after an album of drawings from Rubens's studio have been studied in Eidelberg 1997a, who disagrees on certain points of chronology and attribution with our catalogue raisonné of Watteau's drawings (Rosenberg and Prat 1996). We are inclined to accept the core of his argument, although it entails Watteau's authorship of some drawings of rather poor quality.
9. Regrettably, the "beautiful head" executed by Van Dyck in the *trois crayons* technique and acquired by Tessin in Paris in 1715, with which "Watteau was enchanted," is lost, as are the copies that Watteau is said to have made of it "*à différentes reprises*." See Rosenberg and Prat 1996, p. 1420.

Problems of Connoisseurship in the Drawings of the Watteau School

New Attributions to Pater, Lancret, and Portail

by Margaret Morgan Grasselli

While the drawings of Antoine Watteau (1684–1721) have been the subject of considerable scrutiny in recent years and have had no fewer than two major catalogues raisonnés devoted to them,[1] the drawings of his followers continue to elicit comparatively little attention. Of Watteau's main satellites, Nicolas Lancret (1690–1743) is the only one to have been honored with a monographic exhibition, including fifteen drawings,[2] and Jacques-André Portail (1695–1759) is the only one whose drawings have been the subject of a book—mainly of pictures, but a book nonetheless.[3] A number of articles have addressed connoisseurship problems in the drawings of the Watteau school, but they are few and far between and have reproduced relatively few drawings by the various followers.[4] The natural result of such neglect is continued confusion about the individual drawing styles of both his major and minor followers and recurring errors of attribution. Both of these problems can be easily cured, but only if a greater number of the drawings by Watteau's imitators and followers can be reproduced under their proper attributions. Publications and exhibitions such as this one, in which several drawings by each of Watteau's imitators and followers can be seen, studied, reproduced, and discussed together, will make all the difference in helping to distinguish the various hands. Close study of the exhibited drawings will in fact show that, for the most part, it is not especially difficult to distinguish a Jean-Baptiste Pater (1695–1736) from a Lancret, for example, or a Lancret from a Portail, if one only knows what to look for. To prove that and to provide a kind of basic key to the kinds of stylistic differences that one finds in the drawings of the Watteau school, I should like to focus on the draftsmanship of just those three artists, using as examples a number of drawings that have previously been attributed wrongly to one or other of them or to Watteau himself.

Among the small group of artists who followed in the footsteps of Watteau, Pater holds a special place as Watteau's only documented pupil and his most faithful imitator. He, more than any other, carried on the *fête galante* tradition as it had been established by Watteau, to the extent that he has long been dismissed as little more than a servile imitator of no originality.[5] Whether or not that judgment is completely warranted, Pater himself apparently made no bones about his debt to Watteau, reportedly avowing shortly after his master's death that he owed everything he knew to him.[6]

Pater's drawing style, like his paintings, was deeply influenced by Watteau, not only in the choice of medium—almost invariably Watteau's cherished red chalk—but also in subject matter, which consisted mainly of lively studies of elegantly clad and posed ladies and gentlemen. Until the

publication of the first catalogue raisonné of Watteau's drawings by K.T. Parker and Jacques Mathey in 1957, it was not all that uncommon to find Pater's drawings attributed to Watteau himself. In recent years, however, such errors have become relatively rare, mainly because Watteau's drawing style has become considerably better known. It is time now for Pater's draftsmanship to be more clearly defined in its own right.

The most prominent features of Pater's mature style are fluttery contours, ornamental patterning of light and shade, and elegant complication of the draperies. The chalk strokes tend to be quick and agitated rather than long and smooth, and rapid accents skitter almost haphazardly along folds and contours. But under the eye-catching intricacies of the draperies and the sprightly chalk lines, Pater's figures are rather awkwardly constructed or oddly proportioned, and the forms are often quite flat (see, for example, cat. no. 73).

Pater did occasionally draw in a somewhat less fussy mode, usually in his studies of soldiers and men. In those drawings, the contours are longer and smoother than those he used for his studies of women; accents are used more selectively; light and shade are less elaborately patterned; and the forms seem generally more substantial. Pater's soldier drawings, some of which once passed as the work of Watteau himself,[7] approach most closely the character of his master's drawings. But even so, Pater's studies of soldiers are more generalized, surface-oriented renderings than the incisive, full-bodied, animated figures drawn by Watteau.

One more notable feature of Pater's drawings is the marked family resemblance that links them together, due mainly to the way he rendered features and faces. The eyes, for example, generally consist simply of solidly colored irises and long eyelids that slant upward toward the temples, giving the model an inquisitive or sly expression. The nose is always prominent—whether long, bulbous, porcine, or otherwise misshapen—with deeply accented nostrils. The face is usually ovoid, broad at the eyes and tapering sharply to a

Figure 52. Jean-Baptiste Pater, *Dancing Man*. Red chalk, 7⅛ × 2⅛ in. (18.1 × 5.4 cm). Private collection, New York; *Two Studies of Men Seated on the Ground*. Red chalk, 7⅛ × 3 in. (18.1 × 7.6 cm). Private collection, New York

small mouth and pointed chin. A few wisps of hair complete the Pater "look."

Those same features are abundantly evident in two drawings in a New York private collection, *Dancing Man* and *Two Studies of Men Seated on the Ground* (fig. 52),[8] both of which were once attributed to Watteau. The *Dancing Man* is drawn with a finely sharpened piece of chalk with nervous squiggles animating the contours, while the two seated figures are drawn with a blunter chalk and in a more rapid, sketchy style. The quality of the chalk strokes in both and

Figure 53
Jean-Baptiste Pater,
Standing Man with a Stick.
Red chalk,
6¼ × 3½ in.
(15.9 × 8.9 cm).
The Art Museum,
Princeton University;
Gift of Mrs. Christian H.
Aall in honor of Allen
Rosenbaum

Open Air (*Réunion en plein air*; Potsdam, Sans Souci; Ingersoll-Smouse 1928, fig. 43) and in *The Festival at the Bezons Fair* (New York, Metropolitan Museum of Art; Ingersoll-Smouse 1928, fig. 45). As is usual with Pater's work, these paintings are not dated, and neither the paintings nor the drawings can be assigned dates until further work has been done on Pater's development as an artist.

A particularly handsome study by Pater but formerly attributed to Watteau is *Standing Man with a Stick* in Princeton (fig. 53).[9] The figure does not appear in any known paintings by Pater, but all aspects of the execution are unmistakably his, except that this man seems to have somewhat more character in the facial expression than is found in most of Pater's drawings, and the study as a whole is more beautifully finished and complete. Within Pater's painted œuvre, this figure seems to have most in common with some of the unusually individualized characters in Pater's delightful illustrations of both the *Roman comique* by Scarron and the *Contes* of La Fontaine, which are known to have been executed during the last seven years of Pater's career, 1729–36. Whether or not the Princeton study actually dates from that period, it is doubtful that it was drawn much earlier, for its suavity and assured execution seem to be the work of a fully mature artist.

For a period of time between 1711 and 1716 (the exact dates are not known), Pater studied with Watteau and became intimately acquainted with both his drawings and his paintings. Watteau was apparently not an easy master to work with, but he seems to have tolerated Pater's presence in his studio, at least for a while.

One aspect of Pater's activities in Watteau's studio is revealed in *A Man Reclining on the Ground, and Two Studies of a Man's Head* (fig. 54), a drawing with studies by both Watteau and Pater on the same page.[10] The study of the reclining man was used by Watteau in the backgrounds of three of his paintings—*Gathering in the Open Air* (*Réunion en plein air*; Dresden, Gemäldegalerie), *Les Champs-Elysées*

the particular handling of the facial features are perfectly identifiable as the work of Pater. As is the case with many drawings by Pater, these have been radically trimmed, compressing the figures into a much smaller space than Pater originally intended, and even cutting off bits of the actual figures. These were not, however, cut from the same sheet or drawn at the same time, as the different handling of the figures attests.

The attributions are confirmed by the fact that both drawings are related to figures in paintings by Pater: the dancer appears in the center of *Village Dance* (*Bal villageois*; now known through a copy in Potsdam, Sans Souci; Ingersoll-Smouse 1928, fig. 220); seated men similar to the ones on the second sheet can be found in *Gathering in the*

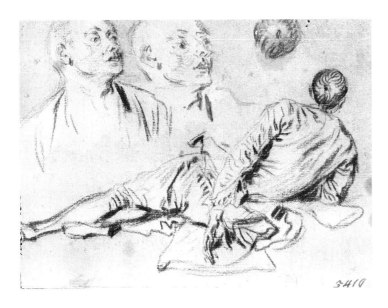

Figure 54. Antoine Watteau and Jean-Baptiste Pater, *A Man Reclining on the Ground, and Two Studies of a Man's Head*, 1714-15. Red chalk with pale green wash on cream paper, 4 × 5⅜ in. (10.2 × 13.7 cm). Staatliche Graphische Sammlung, Munich

(London, Wallace Collection), and *Country Amusements* (*Divertissements champêtres*; London, Wallace Collection)[11]— and he used the leftmost study of the bust of the man as the basis for a figure in *Pastoral Pleasure* (*Plaisir pastoral*; Chantilly, Musée Condé).[12] Both of those studies are clearly by Watteau himself. The sketch of the head and shoulders of the man at upper left is especially masterly, capturing simply and clearly the tautness of the skin and muscles as the man thrusts his chin forward and lifts his head high. The second head study, however, which initially seems to be a variant of the first but with slight changes in position, turns out instead to be a copy by Pater, whose hand is evident in the misshapen nose, large ears, and protruding eyes. While it follows the basic outlines and accenting of the Watteau original, it does not have the same spark of life and the same sense of real tension. In trying to imitate Watteau's spontaneity, Pater lost the purpose of the individual lines, copying the appearance of Watteau's contours and accents while neglecting the underlying structure.

The part of the drawing that is by Watteau is datable to around 1714–15 on the basis of its style and its connection to *Pastoral Pleasure*, which is approximately datable to that time.[13] This sheet as a whole seems to indicate that Pater was still working with Watteau in 1714. How much longer he may have remained with Watteau is not known, though he was certainly back in their mutual hometown, Valenciennes, by the fall of 1716.

Within Watteau's orbit, Pater's drawings are most often confused with those of Nicolas Lancret, his close contemporary and principal rival. But while their drawings indeed share a certain generic kinship that stemmed from Watteau's influence on both of them, they also reveal some critical differences. Beside Pater's somewhat exaggeratedly elegant men and women, Lancret's figures generally seem larger and heavier. Lancret's surfaces are usually less intricately patterned by scattered accents and broken patches of light and shade, while his contours, though often rather jagged, are more angular and purposeful than Pater's flickering, restless lines and squiggles. Lancret's faces are as heavy and solid as his bodies, dominated by large, wide-set eyes and broad, flat cheeks. His hands, too, seem square and blunt beside Pater's, which can be disproportionately long and sometimes even rather clawlike. Further, while Pater had a marked preference for red chalk and only on the rarest occasions combined it with a few touches of white or black, Lancret made his drawings in a variety of chalk combinations—in *trois crayons*, in either red or black chalk heightened with white, or in red or black chalk alone.

As is the case with Pater, few of Lancret's drawings are now misattributed to Watteau, simply because the works of both artists are better known and more widely published. At the same time, however, the full range of Lancret's drawing style is much broader than one would expect from an artist who is still known almost solely as one of Watteau's principal followers, and a surprising number of Lancret's

Figure 55
Nicolas Lancret,
Standing Man Seen from Behind,
early 1720s.
Red chalk,
8¼ × 3¾ in. (21 × 9.5 cm).
Royal Cornwall Museum,
Truro, England

are relatively fine and more or less unbroken; the modeling is quite restrained, consisting only of a few judicious patches of hatching; accents are limited to some stronger touches that pick out a hem, a fold, or an outline. The figure's unusual proportions—quite elongated with a small head, narrow shoulders, long legs, and wide hips—are typical for Lancret and are an unmistakable feature of his drawings of the early 1720s. The drawing may have been used as the basis for the caped and bareheaded man standing at left in *The Dance Before a Fountain* (*La Danse devant la fontaine*; Wildenstein 1924, pl. 47),[15] but there are significant changes in the costume and the pose of his head, and the relationship is somewhat tenuous. Nevertheless, the attribution of the drawing to Lancret is sure.

The Truro *Seated Man* (fig. 56), of which the attribution has bounced back and forth between Lancret and Pater,[16] is drawn in an equally characteristic but heavier Lancret style, with strongly accented, broken contours and rather blocky forms. Both the large, blunt-fingered hands and the face are unmistakably Lancret in type. The strong contrast between the man's lightly sketched face—hardly visible at all—and the bolder presentation of the rest of the figure is relatively common in Lancret's drawings, especially when he is more concerned with details of pose and costume than with facial expression. Both the character of the drawing and the figure's stocky proportions allow this sheet to be placed in the 1730s, well after Watteau's influence had faded from Lancret's style. This young man appears at right in *The Shepherds' Dance* (*La Danse des bergers*; Berlin, Charlottenburg Palace; Wildenstein 1924, pl. 44), one of Lancret's most beautiful outdoor dance compositions. As is often the case with Lancret's translation of his drawn figures to his paintings, he has made some changes to the pose and the costume (indeed, almost half the figure is hidden behind a woman in the painting), but the connection seems very convincing.

The third Truro drawing (fig. 57) is least obviously

studies are still wrongly attributed to other artists—mainly to Pater—or remain anonymous. Examination of a number of these, while restoring them to their proper artist, will help to pinpoint some of the characteristics of Lancret's draftsmanship.

Three drawings in the De Pass collection at the Royal Cornwall Museum, Truro, England, for example, show Lancret working in three different modes: *Standing Man Seen from Behind*, *Seated Man*, and *Seated Woman* (figs. 55, 56, 57). Of those, only the *Standing Man Seen from Behind* has consistently been placed in the vicinity of Lancret, but always with a certain amount of hesitation as to whether it was actually by him.[14] It is in fact drawn in one of Lancret's simplest, cleanest, and most characteristic styles. The contours

Figure 56
Nicolas Lancret,
Seated Man, 1730s.
Red chalk,
6 × 4⅛ in.
(15.2 × 10.5 cm).
Royal Cornwall
Museum, Truro,
England

Figure 57
Nicolas Lancret,
Seated Woman,
ca. 1720.
Red chalk,
4½ × 3¾ in.
(11.4 × 9.5 cm).
Royal Cornwall
Museum, Truro,
England

attributable to Lancret, mainly because it is drawn in his earliest style when the influence of Watteau is strongest and Lancret's own idiosyncracies are not completely developed. Contrary to what one generally expects from Lancret, his attention is focused mainly on the woman's voluminous draperies. The modeling is soft, rounded, and quite atmospheric, and the accenting is less linear than is usual for him. This is the kind of Lancret drawing that is most often confused with those of Pater, precisely because it shows more interest in surface than in the underlying structure, as those of Pater usually do. Indeed, this drawing has been published more than once under Pater's name.[17] Nevertheless, Lancret's touch is clearly evident in the figure's headdress, head, sleeves, and hands, and the beginnings of his forceful accent strokes can be found along the hem and back of the woman's dress. More monumental studies drawn in a similarly atmospheric style can be found on two sheets in the Städelsches Museum, Frankfurt, and the Musée Carnavalet, Paris, all related to figures in Lancret's painting of *Winter* (Wildenstein 1924, pl. 7),[18] known now only through the print by Jean-Philippe Le Bas. The Truro figure does not appear in any known Lancret paintings, though one could imagine that such a woman, dressed in outdoor clothes and seeming to lean forward to warm her hands, might easily have been drawn as a first idea for a figure—eventually unused—in that same painting of *Winter* or in some similar scene of winter activities.

Another example of Lancret's earliest style is a black- and red-chalk study of a bust of a woman in the Museum Boymans-Van Beuningen, Rotterdam, which was formerly

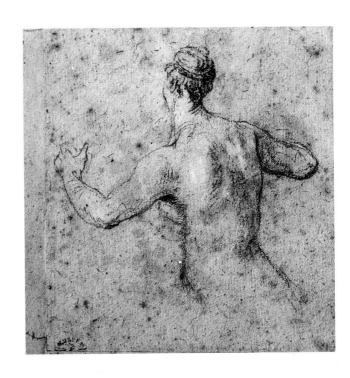

Figure 58
Nicolas Lancret,
Portrait of a Woman,
ca. 1718–19.
Red and black chalks,
6 × 4⅜ in. (15.2 × 11.1 cm).
Museum Boymans-Van
Beuningen, Rotterdam

Figure 59
Nicolas Lancret,
Nude Woman Seen from Behind,
ca. 1720.
Red and black chalks
heightened with white on beige
paper, 4¾ × 4¼ in.
(12.1 × 10.8 cm).
Musée d'Art et d'Archéologie,
Besançon

attributed to Watteau himself (fig. 58).[19] Indeed, in a drawing such as this, Lancret came closest to Watteau's style, not only borrowing the way he combined his media, but also capturing some of the pensive mood that permeates many of Watteau's studies of women. Lancret's hand is most evident in the broad, rather geometric handling of the draperies and in the strokes that define the hair and shoulders. Less characteristically Lancret is the treatment of the face, which has none of the features—especially the eyes—that one usually expects in his drawings. This study was clearly made before Lancret's own personality had imprinted itself on his drawing style, and when Watteau's influence was strongest on his work, probably in 1718 or 1719. The pose and demeanor of the Rotterdam woman are similar to those of a number of figures in Lancret's earliest paintings, but is closest to one of the figures in *Country Pastimes* (*La Récréation champêtre*), known through the engraving (in reverse from the original painting) by Joullain (Wildenstein 1924, pl. 67).

Like Watteau, Lancret rarely drew nudes, and the few such studies that are known show that his knowledge of anatomy was not particularly impressive. A study of a half-length woman seen from behind, in the Musée d'Art et d'Archéologie in Besançon, shows just how awkward Lancret's nudes can be (fig. 59). In this case, the musculature of the woman's upper arms and back is ludicrously bulky compared to the small size of the head, and the lower back seems to have a strange twist to it. Lancret's handling of the chalks, especially in the contours and the hair, is unmistakable, and the same bizarre proportions are found in some of his painted nudes.[20] A similar figure is found at the lower center of one of his rare history paintings, *Diana and Callisto* (Wildenstein 1924, pl. 173), which is now known only through a poor photograph. More intriguing is the possible connection between this drawing and a painting that has always been considered to be the work of Watteau, the portrait of Antoine de La Roque (fig. 95, p. 208): one of

the nymphs frolicking in the background bears a strong resemblance to the one in the Besançon drawing, though with a couple of slight shifts in the pose. In the original painting, which was sold in Paris on May 30, 1988,[21] the facial types of all the nymphs are exactly those that one expects from Lancret rather than Watteau, yet what are Lancret nymphs doing in a Watteau painting? The two artists did know each other and Watteau is said to have advised Lancret to depend less on the teachings of his master and to draw more from nature. Supposedly, two paintings that Lancret made in accordance with Watteau's advice—"from his imagination and by his choice"—were praised by Watteau and were submitted for Lancret's *agrément* at the Royal Academy.[22] It is significant that Silvain Ballot de Sovot, Lancret's biographer, made no mention of a collaboration between the two artists, which would presumably have redounded to his friend's credit. Thus, if Watteau did not actually ask Lancret to paint the background figures, either the painting was left unfinished at Watteau's death, in which case La Roque would have hired Lancret to complete it; or it was damaged early on and Lancret was asked to restore it (the composition of the painting and the poses of the background figures correspond to the engraving after it was published by Bernard Lépicié in 1734). But what if the painting was not in fact made by Watteau, but rather by Lancret? This last possibility may in fact be the best one, even though the painting was engraved and published in the *Recueil Jullienne* as the work of Watteau, thirteen years after Watteau had died but still during Lancret's and La Roque's own lifetimes. That Lancret was somehow involved with the picture is proven by another drawing (cat. no. 59), this one showing La Roque himself in the pose used in the painting, which seems to have more the characteristics of a study made in preparation for the picture than of a copy after it. However it came about, Lancret's participation in the execution of the painting, as indicated by the style of the painted figures and the possible connection with the aforementioned drawings, seems certain.

Whereas Lancret's authorship of the three preceding studies may not have been perfectly obvious at first glance, a few other misattributed sheets can easily be identified as his because they exhibit more of the idiosyncracies associated with his drawing style. A study of a *Seated Woman*, formerly in the collection of the Goncourt brothers,[23] is drawn in the same neat style as the Truro *Standing Man Seen from Behind* (fig. 55), with comparably clean, rather simple contours and the same careful hatching, and sparse accenting. Both drawings were almost certainly made during the same period—probably in the early 1720s—and even though the woman does not appear in any of Lancret's known paintings, the attribution to him is secure.

Two black-chalk drawings in Athens (National Gallery and Alexander Soutzos Museum) seem to be alternative studies for the same figure of an older man kneeling on the ground and pulling a string, probably to spring a bird trap (fig. 60).[24] Several such bird-catchers appear in Lancret's paintings, though none matches exactly either one of these. Nevertheless, it is possible that these were preliminary studies for the barefooted bird-catcher in *The Bird Hunt* (*La Chasse à la pipée*; London, Wallace Collection; Wildenstein 1924, pl. 118), a painting that appears to have been executed no earlier than 1730 and perhaps more likely toward the end of that decade. The delineation of both of the Athens figures is in fact characteristic of Lancret's later style, both in the larger size of the head and its correspondingly heavier features, and in the more open, rather broken contours of the forms as a whole. In such drawings as these, Lancret is far removed from Watteau's influence and is perfectly at home in his more personal and prosaic style.

One becomes so accustomed to a certain angular ruggedness and spareness in Lancret's drawings that his more polished studies sometimes elude recognition. Such is the case with *A Hunter* (fig. 61), a study which was once attributed to Watteau himself but has since been identified

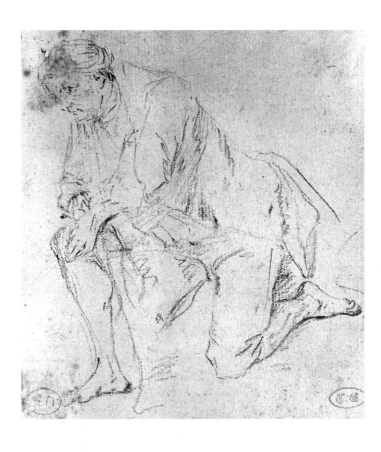

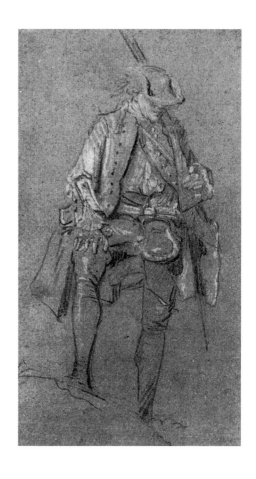

Figure 60
Nicolas Lancret,
Kneeling Man, 1730s.
Black chalk,
4¾ × 4 in.
(12.1 × 10.2 cm).
National Gallery and
Alexander Soutzos
Museum, Athens

Figure 61
Nicolas Lancret,
A Hunter, ca. 1730–40.
Black chalk heightened
with white on gray-
brown paper,
10 × 5⅝ in.
(25.4 × 14.3 cm).
Whereabouts unknown

only as French, *ca.* 1730–40.[25] Drawn in black and white chalks on gray-brown paper, this is a particularly handsome and complete study by Lancret, undoubtedly made in connection with one of his scenes of hunters resting. Although this particular figure does not appear in any of the known paintings by Lancret, another drawing by him, *Hunter Reclining on the Ground*,[26] shows what appears to be the same model in exactly the same costume, including the hat. The two drawings were probably made in the very same session, most likely in the early 1730s. In both studies, Lancret paid special attention to the details of the costume and fully exploited the coloristic effects of the white and black chalks. Both are outstanding drawings in his œuvre, and illustrate

once again how broad-ranging his draftsmanship can be. Whereas Pater's evolved relatively little over the course of his career, Lancret's changed quite dramatically as he asserted his own personality and experimented with different styles and media.

Jacques-André Portail, born the same year as Pater, was not personally acquainted with Watteau, for he did not travel to Paris from his native Brest until after Watteau's death. However, he was attracted not only to Watteau's *fête galante* subject matter, but also, and even more, to the two- and three-color drawing techniques. However, whereas Watteau's drawings were primarily casual studies in which he stockpiled visual information for possible use in later

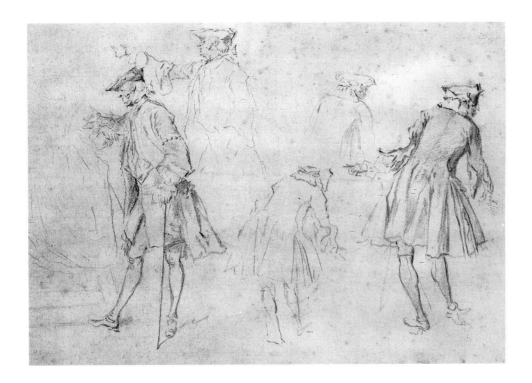

Figure 62
Jacques-André Portail,
Sheet of Sketches.
Red and black chalks,
9¼ × 12⅝ in.
(23.5 × 32.1 cm).
National Gallery of Art,
Washington, D.C.;
Gift of Myron A. Hofer

paintings, Portail's were generally more highly polished compositions or scenes that were complete in themselves (see, for example, cat. nos. 75–77). Many of these—whether of well-dressed ladies and gentlemen, ragged peasants, still lifes, or landscapes—were drawn with an almost miniaturist touch and close attention to detail, with finely controlled chalk strokes and lovely effects of light. Often enhancing the pictorial aspects of those drawings were delicate smudges of stumping as well as adept touches of wash, watercolor, and pastel. These highly finished Portail drawings are easily recognizable and are now almost never mistaken for the work of anyone else, not even Watteau himself. On occasion, however, Portail made some less precise drawings in red and black chalks, usually showing ladies and gentlemen posed in the same kinds of genre-like situations as his more finished drawings—reading, writing, playing musical instruments—but having instead some of the freedom and spontaneity of casual sketches or preparatory studies. Most of these are

equally recognizable as the work of Portail because of the particular handling of the faces and the careful separation of the red and black chalks, but a few studies of this type have been mistaken for the work of another, usually Nicolas Lancret.

One such drawing is a sheet of figure studies in the National Gallery of Art, Washington, D.C. (fig. 62).[27] Although this is certainly an unusual sheet in Portail's known œuvre—the only such sheet of multiple studies that I have come across—the most finished sketches on the page point directly to Portail's authorship. Both the quality of the drawing and the character of the figures and their poses are entirely consistent with his hand. Of special interest on this sheet are the sketchier studies, which show how Portail began his drawings and then proceeded to build up the figures. Most surprising for an artist who is known for the clean precision of his drawings are the deft squiggles and zigzags with which he set down the broad contours of his

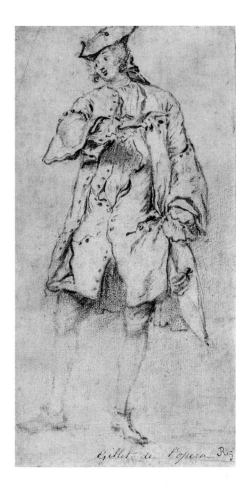

Figure 63
Jacques-André Portail,
Standing Man.
Black chalk with
touches of black ink,
8 × 4⅛ in.
(20.3 × 10.5 cm).
Art Institute of Chicago;
Gift of Julius Lewis

soft, crumbly black chalk, which is used in this case without his customary sanguine. Nevertheless, a number of particular details of the execution and the presentation of the figure point to Portail as the likely author. The style of both the clothing and the hair, for example, are consistent with those found in many of his drawings, as are the overall proportions of the figure. More important, though, is the fact that comparisons can be found for the way in which many individual details in the Chicago study are drawn,[28] including the enlivening of the hem line with a couple of artificial zigzags to suggest folds or pleats; the slight jitter in the lines describing the contour of the sleeves, the cuffs, and the skirt of the coat; the jagged outlining of the lace at the man's wrist; the complicated interplay of the outlines defining the different layers of the man's clothing on his torso; the atmospheric hatchings to the right of the figure. What makes one hesitate over the attribution to him, however, is the awkward sense of disconnection between some of the darkest accents and the rest of the drawing. If one accepts the marks as original—as they appear to be—then the most likely explanation is that this must be one of Portail's earliest known drawings, made before he had completely established his style as a draftsman and before he had achieved complete mastery of his media.

Undoubtedly, many other drawings by Pater, Lancret, Portail, and other followers of Watteau remain to be discovered under the names of other artists, buried away because so few people are familiar with their individual drawing styles. As this discussion shows, the connoisseurship is often not so difficult; it is more a question of publishing and reproducing more drawings from the Watteau school so the works and hands of the individual followers can become more familiar to a wider public. It will not be too long, I hope, before the scholar's pleasure at discovering yet another misattributed study by Lancret or Pater will be replaced by the delight of knowing that the drawing styles of all Watteau's followers are finally properly defined and the

forms. The spontaneous freedom and overall lack of self-consciousness in the drawing make this one of Portail's liveliest and most energetic.

Some of the unusual qualities of the National Gallery study sheet make it possible to suggest a tentative attribution to Portail of another drawing that has long been attributed incorrectly to Lancret, *Standing Man* in the Art Institute of Chicago (fig. 63). The fact that this drawing was executed only in black chalk with some touches of pen and black ink does not instantly militate in favor of the Portail attribution—except that he is the only Watteau follower who heightened some of his drawings with touches of ink—nor at first would one associate with him the rather

drawings themselves are getting some of the attention and appreciation they deserve. As admirers of Watteau's art and sometime bearers of his flame, these artists shared, at least for a time, a common spirit and worked in kindred styles. At the same time, however, they were individuals who impressed their own personalities on their works and were inventive and able artists in their own right. After so many years of being designated as mere followers of Watteau, they are finally beginning to get some of the recognition they deserve for their separate achievements, and their distinctive artistic identities are slowly being defined. This essay is just another step along the way.

Notes

1. Parker and Mathey 1957; Rosenberg and Prat 1996.

2. *Nicolas Lancret, 1690–1743* was organized and catalogued by Mary Tavener Holmes and presented at the Frick Collection, New York, 1991–92. Of the sixteen drawings included in the exhibition, one (cat. no. 29, pl. 34) was not by Lancret.

3. Salmon 1996.

4. The pioneering article in this area was Mathey 1936. A number of other articles focused on drawings by individual artists: Parker 1932; Parker 1933; Mathey 1948b; Mathey 1955; Joachim 1974b; Morgan 1975; Grasselli 1986.

5. Pierre-Jean Mariette, who knew Pater, wrote one of the harshest judgments of his skill (and his avarice): "*Pater est aujourd'hui presque oublié et c'est-ce qui arrivera à tous ceux qui, comme lui, seront des imitateurs serviles de la manière de leur maître. Le défaut de celui-ci était de ne pas savoir mettre une figure ensemble et d'avoir un pinceau pesant. Il n'était occupé qu'à gagner de l'argent et à l'entasser. Le pauvre homme ne se donnait pas un moment de relache: il se refusait le nécessaire et ne prenait de plaisir qu'à compter son or. Je n'ai rien vu de si misérable que lui.*" Reprinted in the aged but indispensable catalogue of Pater's paintings: Ingersoll-Smouse 1928. See also Montaiglon and Chennevières 1860, p. 90.

6. See Edne-François Gersaint, *Catalogue raisonné des diverses curiosités du cabinet de feu M. Quentin de Lorangère ...*, Paris, 1744, reprinted in Ingersoll-Smouse 1928, p. 19.

7. See, for example, Parker 1933, pp. 25-27; and Morgan 1975, pp. 132-33.

8. These drawings were kindly brought to my attention many years ago by Dr. Constance Lowenthal.

9. The drawing arrived at Princeton in 1986 as a Watteau, and was identified as a Pater by me shortly thereafter. It is now properly catalogued at Princeton under Pater's name.

10. Rosenberg and Prat 1996, I, no. 269, consider both head studies to be the work of Watteau himself.

11. For reproductions of these paintings, see Camesasca and Rosenberg 1982, nos. 182, 156, and 183, respectively.

12. Reproduced in Rosenberg and Camesasca 1970, no. 150.

13. The dating of *Pastoral Pleasure* and its related drawings is worked out in detail in Grasselli 1987a, I, pp. 220–23, where the participation of Pater in the Munich drawing was first posited.

14. The drawing was catalogued in Joannides 1994, no. 45, as attributed to Lancret; and Rosenberg and Prat, in the "Rejects" section of their 1996 catalogue of Watteau's drawings (III, R 813), called it only "close in effect" to Lancret.

15. The standard catalogue of Lancret's paintings is seventy-five years old, but still invaluable: Wildenstein 1924.

16. See Joannides 1994, no. 69, where the drawing is published as the work of Pater, and Rosenberg and Prat 1996, III, R 812, where it is described as being close to Lancret.

17. See Joannides 1994, no. 46. Rosenberg and Prat 1996, III, R 814, call it "close in effect" to Pater.

18. Reproduced in Grasselli 1985, pls. 43a, 43b, 46.

19. In the 1970s, when I first studied this drawing, I proposed an attribution to Antoine Pesne, but I now believe firmly that Lancret is the proper attribution.

20. See, for example, the sculpted nudes in *Winter* and *Les Comédiens italiens à la fontaine* (Wildenstein 1924, pls. 13, 74) and some of the bathers in *Les Baigneuses*, *Jeunes filles au bain*, and *Diane et Callisto* (Wildenstein 1924, pls. 102, 103, 173).

21. Drouot [?], May 30, 1988, lot 21 [?].

22. What little is known about Lancret's acquaintance with Watteau comes from Silvain Ballot de Sovot, extracts of whose biography of Lancret are cited in Wildenstein 1924.

23. Red chalk, $6\frac{1}{4} \times 6\frac{1}{4}$ in. It was sold at Christie's, New York, January 12, 1995, no. 86, and was published by Launay 1991, no. 161, properly attributed to Lancret. Rosenberg and Prat 1996 (R 610), however, suggested that it was more likely the work of Pater.

24. The second study is reproduced in Rosenberg and Prat 1996, III, R 30.

25. The drawing first appeared at Parsons & Sons, London, cat. 38, no. 69, where it was attributed to Watteau himself. It was catalogued among the "Rejects" by Rosenberg and Prat (R 279) as French, *ca.* 1730–40.

26. Black chalk heightened with white on gray paper, $6\frac{1}{4} \times 5\frac{5}{8}$ in., Bibliothèque Municipale, Rouen. Reproduced in Holmes 1991, cat. 30, pl. 35.

27. The drawing was formerly attributed to Lancret.

28. For a number of reproductions of Portail's drawings, see Salmon 1996, especially pls. 34–39.

Toute seule elle peut remplir et satisfaire l'attention

The Early Appreciation and Marketing of Watteau's Drawings, with an Introduction to the Collecting of Modern French Drawings During the Reign of Louis XV

by Colin B. Bailey

Figure 64. François de Troy, *Portrait of Jean de Jullienne*, 1722. Oil on canvas, 35½ × 28⅜ in. (90 × 72 cm). Musée des Beaux-Arts, Valenciennes

In François de Troy's belated marriage portrait of the dyer and cloth-merchant Jean de Jullienne (1686–1766; fig. 64)— whose fortune was made from the woolen scarlet "that had no equal in Europe"[1]—the sitter carefully holds a drawing of the recently deceased Antoine Watteau, his name inscribed at the bottom of the sheet. *Porte-crayon* in hand, bewigged but informally attired in a fine silk dressing-gown, Jullienne is presented less as the ardent husband than as the enlightened connoisseur (the pendant to this portrait adheres more strictly to nuptial convention in showing Madame de Jullienne holding the branch of an orange tree, symbol of a sweet and fecund union).[2] An amateur engraver who had taken lessons from François de Troy himself, Jullienne chose to be commemorated as the friend and champion of the painter who had wisely discouraged him from pursuing a career in the fine arts—"in that profession, he would never have amassed the splendid fortune he did," as Pierre-Jean Mariette (1694–1774) wryly noted—thereby rendering him a great service.[3] Both homage and marriage portrait, then, de Troy's *Jean de Jullienne* is also something of a manifesto, announcing as it does a project that would consume the sitter for the next thirteen years—a publishing venture, unique in the history of French art, which aimed at reproducing Watteau's entire painted and graphic œuvre, and so making widely available the legacy of the thirty-seven-year-old artist who had gained international fame as the creator of the *fête galante*.[4]

Much attention has been paid to the drawing of Watteau that Jullienne holds with such reverence, and which—given the prominence of his *porte-crayon*—he might well be thought to have drawn himself. It is a portrait of Watteau, shown standing next to a portfolio of drawings, most probably his own, from the untied leather covers of which certain sheets are visible (details more easily read in François Boucher's engraving after the drawing [fig. 65]). Although we know that Jullienne owned such a drawing, the *Portrait of Watteau* after which Boucher made his engraving—in the Musée Condé since 1897—has long been considered not to be by Watteau.[5] The *function* of this drawing, however, is open to no such doubt. It would serve as the frontispiece to Jullienne's *Figures de différents caractères*—the two-volume set of 351 engravings after Watteau's drawings, published between 1726 and 1728—and its prominence in de Troy's portrait, painted in 1722, strongly suggests that this ambitious undertaking was conceived within a year of the artist's death.

In the lower left-hand corner of the portrait, resting on a piece of black velvet, and placed next to the star-shaped Croix Saint-Michel that was awarded to Jullienne in 1736 (and so painted as an addition by another hand), is a second red-chalk drawing of horizontal format. It shows a seated female figure, whose shoes peek out from underneath her dress, and is taken from the *Woman Seated on the Ground* formerly in the Groult collection (cat. no. 30).[6] As even the most cursory comparison makes clear, the sheet in de Troy's portrait eliminates every one of the eleven hands that constitute the major part of Watteau's drawing, and it is as such, in its reduced state, that the drawing would be reproduced in the first volume of *Les Figures de différents caractères*.[7]

In many ways, this second drawing is even more revealing of Jullienne's ambitions in the reproduction of Watteau's œuvre. For, far from simply copying Watteau's drawings—itself a highly unusual step to take in the commemoration of a modern artist, and a point to which

Figure 65
François Boucher,
Portrait of Watteau,
1727.
Etching and engraving,
13⅞ × 9⅝ in.
(35.1 × 24.5 cm).
The Cleveland
Museum of Art;
Gift of P. & D.
Colnaghi Co.

we shall return—Jullienne was responsible for selecting the motifs to be engraved, abstracting certain elements from composite sheets and thereby simplifying Watteau's compositions (as in the case of the *Woman Seated on the Ground*), in order to produce a sort of pattern book which offered a series of "studies from Nature." As initially conceived, *Les Figures de différents caractères* seems to have been intended, on one level at least, as a compendium of naturalistic models and motifs for the use of artists, academicians, and artisans (Jullienne was running a cloth-making manufactory, after all). And the volumes were priced accordingly. In November 1726 and February 1728 they were advertised at 48 *livres* each[8]—although even this figure was too high for the twenty-nine-year-old painter Etienne Jeaurat, who felt that they "sold rather dear"[9]—and it is worth noting that the publisher and print dealer Charles-Antoine Jombert later included *Les Figures de différents caractères* among the training manuals (*Livres à dessiner*) by

Gérard de Lairesse, Abraham Bloemaert, and Jan de Bisschop that were recommended for "forming both the hand and the taste of those who wish to practice the Art of Drawing."[10]

If Watteau's studies were thus to be disseminated as a renewed syntax for practitioners of the fine and decorative arts, it seems doubly ironic that by mid-century his style came to be disparaged as "infinitely mannered"—and this from a former companion-in-arms.[11] Yet Jullienne may also have misjudged the market for such prints. By the time he was in a position to offer engravings after Watteau's paintings as well, and so present a full Œuvre in four volumes, their prices reflected the more elevated clientele to whom such recueils were traditionally marketed. In November 1734 a second printing of Les Figures de différents caractères was announced as part of the complete Recueil Jullienne, "deserving of a place in the most distinguished Libraries and Picture Cabinets" (the two new volumes incorporated many of the paintings that had passed through Jullienne's hands).[12] One hundred sets were placed on sale at 500 livres, with the Crown reserving ten sets for its own use. Orders received after the end of the following year would be filled, if any sets remained, at a cost of 800 livres.[13] Jullienne was now targeting the sort of connoisseur who had subscribed to the Recueil Crozat six years earlier.[14]

Initially conceived as model books with a practical purpose, Jullienne's Figures de différents caractères now assumed altogether loftier status as bound volumes or recueils that would appeal to the wealthy collector and connoisseur of drawings. However, it is not at all clear that any market for Watteau's drawings existed when Jullienne embarked upon this project. After all, Watteau's drawings had not been available to collectors during his lifetime, and—as Antoine Schnapper has recently noted—there was no tradition in late seventeenth-century or early eighteenth-century collecting for curieux de papier to acquire the work of living artists, unless those artists happened to be in their employ (as, for example, the Corneille brothers and the banker Everard

Jabach, or the premiers peintres Charles Lebrun and Pierre Mignard and the king).[15] As each of Watteau's early biographers was at pains to point out, he made drawings neither as works for the market, nor even as preparatory studies for his own paintings. His drawings "were not conceived in association with a composition of a more important subject"; most of the time he would draw figures from life "with no particular subject in mind."[16] Done for himself, the drawings were also scrupulously conserved, kept in "bound books" (les livres reliés), which followed Watteau on his various—and increasingly eccentric—peregrinations, so that he always had "a large number of them at hand at any one time."[17]

Thus those rare art lovers who had attempted to acquire drawings by Watteau during his lifetime had met with considerable resistance. When the twenty-year-old Swedish nobleman Carl Gustaf Tessin (1695–1770), who had just started taking drawing lessons from Jean II Berain, visited Watteau in his studio in June 1715, he was able to procure only counterproofs by the artist.[18] And even these, as Dezallier d'Argenville later noted, were not made for sale, but to enable Watteau to "see his subjects from both sides."[19] Despite Tessin's enthusiasm for the "Flemish artist" who "works successfully at grotesques, landscapes, and costumes"—and the mutual sympathy that was immediately established between them—the artist's drawings were simply not available for purchase.[20] This is consistent both with Watteau's behavior towards his most eminent patrons and protectors—Crozat and Caylus—to whom he bequeathed drawings only when he was dying, and with the experience of the Florentine connoisseur Francesco Maria Niccolò Gabburri (1676–1742), who, in the early 1730s, searched high and low for a drawing with which to represent Watteau in his collection. Part of the difficulty, but not all, was Gabburri's preference for finished compositional drawings— "disegni grandi storiati"—rare in Watteau's œuvre.[21]

Jeaurat promised Gabburri that he would do everything

in his power to find him a drawing by Watteau, but it was only after both he and Mariette had appealed to Jullienne and Caylus that a group of four drawings—two from each—was forthcoming as a gift.[22] Thus, more than a decade after Watteau's death, with *Les Figures de différents caractères* nearing their second printing, it appears that Watteau's drawings remained almost as inaccessible to collectors as they had been during his lifetime. And this brings us to one of the most vexed (and vexing) issues in Watteau scholarship, for which it seems impossible to arrive at any sort of satisfactory explanation.

What happened to Watteau's drawings after his death?[23] The first and earliest obituaries of the artist, published in August 1721—Antoine de La Roque (1672–1744) in the *Mercure de France*, and by an anonymous correspondent in the *Gazette d'Utrecht*—were categorical on this issue. Watteau had bequeathed "the lion's share of his studies and drawings" (*la grande partie de ses études et de ses dessins*) to an art-loving prelate, the abbé Pierre-Maurice Haranger (*ca.* 1660–1735), canon of Saint-Germain L'Auxerrois, whose parish included the Louvre, and who, as early as 1692, had been listed among Paris's "*Fameux Curieux des ouvrages magnifiques.*"[24] When Jeaurat apologized to Gabburri for his failure to find any drawings by Watteau that might be available for sale, he implied that a single owner still guarded them possessively: "*chi gli ha ne fa tanto caso che è difficile l'avergli.*"[25] The recent discovery of Haranger's post-mortem inventory, which the earlier scholars Dacier and Vuaflart had mistakenly thought to have been destroyed by fire, confirms that, at the time of his death in May 1735, Haranger owned no fewer than 1100 drawings by Watteau.[26]

Yet in March 1744 Watteau's close friend and dealer Edme-François Gersaint (1694–1750) offered a radically different account of the posthumous division of Watteau's drawings, one corroborated by such well placed observers as Caylus (who had despised Haranger),[27] Dezallier d'Argenville,[28] and Mariette—and, until Jeannine Baticle's

publication of Haranger's inventory, it was this account that understandably claimed precedence.[29] According to Gersaint, in whose very arms the painter had died, Watteau bequeathed his drawings equally to four of his closest friends: Jullienne, Haranger, Nicolas Hénin (1691–1724), and Gersaint himself.[30] Since Gersaint had been called upon in May 1735 to list and appraise the works of art in Haranger's estate—and so would have been well acquainted with that collection—his account, if true, would place Watteau's graphic output at over four thousand drawings (an extraordinary number for a career of less than twenty years).[31] While it is certainly the case that Watteau gave some drawings away at the end of his life—the nine sheets left to Crozat "*en reconnoissance de tous les bons offices qu'il en avoit reçus*"; those annotated by Caylus as "having been given by the dying Watteau to me, his friend"[32]—Gersaint's insistence upon an equitable four-way division is also brought into question by the documentary evidence (admittedly of a negative kind).[33] If each of Watteau's beneficiaries had received a more or less equal share of his drawings, we might reasonably expect to find some mention of them in their inventories. Yet not a single drawing is listed in the *inventaire après décès* of Nicolas Hénin, the *intendant et ordonnateur des bâtiments du Roi*.[34] Nor were any of Watteau's drawings to be found among Gersaint's possessions when his communal property was inventoried following the death of his first wife, Marie-Louise Sirois, in April 1725.[35]

With Haranger reinstated as the principal beneficiary of Watteau's "*livres reliés*," a second question presents itself. Given the abbé's ownership of the "lion's share" of Watteau's drawings, how could Jullienne have embarked on *Les Figures de différents caractères*—a project that claimed to reproduce not only those drawings "he had received from Sr. Watteau, who had been his friend," but also all of those "that he had been able to find in private collections?"[36] What seems most likely is that between 1722 and 1728 Jullienne had been able to persuade Haranger to dismantle Watteau's albums—if,

Figure 66. François Boucher, after Watteau, *Portrait of a Seated Man*. From *Les Figures de différents caractères* (no. 69), 1726–28. Etching, 12⅛ × 10⅜ in. (30.9 × 26.3 cm). Bibliothèque Nationale de France

organized haphazardly. In May 1735, Gersaint and his colleague spent an entire day simply "arranging the drawings and putting them in order," before getting down to the business of appraising them.[38] And while neither Haranger's nor Jullienne's names were mentioned in connection with *Les Figures de différents caractères*, Jullienne found an elegant way to acknowledge the abbé's essential contribution to the undertaking.[39] For it is surely not fortuitous that *two* portraits of Haranger—shown relaxed and informal in theatrical dress (fig. 66)—appeared prominently in each volume of the *Recueil*, with Boucher's and Watteau's signatures clearly legible on each plate.[40]

Both the reception and usage of *Les Figures de différents caractères* are subjects worthy of further investigation, but, in the short term, at least, the enterprise—which might have been expected to generate greater interest in Watteau's drawings—seems not to have succeeded at all. For in the very year that Jullienne advertised the four-volume set of prints after Watteau's drawings and paintings for 500 *livres*, Gersaint could appraise Haranger's entire collection of drawings—which included over 1100 sheets by Watteau—for a sum just one half that amount.[41] Nor may it have been Jullienne's intention to give such prominence to Watteau's drawings. A corpus of both the painted and graphic work was announced as early as November 1726,[42] and eight years later, once the volumes of engravings after Watteau's paintings had finally appeared, Jullienne blamed their tardy publication on the paucity of available engravers ("*la difficulté de jouir des graveurs*"),[43] which had resulted in the prints after Watteau's paintings initially being published one at a time.

Intended or not, the order in which the *Recueil Jullienne* appeared and the priority given not merely to Watteau's drawings, but to his "studies from Nature," flouted both aesthetic hierarchies and the conventions of collecting. Indeed, the attention accorded studies rather than finished drawings was altogether exceptional, a fact of which the twenty-seven-year-old Boucher was also well aware. In his

indeed, his drawings were still kept in this way—so that the drawings could be farmed out to the team of artists who set about engraving them.[37] Although the drawings did not circulate among the different engravers—motifs from the same sheet reproduced as separate plates were always engraved by the same hand—they were presumably back in Haranger's possession by February 1728, when the second volume of *Les Figures de différents caractères* appeared. The abbé clearly felt under no obligation to reconstitute Watteau's albums, and even the terse listing of his post-mortem inventory gives the impression of a collection

Figure 67. François Boucher, *The Three Graces at Watteau's Tomb*, 1726. From *Les Figures de différents caractères*, 1726–28. Etching, 13⅞ × 9 in. (35.2 × 23 cm). The New York Public Library, Print Collection, Miriam and Ira D. Wallach Division of Art, Prints and Photographs; Astor, Lenox and Tilden Foundations

frontispiece for the first volume of *Les Figures de différents caractères* (fig. 67), the upper section of the print shows the Three Graces mourning the young artist and placing a laurel crown on his effigy. At lower right the elements of Watteau's genius lay discarded, but it is a drawing, and not a painting— a pilgrim raising his lover to her feet, preparatory to one of the central groups in *The Embarkation to Cythera* (fig. 1, p. 9) —that is secured to the fallen easel.

"People have rarely ventured to engrave painters' studies." Jullienne's understatement was disingenuous, if disarming, since his preface to *Les Figures de différents caractères* shows that he was well aware of the novelty of this undertaking.[44] Where drawings were collected at all in early eighteenth-century France, the preference was for finished sheets and compositional studies—Jabach's *"desseins d'ordonnance"*—and less for first thoughts and sketches (*"les desseins touchés et peu finis"*). As Schnapper has noted, seventeenth-century collectors placed the greatest value on *"les dessins les plus achevés"*—drawings that most approached paintings.[45] It was in precisely these terms that the German banker Everard Jabach (*ca.* 1618–1696) had recommended the finest sheets in his collection, many of which had been retouched with wash highlights in order to appear more finished.[46] In a somewhat desperate letter to the Trésorier de Metz, written in March 1671, Jabach argued that the eight hundred finest "should not even be considered as drawings, but rather as the best and most appealing pictures in Europe, as they will be once they are framed."[47] Seventy years later, Mariette is to be found apologizing for Crozat's Correggios—the great collector's favorite artist—in similar terms. Crozat's 138 drawings by Correggio were "for the most part only Studies, since there are few complete Compositions, and even these Compositions are only light sketches. But where can one find any Drawing by Correggio that is fully worked?"[48]

During Louis XIV's reign, a minority of collectors were attracted to drawings—far more were interested in prints—and it was generally agreed that the collecting of drawings was an activity best left to the scholars and connoisseurs (and, by default, to artists). Writers on the arts were of one mind in observing that drawings were not for "public consumption" and that they could be properly appreciated only by those already well versed in the history of art. Drawings "required much more knowledge than prints" (Dezallier d'Argenville)[49]; they were the perfect type of instruction for the art lover (Dezallier d'Argenville)[50]; one

had to be "relatively advanced in the history of art in order to read them correctly" (Caylus).[51] Gersaint put the case most succinctly in March 1744, in the same catalogue in which his *Life of Watteau* appeared: "There are few lovers of drawings; it is not a medium to which one is easily attracted …. Drawings, the appeal of which is principally to the intellect, can be appreciated only by those with considerable learning."[52] This high-minded and restrictive definition of the drawings collector would break down after mid-century, but traces of it persisted. In May 1777, Charles-Nicolas Cochin (1715–1790)—engraver, art critic, and administrator—who, among his many duties, was responsible for the Crown's Cabinet des Dessins, could not hide his disappointment when Emperor Joseph II failed to schedule a visit to see the king's drawings. He consoled himself with the reflection that the emperor "would be using his time to greater profit, since an interest in drawings is really only appropriate for artists and the most committed art lovers."[53]

As befitted such a scholarly (and practical) activity, early eighteenth-century collectors tended to keep their drawings in volumes (see fig. 68), arranged primarily by school, but also by subject matter, and occasionally by category.[54] Constantin Huyghens (1629–1695) noted in January 1664 that Jabach had employed a man for four years merely to paste his lesser drawings into books. These "*pièces de rebut*," some 2911 drawings, would form part of the collection sold to the Crown in 1671; Jabach's finished drawings (the "*desseins d'ordonnance*"), considered the most important works, were mounted onto card.[55] While the custom of arranging drawings in books had originated in Italy—and Jonathan Richardson (1665–1745) had scolded Crozat for dismantling a volume of Vasari's *Libro dei Disegni*—this manner of presentation was modified in France, where portfolios, *cartons*, and even *pacquets* were used to house drawings, in addition to books and albums.[56] Roger de Piles, for example, kept his collection of over three thousand prints and drawings in portfolios of different sizes, as well as *cartons*

and books—all stored in a *grand armoire* in the antechamber —with the most precious of his drawings bound in two "large books" that were kept, with his pictures, in the "*Cabinet à côté de la Chambre*."[57]

Antoine-Joseph Dezallier d'Argenville (1680–1765)— jurist, naturalist, and art historian; trained in connoisseurship by de Piles—considered it self-evident that drawings would be kept in volumes, the finest sheets arranged by school and by artist, the lesser works grouped by subject (landscape, seascape, animals, grotesques) and function (academies, architectural drawings, ornamental drawings).[58] By 1727 his own collection of drawings filled fifteen volumes—it would number some six thousand sheets by the time of his death—and it is clear from his essay on the arrangement of picture cabinets that the organization of these volumes required care and discrimination.[59] "Filled with choice pieces, such volumes will give far greater satisfaction than those large Compendia, many pages of which have to be turned before one comes across anything worth looking at."[60] Even though we know that Dezallier d'Argenville did not keep all his drawings in this way—as early as 1733, a visitor reported the pleasure he derived from going through Dezallier's portfolios of Northern drawings[61]—it was the general practice among drawing collectors to present their sheets in volumes, ordered as in a library (see fig. 69). Thus, Quentin Lorangère, one of the earliest collectors of Watteau's drawings, arranged his drawings in eleven volumes, with Watteau's eight oil studies and fifty drawings appearing in the volume devoted to *L'Ecole de France* (vol. IV).[62] "A beautiful volume of drawings by the best Masters is a veritable school of painting," Dezallier d'Argenville concluded,[63] and his antiquarianism echoed the advice given by Filippo Baldinucci to Cardinal Leopold of Tuscany, whose immense collection of drawings had been arranged chronologically in books, which, "thus disposed, would be a sort of History of the Art, which might be learnt by looking at them only, without reading."[64]

Figure 68
Carlo Maratti,
*Sebastiano Resta
Examining an Album of
Drawings*, 1689.
Red chalk on white
paper, 10⅛ × 7⅞ in.
(25.7 × 19.8 cm).
Devonshire Collection,
Chatsworth

Figure 68
Carlo Maratti,
*Sebastiano Resta
Examining an Album of
Drawings*, 1689.
Red chalk on white
paper, 10⅛ × 7⅞ in.
(25.7 × 19.8 cm).
Devonshire Collection,
Chatsworth

Figure 69
Gabriel Huquier,
Design for a Frontispiece,
1749. Watercolor and
ink, 11⅝ × 5⅞ in.
(29.5 × 14.8 cm).
Ecole Nationale
Supérieure des
Beaux-Arts, Paris

In the last decades of the seventeenth century and the first third of the eighteenth century, it is certainly possible to find examples of precious drawings being framed and hung, although no collector went as far as the learned cleric François Filhol (*ca.* 1583–1640), who covered the walls of his entire *cabinet* with some eight hundred drawings "by painters from Antiquity to those of our own day."[65] Pierre Mignard hung a drawing by Annibale Carracci of the *Penitent Magdalene* in a richly gilded frame: the rest of his Carracci drawings (the pride of his collection) were kept in three "*grands livres in-folio*," bound and covered in parchment.[66] Raphael's *Christ Handing the Keys to Saint Peter* and *Saint Paul Preaching to the Athenians* (Paris, Musée du Louvre) were both framed and glazed in the 1690s when they hung in the "*grant* [*sic*] *chambre*" of the engraver Claudine Bouzzonet Stella. A century later, the painter François-André Vincent noted that the former drawing, now part of the national collection, was still "*encadré sous verre*": in all likelihood the same glass.[67] Jabach, who continued to amass drawings after selling his first collection to the Crown, affixed certain sheets to canvas—a common enough practice in Italy—and some

of his drawings on colored paper were even mounted onto wood.[68] The erratic, but prodigiously talented, *premier peintre* François Lemoyne went so far as to frame and glaze his own compositions: three prints after his principal history paintings hung in his bedroom, two drawings in the *arrière cabinet*.[69]

It is clear that such examples were exceptional, since, even

in those collections mentioned above, the great majority of drawings were presented in the traditional way: in books, volumes, and portfolios. The size of drawing collections alone—commonly running to thousands of sheets—would have dictated this type of arrangement, as would the scholarly, or connoisseurial, purposes for which such collections were constituted. As Caylus noted in 1732, "Nothing so excites the genius of a Painter, or gives him that inner fire so necessary to composition, as the examination of a fine drawing."[70] In this regard, at least, Watteau had been exemplary: immersing himself, during his stay at the rue de Richelieu, in Crozat's unequalled collection of Italian and Northern old master drawings, as well, perhaps, as participating in those weekly assemblies during which Crozat's drawings were viewed and discussed by connoisseurs and artists.[71]

If the collecting of drawings had been considered an essential component of the study of the history of art, as well as accessory to the practice of painting itself—had not Caylus encouraged artists to form their own collections?[72]—then in the decades following the publication of Jullienne's *Figures de différents caractères* a critical transformation may be said to have taken place. Not only drawings by the old masters, but—even more important—those by living artists began to assume significance as luxury items, a change of status reflected not only in the manner in which they came to be presented and displayed, but also in the prices they could command in the saleroom and the artist's studio.[73]

Some sense of this change may be derived from looking at the way in which theorists and writers on the arts—who were themselves often connoisseurs of drawings—discussed the activity of collecting, and in particular their prejudice against the untutored collector or "*demi-connoisseur*."[74] For Roger de Piles (1635–1709), writing in 1699, no such prejudice yet existed, since there were so few "*Curieux de Desseins*" to begin with.[75] His invective is reserved for those

who collect reproductive prints as a substitute for paintings, "*demi-connoisseurs*" for whom the charms of drawing remain impenetrable.[76] And while de Piles expressed a preference for unfinished drawings or first thoughts, in which the beholder's imagination was invited "to complete the parts that are missing," he was eager to encourage a taste for drawings of all kinds ("*selon qu'ils sont terminés*"), from "*des Esquisses très-legers*" to "*des Desseins très-finis*."[77]

By the 1740s such tolerance was a thing of the past. Dezallier d'Argenville, writing in 1745, mercilessly disparaged the general preference for finished drawings, the taste for which now becomes the mark of Cain. The history of painting could even be rewritten to accommodate such a view:

The great Masters have generally refrained from finishing their drawings; they are happy to make sketches, or to produce scribbles [*griffonemens*] almost out of nothing, but these have no appeal for the *demi-connoisseur*. That sort of collector always wants something finished, something

agreeable to the eye, whereas the true connoisseur thinks otherwise. In a sketch he is able to perceive the mind of a great master at work; and his imagination, kindled by the beautiful flame that illuminates such a drawing, enables him to see what is not yet given form.[78]

And while Dezallier was disdainful of the growing market for drawings, with its concern for provenance as a guarantee of authenticity, he was not above appealing to such commercial instincts in his final salvo against the *demi-connoisseur*: "Beware of drawings that are finished; they are rarely original, indeed they are easier to counterfeit than the others."[79]

By the end of the Ancien Régime, such was the growth of the market for drawings that the academician and collector Claude-Henri Watelet (1718–1786) could rail against the very taste for sketches and first thoughts that had for so long distinguished the true connoisseur. Collectors intent primarily on increasing the size of their portfolios were now vilified for seeking to acquire the merest scrap:

The sketches [*croquis*] of great artists are now esteemed by collectors in the same way that the pious fight over the smallest relic. In both cases, this sort of veneration can be taken too far. For, just as apocryphal fragments do not all deserve to be enshrined in reliquaries, so every insignificant scribble and barely recognizable first thought is not worth the art lover's attention. Nor should those to whom such drawings are shown be expected to revere them.[80]

Watelet's outburst, which appeared in print six years after his death, acquires a certain poignancy when it becomes apparent that his own taste in drawings ran, not surprisingly, to the sketchy and unfinished. Thanking the Orléannais collector and amateur Aignan-Thomas Desfriches (1715–1800) for his gift of a highly finished landscape

drawing—"it seems to me that you have reached a remarkable degree of finish"—Watelet tactfully indicated his preference for the artist's earlier, more sketchy, manner: "Lightly touched drawings [*les dessins touchés*] are, so to speak, a language that I understand and read with the greatest pleasure. Finished drawings, on the other hand, are accessible to everyone."[81]

Increasingly, from the middle of the century, the fashion was for drawings that were elaborately matted and mounted, framed and hung under glass, and even assigned a certain amount of wall space in the collector's cabinet. Consciously or not, this process of commodification was carried out by some of the most ardent connoisseurs and collectors—scholarship and conspicuous consumption being then, as today, not mutually exclusive.[82] The dealer and publisher Pierre-Jean Mariette (see fig. 70), generally accounted the finest connoisseur in eighteenth-century Europe, fastidiously mounted his drawings in elegantly drawn mats, with frames, cartouches, and inscriptions, so that they came to resemble paintings (see fig. 71).[83] Fully aware of the distinction of his collection of drawings—which he considered "possibly the most complete and most choice in Europe"[84]—he was unsparing in his criticism of his contemporaries, particularly Dezallier d'Argenville, whom he savaged both as a connoisseur and as an art historian.[85] Yet Mariette saw no incompatibility in imposing a certain decorative coherence in the arrangement and presentation of his drawings, while maintaining the highest standards in his selection of them ("I am more and more convinced of my resolution never to allow any questionable drawing into my collection").[86] As the English connoisseur Charles Rogers noted admiringly, Mariette kept his drawings in one hundred portfolios, with the majority of them "pasted on thin Cartones of 20 inches by 15, bordered and filletted with gold, and the names of the Masters clearly written."[87] Large or oversize drawings were clearly inappropriate for this collection, and Mariette

Figure 71. Edme Bouchardon, *Michelangelo's Seal*, 1737. Red chalk, 5⅛ × 6⅞ in. (13 × 17.5 cm). Musée du Louvre, Paris

discouraged his Italian correspondents from proposing such sheets. Eager to own a drawing by the Veronese painter Giambettino Cignaroli (1706–1770), he informed the Venetian architect Tommaso Temanza (1705–1789), "You would do me the greatest honour, if it is at all possible, to find me one that does justice to the artist. It should not be too large, however, no larger than the size of my letter to you, once it is unfolded."[88] Two years later, in a celebrated letter to the same correspondent, Mariette was obliged to refuse a drawing by Diziani on similar grounds:

His drawing, fine as it is, would have pleased me more had it been smaller, since my drawings are all arranged in portfolios of the same size—hence my preference for those of moderate dimensions. If you are able to persuade Monsieur Diziani to relinquish a drawing that is no larger than 12 inches by 15 inches, I should be most happy to receive it and would find a place for it in my collection.[89]

The letter ends with a reminder that Cignaroli's drawing is still welcome, provided that it is of the same dimensions as Diziani's, with Mariette clearly more concerned about size than subject matter: "*Je lui laisse maître du sujet.*"[90]

Mariette's care in the presentation of his drawings—did he not "finish" Watteau's *Head of a Flutist* (Paris, Musée du Louvre) so that it could be matted in an oval mount?[91]—and his insistence upon a certain regularity in their arrangement were shared by a growing number of collectors, few of whom aspired to be connoisseurs or scholars. The thriving market for "*dessins ajustés*"—matted drawings mounted with gold fillets and tinted wash borders—was largely the creation of the *marchand-mercier* Jean-Baptiste Glomy (*ca.* 1720–1786), who, in the mid-1740s, began "affixing and matting drawings and prints, carefully and cleanly."[92] Glomy's account books are complete for most of the 1750s and his client list provides a roster of the most energetic collectors of Louis XV's reign: from the *maîtresse en titre*, Madame de Pompadour (represented by Colin, one of her minions) and her brother, the marquis de Marigny, recently appointed minister of fine arts; to financiers such as Randon de Boisset, Savalette de Buchelay, and Grimod de la Reynière; and to honorary members of the Academy such as Fragonard's patrons, the abbé de Saint-Non and Bergeret de Grandcourt.[93] Glomy's best client in the mid-1750s, however, was the painter François Boucher, whom he charged a special rate of one and a half *livres* per drawing— financiers paid double—and at whose studio he would occasionally spend the entire day, affixing drawings, or merely pasting them on to larger sheets.[94]

Glomy was particularly active during the 1750s. With the German-born dealer Paul Charles Alexandre Helle he organized several sales and published the first *catalogue raisonné* of Rembrandt's prints (based on Gersaint's manuscript); he was also responsible for forming the drawings collection of Marie-Joseph, duc de Tallard (1683–1755), one of the principal collectors of Italian old

masters on the eve of the Seven Years War.[95] As a dealer, he did not maintain these early successes. By the late 1760s, Pierre Remy—a former associate who had become the doyen of Parisian picture dealers—maliciously recommended Glomy "as among the best for mounting drawings and applying gold borders to them."[96] Even here Glomy seems to have suffered a decline. In April 1771, he announced in the *Mercure de France* that he had not retired from business, as his competitors claimed, but had moved to the outskirts of Paris, near the Porte Saint-Denis, "*pour être plus tranquille.*" There he continued to mount and frame drawings and prints, with artists still being offered special rates.[97]

Glomy's originality had consisted in applying his painted and gilded borders directly on to the glass that covered the matted drawing, a process that he developed to meet the growing demand for framed drawings intended to be hung rather than stored in portfolios.[98] In catalogues of the 1750s one begins to come across drawings (and prints) sold framed and under glass: the sale of the banker Cottin in November 1752 appears to be the first in which "*Les Estampes et les Desseins Encadrés*" are listed separately, and the category would become a standard one by the 1770s.[99] Tallard's 150 finest old master drawings were framed "*sous des glaces ou verres blancs*"; those "*en feuilles,*" intended to be kept in boxes, were mounted by Glomy on sheets of similarly sized "*papier d'Hollande.*"[100] Whereas Antoine Coypel (1661–1722) had kept his drawings in volumes and portfolios—none was framed[101]—his son Charles-Antoine (1694–1752) presented ninety-two of his best drawings in "gilded frames under glass, with some mounted in wooden frames, either with or without glass."[102] Mariette framed seventy of his favorite drawings in this way, including three by Watteau, one of which, *The Knife Grinder* (Paris, Musée du Louvre), he had acquired already framed at the Jullienne sale (thus explaining the absence of his collector's mark on this work).[103] Jean-Baptiste Greuze's first patron and protector, the abbé Louis Gougenot (1719–1767), hung framed drawings by Greuze,

Jean-Baptiste Pigalle, and Joseph Vien—his favorite living artists—in the antechambers and Salon of his mansion on the rue Notre-Dame des Champs, while three portfolios, "filled with drawings," were kept in the Library.[104] The engraver and *marchand-amateur* Johann Georg Wille (1715–1808)—another early enthusiast of Greuze and the subject of one of his finest portraits—decorated his study "with precious drawings and prints after the greatest masters," when he and his family moved to the second and third floors of their house on the quai des Augustins in February 1770.[105] Desfriches cheerfully oversaw the matting, framing, and glazing of the drawings belonging to his friend and fellow collector Monsignor de Grimaldi, bishop of Le Mans, which he consigned to the Parisian dealer Antoine-Charles Dulac.[106] Only Cochin seems to have been oppressed by the fashion of mounting and framing drawings. Having finally found the time to rework his counterproofs as a Christmas present for his friend Jean-Baptiste Descamps—and having remembered to order the frames for them well in advance—he was thwarted by the tardiness of the "accursed woodcarver," who took more than six weeks to deliver the frames, and so was responsible for "his little gift" arriving more than a month late.[107]

The most spectacular instance of this bipartite presentation of drawings—with certain drawings removed from their boxes and portfolios to be displayed decoratively—is to be found in the new arrangement of Jullienne's picture gallery, in his *hôtel* on the rue des Gobelins, remodeled in 1747 to accommodate "a quantity of paintings and drawings by the greatest masters."[108] The precise hang of the eleven rooms in Jullienne's picture cabinet is recorded in the album that he commissioned in the mid-1750s—of which the publication by Cara Denison is eagerly anticipated.[109] By the time of his death in March 1766, Jullienne's collection of drawings alone numbered some 2380 sheets; 425 were by Watteau, and of these, eleven were framed under glass (twenty-six drawings by Edme

Figure 72
Antechamber (Avant Cabinet de Monsieur), showing Parrocel's *Battle of the Turks* (bottom right). From *Album Jullienne, ca.* 1756. Pen, black ink and watercolor, 7¾ × 10¼ in. (19.6 × 26 cm). Pierpont Morgan Library, New York

Figure 73
Long Gallery (La Gallerie) (detail). From *Album Jullienne, ca.* 1756. Pen, black ink, and watercolor, 7¾ × 24¼ in. (19.7 × 61.5 cm). Pierpont Morgan Library, New York

Bouchardon were presented in this way, ten by François Boucher).[110] From the way his collection was installed in 1756—and only the principal rooms are illustrated in the album—it is clear that not a single drawing by Watteau (or Boucher) was on permanent display. Although Jullienne elected to hang one or two French drawings as paintings—*Battle of the Turks* by Charles Parrocel, a drawing in *trois crayons* some seven feet long (see fig. 72), and Tremolières's *Vow to the Virgin* (whereabouts of both unknown)—more innovative was his arrangement of the Long Gallery, in which red-chalk head studies by various artists were disposed in pairs (for example, Carle Van Loo and Bouchardon, Guido Reni and Federico Barocci) to form a frieze along the upper register of the lateral walls, above the pictures (see fig. 73). On leaving the gallery, the end walls were hung with clusters of drawings—twelve on either side—in which the three schools were once again mixed.[111]

The growing fashion for elaborately matted and mounted drawings, which might on occasion hang alongside paintings and pastels in the collector's cabinet, had obvious implications for the graphic output of living artists—and this is a large topic that would repay further consideration. With the return of the biennial Salon in 1737, drawings could be displayed as independent works in the Salon Carré, although in the first instance it was the sculptor Bouchardon and the engraver Cochin who were most assiduous in presenting their drawings to an enthusiastic public.[112] Despite the willingness of connoisseurs such as Mariette and the chevalier de Damery to lend works on paper to the Salon, painters were initially reticent in exhibiting their drawings (pastels were a different matter). Boucher showed drawings at the Salon only once, in 1745, and Alastair Laing has identified these as plumbago illustrations on vellum, hardly the sort of autonomous drawing that would be so avidly collected in the 1750s and 1760s.[113] Carle Van Loo lent three drawings to the Salon of 1757—the only time he did

so—one of which, now in the Musée de la Comédie-Française, served to advertise his forthcoming portrait of the actress Mademoiselle Clairon as Medea.[114] Portail, who, as *tapissier* of the Salon between 1742 and 1759, might have been expected to take full advantage of this public arena, exhibited drawings only once: *A Woman Sleeping*, shown at the Salon of 1759.[115]

Clearly academicians needed encouragement, and as early as 1748 the abbé Gougenot urged them to extricate their drawings from the "obscurity of their portfolios," and present them at the Salon. At the very least, he argued, this would relieve the art lover from having to go through collections amassed by *demi-connoisseurs*, where entire days could be lost reviewing a pile of mediocrity. If artists could be relied on to exhibit their most recent studies and compositional drawings to the public, they would not only make available "the most serious aspect of their art," but would also assist in the formation of the connoisseurs of the future.[116]

Gougenot's exhortations would be heeded by a younger generation of artists who began exhibiting in the late 1750s and early 1760s: not only genre and landscape painters such as Greuze, Fragonard, Hubert Robert, and Jacques-Philippe de Loutherbourg, but also ambitious history painters such as Vien, Lagrenée, and Durameau. Yet while the number of drawings exhibited in the Salon continued to rise during the 1770s and 1780s—and Gabriel de Saint-Aubin took pains to show visitors inspecting them in his panorama of the Salon of 1767—the Salon was never a primary arena for the dissemination of works on paper by living artists. Artists were quite capable of satisfying demand from the relative privacy of their studios, and the more energetic dealers may have been among their most persistent clients. We know, from Wille's journals, how skillfully Greuze marketed his drawings—both finished compositions and preparatory studies—and Mariette noted, with some asperity, that "certain collectors were prepared to pay prodigious amounts for them."[117] In December 1759, Wille acquired the wash

drawing *Woman Roasting Chestnuts* (private collection)—"the most admirable drawing he has yet produced"—for 192 *livres*, a considerable amount to pay a young *agréé* who was just starting to make a name for himself.[118] In July 1761 Greuze sold Wille a relatively worked up head study (*Head of an Old Man*; private collection) for the father in *L'Accordée de village* (Paris, Musée du Louvre) for 72 *livres*, even though he was still at work on his Salon submission, which would not be ready until early September.[119] Wille could also acquire such drawings at auction. In December 1759, he had purchased from Rémy the *première pensée* for *The Father Reading the Bible to His Family* (Paris, private collection), the painting owned by La Live de Jully with which Greuze had gained admission to the Academy in June 1755.[120]

The most cursory inspection of Parisian auction catalogues of the 1760s and 1770s confirms that drawings by living artists—many not yet in mid-career—passed regularly through the saleroom. Fragonard, who in March 1765 had presented both paintings and drawings to the Academy in support of his candidacy, could expect to receive a substantial income from his red-chalk and bistre-wash drawings.[121] Desfriches later said as much when he informed a correspondent that the artist's best drawings were "fought over with pieces of gold, and are worth it."[122] In recognition of the thriving market for modern drawings, it has been suggested that the abbé de Saint-Non graciously returned to Fragonard the ten red-chalk drawings made in Tivoli during the summer of 1761 (two of which were exhibited at the Salon of 1765), and which, since he had sponsored the artist's visit, were regarded as his property.[123] Fragonard's celebrated dispute over the ownership of the drawings made during his second trip to Italy twelve years later—this time in the company of a less sympathetic Maecenas, Bergeret de Grandcourt—had to be resolved by the courts, with damages of 3000 *livres* being awarded to the artist. Fragonard's altercation with Bergeret de Grandcourt is usually cited as an example of the eighteenth-century artist asserting his

independence as a practitioner of the liberal arts. While his patron's condescending attitude was certainly an instance of benighted, and already old-fashioned, *droit de seigneur*, more than principle was involved in Fragonard's decision to take the case to law. A year's supply of drawings represented considerable revenue for the artist, and property rights, no less than self-esteem, encouraged Fragonard and his spouse to break with custom and pursue Bergeret in court.[124]

In 1767 Diderot attacked the cynicism of certain collectors who acquired the work of living artists as sound investment:

> Here is the reasoning of the opulent man, who employs great artists: "The money I spend *on drawings by Boucher*, or on paintings by Vernet, Casanova, or de Loutherbourg, is money invested at the best rate of interest. During my lifetime I will have the pleasure of looking at excellent works of art, and when the artist dies, either my children or I will be able to sell the piece for twenty times more than I paid for it."[125]

It is noteworthy that Diderot here gave Boucher's drawings—and not his paintings—pride of place. From the early 1750s, as Beverly Schreiber Jacoby has shown, Boucher's drawings were generally conceived and executed as autonomous sheets that fulfilled multiple purposes: studies for paintings (or tapestries) certainly, but also works to be reproduced by the engraver as well as to be collected by financiers and receivers-general.[126] Although Mannlich's tale of Boucher finishing his students' drawings and then selling them as his own to an unsuspecting public has long been dismissed as fanciful—Mannlich was almost eighty when he wrote his *Memoirs*[127]—the demand for Boucher's work was recorded by a more reliable witness, who had crossed the Channel in May 1765, to meet the artist and solicit his participation in an ambitious survey of drawings through the ages. The English collector and connoisseur Charles Rogers

Figure 74. Jean-Charles François after Carle Van Loo, *Corps de garde*, 1757–58.
Soft-ground etching and crayon-manner engraving, 17¼ × 23¾ in.
(43.8 × 60.3 cm). The Metropolitan Museum of Art, New York; Elisha Whittelsey
Collection

(1711–1784), whose two-volume *Collection of Prints in Imitation of Drawings* included the first biography of Boucher in English, noted: "We have often seen the nicest [Art] Lovers surround him in his painting-room and contend with each other for slight Drawings, in which, without ever copying himself, he drew in a thousand different forms the pictures of the Graces and of Beauty."[128] By the 1760s, life seems almost to have imitated art history, with one of the hardiest of critical tropes, that of the *demi-connoisseur* assailing the artist in his studio and fighting over his drawings—had not Caylus, in his *Life of Watteau*, railed against them?[129]—now bearing more than a passing resemblance to market realities.

One final development that bears witness to the growth of a market for drawings by living artists is the proliferation, during the late 1750s and 1760s, of engraving techniques in imitation of different kinds of graphic work. Crozat's monumental *Recueil*, of which only two volumes were published between 1729 and 1742, had reproduced in

facsimile a certain number of wash drawings and those heightened with white by Raphael and his school (as its title made clear, it was intended to be a collection of engravings after "*les plus beaux Tableaux et d'après les plus beaux Desseins qui sont en France*").[130] Experiments by Arthur Pond (1701–1758) in crayon-manner engraving after Annibale Carracci's red-chalk drawings, carried out in London during the 1730s, were known in France; Mariette owned a copy of Pond's *Recueil*.[131] But the decision to reproduce drawings by living artists in facsimile was first taken by the Lyonnais engraver Jean-Charles François, whose crayon-manner engraving after Carle Van Loo's *Corps de garde* (fig. 74)—a drawing exhibited in the Salon of 1757—was advertised in April 1758 as "a study and a print that also serves as a painting"—a nice conflation of the pedagogical and decorative purposes for which these facsimile engravings were produced.[132]

During the 1760s, it was François's most gifted student, Gilles Demarteau (1722–1776), who became the leading exponent of crayon-manner engraving; not surprisingly, the majority of his prints were made after drawings by Boucher, some of which were now produced for the sole purpose of being engraved. Later in the decade, techniques were invented (or rediscovered) to make facsimiles of wash drawings and pastels; engravings of black-chalk drawings on colored papers also began to appear in the 1760s. Unquestionably, these engravings served a didactic purpose: art schools in Paris and the provinces were a primary market for crayon-manner engravings such as Demarteau's academies after Van Loo, or Bonnet's *Head of Joseph* after Jean-Baptiste Deshayes.[133] But such prints also satisfied the demand for works on paper as decoration, and Demarteau's crayon-manner engravings often reproduce the borders and fillets that were regularly found on matted and mounted drawings (see fig. 75).[134] By the 1770s, a number of dealers in Paris were specializing in modern prints, which were advertised as being sold framed and glazed, and their stock would have included facsimiles of

Figure 75. Gilles Demarteau, after Boucher, *The Washerwomen* (*Les Lavandières*), *ca.* 1750–55. Engraving, 12½ × 14½ in. (31.7 × 36.7 cm). Musée du Louvre, Paris

drawings as well.[135] It now became standard practice to hang such engravings, framed and glazed, in the more private rooms. In Bastide's *Petite Maison*, published in 1758, the marquis's second boudoir—in which he finally seduces the capricious Mélite—is decorated with the finest prints of Cochin, Le Bas, and Cars, symmetrically arranged.[136] By 1780, the architect Lecamus de Mezières encouraged his clients to decorate the *cabinet de toilette* with "prints of agreeable subjects, hung in gilded frames."[137]

Of the 266 engravings that Demarteau made after Boucher's drawings, just under half came from the collection of Berthélémy-Augustin Blondel d'Azincourt (1719–1794; see fig. 76), a war hero and son of the *receveur-général* Blondel de Gagny, whose collection of old masters was described as a "fairy palace where nothing was considered curious but in proportion to its being expensive"; and the husband of one of the richest heiresses in Paris, whom he married when she

was fourteen.[138] In 1749, at the age of thirty, Blondel d'Azincourt had written a little treatise on the art of picture hanging and display; at this early stage, his taste, like his father's, was for seventeenth-century Dutch and Flemish cabinet painting.[139] He was an accomplished *graveur-amateur* and one of the first to produce crayon-manner engravings.[140] And as an honorary member of the Academy from October 1767, he was among the most assiduous participants at that institution's Saturday morning lectures.[141] Intimately associated with several up-and-coming artists—he was the protector of Jean Houel and a witness at Jean-Baptiste Peronneau's wedding—he also conducted a notorious liaison with Greuze's wife, and would later be named in the divorce proceedings.[142]

In many respects then, Blondel d'Azincourt was an exemplary collector, with a passion for drawings and the practical skills considered essential for the connoisseur. Except that, perhaps to distinguish his taste from his father's, d'Azincourt's interests had come to focus almost exclusively on the modern French school, and on Boucher in particular.[143] Accordingly, it was as an amateur of Boucher's drawings that d'Azincourt chose to be portrayed in Alexandre Roslin's portrait, exhibited at the Salon of 1755 (see fig. 76). With several sheets negligently arrayed on the table beside him—a group of nymphs by Boucher is visible under his lace cuff—d'Azincourt meets the viewer's eye engagingly, although we seem to have caught him in the act of applying red chalk to the cheeks of Boucher's *Female Head*, the drawing that he holds, rather crumpled, in his left hand.[144] There are obvious similarities between Roslin's *Portrait of Blondel d'Azincourt* and de Troy's *Portrait of Jean de Jullienne* (see fig. 64, p. 68)—both were marriage portraits that appeared some years after the nuptials had taken place—and Balechou's print after de Troy's portrait, which was published in 1752, may well have served as the model for Roslin's commission. Yet while Roslin's *Portrait of Blondel d'Azincourt* communicates little of the solemnity or

Figure 76. Alexandre Roslin, *Portrait of Blondel d'Azincourt*, 1755.
Oil on canvas, 35⅞ × 28⅜ in. (91 × 72 cm). Private collection

veneration that is at the heart of de Troy's representation, it too is a homage of sorts. For if d'Azincourt does not hesitate to assert the rights of ownership over Boucher's drawings, he nonetheless chooses to be shown with the work of a living artist in his hand. And it is his taste for drawings by the leading painter of the modern school—and not for the old masters—that supports his claim to be taken seriously as an art lover.[145]

At the same Salon (1755), Roslin exhibited a *Self-portrait* in encaustic (whereabouts unknown), the wax medium of

the ancients that Caylus relentlessly imposed on the young painters in his circle in the early 1750s.[146] The owner of this *Self-portrait*, Jean-Antoine Levaillant de Guélis, chevalier de Damery (1723–1803), was another military figure, a *noble d'epée* who had fought alongside Blondel d'Azincourt at the Battle of Fontenoy (May 1745) and, like him, had been decorated for his valour. Damery emerges as one of the most progressive collectors during the 1750s and 1760s, acquiring Dutch and Flemish cabinet pictures, modern genre paintings by Jean-Baptiste Oudry, Chardin, and Greuze, and autonomous drawings by young artists.[147] He owned at least twenty such drawings by Greuze, as well as works by Boucher, Van Loo, Lagrenée, and Challe.[148] Edmond de Goncourt recognized Damery's collector's mark on drawings of the highest quality ("*elle n'est jamais sur un dessin médiocre*"), and during the 1760s Damery's name is mentioned repeatedly in Wille's journal as the most generous—and discriminating—of connoisseurs.[149]

Like Blondel d'Azincourt, Damery restricted his collecting largely to the French school—of the four drawings by Watteau that bear his stamp, the most beautiful is the *Two Studies of Women* in Chantilly[150]—but showed a preference for the more fully worked independent drawings of his contemporaries, in particular Greuze (he was godfather to the painter's second daughter).[151] These he willingly allowed to be engraved—at least nineteen drawings by Greuze are recorded as from his collection—and on occasion to be lent to the Salon. Van Loo's bistre-wash *Infantry and Cavalry Skirmish* (whereabouts unknown), which appeared at the Salon of 1757, was engraved five years later by Beauvarlet as from "the cabinet of Monsieur Damery."[152] Van Loo's military drawing most probably hung in Damery's cabinet as well, since the battle-painter Francesco Casanova was later commissioned to produce a pendant to it. Wille praised Casanova's drawing, which was finished in March 1762, "as very proud in execution and very grand in scale."[153] Here, the distinction between painting and drawing

was thoroughly collapsed, with the requirements of decoration determining not only the size and the subject, but also, one would presume, the medium, of Casanova's pendant.

By the end of Louis XV's reign, most collectors of any stature (or of any pretension) owned a certain number of French drawings that were kept on more or less permanent display. Just as the mixing of paintings from the Italian, Northern, and French schools had become a standard feature of Parisian cabinets de tableaux, which were hung not by school, but along decorative principles (the fashion being for a saturated and symmetrical arrangement), so did framed drawings (and prints) gradually find their way on to the walls of studies, bedrooms, and cabinets de toilettes.[154] Drawings thus participated in decorative ensembles in a way barely imaginable half a century before, and while connoisseurs continued to amass portfolios in ever greater quantities—Blondel d'Azincourt's young cousin, the parlementaire Charles-Paul Bourgevin Vialart de Saint-Morys (1743–1795), owned more than twelve thousand drawings, with each school comprehensively represented[155]—a certain type of finished drawing was clearly more desirable for the purposes of display. Presentation sheets, modelli, and autonomous drawings were the categories favored in this development; first thoughts, studies, and ornamental drawings were not.

While this might suggest the victory of Dezallier d'Argenville's demi-connoisseur, a piquant irony is apparent with regard to the eighteenth-century market for Watteau's drawings. By the time these became more widely available, such was the supply of drawings by living artists which catered, consciously or not, to the requirements of the market, that Watteau's figure studies and multiple heads—to take but two of the categories in which he excelled—seem not to have been especially valued. In part, this may have had something to do with the perception that his drawings

were old-fashioned. Gersaint's enthusiasm for Watteau's mature drawings as "beyond all praise" had been attacked by the abbé de Marsy, author of the Dictionnaire abrégé de peinture et d'architecture, as "the vestiges of an old prejudice, for which Monsieur Gersaint, as a friend of the artist, may be excused."[156] The biography of Watteau that Tessin dictated to his wife towards the end of his life bore witness to a similar fall from grace. Watteau, for all his elegance and charm, had been incapable of either grandeur or nobility; his work was classed with Gillot, Lancret, and Pater as "ornaments for a cabinet de toilette."[157]

Rising to his own defense, Gersaint cited the enthusiasm of collectors for Watteau's drawings—"We see in how much esteem they are held from the prices they fetch in the saleroom, when they are from his best period"—but this was manifest wishful thinking.[158] The catalogue of the sale in which Gersaint's comments appeared, that of Angran de Fonspertuis (December 1747), included twenty-three drawings by Watteau, which sold in one lot for six livres.[159] Style and subject matter aside, Watteau's drawings were probably considered insufficiently finished and of inadequate scale to appeal to the type of collector who acquired framed drawings. This may also explain why so few of his drawings were reproduced in the new crayon-manner technique. Demarteau engraved the seated guitarist, the left-hand figure from a sheet that was then in the possession of Marin de La Haye, Blondel d'Azincourt's uncle by marriage.[160] François made crayon-manner engravings of two factitious drawings, the motifs of which had been cobbled together from separate sheets.[161] Both of these plates were reworked by Demarteau, who added details in an attempt to evoke, where none existed, some sort of relationship between the seated and standing characters. In Seated Woman and Couple Walking (Paris, Bibliothèque Nationale, Département des Estampes), Demarteau's efforts to "update" Watteau betrayed his allegiances to the artist whose own hand (and eye) had been formed some thirty years earlier in the etching of the latter's

drawings. The little dog at lower left in Demarteau's engraving, standing on its hind legs and seeking the attention of the seated woman, is a direct quotation from Boucher, whose sentimentality in this instance Watteau would have disowned.[162]

The status of Watteau's drawings as studies rather than finished compositions also worked to their disadvantage. When, in July 1771, the dealer and engraver Gabriel Huquier (1695–1772)—one of the most discriminating connoisseurs of French drawings, active since the 1720s—decided to divest himself of the major part of his collection, the ordering of his sale reflected both commercial and art-historical hierarchies.[163] After the paintings, framed drawings were listed in first place; then drawings of the Italian, French, and Northern schools (in that order); sheets not important enough to appear in their school were grouped by category—landscapes, architecture, and decorations—with "Studies of the finest masters of the different schools" listed last of all.[164] Although no drawings by Watteau appeared in this sale, it was to this last group—that of the Studies—that all but one of Huquier's thirty-seven drawings by Watteau were assigned when the finest works in his collection were sold, after his death, in November 1772. In this sale, only Watteau's monumental *Pair of Hunters with Four Dogs in a Landscape* (Frankfurt, Graphische Sammlung im Städelschen Kunstinstitut) was listed separately.[165] Although we know from Mariette that the drawings sold in November 1772 were the "most choice" of Huquier's collection, those by Watteau are described so generically that none can be identified with complete confidence; and the artist's thirty-six "Studies" sold for only 251 *livres*, less than seven *livres* a sheet.[166]

Collectors such as Jullienne, Mariette, and Jean-Baptiste-François Montullé (1721–1787)—Jullienne's second cousin and successor in the family's dye-works and weaving establishment[167]—who framed certain of their drawings by Watteau and were prepared to pay well for them, were in a

minority. Even Mariette was shocked at the prices Montullé paid for two pairs of superb head studies at the Jullienne sale in 1767: 120 *livres* for *Study Sheet with Eight Studies of Heads* (Paris, Musée du Louvre) and *Study Sheet with Nine Studies of Heads* (fig. 77); 210 *livres* for the surpassing *Eight Studies of a Woman's Head with the Head of a Man at Right* and *Six Bust-length Figures* (both Paris, Musée du Louvre).[168] Of this latter pair, Mariette noted, "*Cela est beau, mais fort cher.*"[169] To grasp just how modest these prices were, it should be noted that in the same period framed drawings by Boucher routinely sold for between 100 and 200 *livres* each[170]; a pair of landscape drawings by de Loutherbourg sold for 741 *livres* at the Randon de Boisset sale (February 1777); and at this same sale Greuze's pen-and-ink wash pendant drawings, *The Departure of the Wet Nurse* and *The Return from the Wet Nurse* (New York, private collection) fetched the staggering sum of 1500 *livres*.[171] Fragonard's watercolor *The Visitation* (whereabouts unknown), a version of one of his most highly prized compositions, sold at the sale of Vassal de Saint-Hubert in March 1779, for 1240 *livres*.[172] By contrast, the most expensive drawing by Watteau sold in the eighteenth century was the *Knife Grinder* belonging to Mariette, acquired by the Crown in December 1775, for 480 *livres* (see fig. 78).[173] Here, the prestige of its provenance may also have been a factor, since only eight years earlier Mariette had bought the drawing with its "pendant," *The Seated Savoyard Woman* (London, British Museum), for a mere 30 *livres*.[174]

The dissemination of Watteau's drawings as independent works of art may not have been accomplished in his own century, despite Jullienne's best efforts and the enthusiasm of the early biographers. Only since the Goncourts' rediscovery of Watteau has it been possible to go beyond eighteenth-century categorization and taxonomy to consider his drawings in exclusively aesthetic terms. For Marcel Proust—to take but one example—it was unquestionable that Watteau's drawings stood as self-sufficient entities,

Figure 77
Antoine Watteau,
Study Sheet with Nine Studies of Heads,
ca. 1715.
Red, black, and white chalks on gray-brown paper,
10¼ × 5¾ in. (26.2 × 14.6 cm).
Musée du Petit Palais, Paris

Figure 78
Gabriel de Saint-Aubin,
Basan, Catalogue Raisonné des Differens Objets de Curiosites … Le Cabinet de Feu M. Mariette (Paris, Chex l'auteur et Desprez),
1775.
6¼ × 3⅞ in.
(15.9 × 9.8 cm).
Museum of Fine Arts, Boston; William A. Sargent Collection. Annotated copy of Mariette's sale catalogue, illustrating pencil drawings by Watteau.

imbued with the humanity and profundity offered the patient viewer by masterpieces of any kind. When he wanted to evoke Swann's fascination with Odette de Crécy at the beginning of their relationship—the happiest of times, when Swann is unaware of so much in her life, past and present—it was to Watteau's head studies (see fig. 77) that Proust turned for the most powerful analogy:

And the life of Odette at all other times, since he knew nothing of it, appeared to him, with its neutral and colorless background, like those sheets of sketches by Watteau upon which one sees, here, there, at every corner and at various angles, traced in three colors upon the buff paper, innumerable smiles.[175]

It diminishes these drawings not at all to be reminded of the rather different reputation and status they enjoyed in their own century. For only then can we properly appreciate the originality—and audacity—of Jullienne's claim, made five years after Watteau's death, that "each figure that has

emerged from the hand of this excellent man has such truth to life and is so natural that it can, on its own, engage the viewer and hold his attention."[176]

Notes

I should like to thank John B. Collins, curatorial assistant, chief curator's office, National Gallery of Canada, for his essential contribution to the preparation of this essay. I am also grateful to Bonnie Bates, Hans Buijs, Cara Denison, Francis Haskell, Alastair Laing, Anne Maheux, Christian Michel, Marianne Roland Michel, Pierre Rosenberg, and Carol Togneri.

1. *Correspondance littéraire*, VII, p. 10, April 1766, "*Il était possesseur du secret de cette belle couleur d'écarlate qui n'a rien de pareil en Europe.*"
2. Brème 1997, pp. 172–75.
3. Mariette 1851–53, III, p. 16, "*Dans sa jeunesse on avoit voulu en faire un peintre. Watteau, son ami, l'en dissuada et lui rendit un grand service. Il n'auroit pas fait dans cet art une aussi brillante fortune.*"
4. For the best introduction to Jullienne's *Les Figures de différents caractères*, see Roland Michel 1987b.
5. Schreiber Jacoby 1986, pp. 81–106. The drawing has been catalogued variously as Boucher's copy after Watteau's lost original, as a copy by Jullienne himself (see Garnier 1996, pp. 25–26), or, most recently, as possibly by Jullienne's teacher, François de Troy (see Brème 1997, p. 184, note 77). It is interesting that Mariette was the first to voice his reservations about this drawing: "*C'est selon moi, un des moins bons desseins de Watteau.*" For his annotations to the Jullienne sale catalogue now in the Victoria and Albert Museum, see Rosenberg and Prat 1996, III, p. 1427.
6. Rosenberg and Prat 1996, II, no. 526.
7. *Les Figures de différents caractères*, I, no. 33.
8. *Mercure de France* (November 1726), p. 2527; (February 1728), p. 361.
9. "*Queste stampe mi piaccion molto, ma par me son troppo care,*" Jeaurat to Gaburri, December 5, 1729, in Schreiber Jacoby 1987, p. 257.
10. "*On doit … les regarder … comme des Recueils d'Estampes propres à former la main & le goût des personnes qui veulent s'exercer dans l'Art du Dessein,*" Jombert 1755, *Préface*.
11. "*Au fond, il faut en convenir, Watteau était infiniment maniéré,*" Caylus [1748] in Rosenberg 1984a, p. 73.
12. *Mercure de France* (November 1734), p. 2480, "*[Ces œuvres] … méritent de tenir une place dans les Cabinets et dans les Bibliothèques les plus distingués.*" Although Jullienne presented a four-volume set to the Academy in December 1739, most authors cite only three volumes, with the engravings after paintings contained in the first.
13. *Mercure de France* (November 1734), p. 2481.
14. Haskell 1987.
15. Held 1963, pp. 74–75; Schnapper 1994, pp. 16, 247–56.
16. "*[Chaque figure] semble n'avoir pas besoin d'être soutenue par la Composition d'un plus grand sujet,*" Jullienne 1726, *Préface*; "*La plupart du temps la figure qu'il dessinait d'après le naturel n'avait aucune destination déterminée,*" Caylus [1748] in Rosenberg 1984a, p. 78.
17. "*De façon qu'il en avait toujours un grand nombre sous sa main,*" Rosenberg 1984a, p. 78.
18. On Tessin's "apprenticeship" with Berain, see Weigert and Hernmarck 1964, p. 386; "*Il va les apresdisners dessiner chez Mr. Berain,*" Cronström to Tessin, May 26, 1715.
19. As noted by Dezallier d'Argenville [1745] (in Rosenberg 1984a, p. 51), Watteau favored red chalk on white paper, "*afin d'avoir des contre-épreuves, ce qui lui rendit son sujet des deux côtés.*"
20. "*Flamand de nation, travaille avec grand succès au grotesque, paysage et mode*"; for Tessin's journal entry dated June 13, 1715, see Nordenfalk 1987, p. 31.
21. Jeaurat to Gabburri, June 14, 1731, in Schreiber Jacoby 1987, p. 257.
22. Schreiber Jacoby 1987, pp. 257–58.

23. For a resumé of this problem see Rosenberg 1985, and Rosenberg and Prat 1996, I, pp. xii–xvi.
24. Laroque [1721] in Rosenberg 1984a, p. 5; for the obituary in the *Gazette d'Utrecht*, sent from Paris on July 28, 1721, see Moureau 1987a, pp. 20–21. For the listing of Haranger as one of the "*Fameux curieux,*" see Pradel 1692, I, p. 229.
25. Schreiber Jacoby 1987, p. 257, letter of June 14, 1731.
26. Baticle 1985.
27. In his unpublished draft, Caylus had referred to Haranger as "*un de (ces) brocanteurs et ramasseurs de guenilles, qui ne peuvent excuser le mauvais choix de leur nombreuse collection que par l'envie et l'espérance de tromper ceux qui se connaissent moins qu'eux,*" see Rosenberg 1984a, p. 84, n. 193.
28. Dezallier d'Argenville [1745] in Rosenberg 1984a, p. 49, "*Watteau légua à quatre de ses meilleurs amis tous ses dessins qui étaient en grand nombre.*"
29. "*Il les partagea à sa mort et les legua un quart à l'abbé Haranger un autre quart à Gersaint un 3e à M. Henin mort Contrllr. des Batiments du Roi, et le 4e à M. Jullienne, tous ses amis. Ce dernier les reunit presque tous dans la suite car, à l'exception de la part de l'abbé Haranger qui fut vendu à sa mort, toutes les autres furent achetées par lui,*" Mariette's annotations to his copy of the Jullienne sale catalogue now in the Victoria and Albert Museum, published in Rosenberg and Prat 1996, III, p. 1427. Mariette was surely mistaken in assuming that none of Jullienne's drawings by Watteau had come from Haranger's collection.
30. Gersaint [1744] in Rosenberg 1984a, p. 39; "*[Il] voulut que ses dessins, dont il me fit le dépositaire, fussent partagés également entre nous quatre; ce qui fut éxécuté suivant ses intentions.*"
31. Roland Michel 1987b, p. 178, estimates the total to have been around 5000; Rosenberg and Prat 1996, I, p. xvi, now place Watteau's total output at between 2000 and 4000 drawings; on this issue, see also Bailey 1997.
32. Mariette 1741, p. 127; "*Desseins que Watteau a laissé en mourant à moy, son ami,*" Caylus's inscription on the verso of seven of Watteau's drawings, for which see Rosenberg and Prat 1996, I, nos. 271, 289, 297; II, nos. 389, 441, 628, 657.
33. Bailey 1997.
34. Dacier and Vuaflart 1921–29, I, pp. 115–17; III, p. 15.
35. Dacier and Vuaflart 1921–29, I, pp. 106–07. Gersaint seems not to have held on to a single drawing by Watteau, even though fifteen by François Lemoyne were noted among his effects at his death and valued at 18 *livres*; see A.N., Minutier Central, LX/298, "*Inventaire après décès,*" April 1, 1750, "*huit academies de feu Mr. Lemoine; sept differents sujets aussi de Mr. Lemoyne [sic].*"
36. "*Pour joindre aux desseins qu'il avoit reçus du Sr. Watteau, qui étoit son ami, tous ceux qu'il a pu trouver dans les Cabinets des Curieux,*" Jullienne 1726, *Préface*.
37. Roland Michel 1987b, pp. 120–22. Boucher, who was responsible for 116 of the 351 plates, is assumed to have worked on the project in the five years leading to his departure for Rome in March–April 1728. It was Jullienne's generous fee of 24 *livres* a day that allowed Boucher to finance a visit that should have been paid for by the Bâtiments.
38. Baticle 1985, p. 66, "*à arranger et mettre en ordre partie des dessains [sic].*"
39. Jullienne (1726, *Préface*) referred to himself simply as "*la personne qui met ce recueil en lumière.*"
40. *Les Figures de différents caractères*, I, no. 69, II, no. 198. The annotated set in the Bibliothèque de l'Institut, which belonged to René de Voyer d'Argenson, marquis de Paulmy (whose family had long been doyens of Haranger's church), noted that it was after Haranger's drawings "*qu'ont été fait la plupart des gravures de ce Recueil*"; see Dacier and Vuaflart 1921–29, I, p. 53; and Baticle 1985, p. 56.
41. Baticle 1985, p. 60, noting Gersaint's evaluation (and probable price of purchase) of 250 *livres*.
42. *Mercure de France* (November 1726), p. 2528, noting that the first volume of *Les Figures de différents caractères* "*sera suivi de quelques autres, où l'on trouvera l'Œuvre entier de Watteau.*"
43. *Mercure de France* (November 1734), pp. 2479–80. Jullienne was voicing the same complaint as had Crozat in April 1728, when he blamed the slowness with which his *Recueil* had been produced on the Crown's monopoly of the engravers, the best of whom were still employed in commemorating Louis XV's coronation.
44. "*On ne s'est guère avisé de faire graver les études des peintres,*" Jullienne 1726, *Préface*.

45. Schnapper 1994, pp. 247–78 *et passim*.

46. Monbeig-Goguel 1988.

47. "*Aussi ne doivent-ils pas passer pour des dessins, ainsi pour des meilleurs et plus friands tableaux de l'Europe, lorsqu'ils seront embordurés,*" Grouchy 1894, pp. 19–20.

48. Mariette 1741, p. 36, "*Ce ne sont, à la verité, pour la plupart que des Etudes. Il y en a peu de Compositions entières, et ces Compositions en sont encore que de légers croquis. Mais où trouve-t-on des Desseins du Corrège qui soient arrêtés?*"

49. Dezallier d'Argenville 1727, p. 1317, "*Cette curiosité demande beaucoup plus de sçavoir que les Estampes.*"

50. Dezallier d'Argenville 1762, I, p. xxxviii, "*Les Desseins des grand maîtres … sont la meilleure instruction pour un Amateur.*"

51. Caylus 1732, p. 318, "*Il est certain que l'on est fort avancé dans la connoissance des arts lorsqu'on les sçait bien lire.*"

52. "*Il y a peu d'amateurs de Desseins: on se livre difficilement à ce genre de curiosité … Les Desseins, dont l'ouvrage est ordinairement tout esprit, exigent une connoissance consommé, pour y pouvoir être sensible,*" Gersaint, *Catalogue raisonné des diverses curiosités de Cabinet de feu M. Quentin de Lorangère*, Paris, 1744, pp. 18, 38. This may help explain Gersaint's decision to abandon the commerce of paintings and drawings for that of shells and *chinoiseries*, with Watteau's shop sign "*Au Grand Monarque*" being replaced by Boucher's calling card "*A la Pagode*"; see McClellan 1996.

53. Michel 1986, p. 26.

54. James 1997, pp. 138–69 ("The History of Preservation of Works of Art on Paper") provides an excellent summary of the available literature on this topic.

55. Schnapper 1994, p. 278.

56. James 1997, pp. 2–35.

57. Mirot 1924, pp. 65–67.

58. Labbé and Bicart-Sée 1996.

59. Dezallier d'Argenville 1727, p. 1307, where he notes that his collection "*embrasse tout au plus cinquante volumes d'Estampes et une quinzaine de volumes de desseins.*" By 1762 the collection had grown and was ordered differently, "*rangée chronologiquement par écoles, & composée d'environ six mille desseins originaux & choisis,*" Dezallier d'Argenville 1762, p. xxxviii.

60. "*[Ces volumes] étant remplis de morceaux choisis, satisferont plus que ces grands Recueils, où il faut feuilleter long-tems pour trouver du bon,*" Dezallier d'Argenville 1727, p. 1307.

61. *Mercure de France* (March 1733), pp. 490–94.

62. *Catalogue raisonné des diverses curiosités du cabinet de Feu M. Quentin de Lorangère …*, Paris, 1744, nos. 65–67.

63. "*Un beau Recueil de Desseins des meilleurs Maîtres est une vraie école de Peinture,*" Dezallier d'Argenville 1727, p. 1317.

64. Rogers 1778, II, p. 229.

65. "*A la main des peintres de l'Antiquité et de ceux de nostre tems,*" Schnapper 1988, p. 230.

66. Guiffrey 1874–75, pp. 25–26.

67. Guiffrey 1877, pp. 44–45; Propeck 1988, p. 52. *Saint Paul Preaching to the Athenians* is now considered to be a copy from Raphael's studio.

68. Grouchy 1894, pp. 34, 36, 50; for example, the "*Teste d'un Christ couronné d'espine, sur papier bleu collé sur bois, d'Alberdur.*"

69. Guiffrey 1877, pp. 201–02.

70. Holt 1957, II, p. 325. And see Caylus 1732, p. 320, "*Rien n'excite le génie d'un Peintre et ne lui donne cette chaleur de teste si nécessaire pour la composition, que l'examen d'un beau Dessein.*"

71. Mariette 1741, p. xi, "*On tenoit assez régulièrement toutes les semaines des assemblées chez lui*"; such gatherings may well have included Watteau.

72. Caylus 1732, p. 321, "*Toutes ces raisons m'engageoient à conseiller à un peintre de posséder des desseins et de les étudier.*" At least one protégé, Louis-Joseph Le Lorrain (1715–1759), seems to have taken him at his word; some eight hundred drawings, including sheets by Boucher and Chardin, were in the collection that he sold on the eve of his departure for Russia; see *Catalogue d'une Collection de Tableaux & de Desseins des meilleurs Maîtres de France, d'Italie et de Flandres du Cabinet de M. Le Lorrain*, Paris, March 20, 1758, no. 89

(the drawings sold for 308 *livres*).

73. The growth of a market for drawings during the eighteenth century is only now being investigated (see the articles that are beginning to appear from the *Burlington Magazine* conference on the "Collecting of Prints and Drawings in Europe, *ca.* 1550–1800," held on June 20–21, 1997). For an introduction to the European market for prints at this time, see Griffiths 1994. And on the growth of the Parisian market for old master paintings during the eighteenth century, when the dealer gradually replaces the connoisseur as ultimate arbiter and authority thanks to his ability to provide reliable attributions, see the indispensable article by Pomian 1979.

74. For an introduction to this topic, see Held 1963, pp. 90–92.

75. De Piles 1699, p. 67; and Schnapper 1994, p. 257.

76. De Piles 1699, p. 67.

77. De Piles 1699, p. 70. "*Les Demi-Connoisseurs n'ont point de passion pour cette curiosité, parce que ne pénétrant pas encore assez avant dans l'esprit les Desseins, ils sont plus sensible à celui que donnent les Estampes.*"

78. Dezallier d'Argenville 1762, p. lxi, "*Les grand maîtres finissent peu ses desseins; il se contentent de faire des esquisses, ou griffonemens faits de rien, qui ne plaisent pas aux demi-connoisseurs. Ceux-ci veulent quelque chose de terminé, qui soit agréable aux yeux: un vrai connoisseur pense autrement; il voit dans un croquis la manière de penser d'un grand maître … son imagination animée par le beau feu qui règne dans les desseins, perce à travers ce qui y manque.*"

79. Dezallier d'Argenville 1762, p. lii, "*Défiez-vous des desseins trop finis; rarement sont-ils originaux; ils sont même plus aisé à contrefaire que les autres.*"

80. Watelet and Levesque 1792, I, pp. 546–47, "*Les croquis des grands artistes sont prisés des curieux, comme les moindres reliques des saints sont recherchés par les dévots; aussi cette sorte de vénération, est-elle souvent poussée trop loin; car des griffonemens qui ne désignent presque rien et des indications à peine reconnoissables de composition ou de parties de figures ne méritent certainement pas plus l'affection de certains amateurs, et la vénération qu'ils exigent de ceux à qui ils les montrent que certains fragmens apocriphes ne méritent les honneurs d'une chasse.*"

81. Ratouis de Limay 1907, p. 176, "*Les desseins touchés sont, pour parler ainsi, une écriture que j'entends et lis avec plaisir; les desseins finis sont plus à la portée de tout le monde.*" This is borne out by comparing the twelve lots of "*dessins encadrés*" (eight of which were still lives by Van Huysum and Pérignon) with the 140 lots of "*dessins en feuilles*" in Watelet's possession at the time of his death, see *Catalogue de Tableaux, Dessins montés et en feuilles … le tout provenant du Cabinet de feu M. Watelet*, Paris, June 12, 1786, nos. 88–241.

82. See Roland Michel 1987a, pp. 243–53; Monbeig-Goguel 1987.

83. Bacou 1967; Marois 1984. Indeed, to give but one example, Mariette considered Veronese's *Christ Served by the Angels* (whereabouts unknown; copy in Bremen, Kunsthalle), a drawing "*d'un terminé et d'une condition parfaites*" acquired towards the end of his life, the equal of any of his paintings: "*il peut tenir place auprès d'un de ses meilleurs tableaux,*" Müntz 1890, p. 134 (letter of December 12, 1769).

84. "*Peut-être la plus complette et la mieux choisie qui soit en Europe,*" Müntz 1890, p. 133. Mariette had held this opinion for some time; as early as September 1756 he informed another Italian correspondent, "*Je puis pourtant me vanter de posséder le plus bel assemblage de desseins qui soit en France,*" Müntz 1884, p. 346.

85. "*Il se crut assez habile pour manier le crayon et même le pinceau; mais l'un et l'autre lui réussirent fort mal.*" Mariette was also jealous of Dezallier's *Abrégé*: "*Si le succès décidait de la bonté d'un ouvrage, les siens auraient été excellents. Il s'en faut beaucoup que les vrais connoisseurs en portassent ce jugement.*" These comments, taken from the *Abécédario*, are cited in Labbé and Bicart-Sée 1996, pp. 17, 29.

86. "*Je suis plus que jamais dans la résolution de ne rien admettre de douteux dans ma collection,*" Müntz 1890, p. 131 (letter of February 22, 1769).

87. Rogers 1778, II, p. 233. As Basan indicated in the catalogue of Mariette's posthumous sale (November 15, 1770; January 30, 1776), some 3400 drawings were kept in this way; 6000 more were arranged in books and volumes.

88. Müntz 1890, p. 106, "*Vous me ferez plaisir, au cas où vous trouverez la chose possible, de m'en procurer un qui lui fit honneur. Je ne le voudrais pas trop grand, ni qu'il passa l'étendue de cette lettre déployée*" (letter of January 25, 1767).

89. Müntz 1890, p. 121, "*Son dessein, quelque bon qu'il soit, me plairoit davantage, s'il était*

moins grand, car tous mes desseins rangés dans des portefeuilles de même grandeur me font préférer ceux qui sont d'une taille moyenne; de façon que si vous pouviez engager M. Diziani à m'en céder un qui ne passât pas douze pouces dans un sens, sur quinze à seize pouces dans l'autre sens, je le recevrois bien volontiers et lui donnerois place dans ma collection" (letter of February 22, 1769). This letter is cited in Bacou 1967, p. 22, and James 1997, pp. 20–21 (where the bibliographic reference is inaccurate).

90. Müntz 1890, p. 121, *"Je ne serois pas non plus fâché d'en avoir encore de M. Cignaroli, dans la grandeur que je viens de donner."*

91. See the illustration in James 1997, p. 195.

92. See the "Avis aux Amateurs de dessins & estampes" that Glomy published in the *Mercure de France* (April 1771), pp. 205–06, in which he noted that he was *"connu depuis plus de vingt-cinq ans ... par son talent de coller et ajuster les dessins et estampes avec soin et propreté."*

93. Glomy's *Journal des ouvrages* is in the Fondation Custodia, Institut Néerlandais, Paris [inv. 9578]. I am extremely grateful to Hans Buijs for verifying the transcriptions for me. On Glomy, see Lugt 1921, pp. 189–90, and James 1997, pp. 22–23.

94. See, for example, Glomy's *Journal des ouvrages*, June 3, 1758, *"Pour avoir travaillé trois journées et deux après midi chez luy [Boucher] à 6 Livres par jour"*; July 24, 1758, *"Pour avoir collé 100 desseins sur 47 Cartons à 4 sols chaque feuille."*

95. Lugt 1921, p. 190.

96. Grimm 1877–82, VII, p. 239 (February 1767). *"Il se fait un plaisir d'announcer que M. Glomy est un des premiers pour coller les dessins et pour les ajuster avec des filets de papier d'or."* This was in response to Glomy having described Remy's participation in the Bailly sale of the previous December as providing the measurements of the pictures.

97. *Mercure de France* (April 1771), p. 206. During the 1770s Glomy is also listed as a restorer of old master prints, as well as someone who will hang and arrange picture cabinets (a service normally provided by the *tapissier*); see Lebrun 1777, pp. 172–73, *"[Sr. Glomy] fait prisées et ventes et arrange les Cabinets."*

98. On the history of *verre églomisé* see Guth 1957 and Eswarin 1979.

99. *Catalogue d'un Cabinet de diverses curiosités, contenant une Collection choisie d'Estampes, de Desseins, de Tableaux* [Cottin], Paris, November 27, 1752, nos. 288–342.

100. *Catalogue raisonné des Tableaux, Sculptures, tant marbre que de bronze, Desseins et Estampes* [duc de Tallard], Paris, March 22, 1756, p. 94; *"Feu Monsieur le Duc, pour mieux jouir de quelques-uns de ces morceaux, en avoit fait encadrer sous verre un assez grand nombre; et le surplus étoit destiné à être renfermé dans des boîtes, après avoir été ajusté proprement, et mis d'une même grandeur, sur un papier d'Hollande renforcé d'un autre papier."*

101. Garnier 1989, p. 254.

102. A.N., Minutier central, LXXVI/337, "Inventaire après décès," September 27, 1752, *"Dessins encadrés les uns dans leur bordure de bois doré sous glace et verre, les autres dans leur bordure brune avec verre et sans verre. No. 98: Item, quatre vingt douze dessins tant de Raphael que du Corege, Guide, Carache, Parmesan, Vandick, Rimbrand, Lebrun, Coypel père."*

103. Rosenberg and Prat 1996, I, no. 303.

104. A.N., Minutier central, XCII/711, "Inventaire après décès," October 23, 1767.

105. Wille 1857, I, p. 429, *"Mon cabinet de travail, que j'ay garni amplement de desseins précieux et d'estampes d'anciens grands maîtres."*

106. Ratouis de Limay 1907, pp. 102–03.

107. Michel 1985, p. 25 (letter to Descamps of February 9, 1777).

108. Lieudé de Sepmanville 1747, p. 30, *"qui a nouvellement fait construire une galerie où il a rassemblé quantité de Tableaux et de Desseins des plus grands Maîtres."*

109. Dacier and Vuaflart 1921–29, I, pp. 238–40. I am grateful to Cara Denison for making it possible for me to consult the Jullienne Album.

110. Rosenberg and Prat 1996, III, p. 1427. Of the Watteaus, lot nos. 769–75 are indicated as having been framed.

111. Pierpont Morgan Library, New York, *Album Jullienne* [1966.8], fols. 40, 48, 76, 78, 80.

112. Bouchardon exhibited five drawings in the Salon of 1737 (including head studies of Mariette's children and *Les Vendanges célébrées dans les Campagnes d'Athènes*, known as the *Cachet de Michel Ange* [see fig. 71, p. 78; and Propeck 1988, p. 75]), and three red-chalk drawings in the Salon of 1741; Cochin exhibited at the Salons of 1741, 1742, 1743, 1750, and 1755. I hope to publish, in collaboration with John Collins, a full list of works

on paper shown at the Paris Salon between 1699 and 1789.

113. Laing, Rosenberg, and Marandel 1986, pp. 24–25.

114. Sahut 1977, nos. 366 (where the connection with the Salon of 1757 envoi is not noted), 486, 489. See the *livret* to the *Salon de 1757*, nos. 7–9, in which, to confuse matters, two of Van Loo's drawings are identified as *"Esquisses."*

115. McCullagh 1992, p. 92.

116. Gougenot 1748, pp. 77–78, *"On voudroit que les Artistes, au lieu de les ensevelir dans l'obscurité des porte-feuilles, s'empressent d'en exposer au Sallon plus souvent qu'ils n'ont encore fait ... Les Maîtres en se communiquant les uns aux autres leurs pensées par une pareille exposition, pourroient présenter sous un seul coup d'oeil la plus sçavante partie de leur Art."* Schreiber Jacoby (1987, p. 270) was the first to draw attention to this text.

117. Mariette 1851–53, II, p. 331, *"Il a fait aussi nombre de dessins, qui dans le commencement lui ont été payés prodigieusement par quelques curieux."*

118. Wille 1857, I, p. 129, *"le dessein le plus admirable qu'il ait fait jusqu'à présent."* (Greuze's drawing reappeared in 1990 with Didier Aaron, New York.) To give some context for this price, the following August Wille acquired a pair of still life paintings by Chardin for a *prix d'ami* of 36 livres (*Tinned Copper Pot, Pepper Box, Leek, Three Eggs, and a Casserole on a Table* [Detroit Institute of Arts] and *Mortar and Pestle, Bowl, Two Onions, Copper Pot and Knife* [Paris, Musée Cognacq-Jay]).

119. Wille 1857, vol. I, p. 175; Munhall 1976, pp. 80–81.

120. Wille 1857, I, p. 125.

121. Wille (1857, I, pp. 284–85) noted that, along with the paintings he had submitted in support of his admission to the Academy, Fragonard had shown *"des desseins de diverses manières qui avoient bien du mérite."*

122. Ratois de Limay 1907, p. 27 (letter to President Haudry, February 1780).

123. Rosenberg 1987, p. 150.

124. Rosenberg 1987, p. 362, 370.

125. *"Voici comment raisonnent la plupart des hommes opulents qui occupent les grands artistes: La somme que je vais mettre en dessins de Boucher, en tableaux de Vernet, de Casanove, de Loutherbourg, est placée au plus haut intérêt. Je jouirai toute ma vie de la vue d'un excellent morceau. L'artiste mourra; et mes enfants et moi nous retirerons de ce morceau vingt fois le prix de son premier achat,"* Diderot 1957–67, III, p. 53 (emphasis mine).

126. Schreiber Jacoby 1987.

127. Mannlich 1989–93, II, p. 157; Slatkin 1972, pp. 279–80.

128. Rogers 1778, II, p. 197, cited also in Slatkin 1967, p. 610.

129. Caylus [1748] (in Rosenberg 1984, p. 66) railed against the intrusions of *"les demi-connoisseurs et les désoeuvrés ... ces brocanteurs, soi-disant curieux ... [qui] s'emparent des esquisses, se font donner les études."*

130. As Francis Haskell has noted, the techniques required to reproduce these drawings, which had to be invented or rediscovered by engravers such as Caylus and Robert de Séry, constituted "the greatest novelty of the *Recueil*," Haskell 1987, p. 35.

131. Hérold 1931, pp. 10–12.

132. *"Un dessein d'étude et une estampe qui font tableau,"* Carlson and Ittman 1984, p. 132, citing the *Mercure de France*.

133. Carlson and Ittman 1984, pp. 132–36, 188–97.

134. For such examples, see Jean-Richard 1978, nos. 597, 622, 634, 639–41, 655, 685, 687, 694.

135. For example, the print dealers Jean Alibert, *"fait le commerce d'estampes sous verre"*; Alexis Auvray, *"on trouve chez lui les Estampes modernes et il les monte très bien à juste prix"*; Bligny, *"tient magasin des Estampes modernes montées sous verre blancs"*; Chereau, *"tient magasin d'Estampes modernes"*; Desmarais, *"vend, achète, troque des Estampes anciennes et modernes; colle très proprement les Dessins"*; Hamond, *"vend et achète toutes sortes d'Estampes montées et non montées"*; Maigret, *"vend des Estampes anciennes et modernes et les monte très bien sous beaux verres blancs"*; François Renaud, *"lave et blanchit les Estampes et ajuste les Dessins avec filets d'or,"* Lebrun 1776, pp. 171, 214, 216, 219–22, 224.

136. Bastide 1993, p. 65.

137. *"Un estampe d'un sujet agréable qui sera renfermé dans un cadre doré,"* Le Camus de Mezières 1780, p. 126.

138. Bailey 1987. The enthusiastic description of Blondel de Gagny's picture cabinet was made by Dr. Johnson's travelling companion, Mrs. Hesther Thrale.

139. "*La Première Idée de la curiosité*," in Bailey 1987, pp. 446–47.

140. Hérold 1931, pp. 48–52.

141. Montaiglon 1875–92, VII, p. 371–72.

142. See Bailey 1987, pp. 434–35; on Blondel d'Azincourt and Perronneau, see Vaillat and Ratouis de Limay 1900, pp. 28–29; on Greuze and d'Azincourt, see Boilly 1852–53, pp. 164–65, "*Ce fut M. Dazincourt qui premier fut cause des désordres de ma maison. Il y vint d'abord comme amateur; bientôt madame Greuse s'empara, et elle l'aima avec fureur.*"

143. Hebert (1766, p. 82) noted that his collection included five hundred drawings by Boucher.

144. Alastair Laing kindly informs me that the head study Blondel d'Azincourt holds should be associated with Boucher's *Head of a Young Woman*, sold at Christie's, London, July 2, 1991, lot 330; the drawing that perches precariously on the arms of the sitter's *fauteuil* might be connected to one of the "*dessins à la pierre noire & à la sanguine, dans l'un on remarque quatre Nymphes au bain*" that were sold as part of Blondel d'Azincourt's collection on February 10, 1783, lot 154.

145. Connoisseur portraits are relatively rare in eighteenth-century France, but it is conceivable that Blondel d'Azincourt could have seen Aved's *Portrait of Tessin* (Stockholm, Nationalmuseum) when it was exhibited at the Salon of 1740; the sitter is shown holding a print by Marc Antonio Raimondi after Raphael's *Triumph of Galatea*, see Grate 1994, pp. 38–39.

146. Lundberg 1957, p. 22.

147. For biographical information on this interesting, but little-studied, collector, see Bourgeois 1905, pp. 57–59, and Gosset 1914. Munhall (1976, p. 96) has a good discussion on the presumed portrait of Damery.

148. Gosset (1914, pp. 8–11) provides a listing of modern French works engraved as from Damery's collection; Challe's *Study of a Seated Male Youth in Classic Costume* most recently appeared in Galerie Thomas Leclaire, Hamburg.

149. Goncourt's accolade from *La Maison d'un artiste* (Paris 1881) is quoted in Munhall 1976, p. 96; Wille (1857, I, p. 154) noted in his journal for April 16, 1761, "*Je l'ay embrassé de tout mon coeur, car c'est un très-digne officier et grand amateur des beaux-arts.*"

150. Rosenberg and Prat 1996, II, no. 529. Damery's other Watteaus are *Two Heads of Old Men, after Van Dyck* (whereabouts unknown; no. 348); *Kneeling Servant Holding a Clyster, with Two Male Heads Turning to the Right* (Paris, Musée du Louvre; no. 487); and *A Standing Man Dressed as Mezzotin, Turning Toward the Left* (Paris, private collection; no. 586).

151. Herluison 1873, p. 116.

152. Sahut 1977, no. 486.

153. Wille 1857, I, p. 192, "*une bataille très-fièrement faite et très-grande pour étendue.*"

154. Bailey 1987; Monbeig-Goguel 1987; McCullagh 1992.

155. Arquié-Bruley, Labbé, and Bicart-Sée 1987, I, pp. 127–31.

156. Marsy 1746, p. 42, "*Il faut beaucoup rabattre de cet éloge. C'est un reste de l'ancien préjugé et ce préjugé est pardonnable à M. Gersaint ancien ami de Watteau.*"

157. Tessin [1762] in Rosenberg 1984a, p. 97.

158. "*On voit assez le cas qu'on en fait, par les prix où on les pousse dans les ventes, quand ils sont de son bon temps,*" Gersaint [1747], in Rosenberg 1984a, p. 44.

159. *Catalogue raisonné de bijoux, porcelaines, bronzes … de M. Angran, Vicomte de Fonspertuis*, Paris, December 1747, March 4, 1748, no. 301.

160. Rosenberg and Prat 1996, II, no. 596.

161. Rosenberg and Prat 1996, III, p. 1412, G. 194, 195.

162. Rosenberg and Prat 1996, III, p. 1412 (illustrated with G. 194). For Boucher's *Dog Standing on Its Hind Legs* (London, Courtauld Institute), a drawing in *trois crayons* preparatory to the dancing dog in the *Joueur de flute* (from the tapestry series *La Noble Pastorale*), see Kennedy and Thackray 1991, pp. 16–17. Demarteau also engraved *L'Enfant berger*, in which the little dog appears, in the crayon-manner technique: Jean-Richard 1978, p. 77 (no. 196).

163. Bruand 1950.

164. *Catalogue des Tableaux, Gouaches, Desseins en feuilles & sous verre … du Cabinet de M★★★* [Huquier], Paris, July 1, 1771, p. v, "*Desseins d'Etudes des meilleurs maîtres des différentes Ecoles.*"

165. Rosenberg and Prat 1996, I, no. 194; this sheet was inscribed by Huquier with the artist's name, as was his custom.

166. Mariette had noted of the sale of July 1771, "*C'est le rebut de sa collection. Il en a reservé, me dit-il, mille de choix;*" see the annotated copy of the Huquier sale catalogue in the Rijksbureau voor kunsthistorische en ikonografische Documentatie, The Hague. In the *Catalogue de Tableaux à l'huile, à gouasse & au pastel; Peintures de la Chine, enluminures; Desseins précieux, & Estampes choisies … de feu M. Huquier, Graveur*, Paris, November 9, 1772, only the great *Crouching Nude Male* (Paris, Musée du Louvre) has been identified as part of lot 441, "*Cinq (dessins) à la sanguine et à la pierre noire.*"

167. On Montullé, see Dacier and Vuaflart 1921–29, II, pp. 203–204, 252–58.

168. Rosenberg and Prat 1996, II, nos. 415, 609; 484, 482.

169. Rosenberg and Prat 1996, III, p. 1427. At Montullé's sale of November 19, 1787, these two pairs of drawings, each framed and under glass, sold for 166 *livres* and 239 *livres* respectively, a slight (and insignificant) rise in price since the Julienne sale twenty years earlier.

170. See *Catalogue raisonné des Tableaux, Desseins & Estampes … de M. de Jullienne*, Paris 1767, nos, 932, 934; *Catalogue de Tableaux & Desseins précieux de Maîtres célebres des trois Ecoles … du Cabinet de feu M. Randon de Boisset*, Paris, February 27, 1777, nos. 331–376 bis.

171. *Catalogue de Tableaux & Desseins précieux de Maîtres célebres des trois Ecoles … du Cabinet de feu M. Randon de Boisset*, Paris, February 27, 1777, no. 321 (de Loutherbourg), no. 374 (Greuze).

172. *Catalogue d'une riche collection de Dessins & Estampes des plus grand Maîtres … qui composent le Cabinet de M★★★* [Vassal de Saint-Hubert], Paris, March 29, 1779, no. 179.

173. Courajod 1872, p. 360, "*9e vacation, no. 1394.*"

174. Rosenberg and Prat 1996, I, no. 303.

175. Marcel Proust, *Remembrance of Things Past*, translated by C.K. Scott Moncrief and Terence Kilmartin, 3 vols., New York, 1981, I, p. 262; *A la Recherche du temps perdu*, 3 vols., Paris (Editions Gallimard), 1954, I, p. 240, "*La vie d'Odette … lui apparaissait, avec son fond neutre et sans couleurs, semblable à ces feuilles d'études de Watteau où on voit çà et là, à toutes les places, dans tous les sens, dessinés aux trois crayons sur le papier chamois, d'innombrables sourires.*"

176. "*Chaque figure sortie de la main de cet excellent homme a un caractère si vrai et si naturel, que toute seule elle peut remplir et satisfaire l'attention,*" Jullienne 1726, *Préface.*

Catalogue

1 Children Imitating a Triumphal Procession

ca. 1707–08
Red chalk on cream paper
6⅜ × 8½ in. (16.3 × 21.5 cm)

The Fine Arts Museums of San Francisco,
Achenbach Foundation for Graphic Arts;
Gift from the Collection of Mr. and Mrs.
John Jay Ide (1993.43.2)

Provenance David and Constance Yates, New
York

Literature Goncourt 1875, p. 251, under
no. 411; Parker and Mathey 1957, I, under
no. 109; San Francisco 1989, no. 41; Grasselli
1993, pp. 104, no. 1, 106, under no. 3, fig. 1;
Rosenberg and Prat 1996, I, no. 13

Notes
1. Reproduced in Dacier and Vuaflart
1921–29, II, nos. 221 and 273.
2. Rosenberg and Prat 1996, I, no. 11.
3. Rosenberg and Prat 1996, I, no. 12.
4. For the painting see Rosenberg and
Camesasca 1970, no. 19.
5. Grasselli 1993, p. 104, under no. 1.
6. Rosenberg and Prat 1996, I, no. 13,
fig. 13a.

Among Watteau's earliest paintings, probably made only a few years after his arrival in Paris from his native Valenciennes, were *The Children of Bacchus* and *The Children of Silenus*, known today only from engravings, which may have been made while he was still employed in Claude Gillot's workshop.[1] These works, despite possessing a vigor and charm evident even in reproductions, were fairly conventional exercises that followed in a long tradition of bacchanals with children, putti, and baby satyrs that were intended to evoke antiquity, and found their immediate sources in paintings by Poussin, Rubens, and Titian. Gillot himself made a specialty of this very type of Bacchic scene (fig. 79).

The present drawing demonstrates the next step in Watteau's artistic evolution. It is one of a small group of drawings made by the artist early in his career, in which playful children—naked except for a few props—parody adult activities; directly comparable sheets include the *Allegory of Spring* in the Art Institute of Chicago[2] and the *Allegory of Winter* in the Städelsches Kunstinstitut, Frankfurt am Main,[3] which have similar shallow, frieze-like compositions. The dry, rather thin handling of red chalk, the even lighting, and weightless, attenuated figures are still reminiscent of Gillot's manner, but the military props and the contemporary beret that one of the children wears remove the scene from the world of antiquity favored by Gillot in his bacchanals; the subject assumes the air of play-acting. The purpose of the drawing is unknown, though the Frankfurt *Allegory of Winter* served as the study for a painting now in the Musée Carnavalet, Paris,[4] and it is possible that the present sheet was originally intended as a study for a painting as well. Watteau rarely made full compositional drawings after the earliest years of his career and preferred sketching from the live model; when he did turn to working from his imagination, even in his mature career, he often reverted to a drawing style reminiscent of that of Gillot.

The drawing was probably made near the end of Watteau's time in Gillot's shop, around 1707 or 1708; it was soon afterward, as Grasselli has noted, that Watteau would produce paintings of military subjects inspired, albeit indirectly, by the actual experience of war.[5] Within a couple of years, such playful putti would come to appear old-fashioned, even archaic, in the context of Watteau's emerging naturalism.

Children Imitating a Triumphal Procession was etched by Jean Audran for the first volume of *Les Figures de différents caractères* and was published as plate 58.[6]

Figure 79. Claude Gillot, *Satyrs.* Red chalk, 10¼ × 15 in. (26 × 38.1 cm). The Pierpont Morgan Library, New York

2 Four Theatrical Figures and Two Studies of a Man Seated on the Ground

ca. 1708 and 1712
Red chalk on cream paper
6½ × 8⅛ in. (16.5 × 20.5 cm)
Inscribed in graphite, at lower right:
WATEAU

The Pierpont Morgan Library, New York
(I.275)

Provenance M. Rigall; Charles Fairfax
Murray, London (1849–1914); acquired
along with his entire collection in 1910 by
J. Pierpont Morgan (1837–1913)

Exhibitions Providence 1975, no. 34;
Washington, Paris, and Berlin 1984–85,
no. 15; Paris and New York 1993–94, no. 34

Literature Parker 1931, p. 30 and no. 2, pl. 2;
Parker and Mathey 1957, I, no. 25, repr.;
Mathey 1959b, pp. 40, 44–45; Mathey 1960,
p. 358, fig. 16; Cailleux 1961, p. iii, figs. 4
and 6; Eidelberg 1970, p. 67 and fig. 34;
Eidelberg 1973, p. 236, note 24; Zolotov
1973, pp. 28 and 146, under no. 12, repr.
(entry by V. Alexeyeva); Eidelberg 1977,
p. 129, note 40; Rosenberg and Camesasca
1982, under no. 30d; Posner 1984,
pp. 47–49, fig. 41, pp. 258 and 290, note 56;
Roland Michel 1984a, pp. 94–95, 250, 277,
note 9; Rosenberg and Grasselli 1984,
pp. 83, 250, figs. 4a and 4b, p. 292, fig. 13,
pp. 295, 338, fig. 7, p. 340; Moureau 1984b,
pp. 523–24; Börsch-Supan 1985, p. 21,
no. 10, repr.; Zolotov 1985, pp. 103–04,
under no. 22, repr. (entry by V. Alexeyeva);
Eidelberg 1986, p. 104; Boerlin-Brodbeck
1987, p. 163, note 1; Grasselli 1987a,
pp. 65–67, note 21, pp. 70, 83, 138–39, 181,
no. 21, fig. 48; Grasselli 1993, p. 106, under
no. 4; Rosenberg and Prat 1996, I, no. 23

Notes
1. The two surviving panels from the Hôtel
de Nointel are discussed in Rosenberg and
Grasselli 1984, nos. P2 and P3.
2. Rosenberg and Grasselli 1984, no. P22.
3. Rosenberg and Grasselli 1984, no. P38.
4. Rosenberg and Prat 1996, I, no. 196.
5. Eidelberg 1970, fig. 30.

The dating of this celebrated drawing has long confounded scholars. All but one of the figures on the sheet reappear directly or with slight modifications in paintings by Watteau. The upper tier of figures, who wear the costumes of theatrical characters or mythological deities, seem to have been drawn from the artist's imagination, and have a slightly abstracted and pronounced Gillotesque flavor, as Parker and Mathey first observed. The two sketches of a seated young man seen from two angles on the lower tier are more incisively drawn and were probably studied from life. Watteau's differing responses to imaginative stimuli and the direct confrontation with the model would inevitably be expressed in distinctive modes of representation. The contrast between these modes is made all the sharper by the period of three or four years that separates the execution of the upper sketches and the lower: the pilgrim with a staff, on the upper left of the page, and Bacchus on the upper right, both reappear in modified form in the decorative paintings made for the Hôtel de Nointel,[1] and which probably date from around 1708, while the seated men were quite directly transplanted into the *Gathering near the Fountain of Neptune* (*L'Assemblée près de la fontaine de Neptune*; Madrid, Prado), an obviously more mature painting which is generally dated around 1712.[2] It was common practice for Watteau, a ceaseless notetaker, to go back and draw on sheets previously used.

The female figure in theatrical dress does not reappear in any of Watteau's known paintings, but the cavalier in profile who stands to the right of her seems to have provided the initial idea for the figure of Amor in *Love in the French Theater* (*L'Amour au théâtre français*; Berlin, Staatliche Museen, Gemäldegalerie).[3] That painting is certainly a work of the artist's maturity—perhaps of around 1715—and a more advanced red-chalk study for Amor in a private collection in Paris served as the working model for the painting.[4]

The Pierpont Morgan Library sheet was not engraved, but it must have been available to Quillard, who copied the seated boy on the left in a sheet of studies published by Eidelberg.[5]

3 Four Studies of Women, Alternately Standing and Seated

ca. 1710

Red chalk on cream paper

5½ × 8 in. (16.5 × 20.5 cm)

Indianapolis Museum of Art; The Clowes Fund (C10082)

Provenance Eugène Rodrigues, Paris (1853–1928; Lugt 897 at the lower right; Dr. George Henry Alexander Clowes (1877–1958), Indianapolis, in 1955

Literature Fraser 1973, pp. 158–59 (as "Circle of Watteau"); Rosenberg and Grasselli 1984, p. 253, fig. 2, p. 254; Grasselli 1987a, pp. 94–96, 117–18, no. 33, fig. 79; Rosenberg and Prat, I, no. 68

Notes

1. The other drawings are in the Musée Carnavalet, Paris (Rosenberg and Prat 1996, I, no. 104), the Ecole Nationale Supérieure des Beaux-Arts, Paris (Rosenberg and Prat 1996, I, no. 67), and in an unknown private collection (Rosenberg and Prat 1996, I, no. 58).

2. The Battle of Malplaquet, during which Watteau's friend and biographer Antoine de La Roque lost a leg, was fought near Valenciennes on September 11, 1709.

3. Inventory no. NM THC 4050.

4. See Bjurström 1982, no. 1292.

The second figure from the left, the seated woman with a *fontange* and long mantle, was employed as a study for the elegant woman in the military encampment in *The Halt* (*Alte*; Madrid, Thyssen-Bornemisza Collection). Watteau's painting was first recorded as being in Jullienne's collection in 1729, when it was engraved by Moyreau for the *Recueil Jullienne*; it was probably made during or just after Watteau's return visit to Valenciennes in 1709–10, a date confirmed by the style of the woman's costume. Three other drawings for the painting are also known, comprising a total of eight studies for the principal figures in *The Halt*, most of whom are resting soldiers[1]; these studies form a stylistically coherent grouping that was evidently executed over a very short period of time.

The Indianapolis studies of women (or, as is more likely, studies of a single woman seen in a variety of poses) carefully record rich, intricate folds of fabric and the effects of fractured light and shadow across heavy, billowing draperies. Although probably modeled in the studio, the sketches were inspired by the camp followers—wives, girlfriends, prostitutes—who accompanied the garrisons of soldiers from encampment to encampment, feeding them and ministering to their needs. Watteau would have encountered such women on his brief return trip to his hometown, which was just a few miles from the site of one of the bloodiest battles of the War of the Spanish Succession.[2]

A counterproof of the drawing, from which was cropped the seated figure reading a book on the right, is in the Nationalmuseum, Stockholm[3]; it was probably one of the collection of counterproofs acquired by Count Tessin directly from Watteau in June 1715.[4]

4 Studies of Two Soldiers

ca. 1710
Red chalk on cream paper
5 × 6 in. (12.3 × 15.3 cm)
Inscribed in pen, lower left: *Vateau*
Private collection

Provenance Sale of "cabinet de M.F.," Paris,
Hôtel Drouot, March 16, 1863, no. 127;
Jean Gigoux (1806–1894; without mark); his
sale, Paris, Hôtel Drouot, January 20–22,
1873, no. 293; Camille Groult (1837–1908);
his son, Pierre Bordeaux-Groult

Literature Goncourt 1875, under nos. 430
and 431; Parker and Mathey 1957, I,
no. 256, repr.; Cailleux 1959, n.p.; Cormack
1970, p. 12; Eckardt 1973, under no. 4,
repr.; Zolotov 1973, p. 131, under no. 1,
repr., p. 132 (entry by I. Kouznetsova);
Posner 1984, p. 33 and notes 37, 40, p. 279,
note 43; Roland Michel 1984a, pp. 167, 250;
Rosenberg and Grasselli 1984, p. 256, fig. 2;
Zolotov 1985, p. 103, under no. 21, repr.
(entry by I. Kouznetsova); Grasselli 1987a,
pp. 90–92, no. 31, fig. 70, Rosenberg and
Prat 1996, I, no. 66

Notes
1. For the painting, see Rosenberg and
Grasselli 1984, no. P6.
2. Rosenberg 1985, pp. 9 and 14.
3. Grasselli 1987a, p. 92.
4. Reproduced in Rosenberg and Prat 1996,
I, p. 104, figs. 66b and 66c.

Watteau employed both figures on this sheet in *The Bivouac* (*Camp volant*; Moscow,
Pushkin Museum). The painting was commissioned from the print dealer Pierre Sirois
and almost certainly executed at the beginning of 1710.[1] It is likely that the drawing was
one of several studies of camps and soldiers that Jullienne states Watteau made from life
during his brief return to his native Valenciennes in 1709–10.[2]

As Grasselli has noted, these sketches are drawn on a larger scale and with a greater
assurance than Watteau's earliest drawings.[3] The style is more angular than is found in an
exactly contemporary drawing such as the *Four Studies of Women* (cat. no. 3). Watteau also
abandons the doll-like facial types characteristic of his Gillotesque mode in favor of a
new level of naturalistic observation and psychological acuity: the reclining soldier resting
on his elbows eloquently conveys the fatigue and deadening monotony of army life.

Jean Audran made etchings of each of the two figures, which were published as plates 75
and 76 in *Les Figures de différents caractères*.[4] The drawing has been trimmed along the top
edge, on the left side, and on the right, where the traces of another study are apparent.

5 Bust of a Man in a Tricorn Hat, with a Panoramic Landscape

ca. 1715 and 1713–14
Red chalk on cream paper
4⅞ × 6⅝ in. (12.5 × 16.7 cm)
Inscribed in red chalk, at the upper right: *8*

Private collection, New York

Provenance A. Strölin; Alfred Strölin (1912–1974), Paris; Lausanne, private collection, sold, London, Christie's, 12 December 1978, no. 110, pl. 26

Literature Parker and Mathey 1957, II, no. 719, repr.; *The Watteau Society Bulletin,* 1984, no. 1, pp. 40, repr., 42; Rosenberg and Prat 1996, I, no. 205

This little-known sheet has never before been exhibited and cannot be connected with any known painting. Rosenberg and Prat have suggested that the number inscribed in the upper right corner of the drawing might indicate that it once constituted a page in a disassembled sketchbook; if so, no other pages of the *carnet* have been identified. The drawing is composed of two studies that may have been made at different times: Rosenberg and Prat have placed the summarily evoked landscape, with its smudged massing of trees and ornamental châteaux, around 1713 or 1714, and believe the bust of a man to have been sketched sometime shortly afterward. Even the tricorn hat, which perches somewhat precariously on the man's head, might have been added to the figure as an inspired afterthought. The soft, atmospheric handling of chalk gives the drawing a delicate, stylistic coherence, and the evocative juxtaposition of apparently unrelated images has the haunting eloquence of a dream.

6 Standing Woman Holding a Spindle

ca. 1713–14 and 1717–18
Two shades of red chalk on cream paper
6½ × 4¾ in. (16.4 × 12.2 cm)
The Metropolitan Museum of Art, New York; Bequest of Anne D. Thomson, 1923 (23.280.5)

Provenance Acquired between 1774 and 1781 by Horace Walpole (1717–1797); bequeathed to Anne Damer; Lord Waldegrave, great-nephew of Walpole; perhaps his sale, London, May 24–June 13, 1842, no. 1266/43–48; Graves; Charles Sackville Bale (1791–1880); his sale, London, June 9–14, 1881, no. 2502; John Postle Heseltine (1843–1929)

Exhibition Washington, Paris, and Berlin 1984–85, no. 30

Literature Goncourt 1875, under no. 470; Parker 1931, p. 19; Mathey 1940, pp. 155 and note 4, p. 156; Parker and Mathey 1957, I, no. 500, repr.; Nemilova 1964a, p. 106, fig. 53; Nemilova 1964b, pp. 89, fig. 7, p. 98, note 26; Eisler 1966, p. 174, fig. 12; Munhall 1968, p. 94, note 13; Zolotov 1973, under no. 4, repr. p. 135 (entry by I. Nemilova); Posner 1975b, pp. 279, 284, note 3; Eidelberg 1977, p. 130, note 49, pp. 161–64, fig. 161; Jean-Richard 1978, under no. 78; Roland Michel 1984a, pp. 135, 140, fig. 113, pp. 249, 277, note 31; Rosenberg and Grasselli 1984, pp. 89, 118, 164, 198, 319; Börsch-Supan 1985, no. 79, repr.; Stuffman 1985, pp. 79, 96, fig. 2; Zolotov 1985, p. 107, under nos. 32–35, repr. (entry by I. Nemilova); Bean and Turčić 1986, no. 330; Grasselli 1987a, pp. 193–94, 197, no. 123, fig. 195; Grasselli 1994b, p. 51; Rosenberg and Prat 1996, I, no. 226

Notes
1. Dacier and Vuaflart 1921–29, I, no. 123.
2. *Les Figures de différents caractères*, I, no. 103.

This remarkable sheet is a striking illustration of Watteau's practice of adding drawings to pages upon which he had previously sketched. The standing woman on the left served as a study for the lost painting *The Spinner* (*La Fileuse*), which was engraved by Benoît Audran for the *Recueil Jullienne*.[1] The drawing itself was etched in reverse by Boucher (who completed her face in the print and added a shadow beneath her figure) for the first volume of *Les Figures de différents caractères*.[2] It is a summarily sketched study of the model's pose and is elaborated only in the play of light and shadow on the richly striped folds of the countrywoman's apron. The style of the sketch permits a dating to around 1713 or 1714, and the rustic subject places it near the start of Watteau's interest in *figures populaires*.

To the right of the woman with the spindle is the monumental head of an elegant woman with downcast eyes. Not only is there no relationship of scale, subject, or mood between the two studies, but the profile is executed in an orangey-red chalk that is entirely different in hue from the brick-red chalk used in the spinner. The handling of the woman in profile is softer, more ample and atmospheric than the linear treatment of the standing woman, and the model herself is recognizable, as Grasselli has noted, from several other drawings that are generally dated to around 1716–17, including sheets in Boston (cat. no. 29) and Williamstown (cat. no. 34).

7 Seated Girl Holding a Distaff and Spinning

ca. 1713–14 and 1716–17

Red chalk on beige paper

6⅛ × 6½ in. (15.6 × 16.5 cm)

Inscribed in pen, gray ink, lower left: *Wattaux*

The Pierpont Morgan Library, New York; Gift of Mrs. Gertrude W. and Seth Dennis (1985.61)

Provenance Sir Frederick Wedmore (1844–1921), London; Mr. and Mrs. Seth Dennis, New York

Literature Wedmore 1894, p. 70, repr.; Parker and Mathey 1957, I, no. 501, repr.; Nemilova 1964a, pp. 103, 104, 108, fig. 56, 175, note 12; Nemilova 1964b, p. 91, fig. 9; Munhall 1968, p. 94, note 13; Zolotov 1973, p. 134, under no. 4, p. 135, repr. (entry by I. Nemilova); Posner 1975b, pp. 279, 284, note 3; Rosenberg and Grasselli 1984, pp. 318–19, fig. 4; Zolotov 1985, p. 107, under nos. 32–35, p. 106, repr. (entry by I. Nemilova); Gitaij 1992, p. 199, under no. 48, repr. p. 198; Grasselli 1994b, p. 51; Rosenberg and Prat 1996, I, no. 227

Notes

1. Fetti's painting is in the Musée du Louvre, Paris (inv. 280). See Rosenberg and Prat 1996, I, no. 351.
2. Dacier and Vuaflart 1921–29, III, no. 121; for the painting, see Rosenberg and Grasselli 1984, no. P31.
3. Hind 1923, no. 200.

The seated girl with a distaff and spindle is clearly the same model who posed for Watteau in the previous drawing (cat. no. 6), and it is probable that both these studies were drawn in a single session. The model's somewhat ungainly pose in the present sketch seems to have been based on a figure in a painting by Domenico Fetti, *The First Age: Eve Spinning and Adam Plowing*, which at the time was in the French royal collections (Watteau is known to have copied Fetti's works on several occasions).[1] The figure was employed in Watteau's playfully erotic painting of a shepherd who peeks up the skirts of a girl spinning wool; known as *Indiscreet* (*L'Indiscret*; fig. 80), the painting was engraved by Michel Aubert for the *Recueil Jullienne* and is today in the Museum Boymans-Van Beuningen, Rotterdam.[2] The idea for the painting and its general composition derive from a satirical etching by Rembrandt, *The Flute Player*.[3] The four large, unrelated studies of hands and arms that complete the page were not drawn in the same session as the spinner, but were probably added several years later, perhaps around the same time as *Woman Seated on the Ground, Seen from the Back, and Eleven Studies of Hands* (cat. no. 30) was made.

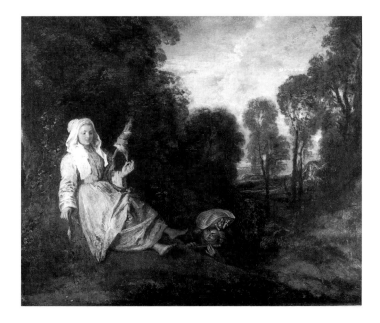

Figure 80. Antoine Watteau, *Indiscreet* (*L'Indiscret*), *ca.* 1714–15. Oil on canvas, 21¹¹⁄₁₆ × 26 in. (55 × 66 cm). Museum Boymans-Van Beuningen, Rotterdam

8 Standing Woman, and a Young Seated Boy Holding a Key

ca. 1713–14 and 1716
Red, black, and white chalks on cream paper
10 × 8½ in. (25.3 × 21.5 cm)

Private collection

Provenance Nathaniel Hone (1718–1784), London; perhaps his sale, London, Hutchins, February 7–14, 1785, part of no. 53 (sixth day); George John, 2nd Earl Spencer (1758–1834; Lugt 1530 at lower right); his sale, London, Phillips, June 10, 1811, no. 819 (1 guinea 11 shillings 6 pence); Edward Coxe; William Esdaile (1758–1837; Lugt 2617 at lower right); perhaps his sale, London, Christie's, June 18–25, 1840, no. 124; John Postle Heseltine (1843–1929)

Literature Parker and Mathey 1957, II, no. 714, repr.; Roland Michel 1984a, p. 133, fig. 101; Rosenberg and Grasselli 1984, p. 156; Goldner and Hendrix 1992, under no. 79; Rosenberg and Prat 1996, I, no. 228

Notes
1. Parker and Mathey 1957, II, under no. 714; Rosenberg and Grasselli 1984, p. 156; Goldner and Hendrix 1992, under no. 79; Rosenberg and Prat 1996, I, under no. 228.
2. See Rosenberg and Grasselli 1984; Goldner and Hendrix 1992; and Rosenberg and Prat 1996, I.

Neither of the studies on this sheet appears in any of Watteau's known paintings, though the fact that the boy holds a key in his left hand suggests that he, at least, was drawn with a particular composition in mind, as Rosenberg and Prat have observed. It is evident that the standing woman was drawn first, and that Watteau added the boy to the sheet at some later date, taking care to truncate the boy's right shoulder and arm so as not to overlap the previous sketch. Although both studies were executed in the same color of red chalk, the rapid, nervous hatching in the woman's dress and slightly pinched features of her summarily evoked face suggest a date of around 1713 or 1714 for her figure, while the looser and more atmospheric treatment of the boy's coat and the rich, partly stumped, application of black chalk in his face and hair indicate that the sketch of the boy was probably added sometime later—perhaps as much as two or three years. Certainly, his upturned face, with its look of alert compliance, eloquently demonstrates Watteau's mature mastery of the subtlest nuances of human expression.

As previous authors have noted, the same boy modeled for Watteau on a number of occasions, and he reappears in the drawing *Six Head Studies of a Woman and Two of a Boy* in the Louvre, Paris, and in *Two Studies of a Flutist and a Study of the Head of a Boy* (cat. no. 35), among others.[1] He is approximately the same age in all of these drawings, which are all generally dated around 1716–17.[2]

9 The Bower

ca. 1714

Red chalk on beige laid paper
15⅞ × 10⁹⁄₁₆ in. (40.2 × 26.8 cm)

National Gallery of Art, Washington, D.C.;
Ailsa Mellon Bruce Fund 1982 (1982.72.1)

Provenance Acquired before 1857, for 25
francs along with *The Temple of Diana*, by
Edmond (1822–1896) and Jules de Goncourt
(1830–1870; Lugt 1089 at the lower right;
recorded previously as "Gillot" in their sales
receipt, a notation crossed out and replaced
by "Watteau"); Goncourt sale, Paris, Hôtel
Drouot, February 15–17, 1897, no. 349
(3500 francs to Brenot for C. Groult);
Camille Groult (1837–1908); his son, Jean
Groult (1868–1951); his son, Pierre
Bordeaux-Groult

Exhibition Washington, Paris, and Berlin
1984–85, no. 70

Literature Goncourt 1875, p. 210; Fourcaud,
February 1909, p. 131, note 2; Deshairs 1913,
p. 292; Dacier and Vuaflart 1922, III, p. 16,
under no. 25; Parker 1930, p. 8, pl. 7; Parker
1931, p. 19; Huyghe and Adhémar 1950,
p. 204, under no. 25; Parker and Mathey
1957, I, no. 192, repr.; Mathey 1959b, p. 45;
Cormack 1970, pp. 9, 20, no. 7 and pl. 7
(Huquier's engraving); Zolotov 1971, facing
p. 54; Eidelberg 1984, pp. 158, 164, note 8,
repr.; Roland Michel 1984a, pp. 118, 128,
284; Rosenberg and Grasselli 1984, pp. 57,
60, 107, 140, 142, 144, 213; Börsch-Supan
1985, no. 56, repr.; Sutton 1985, p. 150 and
pl. I; Eidelberg 1986, p. 105; Grasselli 1987a,
pp. 303–04, 409–10, no. 186, fig. 376;
Opperman 1988, p. 359; Launay 1991,
no. 375, pl. 10 and fig. 31; Grasselli 1993,
p. 126, note 12; Opperman n.d., p. 50;
Rosenberg and Prat 1996, I, no. 224

Very few ornamental drawings have survived that can be securely attributed to Watteau, although he was an active painter of arabesques for some years, first under Gillot, then in the workshop of Claude III Audran. This and cat. no. 10 are recognized as the finest of the drawings that are known today. Both are conceptually complex and executed with such technical confidence that they are almost certainly the products of the artist's maturity. Paradoxically, it is not certain that any of the surviving decorative drawings by Watteau date from the earliest years of his career when such designs were his principal occupation. *The Bower* (*Le Berceau*) receives its title from the print by Gabriel Huquier published in the *Recueil Jullienne*; it is one of fifty-five ornamental designs by Watteau engraved by Huquier for Jullienne's compendium.[1] If the drawing ever served as the basis for a painted composition, it has been lost without trace.

In the distance of Watteau's composition, under a great flowering trellis, a faintly sketched bacchannal takes place; on either side of it and toward the foreground are two vividly described vignettes of nymphs and satyrs, one of which is reminiscent of Watteau's painting *Jupiter and Antiope* (Paris, Louvre), generally dated to around 1715.[2] Great swags of drapery hang from the corner *rinceaux,* giving shape to a central scallop while serving partially to clothe the nymph on the left; stone urns hidden in the reeds are overturned and release waters that create an organic continuation of the decorative scrolls above them. Every element—the arbor, the figures, garlands, and foliage—intertwine in a design overflowing with imagination and hectic with movement.

Grasselli recognized that Watteau produced his nearly symmetrical composition in the time-honored manner of a professional ornamentalist: he drew the scrolls, trellises, and drapery on the left side of his sheet, folded it vertically down the middle—the crease is still visible—and transferred a pale counterproof of his design to the right half of the page; he then strengthened the arabesque framework throughout, touching up both sides of the sheet before adding the figural groups, corner motifs, and hatching.[3]

A reworked counterproof of the drawing, with considerable strengthening and additional hatching, is in the Houthakker collection, Amsterdam.[4]

Notes
1. Dacier and Vuaflart 1921–29, III, no. 25; for an informative discussion of Huquier's prints after Watteau's ornamental designs, see Eidelberg 1984, pp. 157–64.
2. Rosenberg and Grasselli 1984, no. P36.
3. Rosenberg and Grasselli 1984, no. D70. It was standard practice for Watteau's teacher, Claude III Audran, to follow the same procedure when making an arabesque; see fig. 9, p. 20 for a drawing by Audran that was also folded and counterproofed. In engraving the composition, Huquier remained generally faithful to its design, but simplified and regularized it somewhat while clarifying its sketchier or more rudimentary sections.
4. Fuhring 1988, no. 52.

10 The Temple of Diana

ca. 1714
Red chalk on cream paper
10½ × 14¼ in. (26.7 × 36.2 cm)

The Pierpont Morgan Library, New York;
the Sunny Crawford von Bulow Fund, 1978
(1980.9)

Provenance Acquired before 1857, for 25
francs along with the Washington *Bower* by
Edmond (1822–1896) and Jules de Goncourt
(1830–1870; Lugt 1089 lower center);
Goncourt sale, Paris, Hôtel Drouot, February
15–17, 1897, no. 350 (2350 francs to Brenot
for C. Groult); Camille Groult (1837–1908);
his son, Jean Groult (1868–1951); his son,
Pierre Bordeaux-Groult; sale [Groult], Paris,
Palais d'Orsay, December 14, 1979, no. 11,
repr.

Exhibitions Washington, Paris, and Berlin
1984–85, no. 71; Paris and New York 1993,
no. 37; New York 1995–96, no. 2

Literature Goncourt 1875, under no, 279;
Fourcaud, February 1909, p. 131, note 2;
Deshairs 1913, p. 292; Dacier and Vuaflart
1922, III, p. 103, under no. 225; Réau 1928,
p. 55, no. 59; Parker 1931, p. 19; Brinckmann
1943, pl. 3; Parker and Mathey 1957, I,
no. 191, repr.; Mathey 1959b, p. 45; Cailleux
1967, p. 59, note 5; Eidelberg 1984,
pp. 158–59 fig. 3, p. 164, note 9; Posner 1984,
pp. 61, 91 pl. 11; Roland Michel 1984a,
pp. 128, 260–61, 284, pl. LII; Rosenberg and
Grasselli 1984, pp. 57, 107, 140; Börsch-Supan
1985, no. 57, repr.; Brookner 1985, p. 117;
Rosenberg 1985, p. 50, fig. 6; Sutton 1985,
p. 150; Grasselli 1987a, pp. 304–05, no. 185,
fig. 377; Roland Michel 1987a, p. 136,
fig. 145; Opperman 1988, p. 359; Launay
1991, no. 376, color pl. 11 and fig. 346;
Grasselli 1993, p. 126, note 12; Grasselli
1994b, p. 51; Rosenberg and Prat 1996, I,
no. 233

Notes
1. Dacier and Vuaflart 1921–29, III, nos. 225
and 224, respectively.

Drawn with a virtuosity to rival *The Bower* (cat. no. 9), *The Temple of Diana* offers two alternative arabesque designs integrated into a single composition. At the center of this airy drawing stands a statue of the goddess Diana under an arch, with some of her nymphs prostrate before it. On the left side of the sheet, the arch assumes the form of a garlanded trellis supported by caryatids and surmounted by a stag's head; on the right it becomes a rusticated stone vault bearing an amphora and tapering into a fountain. The left side offers a more complete landscape, with trees and hunting trophies, a pair of whippets and birds flying overhead; the right side is only very loosely indicated, with the suggestion of elegant figures in a *fête galante* and, possibly, a faun embracing a nymph.

The printmaker Gabriel Huquier, who was assigned the task of engraving the design for the *Recueil Jullienne*, was inspired to develop the drawing into two separate prints. In the first, based on the more complete left side of Watteau's sheet, and called *The Temple of Diana*, Huquier balanced Watteau's hunting dogs with a running stag of his own invention on the other side of the trellis. For the second engraving, he took the rusticated vault and the rest of the architectural framework from the less resolved right side of Watteau's drawing and—with considerable imagination—created a grotto that became *The Temple of Neptune*, to which he added the god of the sea.[1]

11 Two Recruits

ca. 1715
Red chalk on cream paper
6¼ × 6¹⁄₁₆ in. (16 × 15.5 cm)
Yale University Art Gallery, New Haven;
Everett V. Meeks, B.A. 1901, Fund
(1961.9.39)

Provenance Jean-Pierre Norblin de la
Gourdaine (1745–1830); Martin Norblin de
la Gourdaine (1781–1854); Baronne de
Conantré; her daughter, Baronne de Rublé;
her daughter, Mme de Witte; her daughter,
Marquise de Bryas (Orange). Paris, Galerie
Cailleux, in 1958

Exhibition Washington, Paris, and Berlin
1984–85, no. 37

Literature Goncourt 1875, under no. 619;
Cailleux 1959, pp. ii–vi, fig. 18; Mongan
1965, p. 45; Haverkamp-Begemann and
Logan 1970, no. 70; Rosenberg and Grasselli
1984, p. 90; Börsch-Supan 1985, no. 23,
repr.; Rosenberg and Prat 1996, I, no. 277

Notes
1. *Les Figures de différents caractères*, no. 242.

Neither of these studies—probably sketches of the same soldier in different poses—is found in any known painting by Watteau, although the soldier who kneels to adjust the buckle of his shoe was etched in reverse by Jean Audran for *Les Figures de différents caractères*.[1] We know that paintings of military subjects were among Watteau's first independent works, but it is evident from the stylistic sophistication of several of his military scenes that he continued to paint such subjects, at least sporadically, well into his maturity; a comparable development can be traced in his drawings of soldiers. The Yale sheet is among the most mature of these studies, and in it Watteau models his figures with an atmospheric shading that suggests they are bathed in the soft illumination of late afternoon. The treatment of form and light, as well as the subtle integrating of the figures into a single, unified space, displays a greater sophistication than is found in Watteau's stiffer and more discrete early studies of soldiers (see cat. no. 4) and suggests a dating of around 1715 for the Yale sketches. The sheet demonstrates Watteau's keen observation of even the smallest details of the recruit's costume: his beribboned hair and tricorn hat, buckled shoes, buttoned leggings, slung rifle, and belted sword and bayonet are all rendered with the same degree of care and affection that he normally reserved for the billowing silk *manteaux* of fashionable Parisiennes.

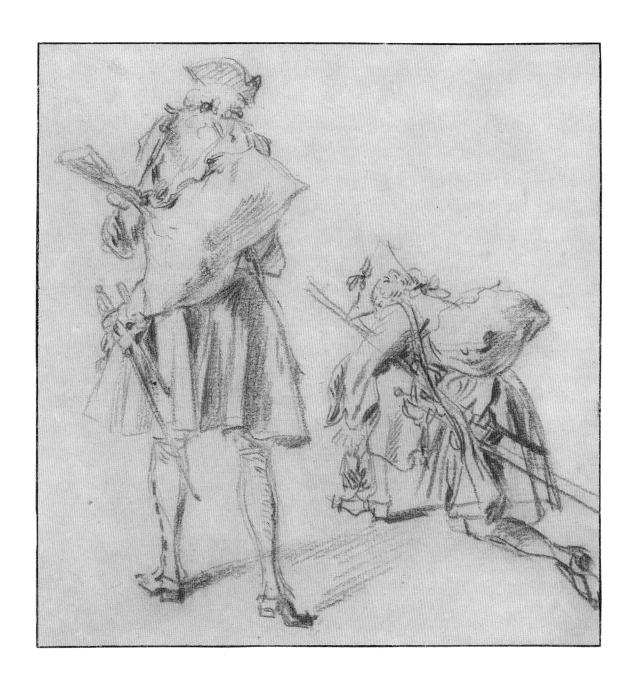

12 Study of Two Persian Diplomats

ca. 1715

Red, black, and white chalks on beige laid paper

11½ × 9½ in. (29.2 × 24.1 cm)

San Francisco Museum of Modern Art; Gift of Hélène Irwin Fagan TL1651.63 (35.1955)

Provenance Bourguignon de Fabregoules collection, Aix-en-Provence; sold with the entire collection around 1840 to Charles-Joseph-Barthélémi Giraud (1802–1882), Aix-en-Provence and Paris; given, with the rest of his collection, to the banker Flury Hérard (Lugt 1015 on the lower right with the no. *540* inscribed in brown ink), Paris; Marquis Philippe de Chennevières, Paris (1820–1899); Lugt 2072 or 2073 at the lower left; his sale, Paris, Hôtel Drouot, 4–7 April 1900, part of no. 521; Henri Michel-Lévy, Paris; his sale, Paris, Galerie Georges Petit, May 12–13, 1919, no. 137 (5000 francs to Helleu); Paul Helleu (1859–1927); Charles Templeton Crocker, San Francisco; Hélène Irwin Fagan, San Francisco

Exhibition Berkeley 1968, no. 21

Literature Parker 1931, p. 20; Parker and Mathey 1957, II, no. 797, repr.; Hattis 1977, no. 184; Sérullaz 1981, pp. 31–32, note 8; Roland Michel 1984a, p. 134; Grasselli 1987a, p. 170, no. 131, fig. 163; Grasselli 1987c, pp. 185, 194, note 13; Rosenberg and Prat 1996, I, no. 287

Notes

1. Rosenberg and Prat 1996, I, no. 281; see pp. 25–26 in the present book.
2. Rosenberg and Prat 1996, I, no. 286.

It has long been assumed that the arrival in Paris on February 7, 1715, of a Persian embassy to the court of Louis XIV gave Watteau the opportunity to sketch several of its members during their six-month stay in Paris; indeed, one of the nine extant drawings of Persians by Watteau bears an old inscription identifying the sitter as the Persian ambassador Mehemet Riza Bey.[1] However, it is not clear how Watteau would have had access to members of the embassy and no evidence survives to indicate that any of the Persians sat to the artist, though several of the drawings are clearly portraits. Is it possible that the much publicized arrival of the exotic ambassador and his colorful entourage inspired Watteau—who loved to dress his friends in fanciful costumes and draw them—to add Persian-style clothing to the costume trunk from which he dressed his models?

The present study is the largest of the group, and the only one drawn in three chalks—though the use of white chalk is, admittedly, very tentative. The relatively coherent style of the group suggests that they were all made within a short period of time, and the similarity of their bold red-and-black-chalk technique to that used in the Savoyard drawings (see cat. no. 14)—themselves dated with reasonable confidence to 1715—supports the view that the Persian studies also date from that year.

The principal study on the sheet is one of the most physically imposing of the group. Although essentially a costume study, it fully conveys the model's commanding presence and air of authority. The effect is achieved by emphasizing the model's bulk and by Watteau's use of sharp, rhythmic accents in his shoulder, arm, and powerful right hand; Watteau also lowered the vantage point from which he studied the model, thus allowing his stern-visaged subject to tower over us. It is likely that this sketch represents a rapid, full-length study of the same model drawn by Watteau in his celebrated three-quarter-length portrait drawing in the Louvre (fig. 14, p. 27).

The second, bust-length study on the sheet is of the same model who reappears full-length in another of the Persian drawings in the Fondation Custodia, Institut Néerlandais, Paris.[2] Little about his physiognomy appears "oriental," but he sports the identical fleece-lined hat worn by a mustached model in drawings in the Victoria and Albert Museum, London (fig. 81, p. 116), and the Morgan Library (cat. no. 13).

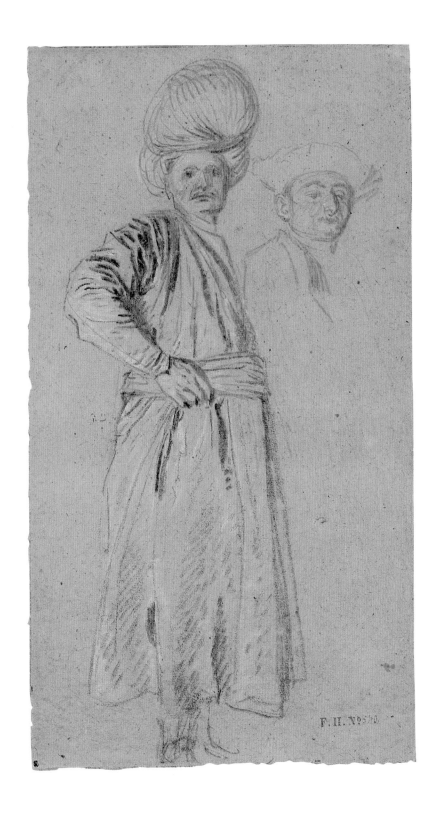

115

13 A Member of the Persian Embassy

ca. 1715
Red and black chalks on cream paper
12½ × 5¼ in. (29.3 × 14.6 cm)
Thaw Collection; The Pierpont Morgan
Library, New York

Provenance Claire-Amélie Masson née Falaize
(1795–1839; according to the inscription at
the back of the old mount); Mme Chauffard,
Paris, in 1939. Sold, Paris, Palais Galliéra,
December 7, 1971, no. 5, repr.

Exhibitions New York, Cleveland, Chicago,
and Ottawa 1975–76, no. 33; Washington,
Paris, and Berlin 1984–85, no. 48; Paris and
New York 1993–94, no. 36

Literature Goncourt 1875, under no. 351;
Mathey 1940, p. 159; Parker and Mathey
1957, II, no. 796, repr.; Jean-Richard 1978,
under no. 36; Sérullaz 1981, pp. 30–32, fig. 7
and note 9; Roland Michel 1984a,
pp. 133–34; Rosenberg and Grasselli 1984,
p. 114; Börsch-Supan 1985, no. 48, repr.;
Grasselli 1985, p. 44; Grasselli 1987c, pp.
185, 194, note 13; Roland Michel 1987b,
p. 124; Rosenberg and Prat 1996, I, no. 284;
Grasselli in Clark 1998, p. 168, under no. 34,
repr.; Roland Michel in Clark 1998, p. 61.

Notes
1. Rosenberg and Prat 1996, I, no. 284;
Roland Michel 1987b first observed that
both drawings are on identical paper of the
same height, and proposed that a single sheet
had been cut into two.
2. Rosenberg and Prat 1996, I, no. 285; see
also Grasselli 1998, cat. no. 34.

This drawing, and a sensitive portrait sketch in the Victoria and Albert Museum, London (fig. 81), represent the same slim, mustached young man in Persian dress, and may originally have formed a single sheet.[1] Both drawings were etched by Boucher for *Les Figures de différents caractères*, the present study appearing as plate 4 in the first volume, the London drawing as plate 215 in the second volume.

The drawing's technique is characteristic of most of the Persian studies and similar to the contemporaneous studies of Savoyards and other *figures populaires* (see cat. no. 14): it is essentially a complete and fluent drawing in red chalk with touches of black chalk added over the red to accent the hair, mustache, eyebrows, fur-lined cape and peaked hat. Here, Watteau seems most taken with his wide-eyed model's attenuated, almost feline grace, and he carefully manipulated the young man's elaborately striped costume to indicate his body beneath and the play of light across its rich surface.

A third drawing (fig. 82), of a standing figure seen from behind, depicts either the same model as in the present and Victoria and Albert drawings, or another in the identical costume; the three studies might well have been made in a single modeling session.[2]

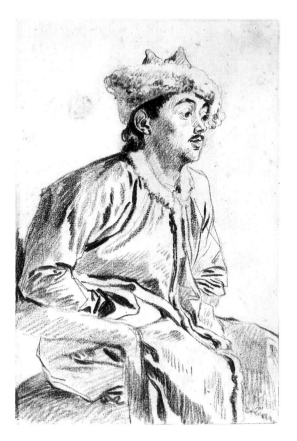

Figure 81
Antoine Watteau,
Seated Persian, ca. 1715.
Red and black chalks,
10¹¹⁄₁₂ × 7²⁄₃ in.
(27.6 × 19.4 cm).
Victoria and Albert Museum, London

Figure 82
Antoine Watteau,
Standing Man in Persian Costume Seen from Behind, ca. 1715.
Red chalk on cream antique laid paper,
12⅝ × 5¼ in. (32.1 × 13.3 cm).
Fogg Art Museum, Harvard University Arts Museums; Loan from the Collection of Jeffrey E. Horvitz

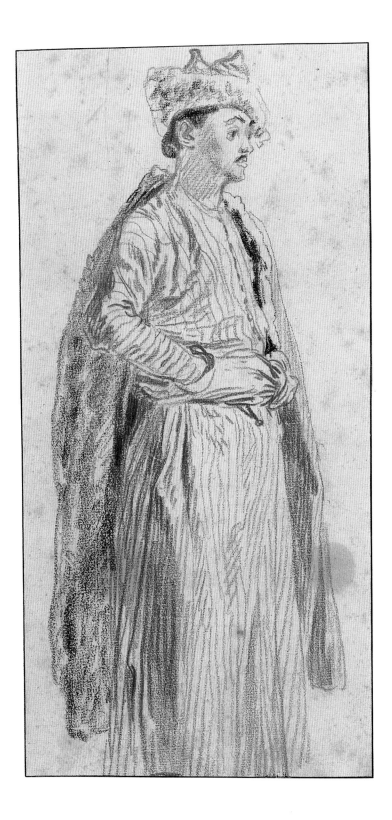

14 The Old Savoyard

ca. 1715
Red and black chalks, with stumping, gray and red wash on buff laid paper, laid down on cream wove card, laid down on cream board
14⅛ × 8¾ in. (35.9 × 22.1 cm)
The Art Institute of Chicago; Helen Regenstein Collection (1964.74)

Provenance Perhaps Jean de Jullienne (1686–1766); his sale, Paris, March 30–May 22, 1767, perhaps part of no. 769 (25 *livres 2 sols* with a pair). Mrs. A.L. Grimaldi and others sale, London, Sotheby's, February 25, 1948, no. 85, repr.; "G.W., London," in 1957; Mrs. Corina Kavanagh of Buenos Aires and others sale, London, Sotheby's, March 11, 1964, no. 220, repr.

Exhibitions Toronto, Ottawa, San Francisco, and New York 1972–73, no. 153; Chicago 1976, no. 30; Paris 1976, no. 1; Frankfurt 1977, no. 1; Washington, Paris, and Berlin 1984–85, no. 52

Literature Goncourt 1875, under no. 370; Parker and Mathey 1957, I, no. 492, repr.; Edwards 1966, pp. 8–14, fig. 1; Munhall 1968, p. 89, fig. 5, pp. 91, 94, note 13; Joachim 1974, no. 26; Posner 1975, p. 282, note 22; McCullagh 1976, p. 16; Jean-Richard 1978, under no. 42; Roland Michel 1984a, pp. 100, 135 color pl. XVII; *The Watteau Society Bulletin* 1984, no. 1, p. 42; Rosenberg and Grasselli 1984, pp. 59, 117–18, 120, 145; Börsch-Supan 1985, no. 54, repr.; Grasselli 1985, p. 44; Rosenberg 1985, pp. 51, 53, fig. 12; Grasselli 1987a, pp. 190, 231, 284, no. 119, fig. 190; Grasselli 1987b, p. 96, note 6; Grasselli 1987c, pp. 185, 186, figs. 7, 94, notes 14 and 17; Rosenberg and Prat 1996, I, no. 290; Roland Michel in Clark 1998, fig. 23.

In this monumental drawing of a humble subject, Watteau created one of his most powerful and enduring images. Dressed in rags, with a "curiosity box" on his back and a marmot box slung under his arm, Watteau's bearded old man was one of the thousands of rural laborers who, every desolate winter, left the mountain regions of their native Savoy to migrate to the large cities of France, Italy, and Germany, where they worked as chimney sweeps, knife-grinders, shoe-shine boys, or—like *The Old Savoyard*—street entertainers. In Paris, most lived in extreme poverty in their own communities, their primary concern being to send money back to their families; in the warm weather they returned home to tend their farms.[1]

More than a dozen drawings of Savoyards by Watteau have survived, and the old man in the present study is the subject of three of the others as well.[2] Although he is posed differently in each, he wears the same ragged clothes and carries the tools of his trade: the small wooden box with a trained marmot—some of the animal's straw litter can be seen sticking out from under the lid—and the large case that held a magic lantern, or peep-show of dioramic cutouts that were viewed through a series of lenses.[3]

Like Watteau's drawings of Persians, the Savoyard drawings reflect the artist's growing interest in naturalistic observation and in the close, sympathetic study of "exotic" types. Both series are executed principally in firm, bold strokes of sanguine vigorously accented in black chalk, and they can be presumed to date from around the same moment. Two external pieces of evidence seem to corroborate a dating of 1715 for the Savoyard series: a counterproof of the *Seated Savoyard* was acquired directly from Watteau by Count Tessin in June of that year[4]; and the original of the drawing, now in the Uffizi in Florence, was engraved by Edme Jeaurat for a print series not published until 1715.[5]

Although the Savoyard drawings are closely comparable to the Persian sketches in manner, several of them are executed in a somewhat more complex technique that indicates a further advancement in Watteau's development. The Rotterdam *Savoyard with a Curiosity Box* employs heavy stumping in both the red and black chalks, and both the Florence and Chicago sheets are partially worked in wash: in fact, *The Old Savoyard* is extensively stumped and touched with gray and sanguine washes to create a pictorial richness rarely surpassed in Watteau's drawings. The portrait of *The Old Savoyard* does not reappear in any of Watteau's paintings, but with its dense chalking and colored washes it occupies a status midway between drawing and painting, as Marianne Roland Michel has observed.[6] Several drawings in the series were etched for *Les Figures de différents caractères*, including the present sheet (reproduced as plate 20 by François Boucher).

Like the Le Nain brothers, Georges de La Tour, and, indeed, Rembrandt before him, Watteau has refused either to caricature or to sentimentalize his depiction of a peasant, who stands before us, dignified and with unvarnished humanity.

Notes

1. The most thorough discussion of the theme of Savoyards in art is found in Munhall 1968.

2. Rosenberg and Prat 1996, I, nos. 290–303. The old Savoyard is found in three drawings in addition to the present one, Rosenberg and Prat 1996, nos. 291, 292 and 293; he also appeared in a lost drawing known through Boucher's etching for the title page of the second volume of *Les Figures de différents caractères*, no. 133 (see Rosenberg and Prat 1996, III, no. G52).

3. Rosenberg and Prat 1996, I, no. 291; in a drawing in Rotterdam, he stands beside the opened *boite à curiosité* displaying its illusionistic scenes; for a discussion of *boites à curiosités*, see Munhall 1968, p. 91.

4. Bjurström 1982, no. 1300.

5. Rosenberg and Prat 1996, I, no. 292; on the publication and dating of the print series, *Les Figures françoises et comiques*, see Dacier and Vuaflart 1921–29, II, p. 74, and Grasselli 1987a, p. 202.

6. Roland Michel 1984a, p. 135.

15 Landscape, after Domenico Campagnola (?)

ca. 1715–16

Red chalk on cream laid paper

8¾ × 12 in. (22.3 × 30.4 cm)

The Fine Arts Museums of San Francisco; Achenbach Foundation for Graphic Arts Purchase (1975.2.14)

Provenance Martin Norblin de la Gourdaine (1781–1854); his sale, Paris, Hôtel Drouot, February 5, 1855, no. 257 (20 francs); E. Norblin; his sale, Paris, Hôtel Drouot, March 16–17, 1860, no. 161. Henri Leroux, Versailles, in 1957; his sale, Paris, Palais Galliéra, March 23, 1968, no. 22, repr. (33,000 francs); Paris, Galerie Cailleux (mark at the lower right, not cited by Lugt)

Exhibitions Bordeaux 1969, no. 154; San Francisco 1985, no. 49

Literature Goncourt 1875, p. 339; Parker and Mathey 1957, I, no. 436, repr.; Hattis 1977, no. 183; Roland Michel 1984a, pp. 104–05, 147, color pl. XIX; Grasselli 1985, p. 44; Cafritz 1988, p. 155, fig. 145, pp. 159, 178, note 54; Grasselli 1994b, p. 53; Eidelberg 1995, pp. 114, 134, note 34; Rosenberg and Prat 1996, I, no. 431.

Notes

1. Hattis 1977, p. 206, and J.R. Goldyne in Johnson and Goldyne 1985, p. 114, mention an engraving of 1517 by Giulio and Domenico Campagnola entitled *Shepherds in a Landscape* as a possible source for the San Francisco drawing, but, as Rosenberg and Prat (1996) have observed, under no. 431, the variations between the print and Watteau's drawing are considerable, and the connection seems generic to our eyes.

2. Mariette 1853–55, I, p. 294.

Although the Venetian original has not been found,[1] there is no reason to doubt that the present sheet is a copy of a lost drawing by Domenico or Giulio Campagnola, or another landscape draftsman in Titian's circle. The sheet displays Watteau's distinctive manner—which he seemed to confine to his copies of Renaissance landscape drawings—of reproducing their curving, rhythmic pen strokes with lighter but equally discrete notations in red chalk. This drawing in San Francisco is one of the most ambitious and beautifully preserved of the twenty or so such copies that have come down to us, although we know that Watteau made many more: Mariette mentioned that Watteau copied all of Domenico Campagnola's drawings in Pierre Crozat's collection, which numbered in excess of one hundred and twenty,[2] many of which had been brought to Paris by Crozat when he returned from Italy in April 1715. Surprisingly, not a single surviving Campagnola drawing copied by Watteau has been traced directly to Crozat's collection.

With its rhythmically swelling hillocks, decorative foliage, and ornamentally thatched farm buildings carefully arranged for maximum pictorial effect, the San Francisco sheet is among Watteau's most frankly artificial landscape drawings, and the closest in spirit to the pastoral groves of Giorgione, Titian, and their circles. Such Italianate reveries would provide the inspiration for the Arcadian settings of many of Watteau's *fêtes galantes*.

121

16 Landscape with Child Holding Lamb, after Domenico Campagnola

ca. 1715
Red chalk on cream paper
8 × 13⅛ in. (20.2 × 33.4 cm)

The Art Museum, Princeton University; Gift of Miss Margaret Mower for the Elsa Durand Mower Collection (1972.1)

Provenance Colghlan Briscoe (first half of the twentieth century; ancient mark Lugt 347c lower right, currently invisible, but visible in the Parker and Mathey reproduction); sale, London, Christie's, July 24, 1953, no. 85; Ludwig Burchard, London, in 1957; Colnaghi, London, in 1966; Seiferheld & Co., New York

Literature Parker and Mathey 1957, I, no. 428, repr.; Cailleux 1967, pp. 56–57; Cafritz 1988, fig. 143; Eidelberg 1995, pp. 115, 134, note 35; Rosenberg and Prat 1996, I, no. 345

Notes
1. For the Uffizi drawing, see Rosenberg and Pratt 1996, I, fig. 345a; a proof of Lefebvre's print is part of the folio *Paisages de Titian*, inv. 7620, p. 27, in the Institut Néerlandais, Fondation Lugt, Paris; it is reproduced in Rosenberg and Prat 1996, I, fig. 345b.

The source of Watteau's copy is a drawing now in the Museo degli Uffizi, Florence, which has been alternately attributed to Titian, the circle of Titian, and Domenico Campagnola, and which was engraved, in reverse, by Valentin Lefebvre in 1680–82.[1] It is not known whether the original sheet was in France during Watteau's lifetime, or if a copy of the drawing, now lost, might have been in Crozat's collection and therefore available to the artist. A third possibility, raised by Rosenberg and Prat, that Watteau could have copied Lefebvre's engraving and reversed the image, seems the least convincing explanation.

As was his usual practice in copying the Venetian landscapists, Watteau reproduced Campagnola's original pen and brown-ink composition in his preferred red chalk, thereby reducing its contrasts, softening its effect, and intensifying the atmospheric qualities in the process. The change of medium gives Watteau's copy a greater sense of pictorial unity than is found in Campagnola's original, and provides for a gentler and more fluid transition from one undulating plane into the next. It is worth observing that Watteau nevertheless reproduced Campagnola's composition with great exactitude: more accurately, in fact, than did the engraver Lefebvre.

17 Sheet of Studies: Four Faces and Three Figures, after Rubens's "Marie de Médicis" Cycle

ca. 1715
Red, black, and white chalks on tan paper
7⅝ × 9⅞ in. (19.5 × 25 cm)
Inscribed in pen, lower center: *Ant. Watteau*
Private collection, New York

Provenance Comte Nils Barck (1820–1896), who traded bronze antiques for drawings with Carl Gustav Tessin (1695–1770) and Louise-Ulrica of Sweden (see Lugt 1921, no. 1959). Count Adolphe-Narcisse Thibaudeau (1795–1856); his sale, Paris, April 20–25, 1857, no. 663. John Postle Heseltine (1843–1929; cat. 1900, no. 8; cat. 1913, no. 90, color repr.). Gentile di Giuseppe sale, Paris, Galerie Charpentier, April 5, 1938, no. 25, repr. (48,000 francs to N. Beets). Siegfried Kramarsky, New York, in 1957; W.H. Kramarsky in 1982

Exhibitions Providence 1975, no. 37; Frankfurt 1982, no. Cb12; New York 1988, no. 38

Literature Alfassa 1910, p. 14, note 2; Gillet 1921, p. 37; Réau 1928, p. 52, no. 5; Dacier and Vuaflart 1921–29, I, p. 27; Hérold 1931, pp. 44–45; Parker 1931, p. 24; Van Puyvelde 1943, p. 16; Parker and Mathey 1957, I, no. 266, repr.; Mathey 1967, p. 92; Zolotov 1971, p. 69, repr.; Zolotov 1973, p. 19, repr.; Roland Michel 1984a, pp. 29, fig. 13, 145, 231; Zolotov 1985, p. 19, repr.; Grasselli 1987a, pp. 75–76, no. 214, fig, 62; Grasselli 1994b, p. 52; Rosenberg and Prat 1996, I, no. 349

The figures on this sheet are all copied from paintings in Rubens's cycle *The Life of Marie de Médicis* (*ca.* 1622–24; Paris, Louvre), housed during Watteau's lifetime in the Luxembourg Palace, Paris. The trio of figures in red chalk, depicting the queen surrounded by a herald and a lady-in-waiting, reproduces a group in the sixth panel in the cycle, *The Disembarkation of Marie de Médicis* (fig. 84), and was almost certainly the first of the studies that Watteau drew on the page. The high, somewhat distant placement of these figures on the paper reflects their position in Rubens's painting, where they appear in the middle ground and are viewed from below. Watteau copied the poses and attitudes of these characters accurately, although he simplified the queen's costume by eliminating the patterning in her gown, and he chose to remove any trace of the personification of France who bows before the queen in the painting.

The four head studies in *trois crayons* were probably added at a somewhat later moment, and Watteau was careful when including them not to overlap his previous sketch. They all reproduce faces found in the vast tenth canvas of the cycle, *The Coronation of Marie de Médicis* (fig. 83). The female busts belong to two princesses in the queen's entourage, who assume prominent positions in the central foreground of the painting. Watteau repeats their spatial relationship in his drawing, though he barely indicates their crowns with a few strokes of black chalk, and he softens their gentle faces, drawing each with light-suffused, vaporous strokes. The bearded men are found in the background of the painting, seated in a raised gallery located directly above the women's heads. Watteau has switched the positions of the men, but, more interestingly, he has drawn their heads to the same scale as those of the princesses, although, in the painting, they appear much smaller.[1]

Caylus acknowledged that Watteau copied the old masters with an eye "to their possible usefulness," attending to the aspects of their work that were most in keeping with his own. In the present sheet of sketches, as in most of his copies, Watteau selected the faces, figures, and poses that might provide him with material for his own paintings, while ignoring Rubens's sprawling compositions that could offer him little guidance in the designing of his own intimate canvases.[3] Although none of the motifs on this sheet reappears exactly in any of Watteau's pictures, the queen's regal pose is reflected in any number of the artist's original drawings of standing women—themselves often posed wearing seventeenth-century costumes—which he made in preparation for the *fêtes galantes*.[4] Moreover, the contemplative heads of old men and elegant young woman are little different from those found in many of the *trois crayons* studies that Watteau drew from nature.

Figure 83
Peter Paul Rubens,
*The Coronation of Marie
de Médicis, ca.* 1622–24
Oil on canvas,
154 × 283⅝ in.
(394 × 727 cm).
Musée du Louvre, Paris

Figure 84
Peter Paul Rubens,
*The Disembarkation of
Marie de Médicis,
ca.* 1622–24
Oil on canvas,
154 × 115½ in.
(394 × 295 cm).
Musée du Louvre, Paris

Notes

1. As Rosenberg and Prat (1996, I) were the first to note. While it is not reproduced in this or any of Watteau's known copies after Rubens, the dog that lies in the foreground of the *Coronation* is meticulously transcribed—in reverse—in two of Watteau's most celebrated paintings, *The Music Party* (*Les Charmes de la vie*; London, Wallace Collection) and *Gersaint's Shopsign* (*L'Enseigne de Gersaint*; fig 2, p 14).
2. See Rosenberg and Camesasca 1970, no. 184, and Rosenberg and Grasselli 1984, no. P73, respectively.
3. A rare instance of Watteau copying a complete composition by Rubens is found in *The March of Silenus* in the National Gallery of Art, Washington, D.C. (Rosenberg and Grasselli 1984, no. 131; Rosenberg and Prat 1996, III, no. R838), although even here he has copied Rubens's painting *The Triumph of*

Silenus (London, National Gallery) freely, and with many variations. It is a curious, quite savage, but powerful drawing, of which the attribution to Watteau has been vigorously opposed by Eidelberg (1984) and, more recently, by Rosenberg and Prat, who reject it from their catalogue raisonné (1996). It is true that it is not easily compared to any of Watteau's known drawings, and that it bears strong similarities to the style of Antoine Coypel (as Rosenberg and Prat observed). Yet the drawing of ears, heavy accenting of lips, fingers, and eyes, and the pinched faces of several of the figures seem to our eyes the work of Watteau himself, and I concur with Grasselli (verbal opinion) and Roland Michel (1998) in maintaining it in the *corpus*.
4. For example, see Rosenberg and Prat 1996, I, nos. 123 and 220.

18 Henri IV Receiving the Portrait of Marie de Médicis, after Rubens

ca. 1713–14
Red-chalk counterproof on buff paper
5½ × 7⅜ in. (14.1 × 18.8 cm)
Private collection

Provenance Paris, Galerie Ratton-Ladrière in 1992

Literature Rosenberg and Prat 1996, I, no. 244

Notes
1. Other copies of the Luxembourg cycle by Watteau that appear to date from after his training with Audran include Rosenberg and Prat 1996, I, nos. 175, 349 (our cat. no. 17), and 352.
2. On Tessin's visit to Watteau, see Bjurström 1967, p. 103.

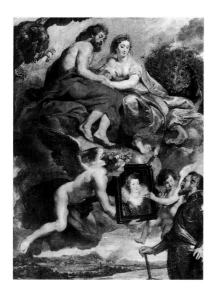

Figure 85. Peter Paul Rubens, *Henri IV Receiving the Portrait of Marie de Médicis* (detail). ca. 1622–24. Oil on canvas, 154 × 115½ in. (394 × 295 cm). Musée du Louvre, Paris

This little-known sheet was discovered in 1992 when it appeared on the Paris art market. It is a counterproof of a lost study by Watteau that copies the head of King Henri IV and the upper body of the angel beside him from Rubens's *Henri IV Receiving the Portrait of Marie de Médicis* (ca. 1622–24; Paris, Louvre). In Rubens's monumental canvas, which is the third painting in the series depicting episodes from the life of Marie de Médicis, the angel directs the king's attention to a portrait of his future queen (fig. 85). Watteau made numerous copies from Rubens's vast cycle, housed since 1625 in the Luxembourg Palace, Paris, always selecting individual figures or small groups to study, rather than copying Rubens's complete multifigural compositions. By focusing on small areas of the paintings, Watteau isolated witty vignettes and telling moments revelatory of the carefully observed human emotions present in Rubens's paintings, but which are easily overlooked amid their overblown Baroque stagecraft. Here, Watteau draws attention to the king's look of rapt wonder and poignant longing as he first gazes upon Marie de Médicis's image, and contrasts it wittily with the angel's satisfaction as he assesses the king's reaction.

Watteau had easy access to the Luxembourg Palace through Claude III Audran, who was curator of the palace, and there is every reason to assume that Watteau made copies of Rubens's cycle from the beginning of his training in Audran's shop. However, most of Watteau's extant copies display such a high level of accomplishment and easy virtuosity that they probably date from later in his career; the present drawing seems likely to have been made around 1713 or 1714.[1]

Watteau regularly counterproofed his drawings. A counterproof is made by applying a slightly wet piece of paper over an original chalk drawing and running the two sheets through a press: a mirror-image impression of the original results. Because red chalk is especially soft and friable, the principal reason for counterproofing was to fix the original drawing by removing excess chalk and thus prevent it from smearing. However, the exercise had the additional advantage of producing a replica of the image in reverse. Watteau kept his counterproofs and sometimes employed them as studies for paintings, occasionally reworking them in chalks or wash. As he was said to have kept his original drawings bound in books to be referred to when composing paintings, counterproofs might also have provided him with a painless way to satisfy collectors' demands for his drawings: he sold more than two dozen counterproofs to Count Tessin when the young collector visited his studio in June 1715.[2]

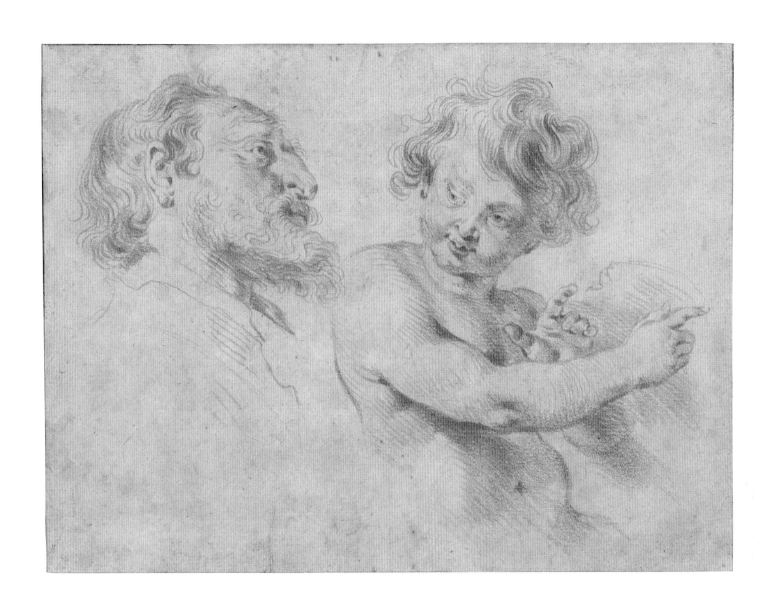

127

19 Six Studies of Men's Heads and One of a Donkey, after Veronese

ca. 1715
Red chalk on cream paper
9½ × 12⅜ in. (24.2 × 31.4 cm)
The Pierpont Morgan Library, New York
(I.276)

Provenance Nicolas Haym (1679–1729; Lugt 1970 on the lower right of the verso); John Spencer (1708–1746); George John, 2nd Earl Spencer (1758–1834; Lugt 1530 at lower right); his sale, London, Phillips, June 10, 1811, no. 828. Charles Fairfax Murry, London (1849–1914); acquired with the rest of his collection in 1910 by J. Pierpont Morgan (1837–1913)

Exhibitions Providence 1975, no. 40; Washington, Paris, and Berlin 1984–85, no. 132

Literature Parker 1931, p. 25 and note 4; Parker and Mathey 1957, I, no. 347, repr.; Rosenberg and Grasselli 1984, p. 216; Börsch-Supan 1985, no. 46, repr.; Grasselli 1987a, p. 246, no. 266, fig. 291; Moureau 1988, p. 450; Coutts 1994, p. 24, note 11; Eidelberg and Rowlands 1994, p. 224, repr. pp. 225, 272, note 110; Rosenberg and Prat 1996, II, no. 419; Rowlands 1996, pp. 206, 208, fig. 24d

Not only did Watteau favor a limited number of artists when copying, he was highly selective in the aspects of their works he chose to study and the manner in which he did so. He confined himself to copying the landscape drawings of Titian and Campagnola, but with Veronese—his other favorite Venetian Renaissance master—he seems to have been attracted almost exclusively to the artist's painted compositions.[1] As was his practise, he copied only individual figures or small figural groups isolated from Veronese's large, classically composed religious paintings and altarpieces.

The present sheet is one of more than a half dozen drawings by Watteau copied after paintings by Veronese.[2] The four male heads that run along the top of the page are all drawn from Veronese's *Christ and the Centurion* (fig. 86): the three studies at left reproduce the figures standing at the far right in the painting, while the fourth copies the head of the kneeling centurion; the other two heads and the head of the donkey derive from unknown sources. Three more studies from the painting are found on a similar sheet in the Musée du Louvre, Paris.[3] Veronese's painting, which belonged to Ferdinando Carlo Gonzaga, the last duke of Mantua, until his death in 1708, must have been in a Parisian collection by 1715, the approximate date when Watteau made his drawings, but its owner remains a mystery; it is possible that it was with a dealer when Watteau copied it.[4]

In this drawing, Watteau assembled his various sketches with the same sense of random elegance that he employed in his studies from life after about 1715; apparently he did not approach the making of sketches that were inspired by a painted model any differently from studies made from the live model, and these heads are rendered with lifelike plasticity. However, he did adopt a rather dry, measured red-chalk technique in this and the other copies after Veronese. As Grasselli has observed, Watteau's touch is, in general, "quite disguised by the rather calculated technique of these drawings," which are realized in "clearly divided patches of light and dark and a very studied, careful placement of each stroke."[5]

It is easy to understand why Watteau was attracted to the bright palette and dynamic organization of Veronese's multifigural scenes, which offered affinities to a number of his own *fêtes galantes*. In fact, a serving boy on the Louvre sheet whom Watteau also copied from *Christ and the*

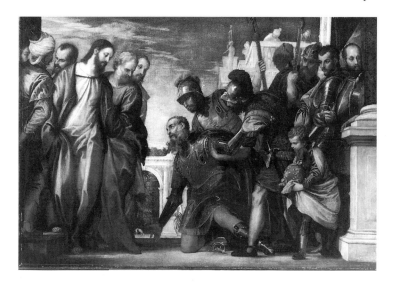

Figure 86. Paolo Veronese and workshop, *Christ and the Centurion, ca.* 1575. Oil on canvas, 55⅜ × 81⅛ in. (140.6 × 206.1 cm). The Nelson-Atkins Museum of Art, Kansas City, Missouri; Purchase Nelson Trust

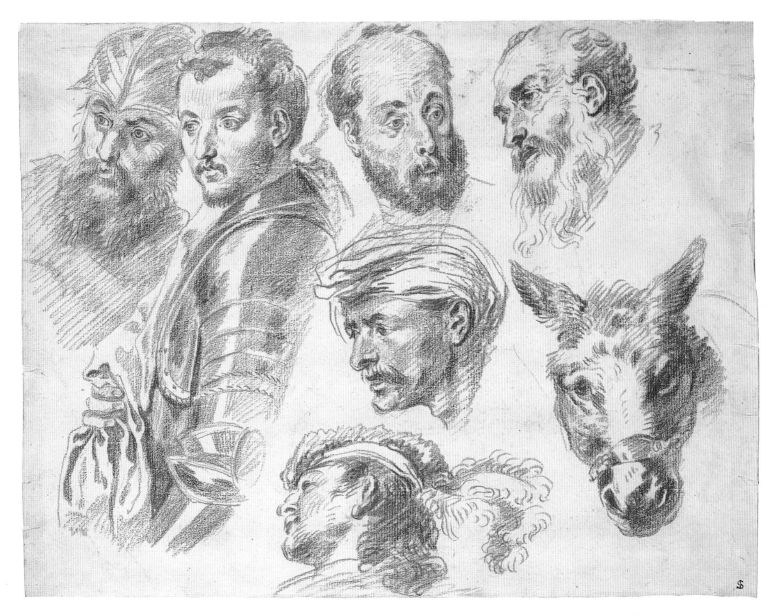

Notes

1. Only one drawing by Watteau made after a drawing attributed to Veronese is known; see Rosenberg and Prat 1996, I, no. 251.

2. The others are Rosenberg and Prat 1996, I, nos. 250, 354, 356, 359, and II, nos. 418 and 420.

3. Rosenberg and Prat 1996, II, no. 420.

4. Rowlands 1996, under cat. no. 24, p. 206.

5. Grasselli 1987a, I, p. 246.

6. Rosenberg and Prat 1996, II, no. 420.

Centurion was transplanted, in reverse, into his celebrated painting *Pleasures of the Dance* (*Les Plaisirs du bal*; London, Dulwich Picture Gallery), a work profoundly influenced by Veronese's great feast scenes.[6] But it is the acuity and variety of male expressions and poses that are Veronese's lesson here, so eloquently interpreted by his most receptive French pupil.

20 Standing Male Figure and Study of a Head

ca. 1715

Red, black, and white chalks on tan antique laid paper

10⅝ × 8¼ in. (27 × 21.1 cm)

Fogg Art Museum, Harvard University Art Museums; Bequest of Frances L. Hofer (1979.52)

Provenance Paignon-Dijonval (1708–1792); Andrew James (died before 1857); his daughter, Sarah Ann James, London; her sale, London, Christie's, June 22–23, 1891, no. 294 (20 guineas to A. Tooth); Camille Groult (1837–1908); his son, Jean Groult (1868–1951); his son, Pierre Bordeaux-Groult; sale Paris, Palais Galliéra, April 11, 1962, no. 40, pl. XXIX; Robert M. Light, Boston; acquired from him by Philip Hofer, in 1973 (?)

Exhibition Tampa and Cambridge 1984, no. 27

Literature Goncourt 1875, p. 351, no. 7; Parker and Mathey 1957, II, no. 650, repr.; Roland Michel 1984a, pp. 97, 100, fig. 65; Rosenberg and Grasselli 1984, p. 147, fig. 2, 150; Grasselli 1987a, pp. 198, 277–78, no. 139, fig. 206; Grasselli 1987c, pp. 186, 188, fig. 10, p. 194, note 20; Rosenberg and Prat 1996, II, no. 404

Notes

1. Grasselli 1987b, pp. 185–86.
2. Grasselli 1987a, p. 278.
3. It is interesting to compare the Fogg sheet to another, superficially similar drawing, *A Standing Woman, and a Young Seated Boy Holding a Key* (cat. no. 8) in which the study of the boy's head—with its free and confident use of black and white chalks—was evidently added later to a sheet already bearing a red-and-white chalk sketch of a standing woman from a less advanced moment in the artist's development.
4. Roland Michel 1984a, p. 100.

This sheet, with two studies of a man in a high hat, seems to be an early experiment by Watteau in the *trois crayons* technique that he would shortly thereafter master with apparent effortlessness. On the right, Watteau quickly sketched, in red and white chalks, the full, standing figure of a man wearing the costume of a stage doctor from the *commedia dell'arte*, with a seventeenth-century ruff, tall hat, and cape; his face is summarily indicated, but a few strokes of red chalk convey the impression of an older man with sly, squinting eyes and a sour, downward turn to the mouth. To the left, Watteau has made a larger, detailed study of the head of the model, who wears the same hat and ruff, but now his face is younger and more handsome: his expression is sweet, rendered more meticulously but no less vividly as he seems on the point of smiling. Although conceived in red and white chalks, Watteau has tentatively added a few touches of black chalk to the head study to give it greater life, reinforcing the model's eyebrows and eyes, deepening shadows around the head, and gently suggesting traces of beard. It was in such separate head studies as this that Watteau seems to have introduced the *trois crayons* technique into his drawings (see cat. no. 17).[1]

The style of the present studies suggests that they were made not long after the Persian and Savoyard drawings, that is, around 1715. Grasselli has observed that the long, broad strokes of red chalk and simple division of two and three chalk studies on the same page—as found in the Fogg sheet—characterize the forthright technique of a number of Watteau's drawings that seem to date from this period.[2] Certainly both the head and figure studies were made in the same session, as the handling of each is identical.[3]

This drawing was not translated into any of Watteau's surviving works and nothing is known of its source of inspiration; however, it exudes a kind of quality, as Marianne Roland Michel has noted, which makes one think that Watteau drew a friend in theatrical costume, perhaps a real actor.[4]

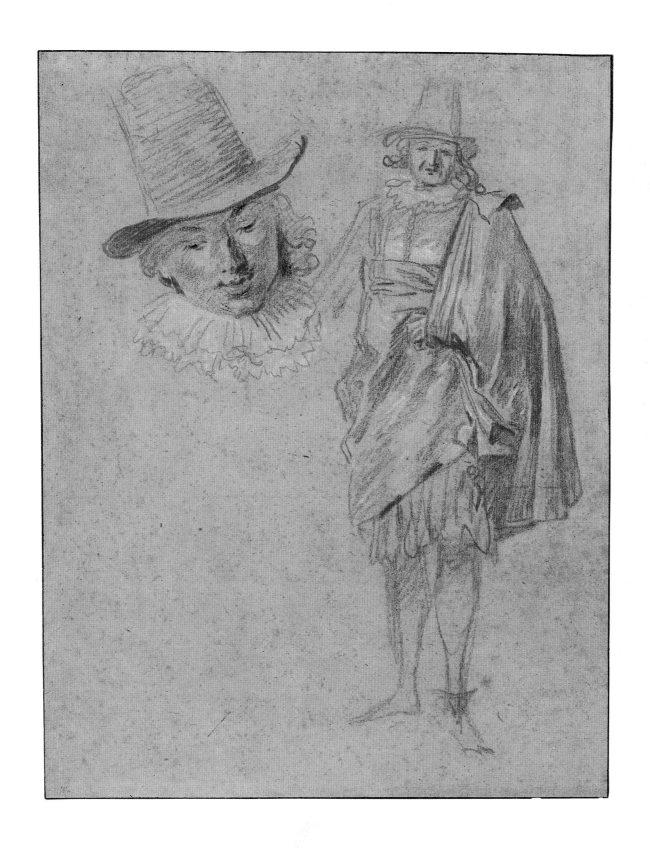

21 Six Studies of Heads

ca. 1715
Black, red, and white chalks on tan antique laid paper
8¾ × 8½ in. (22.2 × 21.7 cm)

Fogg Art Museum, Harvard University Art Museums; Bequest of Meta and Paul J. Sachs (1965.336)

Provenance Lord Ivor Spencer-Churchill (1898–1956); Durlacher Brothers, London

Exhibitions Providence 1975, no. 43; Washington, Paris, and Berlin 1984–85, no. 21

Literature Parker 1931, p. 48, no. 86, p. 86; Huyghe and Adhémar 1950, under no. 208; Parker and Mathey 1957, II, no. 712, repr.; Mongan 1966, p. 161 and note 1; Posner 1984, pp. 245, 289, note 37; Rosenberg and Grasselli 1984, pp. 91–92, 446–47, fig. 4 (detail); Eidelberg 1986, p. 105; Grasselli 1987a, pp. 182, 184, 186, 395–96, no. 99, fig. 181; Grasselli 1987c, pp. 183–84, fig. 4, p. 29, note 9; Opperman, n.d., p. 50; Rosenberg and Prat 1996, II, no. 413; Roland Michel in Clark 1998, p. 53, fig. 1

Notes
1. Rosenberg and Prat 1996, II, no. 414.
2. Rosenberg and Grasselli 1984, no. P72; Thornton 1965, pp. 107 and 168, first recognized that the striped dress worn by Iris in the painting was made of silk produced in England in 1718, providing solid evidence to support the late dating that had traditionally been assigned to the painting.

Among the greatest of the artist's drawings in North America, the *Six Studies of Heads* in the Fogg Art Museum is probably a relatively early example of Watteau's characteristic *trois crayons* technique. He was still thinking essentially in one color, and drew his studies of the woman's head entirely in red chalk, returning to them only afterward to reinforce with black accents what had already been drawn, and to overlay—with unmatched delicacy—crisscrossing strokes of white heightening to the areas left blank in the initial red-chalk drawing. Watteau employed his black chalk most extensively in the coiffure of the woman at lower right, but it is in the sketch directly above—the exquisite profile study—that his mastery is in greatest evidence. By gently modulating the pressure applied to parallel strokes of red and white chalk, he modeled his sitter's flesh, recreating the subtlest effects of light and shadow as they cross her cheek, define the shape of her jaw, and model her neck and collar bone.

The same model appears in *Five Studies of a Woman's Head* in the Louvre, a drawing almost identical to the Fogg sheet in technique and handling, and almost certainly made around the same time.[1] Both drawings would appear to be cautiously calibrated—if exceptionally suave—experiments in *trois crayons* life studies made when the artist was still exploring the possibilities of his media, and therefore presumably date from around 1715. Curiously, while none of the studies of the female model in the Fogg sheet appears in any of Watteau's paintings, the two sketches of the child—a small boy?—were used as studies for *Iris; or The Dance* (*La Danse*; Berlin, Staatliche Museen, Gemäldegalerie), a late painting made when Watteau was in London in 1719–20.[2] While Watteau's unorthodox method of composing paintings confirms that there was nothing exceptional in his having turned to a study made years earlier when preparing a new work, it might be that the studies of the child used in *Iris; or The Dance* were themselves added to the Fogg sheet a little after the female studies, as Rosenberg and Prat have suggested. In fact, the studies of the child reveal a somewhat looser and more supple application of chalks and an easier integration of colors, which might support the argument that they were drawn at a subsequent time, though still several years before they found their way into paint.

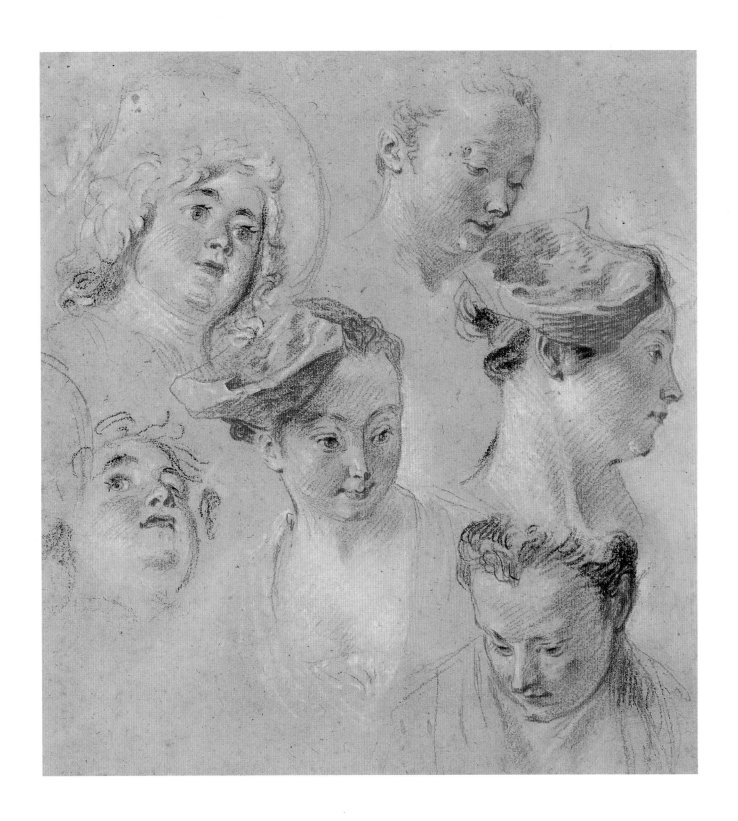

133

22 Five Studies of Children

ca. 1716
Red chalk on cream paper
8¼ × 14 in. (21 × 33.5 cm)
Private collection

Provenance Camille Groult (1837–1908); his
son, Jean Groult (1868–1951); his son, Pierre
Bordeaux-Groult; Wildenstein & Co., New
York

Literature Goncourt 1875, under no. 545;
Mathey 1940, p. 160; Parker and Mathey
1957, II, no. 691, repr.; Cormack 1970,
p. 34, under no. 78; Rosenberg and Grasselli
1984, p. 215; Grasselli 1987a, pp. 237,
239–40, 246, 302, no. 173, fig. 276;
Ingamells 1989, p. 357; Vivian 1989, under
no. 2; Rosenberg and Prat 1996, II, no. 440

Notes
1. Ricci's drawing is catalogued in Blunt and
Croft-Murray 1957, no. 351, and in Vivian
1989, no. 2.
2. See Grasselli 1987a, pp. 236–40; for a
summary of Ricci's career in England and
journey through France, see Daniels 1976,
pp. xiv–xv.
3. Blunt and Croft-Murray 1957, nos.
352–54.
4. No. 168.
5. See Ingamells 1989, cat. no. P389.

This deservedly admired sheet—bearing several of Watteau's most charming and well-observed studies of children—has never before been publicly exhibited. It establishes a significant marker in the chronology of the artist's drawings because it was reproduced by Sebastiano Ricci—in a copy now in the Royal Library at Windsor Castle (fig. 87)—when the Venetian artist passed through Paris towards the end of 1716.[1] Although the precise dates of Ricci's trip are not known, he was visiting the city on his way back to Venice from England, where he had worked since 1711, and in a letter from Pierre Crozat to Rosalba Carriera dated December 22, 1716, the collector mentions having just taken him to see Watteau. Since Ricci is recorded as once again in Venice by March 20, 1717, his copy provides a *terminus ante quem* for Watteau's original.[2]

Watteau's captivating drawing contains five studies of what appear to be two different children: the left and right sketches on the upper rung are of the same young girl resting her folded arms on a tabletop; the child in the center—perhaps a small boy—reappears at bottom left without his hat, and probably in the final sketch as well, though his hair is parted differently and his costume is left undefined. Clearly the studies were all drawn in a single sitting. The handling of the brick-red chalk is exceptionally robust with bold contrasts of light and shade, each face emerging from the strongly directed illumination with glimmering brilliance and modeled with deep shadow.

It seems likely that when Crozat and Ricci paid him a call, Watteau would have shown his patron and the visiting artist his most recent works. The present drawing displays a new degree of confidence not only in the self-assured handling of each sketch, but in the easy physical and psychological rapport among the studies, eloquently expressed in their rhythmic placement across the page. In copying the sheet, Ricci reproduced each head with great fidelity, but he completely altered the *mise-en-page*, an act that supports our view (see pp. 32–33) that Watteau's contemporaries regarded such sheets of multiple head studies not as single compositions, but as pages bearing numerous individual drawings, with each study accorded autonomous status.

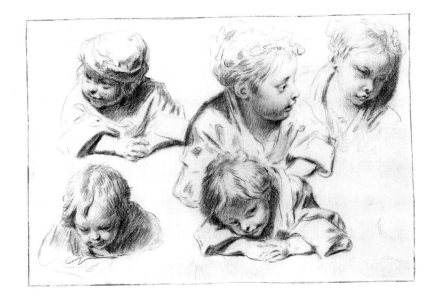

Figure 87. Sebastiano Ricci, after Watteau, *Five Studies of Children*. Red and black chalks, 7¾ × 11⅝ in. (19.6 × 29.5 cm). The Collection of Her Majesty Queen Elizabeth II

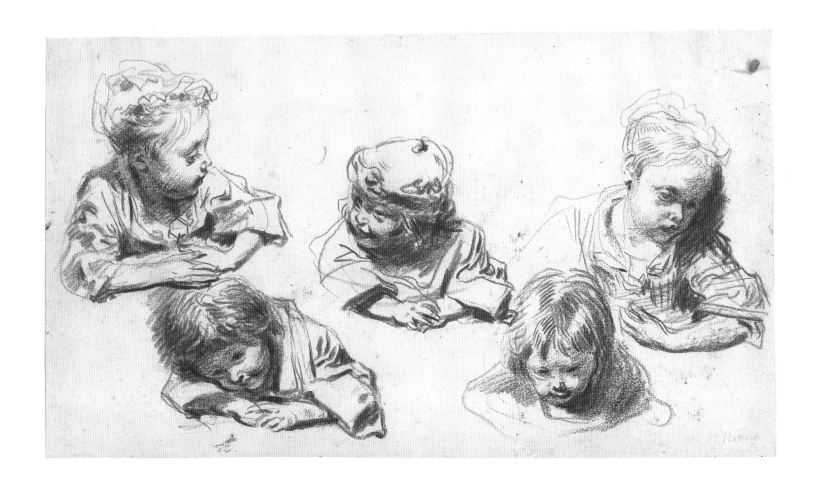

Three other copies of Watteau drawings by Ricci have been identified, and all reproduce studies of children; they entered the English Royal Collection by way of Consul Smith.[3] The boy resting his head on his arm on the lower left of the present drawing was etched in the same direction for *Les Figures de différents caractères* by P.C. Tremolières, proof that the original remained in Paris after Ricci had copied it.[4] The amusing central sketch of the smiling little boy in a cap was employed as a study for Watteau's *Les Champs-Elysées* (London, Wallace Collection), generally dated to about 1716–17 or later.[5]

23 Two Heads of Men, and an Arm and Three Hands, One Holding a Mask

ca. 1716–17
Red, black, and white chalks on buff paper
8¾ × 9¾ in. (22.2 × 24.7 cm)

Private collection

Provenance Camille Groult (1837–1908); his son, Jean Groult (1868–1951); his son, Pierre Bordeaux-Groult; sale, Paris, Palais Galliéra, March 30, 1963, no. 18, pl. V; Florence J. Gould (1895–1983), Cannes; sale of her estate, New York, Sotheby's, April 24, 1985, no. 5, color repr.

Exhibition London 1954–55, no. 266

Literature Parker and Mathey 1957, II, no. 746, repr.; Nemilova 1964a, p. 87, fig. 36; Mathey 1967, pp. 92–93, fig. 5 (detail); Nemilova 1970, pp. 150, repr., 157, note 21; Zolotov 1973, p. 139, under no. 6, repr. (entry by I. Nemilova); Nordenfalk 1979, pp. 114–15, fig. 8, p. 137, note 25; Roland Michel 1984a, p. 137; Rosenberg and Grasselli 1984, pp. 153, 287, fig. 1 (detail), pp. 382–83, fig. 6; *The Watteau Society Bulletin* 1984, no. 1, p. 43; Zolotov 1985, pp. 98–99, under nos. 8–11, repr. p. 100 (entry by I. Nemilova); Rosenberg 1987, p. 105 and note 8; Grasselli 1994b, p. 56; Rosenberg and Prat 1996, II, no. 456

Notes
1. See Rosenberg and Grasselli 1984, no. P55.
2. Dacier and Vuaflart 1921–29, III, no. 72.
3. Dacier and Vuaflart 1921–29, III, no. 174.
4. See Rosenberg and Grasselli 1984, no. P19.
5. See Rosenberg and Prat 1996, II, nos. 461, 475, 484 and 609.
6. Nordenfalk 1979, p. 137, note 25.
7. Rosenberg and Prat 1996, II, no. 457, p. 756.
8. For example, the faint shadow of a female nude lightly drawn in red chalk—handled in the same way as the present sheet—is found in a sheet in the British Museum, London, to the left of a more finished, three-quarter-length portrait of a clergyman in *trois crayons* (BM inv. 1886–6–9–39), Rosenberg and Prat 1996, II, no. 657.

Watteau employed these haunting figure studies in several of his paintings. The most finished of the heads, on the upper left, was incorporated into *The Love Lesson* (*Leçon d'amour*; Stockholm, Nationalmuseum),[1] as was the hand turning a musical score. The same head was also used in the now lost *Concert champêtre*, known today from an engraving by Benoît Audran for the *Recueil Jullienne*.[2] The lower head was preparatory to the figure of the guitarist in *The Rendezvous* (*Le Rendez-vous*; private collection, New York).[3] Finally, the hand holding a mask appears in *The Enchanter* (*L'Enchanteur*; National Trust, Brodick Castle, Isle of Arran, Scotland).[4] It is reasonable to date all of these paintings to around 1716–17, and this is also the probable date of the present drawing.

The same model undoubtedly sat for both head studies and was a favorite of Watteau's at this period: he posed for the drawing of the *Seated Guitarist* (fig. 18, p. 30), which was transposed without modification into the painting *The Guitarist* (*Le Donneur de sérénade*; fig. 19, p. 30) in the Musée Condé, Chantilly, as well as for a handful of other drawings.[5]

Before executing these evanescent sketches in *trois crayons*, Watteau faintly outlined in graphite the form of a young woman seen from the back, holding a guitar. Nordenfalk believed the figure to be preparatory to the guitar player in the painting *The Music Party* (*Les Charmes de la vie*; London, Wallace Collection).[6] Rosenberg and Prat regard the sketch as too slight and maladroit to be by Watteau himself, and suggest that it could have been added in the nineteenth century by Camille Groult (1837–1908), who is reputed to have "enriched" by his own hand several of the many drawings by Watteau in his collection.[7] However, the pencil sketch seems entirely characteristic of a *première pensée*, which Watteau then abandoned without further development; such schematic initial ideas, quickly rejected, can be found on other sheets by the artist.[8]

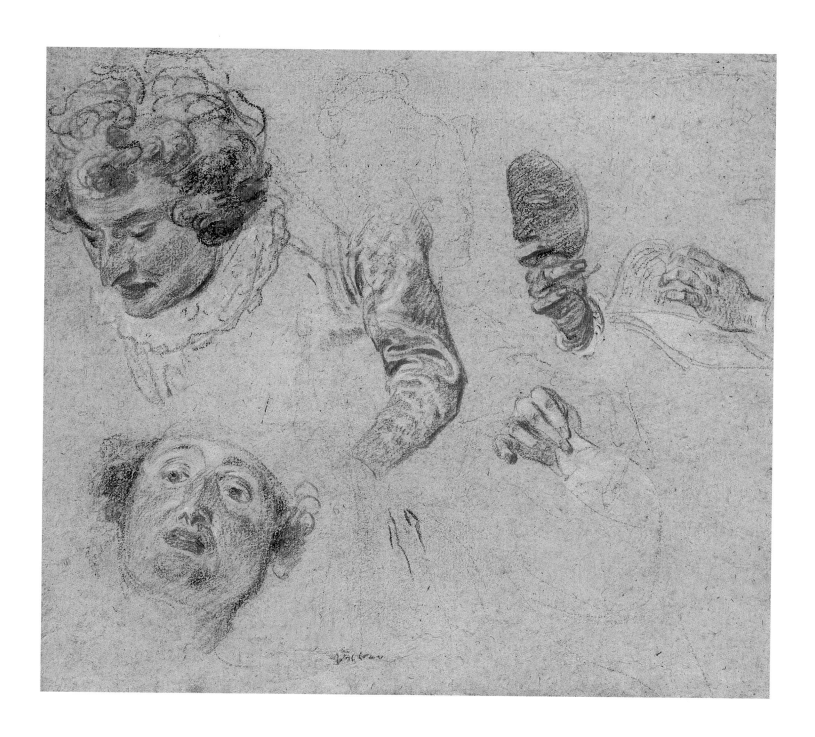

24 The Remedy

ca. 1716–17
Red, black, and white chalks on buff paper
9¼ × 14⅝ in. (23.4 × 37 cm)
The J. Paul Getty Museum, Los Angeles
(86.GB.594)

Provenance Frédéric Villot (1809–1875), Paris;
his sale, Hôtel Drouot, May 16–18, 1859,
no. 184 (unsold); F. Villot sale, Paris, Hôtel
Drouot, December 6, 1875, no. 46;
Alexandre Dumas *fils* (1824–1895); Antoine
Vollon (1833–1900); Camille Groult
(1837–1908); his son, Jean Groult
(1868–1951); his son, Pierre Bordeaux-
Groult; New York; John R. Gaines,
Lexington (Kentucky)

Exhibition Washington, Paris, and Berlin
1984–85, no. 88

Literature Cellier 1897, p. 91, no. 14; Mathey
1937, p. 39; Mathey 1938, pp. 372–73, fig. 3;
Mathey 1948, p. 48; Huyghe and Adhémar
1950, p. 54, note 20; Parker and Mathey
1957, II, no. 865, repr.; Mathey 1959b,
pp. 49, 79, no. 126; Rubin 1968–69, p. 64,
note 37; Cormack 1970, p. 41, no. 114 and
pl. 114; Posner 1972, pp. 385–88, note 5 and
fig. 2; Posner 1973, p. 35, fig. 13,
pp. 99–100, notes 35 and 40; Eidelberg 1977,
pp. vi, 38; Posner 1984a, p. 102, fig. 80,
p. 105; Roland Michel 1984, p. 135;
Rosenberg and Grasselli 1984, pp. 60, 174,

The most overtly erotic of all Watteau's surviving works, *The Remedy* remains a startlingly candid and voluptuous image. Reclining on a loosely made bed, a young naked woman turns and awaits the enema that her maid is about to administer. The theme derives from a tradition in Netherlandish art dating back to the early seventeenth century, and Watteau could have been familiar with it from any number of examples, from anonymous, pornographic engravings, to more mildly licentious prints by Abraham Bosse and paintings by Jan Steen.[1] The salacious subtext that attached to depictions of the administration of an enema—a common curative in the seventeenth and eighteenth centuries and prescribed for a range of ailments—is demonstrated in the verse appended to a print of the subject by Bosse published in 1633. As the apothecary approaches the bedside of his female patient, armed with his metaphorically potent clyster, he says, "I have the syringe ready; so be quick, Madame, to make the best of this libation. It will refresh you, for you are all afire, and the tool that I have will enter gently."[2] The nature of the patient's malady, and the remedy that will cure it, are thus made abundantly clear.

Although the subject itself was not new, Watteau brought to it an undisguised carnality absent from all but the most shameless earlier renderings of the theme, and he did so with unequaled artistry and technical mastery. Of the nude studies that have survived, *The Remedy* is Watteau's most delicately drawn and suavely finished, in which the artist took evident delight in reproducing the undulating curves, supple flesh, and roseate skin of his model. Watteau created a profound study of female sensuality and his model's frank, physical display evokes, as Donald Posner has observed, the unashamed nudity of a pagan goddess.[3]

Watteau rarely made compositional studies, and this one is unusually complete. It may have served as the preparatory drawing for a small and very beautiful panel painting of the same reclining woman in the Norton Simon Museum, Pasadena (fig. 88), although the panel was at some point cut at the bend in her knees. Technical examination of the painting does not reveal any remnants of the clyster or servant and it has not been possible to determine whether the fragmentary painting originally reproduced the composition of the drawing in its entirety.[4] We do know that on his deathbed Watteau insisted that any works of his that might be considered lewd should be destroyed.

Figure 88. Antoine Watteau, *Reclining Nude*, ca. 1716–17. Oil on panel, 5½ × 6¾ in. (14 × 17.1 cm) painted surface, 6 × 6⅞ in. (15.2 × 17.5 cm) panel. The Norton Simon Foundation, Pasadena, California

333–34 fig. 4; Börsch-Supan 1985, no. 99, repr.; Grasselli 1987a, pp. 316–17, 419, no. 201, fig. 389; Goldner and Hendrix 1992, no. 80; Grasselli 1994b, p. 54; Rosenberg and Prat 1996, II, no. 486

Notes

1. Several of these earlier Northern and French depictions of the remedy subject are reproduced in Posner's exemplary studies; see Posner 1972; Posner 1973, especially pp. 31–48; and Posner 1984, pp. 105–06.
2. Posner 1984, p. 105.
3. Posner claims she offers an unsurpassed "image of voluptuous receptivity." Posner 1972, p. 388.
4. Rosenberg and Camesasca 1970, no. 135; for a discussion of the technical analysis of the painting, see Posner 1972, p. 386.
5. Grasselli 1987a, pp. 316–17. Grasselli also notes that in another drawing, *Rosalba at Her Toilette* in Amsterdam (Rosenberg and Prat 1996, II, no. 655), Watteau seems to have added, almost as an afterthought, a rapidly sketched setting around a more finely finished figure, thereby turning a simple study into a complete composition; Rosenberg and Grasselli 1984, p. 419.
6. Rosenberg and Prat 1996, II, no. 487; Rosenberg and Grasselli 1984, no. P62.

Grasselli has noted that the drawing was executed in two distinct modes, with the maid, the curtain, and the bedstand rendered in rougher, more staccato strokes than are found in the consummately handled nude and her bedclothes; she argues convincingly that all of the background elements were added some time after the nude was completed.[5] Certainly Watteau had difficulties with the figure of the maidservant: her figure contains numerous *pentimenti*, most prominent in the alternative positions of her head, which Watteau drew twice; beneath her figure is a discarded study for the head of the nude model. Obviously dissatisfied with the sketch, he made a separate study of the maid's pose on a sheet in the Louvre, which also bears sketches for two figures in the Berlin version of *The Embarkation to Cythera* (*Le Pèlerinage à l'isle de Cithère*), a painting that can be dated to 1717–18.[6]

25 A Seated Woman Turning to the Right

ca. 1716–17

Red, black, and white chalks on beige paper
8½ × 5 in. (21.6 × 12.7 cm)

The Metropolitan Museum of Art, New York; Robert Lehman Collection 1975 (1975.1.763)

Provenance Schwab, Manchester; Schaeffer Galleries, New York; acquired on October 24, 1958, by Robert Lehman (1887–1969), New York

Exhibitions New York 1980, no. 37; Washington, Paris, and Berlin 1984–85, no. 86

Literature Parker and Mathey 1957, II, no. 556, repr.; Börsch-Supan 1985, no. 89, repr.; Rosenberg and Prat 1996, II, no. 494

Notes
1. Rosenberg and Grasselli 1984, p. 161. For comparable bows, see cat. no. 36 in this book.

The palpable sense of energy in this *Seated Woman* is conveyed through the strong contrapuntal movement of her pose, her immediacy of gesture and alertness of expression, and the obvious rapidity with which Watteau executed his sketch—the handling is almost brusque and he evidently completed it in one session. Rosenberg and Prat have noted that the undisguised *pentimenti* in the fingers of her raised hand create the sensation of vibration and add to her particularly vivid impression of motion. Although the drawing has sometimes been referred to as *Seated Girl with Butterfly*, it is more likely that the black and red, fluttering creature on her elbow is actually a bow.[1] The sketch has clearly been cut from a larger sheet (small strips of paper have been added to three sides to make the cropping less abrupt) and her gesture of recoil—her right hand protecting her breast—might have been in response to the figure of an overeager suitor later torn from the page. The *Seated Woman* does not appear in any of Watteau's paintings.

While sketched with speed, the drawing in no way feels incomplete or hasty, such was Watteau's facility by this point in his career; even in the drawing's summarily evoked lower half, the bend of the model's knees and positioning of her legs beneath her skirts are made entirely convincing with just a few heavy strokes of black and white chalks. Such dense white chalking is found in several of Watteau's studies of full-skirted women probably made around 1716 or 1717, including *A Seated Woman Turning to the Left* (cat. no. 26) and *A Couple Seated on a Bank* (fig. 21, p. 30).

26 A Seated Woman Turning to the Left

ca. 1717

Red, black, and white chalks on beige paper
9¼ × 5⅝ in. (23.5 × 14.2 cm)

Private collection, New York

Provenance Camille Groult (1837–1908); his
son, Jean Groult (1868–1951); his son, Pierre
Bordeaux-Groult; Artemis in 1978; Eugene
Victor Thaw, New York in 1979

Exhibitions Washington, Paris, and Berlin
1984–85, no. 85; New York 1999a, no. 7

Literature Goncourt 1875, under no. 578;
Bouvy 1921, p. 17 (the engraving); Parker
1931, pp. 29, 31, 34; Parker and Mathey
1957, II, no. 547, repr.; Mathey 1959b,
fig. 12; Rosenberg and Grasselli 1984,
pp. 150, 162, 169, 386, fig. 9, p. 394 and
fig. 4, p. 395; Börsch-Supan 1985, no. 88
repr.; Nochlin 1985, repr. p. 73; Grasselli
1987a, pp. 274, note 57, 277, 283, 285, 287
note 69, 288, no. 191, fig. 332; Roland
Michel 1987b, p. 124, and note 26;
Rosenberg 1991, color repr. on front cover;
Grasselli 1993, p. 112, under no. 8;
Rosenberg and Prat 1996, II, no. 543

Notes

1. Rosenberg and Grasselli 1984, no. P56.
2. Rosenberg and Camesasca 1970, no. 180.
3. Rosenberg and Grasselli 1984, no. P60.
4. Rosenberg and Prat 1996, II, nos. 395,
541, and 542, respectively.

One of the most ravishing of Watteau's studies of seated ladies, *A Seated Woman Turning to the Left* demonstrates his art at its most seductive. An extravagantly dressed young model responds both with spirit and gentle modesty to an unseen suitor's advances; the direction of her glance is concealed by her toque, which also sets off her exquisite profile; her silhouette is firmly outlined, but she turns in a pose eloquent with emotional ambiguity. So masterly was Watteau's control of his three chalks that he could confidently articulate the position of his model's entire lower body with only two dense smudges of white to indicate the shimmer of light where the silk gown falls between her knees.

Watteau must have been pleased with this superbly preserved study, for, as Grasselli observed, he adopted it without the slightest change of pose or costume—including the brilliant white highlights—in his *Assembly in a Park* (*L'Assemblée dans un parc*; fig. 89).[1] He used it again—this time with slight alterations to the position of the model's right arm and hands—in *Venetian Fêtes* (*Fêtes vénitiennes*; Edinburgh, National Gallery of Scotland),[2] and, perhaps, a third time, though less faithfully, in *The Enchanted Isle* (*L'Ile enchantée*; private collection, Switzerland).[3]

The drawing was etched by Benoît Audran for *Les Figures de différents caractères* (no. 201). The shoulder cape, gown, ruff, and toque that the model wears must have come from Watteau's costume trunk, for they reappear in several drawings that seem to date from the period of around 1715–17, including sheets in the Metropolitan Museum of Art, New York; the British Museum, London; and the Teylers Museum, Haarlem.[4]

The truncated male leg that extends into the drawing does not seem to belong to any surviving study by Watteau, and Rosenberg and Prat believe that, because no male figure positioned in such a way appears in any of the paintings for which *Seated Woman Turning to the Left* served as a study, the lost sketch may not have been conceived in direct rapport with her figure. However, even when Watteau drew figures in tandem he did not necessarily keep them together in his subsequent paintings (see fig. 21, p. 30; fig. 22, p. 31)

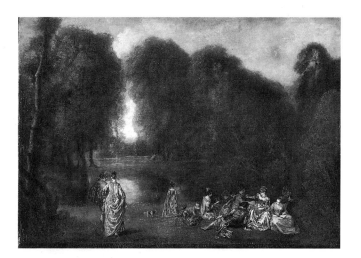

Figure 89
Antoine Watteau,
Assembly in a Park, (*L'Assemblée dans un parc*) *ca.* 1717.
Oil on walnut panel,
12¾ × 18⅜ in. (32.4 × 46.4 cm).
Musée du Louvre, Paris

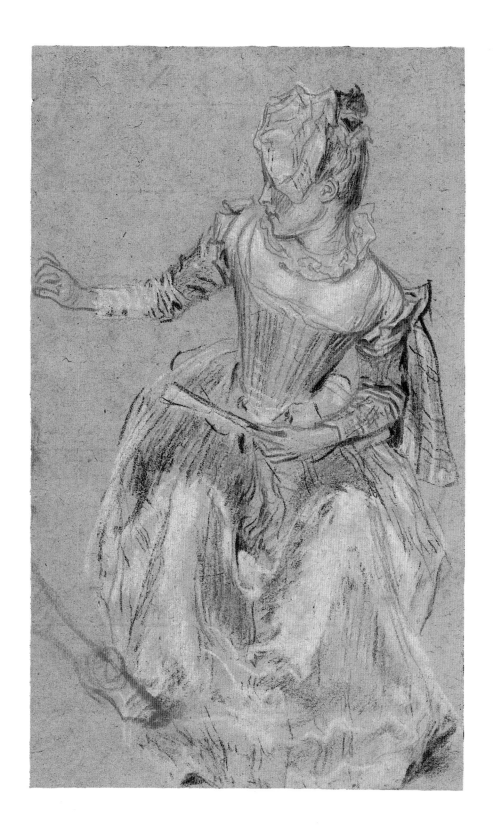

27 Seated Young Woman

ca. 1716–17

Red, black, and white chalks on cream paper
10 × 6¾ in. (25.4 × 17.1 cm)

The Pierpont Morgan Library, New York
(I.278a)

Provenance Sarah Ann James collection (?);
Thomas Agnew & Sons, London; acquired
by J. Pierpont Morgan (1837–1913) in 1911

Exhibitions Providence 1975, no. 44; New
York 1981, no. 99; Washington, Paris, and
Berlin 1984–85, no. 61; Paris and New York
1993–94, no. 38

Literature Goncourt 1875, under no. 591;
Mantz 1892, p. 112 (the engraving); Séailles
1923, p. 85 (the engraving); Parker and
Mathey 1957, I, no. 531, repr.; Cormack
1970, p. 29, no. 47, and pl. 47; Eckardt 1973,
under no. 25, repr.; Posner 1973, pp. 54,
101, note 61; Jean-Richard 1978, under
no. 104; Posner 1984, pp. 71–72, 93, color
pl. 13; Roland Michel 1984a, pp. 140, 144,
color pl. XXXI, p. 253; Rosenberg and
Grasselli 1984, pp. 139, 167; Börsch-Supan
1985, no. 63, repr.; Sutton 1985, pp. 151,
155, pl. II; Grasselli 1987a, pp. 261, 368,
note 60, no. 177, fig. 315; Grasselli 1987b,
pp. 97–98, fig. 6; Rosenberg and Prat 1996,
II, no. 497; Roland Michel in Clark 1998,
p. 62, fig. 15.

Notes
1. Posner 1984, p. 71.

The fame of this drawing is easy to understand, for few of Watteau's studies convey a more appealing directness and simplicity, yet none is more sophisticated in pose or suave in handling. With the utmost delicacy of hatching, Watteau employs his three chalks to such effect that the drawing seems less to evoke the softness and smoothness of the model's flesh than to be made from the stuff of life itself. Donald Posner has written of this sketch:

> The straight hatching spreading broadly across her dress and a few heavy, repeated strokes of black chalk give the form an amplitude and density that—contrasting with the diaphanous area around her right shoulder and arm where light bleaches out the contours and folds of the chemise—pulls the balance down to the invisible cushions beneath her. The black chalk touches an arm, the neck and chin, and blots a nipple. Not shadows, these marks are bursts of energy at nodal points, traces of the body's movements. One scribbled line is an eyebrow and, moving in different directions, many make the shape and mass of an upswept coiffure. The right hand seems to move before our eyes. Movement, gesture, the vital animation of form is the primary content of drawings like this. And it is expressed with an intensity and focus wholly new in the history of art.[1]

It is a mark of how far Watteau's drawings depart from academic practice—and yet how utterly natural and convincing they are made to appear—that few of us looking at the *Seated Young Woman* ever notice that her weight settles firmly on air and her crossed right leg simply vanishes from view.

The *Seated Young Woman* does not appear in any of Watteau's paintings, but the figure was etched in reverse for *Les Figures de différents caractères* by François Boucher (no. 214), who provided her with a simple step to rest on. Boucher would also have been impressed by Watteau's incisive chalk technique and by his understanding of women's intimate movements: the nape of the neck, the particular turn of a head.

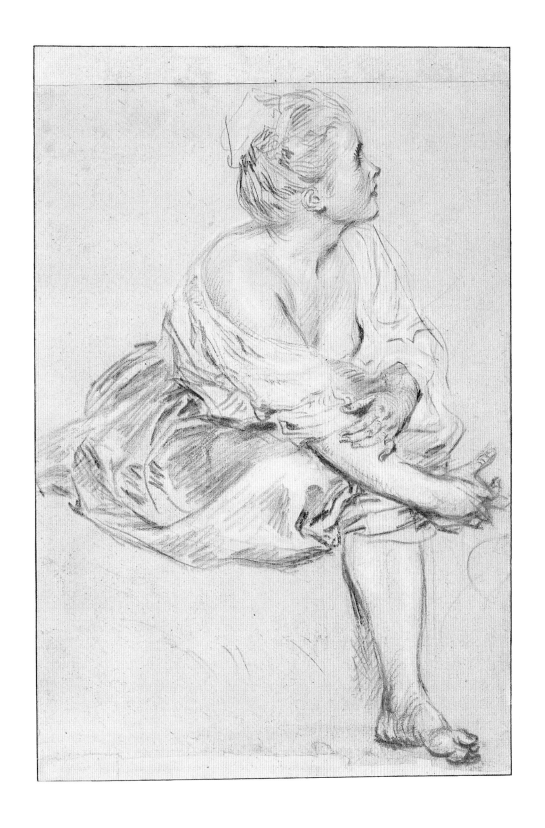

28 Seated Man Seen from Behind, and Another Study of His Right Arm

ca. 1716–17
Red, black, and white chalks on beige paper
8⅛ × 9 in. (20.8 × 22.7 cm)
Thaw Collection; The Pierpont Morgan
Library, New York (Thaw 11.9)

Provenance Sir Thomas Lawrence
(1769–1830); Andrew James (dead before
1857); his daughter, Sarah Ann James,
London; her sale London, Christie's, June
22–23, 1891, no. 300 (18 guineas to Meder);
Camille Groult (1837–1908); his son, Jean
Groult (1868–1951); his son, Pierre
Bordeaux-Groult; sale Paris, Palais Galliéra,
March 30, 1963, no. 17, color repr.; Henry
Farman, Paris, his sale, Palais Galliéra, March
15, 1973, letter G, repr.; Anne Wertheimer
(1898–1981), Paris; Clare and Eugene Victor
Thaw, New York, after 1982

Exhibitions Washington, Paris, and Berlin
1984–85, no. 95, repr.; New York and
Richmond 1985–86, no. 9; Paris and New
York 1993–94, no. 35

Literature Goncourt 1875, p. 351, no. 13;
Parker and Mathey 1957, II, no. 641, repr.;
Börsch-Supan 1985, no. 92, repr.; Grasselli
1985, p. 44; Boerlin-Brodbeck 1987, p. 163,
notes 1 and 2; Grasselli 1987a, pp. 297–98,
and note 79, p. 350, note 43, no. 199,
fig. 368; Grasselli 1987b, p. 97, fig. 5;
Grasselli 1993, p. 116, under no. 10, p. 126,
note 23; Denison *et al.* 1994, p. 258;
Rosenberg and Prat 1996, II, no. 503;
Roland Michel in Clark 1998, p. 61, fig. 14.

Notes
1. Rosenberg and Camesasca 1970, no. 160.
2. Rosenberg and Prat 1996, II, no. 599.
3. Rosenberg and Camesasca 1970, no. 178.
4. Rosenberg and Grasselli 1984, no. P51;
Grasselli first made this association.

Among Watteau's most powerful and emphatic figure studies, the *Seated Man Seen from Behind* employs three chalks but was drawn principally in slashing, staccato strokes of heavy black crayon. The figure served as a study for the reclining man in the right background of Watteau's *The Scales of Love* (*La Gamme d'amour*; London, National Gallery) and was transposed without adjustment onto that canvas.[1] The sketch also seems to have served as the basis for the figure of a reclining lover in the right foreground on one of Watteau's rare compositional drawings, *Study for "The Pleasures of Love"* (*Plaisirs d'amour*) in the Art Institute of Chicago (fig. 36, p. 40).[2] The Chicago sheet, which was executed in red chalk over traces of graphite, served as the compositional study for a painting in the Gemäldegalerie, Dresden; however, in the final painting the pose of the reclining—or seated—figure underwent substantial alterations.[3]

The separate study of a right shoulder and arm that appears on the far right of the present sheet was obviously drawn at the same modeling session, but was not employed in either *The Scales of Love* or *The Pleasures of Love*; rather, it might have served as the study for the arm of a seated man who turns toward a woman holding a fan in the lower right corner of *The Pleasures of the Dance* (*Les Plaisirs du bal*; London, Dulwich Picture Gallery).[4]

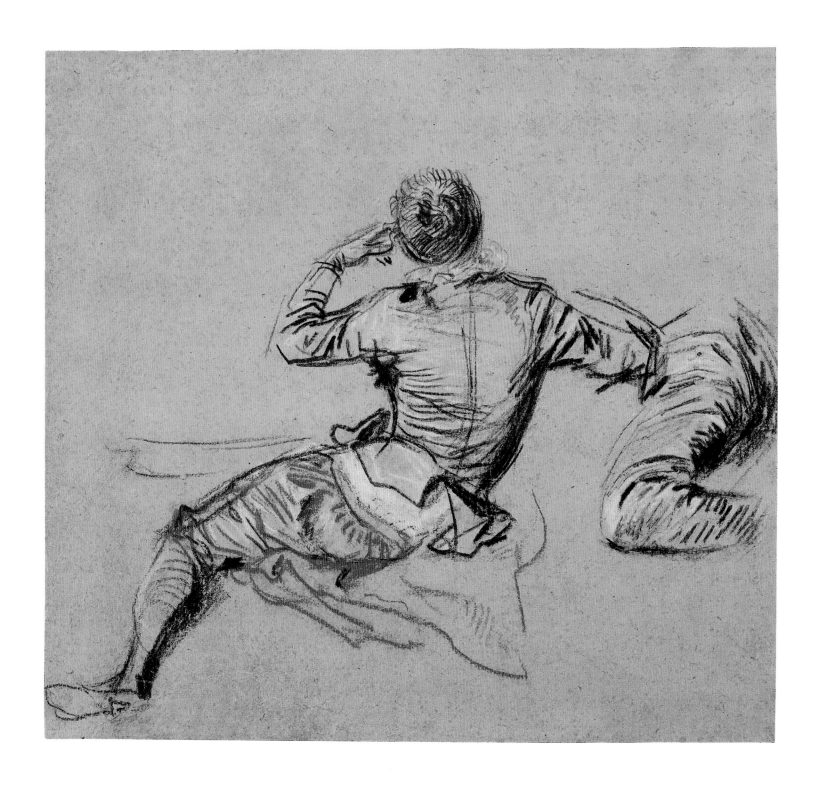

29 Three Studies of a Woman and a Study of Her Hand Holding a Fan

ca. 1716–17
Red, black, and white chalks on tan paper
13½ × 9½ in. (34.1 × 24.1 cm)
Museum of Fine Arts, Boston; Bequest of
Forsyth Wickes 1965 (65.2610)

Provenance Perhaps Gabriel Huquier
(1695–1772; Lugt 1285 at the lower right);
perhaps his sale, Paris, November 9, 1772,
part of nos. 441 and 444. Andrew James
(before 1857); his daughter, Sarah Ann
James, London; her sale, London, Christie's,
June 22–23, 1891, no. 328 (270 guineas to
Stephan Bourgeois). Camille Groult
(1837–1908); his son, Jean Groult
(1868–1951); New York, private collection

Exhibitions London 1878, no. 13; London
1954–55, no. 281

Literature Goncourt 1875, p. 353, no. 41;
Parker 1930, p. 27, under no. 55; Parker
1931, p. 39, and note 3; Parker and Mathey
1957, II, no. 786, repr.; Nemilova 1964a,
fig. 54; Nemilova 1964b, p. 90, fig. 8,
p. 98, note 35; Mathey 1967, p. 92; Zolotov
1971, p. 89, repr.; Zolotov 1973, under
no. 4, repr. p. 135 (entry by I. Nemilova);
Hutton 1980, p. 31, under no. 58;
Rosenberg and Grasselli 1984, pp. 95, 149,
fig. 1, pp. 410, 415, fig. 8; Zolotov 1985,
under no. 35, repr. p. 107 (entry by I.
Nemilova); Grasselli 1987a pp. 194, 294,
note 76, pp. 295–96, 298–99, no. 189,
fig. 365; Roland Michel 1987a, p. 29, fig. 18;
Munger and Zafran 1992, no. 96; Grasselli
1993, p. 112, under no. 8; Rosenberg and
Prat 1996, II, no. 522

Notes
1. Rosenberg and Prat 1996, II, nos. 521 and
520, respectively.
2. See Grasselli 1987a, p. 299.
3. Rosenberg and Camesasca 1970, no. 161.
Seated Man Seen from Behind (cat. no. 28) and
Two Studies of a Seated Guitarist from the
British Museum (fig. 20, p. 30) also served as
studies for *The Scales of Love.*
4. Rosenberg and Grasselli 1984, no. P63.
5. Reproduced in Rosenberg and Prat 1996,
II, nos. 522b and 522a, respectively; the lost
counterproof was auctioned at Lepke, Berlin,
October 30, 1917.

The model who posed for this justly celebrated sheet was a favorite of Watteau's in the years around 1717, when the artist was creating his most ambitious *trois crayons* studies. Her delicate beauty can be recognized in the profile sketch beside the *Standing Woman Holding a Spindle* (cat. no. 6), again in the *Studies of a Flutist and Two Women* (cat. no. 34), and probably in *A Seated Woman Turning to the Left* (cat. no 26). Drawn with finely sharpened chalks that allowed for the greatest nuance of tonal effects, yet with the unconstrained mixture of crayons that characterize the greatest drawings of this period, *Three Studies of a Woman and a Study of Her Hand Holding a Fan* is at once refined and spontaneous, carefully controlled yet seemingly unmeditated.

The drawing is closely related to two other sheets of bust-length studies of the same model, one in the British Museum, London, and the other in a private collection in New York; presumably the three sheets were drawn in quick succession, in one or two modeling sessions.[1] All three drawings demonstrate similarly fluent arrangements of heads in a spiralling motion down the page, suggesting that the model was depicted in the successive stages of a single sequential movement.[2] As always, Watteau carefully observed the play of light across the model's skin, while meticulously recreating every detail of coiffure and costume, down to her tiny drop earrings.

The figure turning away on the upper left of the page was used as a study for the seated woman holding sheet music who listens to a guitarist's serenade in two paintings, *The Scales of Love* (*La Gamme d'amour*; London, National Gallery)[3] and *Gallant Recreation* (*Récréation galante*; Berlin, Staatliche Museem, Gemäldegalerie).[4] In the latter painting, a second woman to the right of the guitarist holds a closed fan in an upright position that is different from that held by the phantom figure on the upper right of the Boston sheet, but it is nevertheless possible that the present drawing represented a first idea for her pose. Neither of the lower sketches on the Boston sheet reappears in any of Watteau's known paintings, and none of the sketches was etched for *Les Figures de différents caractères*. Two counterproofs were pulled from the drawing: one is known only from an old sale catalogue, while the other—a beautiful proof, once in the collection of the painter Thomas Lawrence—is in the British Museum.[5]

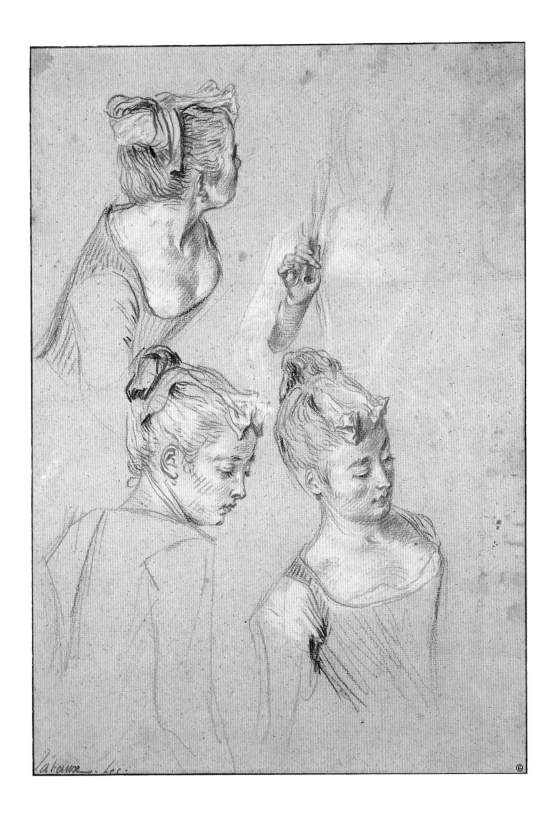

149

30 Woman Seated on the Ground, Seen from the Back, and Eleven Studies of Hands

Antoine Watteau

ca. 1717
Red, black, and white chalks on gray-yellow paper
9 × 14 in. (22.9 × 35.5 cm)
Private collection

Provenance Jean-Baptiste-Pierre Lebrun (1748–1813); Lebrun sale, Paris, April 11–30, 1791, part of no. 344 (97 *livres* to Jauffret). Camille Groult (1837–1908); his son, Jean Groult (1868–1951); his son, Pierre Bordeaux-Groult; Wildenstein & Co., New York

Literature Goncourt 1875, under no. 383, and p. 333; Parker and Mathey 1957, II, no. 824, repr.; Mathey 1958, p. 205, fig. XI (detail); Mathey 1959b, pp. 49, 78, no. 123, repr. (detail); Eidelberg 1977, pp. 176, 197, fig. 110; Jean-Richard 1978, under no. 47; Posner 1984, pp. 237, 288, note 19; Roland Michel 1984a, p. 136; Rosenberg and Grasselli 1984, pp. 415–16, fig. 11 (detail), p. 424. fig. 8 (detail); Börsch-Supan 1985, pp. 154, 160, note 12; Grasselli 1987a, pp. 290, note 72, pp. 292, 294, note 76, p. 386, no. 212, fig. 362; Rosenberg and Prat 1996, II, no. 526

Notes
1. Mathey 1967.
2. Dacier and Vuaflart 1921–29, III, no. 139.
3. Rosenberg and Grasselli 1984, no. P66.
4. Rosenberg and Grasselli 1984, no. P63.
5. See the essay by Colin B. Bailey in the present book.

The present sheet, with its eleven studies of male and female hands held in various poses and attitudes, attests to the truth of Jacques Mathey's observation that Watteau's extremely supple and sensitive drawings of hands—in which he used his chalks with the same care and curiosity recognizable in his studies of heads—"are as good as a signature."[1]

The beautiful sketch of the seated woman was first employed as the study for a partially seen figure in the middle ground of *Gallant Assembly* (*Assemblée galante*), a lost work painted for the comtesse de Verrue that is known through an engraving made by Jean-Philippe Le Bas for the *Recueil Jullienne*; the two studies of women's hands positioned on the drawing immediately above her skirt were used for the hands of the woman seated beneath a guitarist in the same painting.[2] The sketch of the seated woman was used soon afterward as the model for the woman on the grass who is embraced by an overeager suitor in *Peaceful Love* (*L'Amour paisible*; Berlin, Schloss Charlottenburg); there her headdress was slightly modified with the addition of a plume.[3] Only one other hand study from the sheet—the sketch in the lower right corner that has a ribbon tied around the wrist—has been identified in any of Watteau's paintings: it served as a study for the woman in white who holds a closed fan at the center of *Gallant Recreation* (*Récréation galante*; Berlin, Staatliche Museen, Gemäldegalerie).[4] The figure of a woman in lost profile in the drawing *Three Studies of a Woman and a Study of Her Hand Holding a Fan* (cat. no. 29) reappears in the same painting. All three of the paintings appear to date from around 1717–18.

The seated woman was etched in reverse by François Boucher for the first volume of *Les Figures de différents caractères* (no. 33). Interestingly, the sketch of her figure—abstracted from the full sheet—is also seen in the lower left corner of François de Troy's *Portrait of Jean de Jullienne* (fig. 64, p. 68), a tribute to the impresario who was responsible for the great project that reproduced Watteau's life's work.[5]

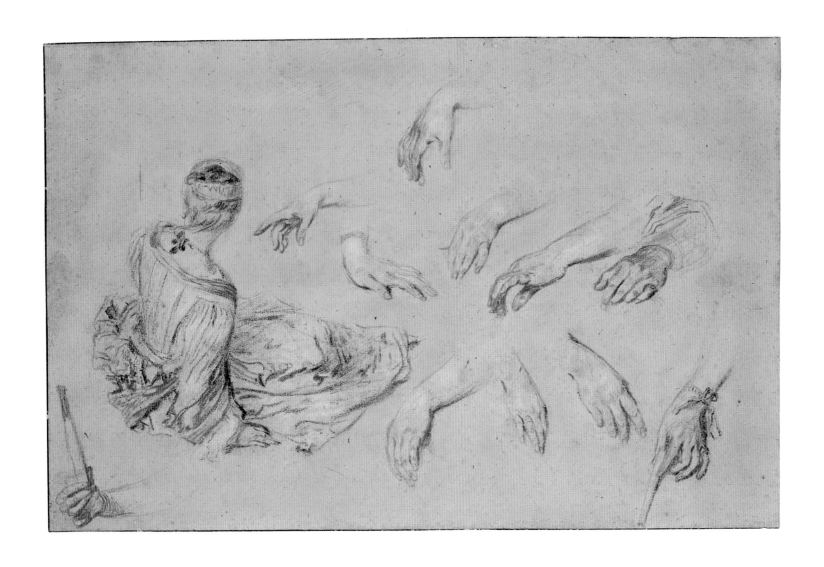

31 Three studies of Seated Women

ca. 1717

Black, red, and white chalks on gray-brown paper

10¼ × 15⅞ in. (26 × 37 cm)

The Art Institute of Chicago; Gift of the Joseph and Helen Regenstein Foundation (1958.8)

Provenance John Spencer (1708–1746); George John, 2nd Earl Spencer (1758–1834; Lugt 1530 at the lower right); his sale, London, Phillips, June 10–17, 1811, no. 822 (4 guineas 6 pence to Edward Coxe); Coxe sale, London, Squibb, April 13–15, 1815, no. 132; William Esdaile (1758–1837; Lugt 2617); his sale, London, Christie's, June 18, 1840, no. 1242; Andrew James (dead before 1857); his daughter, Sarah Ann James; her sale, London, Christie's, June 22–23, 1891, no. 338 (210 guineas to Wertheimer); H.A. Josse; Josse sale, Paris, Galerie Georges Petit, May 28–29, 1894, no. 45, repr. (3200 francs); Camille Groult (1837–1908); his son, Jean Groult (1868–1951); his son, Pierre Bordeaux-Groult

Exhibitions London 1878, no. 2, repr.; Chicago 1976, no. 28

Literature Goncourt 1875, pp. 353–54, no. 50; Parker and Mathey 1957, II, no. 831, repr.; Joachim 1974, no. 27; Roland Michel 1984a, p. 78; Grasselli 1985, p. 44; Roland Michel 1987a, p. 183, fig. 215; Rosenberg and Prat 1996, II, no. 538

Notes

1. Roland Michel 1984a, p. 78.
2. Engraved by Bernard Báron for the *Recueil Jullienne*: Dacier and Vuaflart 1921–29, III, no. 23; the right-hand sketch from *Two Studies of a Flutist and a Study of the Head of a Boy* (cat. no. 35) is also a study for this painting, formerly in the collection of Lord Iveagh, acquired for Los Angeles in 1999.
3. Engraved by S.-F. Ravenet, though not included in the *Recueil Jullienne*; Dacier and Vuaflart 1921–29, III, no. 311.

The most striking feature of this handsome sheet of studies is the pronounced use of black chalk, which is rarely accorded such prominence in Watteau's *trois crayons* drawings. Watteau has also mastered a new degree of fluency in his use of different chalks, for, as Roland Michel has observed, a close examination of the sheet reveals that Watteau seems to have worked his black and red chalks simultaneously.[1] He did not lay in the outlines of the sketches in sanguine—as had been his standard practice—going over them with black crayon where appropriate; instead, parts of the figures have been sketched in with red—the head and hat of the woman with the guitar, for example—while other areas have been laid down in black, as is apparent in all the dresses. The head of the woman at right seems to have been conceived in both red and black chalks from the outset, while the head of the woman holding a music book was first sketched in graphite, then entirely redrawn in a new position in sanguine. As is often the case in Watteau's drawings, the very obvious pentimenti in the latter sketch—both in her head and the pages of the book—add to its sense of almost vibrating life and movement.

Although the gown is the same in all three studies, it is not certain that only one model sat for them, and it is possible that Watteau put two different subjects in a dress taken from his trunk of costumes; the face of the woman at right is not obviously identical to that of the woman in the other sketches. Nor is it clear that Watteau used the studies for paintings: while the sketch on the left is similar to a seated woman reading music in *Perfect Accord* (*L'Accord parfait*; Los Angeles County Museum of Art),[2] and the central guitar player is very close to a figure in the lost *Country Dance* (*Le Bal champêtre*),[3] the numerous differences between the sketches and the painted figures in the final composition make such associations speculative at best.

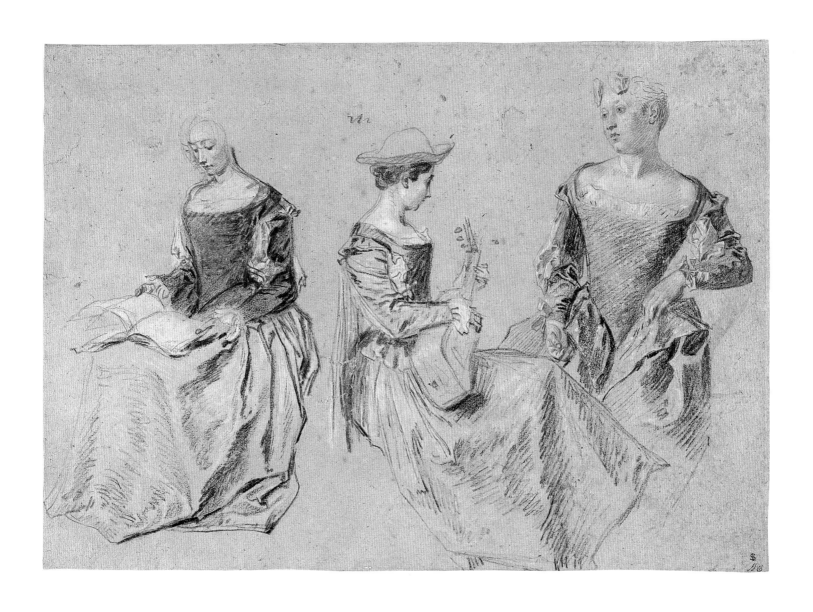

153

32 Two Studies of the Heads of Women

ca. 1717
Black, red, and white chalks on light tan paper
9 × 6⅝ in. (22.8 × 16.8 cm)
Private collection

Provenance John Spencer (1708–1746); George John, 2nd Earl Spencer (1758–1834; Lugt 1530 at the lower right); his sale, London, Phillips, June 10, 1811, perhaps no. 826 or no. 827 (the drawings are not precisely described). Andrew James (dead before 1857); his daugher, Sarah Ann James; her sale, London, Christie's, June 22–23, 1891, no. 329 (24 guineas to Stephan Bourgeois). Camille Groult (1837–1908); his son, Jean Groult (1868–1951); his son, Pierre Bordeaux-Groult

Literature Goncourt 1875, p. 353, no. 42; Parker and Mathey 1957, II, no. 782, repr.; Cailleux 1966, pp. i, v, note 5; Rosenberg and Grasselli 1984, pp. 400, fig. 6 (detail), p. 406; Grasselli 1987a, p. 265, note 46; Rosenberg and Prat 1996, II, no. 574

Notes
1. Rosenberg and Grasselli 1984, no. P61.
2. Parker and Mathey further speculated that the same study was employed again in the lost painting *Le Concert champêtre* (Dacier and Vuaflart 1921–29, no. 72), known from Benoît Audran's engraving, but the present drawing has no connection with that painting whatsoever.
3. Grasselli 1987a, p. 265, notes 46 and 47.

Most authors have associated the graceful profile on the left of this sheet with the female pilgrim standing beside the barque at the lower left of the Paris version of *The Embarkation to Cythera* (*Le Pèlerinage à l'isle de Cithère*; fig. 1, p. 9), the painting that Watteau delivered to the Royal Academy on August 28, 1717.[1] Certainly, the contours of the model's profile, the downward tilt of her head, and her upswept chignon and feathered toque are all found again in Watteau's reception piece, yet to our eyes the similarities seem generic and, like Grasselli, we find the connection between the drawing and painting speculative. Since Watteau often transferred his sketches to paintings without even the smallest alteration, the significant differences in the position of the pilgrim's head in the painting raise doubts as to the drawing's status in relation to it.[2]

It is certainly true that this airy, delicately modeled sheet was probably made at the time when Watteau was at work on the first version of *The Embarkation to Cythera*, and its feeling of romantic plenitude is in keeping with the mood of Watteau's masterpiece. Grasselli accepts eight extant figure drawings as being related to the *Embarkation* and regards only three of these as having been executed specifically with the painting in mind.[3]

However, in the eight-month period that he worked on his ambitious picture, Watteau must have made any number of studies that he hoped would stimulate his imagination and could usefully be employed when the time came for him to paint Love's pilgrims; some of these are undoubtedly lost, but others would probably have gone unused when the final composition was formulated: the present study of a girl in profile and her companion in lost profile (whose aquiline nose and simpler costume were obviously inspired by another model) could well have been among the latter.

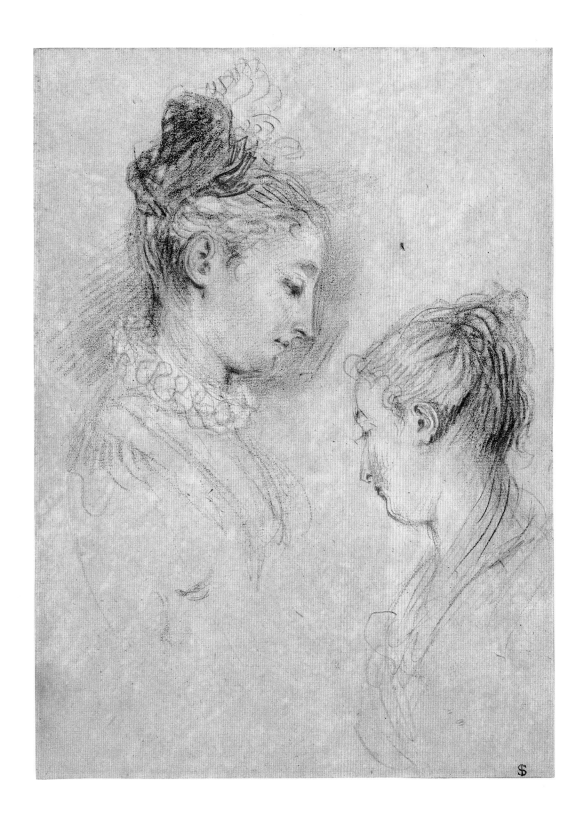

155

33 Two Men Standing

ca. 1717
Red chalk on cream laid paper
7 × 7½ in. (17.8 × 18.9 cm)
National Gallery of Canada, Ottawa;
purchased, 1939 (4548)

Provenance Antoine-Joseph Dezallier
d'Argenville (1680–1765; stamp Lugt 2951),
with his stamp and no. *3270* in pen, brown
ink, at the lower right; his sale, Paris, January
18–28, 1779, part of nos. 392 or 393 (to
Lenglier). Mme de Saint; Hans Maximilian
Calmann (1899–1982), London

Exhibitions Vancouver, Ottawa, and
Washington 1988–89, no. 50; New York
1999b, no. 1

Literature Parker and Mathey 1957, II, no. 655,
repr.; Grasselli 1994b, p. 53; Labbé and Bicart-
Sée 1996, p. 323, no. 3270, not reproduced;
Rosenberg and Prat 1996, II, no. 551

Notes
1. Rosenberg and Camesasca 1970, no. 182.
2. For the identification of Dezallier's paraph
and system of inventory, as well as
information about his collection, see Labbé
and Bicart-Sée 1987, pp. 276–81; for a
catalogue of Dezallier's Watteau drawings,
see Labbé and Bicart-Sée 1996.
3. The series of prints was not published
until 1779; see Rosenberg and Prat 1996, II,
no. 551, and W. MacAllister-Johnson in
Vancouver, Ottawa, and Washington
1988–89, no. 50.

Throughout his career, even during the period when he was most engaged with extending the expressive range of drawing in *trois crayons*, Watteau made studies in red chalk alone. The present sheet of two sketches of an actor dressed as the character Mezzetin, the amorous valet from the Italian *commedia dell'arte*, is a case in point, as it can almost certainly be dated to around the time of *The Embarkation to Cythera*, that is, to about 1717. Although the drawing was not used directly as a study for any of Watteau's known paintings, Parker and Mathey associated it with a prominent figure in *Gathering in the Open Air* (*La Réunion en plein air*; Dresden, Gemäldegalerie),[1] a painting dated to 1717–18. In the painting, the figure faces outward, but his expression, costume, and rakish attitude are identical to the more finished sketch on the left of the Ottawa sheet, and it seems likely that the figure in the Dresden canvas was based on a lost study of the Ottawa model.

The Ottawa page was once in the collection of Dezallier d'Argenville, the art historian and collector who was one of Watteau's principal contemporary biographers and owned more than twenty drawings by the artist.[2] The figure on the left was reproduced "*en manière de crayon*," and in the true direction, by Jean-Charles François, as the fifth plate in a series of six prints after drawings in Dezallier's collection; a proof of the print in which Gilles Demarteau added a garden landscape around the figure is in the Bibliothèque nationale, Paris.[3]

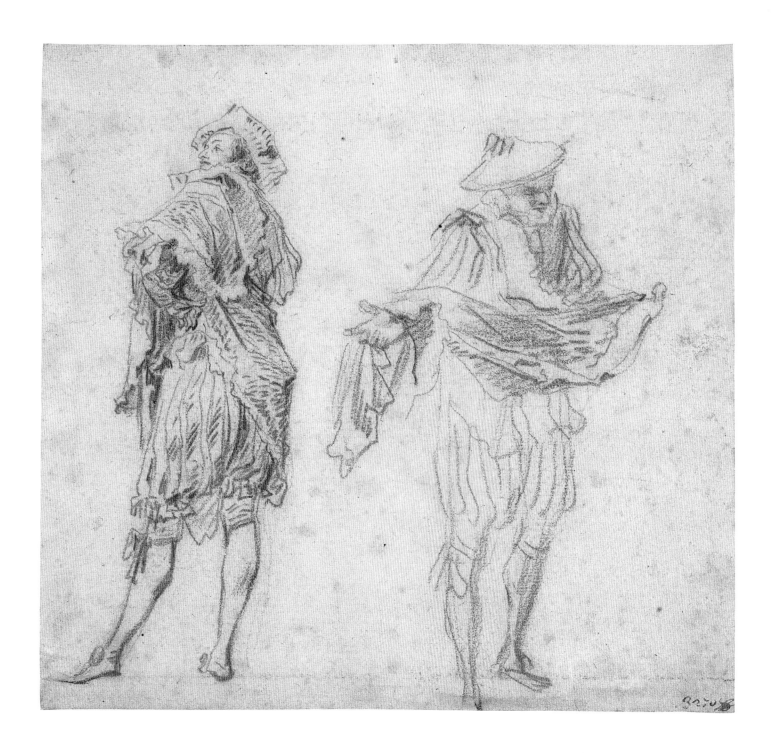

157

34 Studies of a Flutist and Two Women

ca. 1717

Red, black, and white chalks on buff paper
10½ × 9¹⁄₁₆ in. (26.6 × 23.1 cm)

Sterling and Francine Clark Art Institute,
Williamstown, Massachusetts (1955.1839)

Provenance Probably Dominique-Vivant
Denon (1747–1825), though it does not bear
any of his marks (Lugt 779 or Lugt 780);
probably his sale, Paris, May 1–19, 1826,
no. 823. Adrien Fauchier-Magnan
(1873–1965), Paris; his sale, London,
Sotheby's, December 4, 1935, no. 64, repr.
(acquired by Knoedler for Robert Sterling
Clark)

Literature Parker and Mathey 1957, II,
no. 780, repr.; Haverkamp-Begemann,
Lawder, and Talbot 1964, no. 50; Nemilova
1964b, p. 98, note 35; Canaday 1966, repr.
p. 60; Zolotov 1971, repr., p. 70; Eidelberg
1977, p. 168, note 24; Rosenberg and
Grasselli 1984, pp. 95, 150, 347, fig. 8,
p. 348; Grasselli 1987a, p. 194; Rosenberg
and Prat 1996, II, no. 571

Notes

1. The same model is also found in
cat. nos. 6 and 26, and in Rosenberg and
Prat 1996, II, nos. 520 and 521.
2. Rosenberg and Prat 1996, II, no. 415.
3. Rosenberg and Prat 1996, II, no. 532.
4. Rosenberg and Grasselli 1984, no. 42.

The three studies on this sheet seem to date from the same moment and have a looseness and amplitude that imbue them with an impressive monumentality. Although each of the studies of women shows models with the same costume and coiffure, they do not appear to depict the same sitter. The lower sketch portrays one of Watteau's favorite models, whose graceful profile can be found in several drawings, including *Three Studies of a Woman and a Study of Her Hand Holding a Fan* (cat. no. 29).[1] The model for the upper sketch, with her distinctively curled lips and soft chin line, is less easily recognized from other drawings by Watteau, although Rosenberg and Prat identify her as one of the subjects depicted in the *Sheet of Eight Heads* in the Louvre (fig. 23, p. 32).[2] Certainly, the costume of the young flutist can be found again in *A Standing Man Playing the Flute and Two Seated Women* in the British Museum, though as neither drawing reveals the flutist's face one cannot be sure that the same model is depicted wearing it.[3] The British Museum sheet, which also bears two studies of full-length, seated female figures, is very similar in handling to the Williamstown page, is drawn with the same, distinctive pink-toned red chalk, and may have been made during the same modeling session.

The Williamstown page was not etched for *Les Figures de différents caractères*. Rosenberg associated the sketch at the bottom of the sheet with the head of a woman in Watteau's painting *The Italian Serenade* (*La Sérénade italienne*; Stockholm, Nationalmuseum), but the differences in both pose and morphology do not easily support such a relationship.[4]

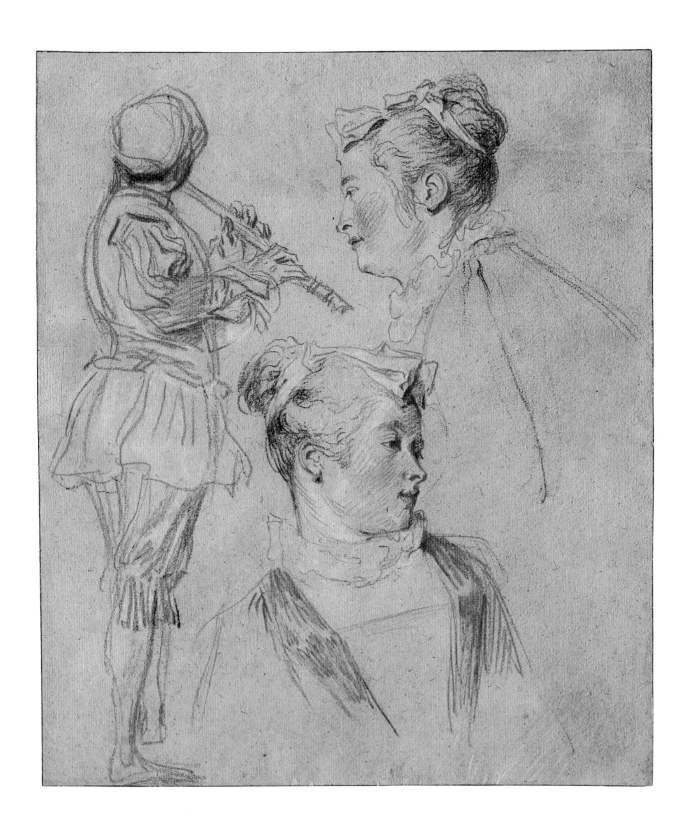

159

35 Two Studies of a Flutist and a Study of the Head of a Boy

ca. 1717
Red, black, and white chalks on brownish paper
8⅜ × 13¼ in. (21.4 × 33.6 cm)
The J. Paul Getty Museum, Los Angeles (88.GB.3)

Provenance Perhaps sold (Chabot de la Mure or Desmarets), Paris, December 17, 1787, no. 227 (22 *livres* with no. 228). Brisart collection; Andrew James (dead before 1857); his daughter, Sarah Ann James, London; her sale, London, Christie's, June 22–23, 1891, no. 335 (130 guineas to Stephan Bourgeois); Camille Groult (1837–1908); his son, Jean Groult (1868–1951); his son, Pierre Bordeaux-Groult; New York, private collection; Wildenstein & Co., New York

Exhibitions London 1954–55, no. 282; Washington, Paris, and Berlin 1984–85, no. 82

Literature Goncourt 1875, under nos. 448 and 609; Mantz 1892, p. 109; Mathey 1938, pp. 375–76, fig. 9; Parker and Mathey 1957, II, no. 837, repr.; Mirimonde 1961, p. 286, note 9; Jean-Richard 1978, under no. 71; Nordenfalk 1979, p. 123; Grasselli 1984, p. 170; Börsch-Supan 1985, no. 72, repr.; Gétreau 1987, pp. 238–39, fig. 12; Grasselli 1987b, p. 96, note 8; Goldner and Hendrix 1992, no. 79; Rosenberg and Prat 1996, II, no. 576

Watteau's love of music is well known and was remarked upon by several of his early biographers. Music-making plays a prominent role in many of his paintings, and is a crucial element in most of the *fêtes galantes,* as well as quite a few of his theater subjects. It is no surprise then that musicians playing their instruments are the subjects of numerous drawings by the artist throughout his career.[1] The present *Two Studies of a Flutist and a Study of the Head of a Boy* is among the most dynamic and compelling of these.

The apparent spontaneity of the drawing and its particular *mise-en-page* might suggest that Watteau recorded an actual concert—he certainly attended the celebrated music parties held at Crozat's *salon* and may well have sketched the events[2]—but the present sheet was made in the studio and probably in two distinct campaigns. A single musician, playing a transverse flute, is represented twice from different angles at distinct moments in his performance; the young boy to the left—who might appear to be listening, transfixed, to the music—was certainly added to the sheet on another occasion (though the coherence of style among the three sketches indicates that it was very soon afterward).

The intensity of the musician's expression, the force with which he presses forward during a demanding passage, then leans back, head raised in a tranquil moment, is so masterfully observed and authentic in effect that we do not hesitate to recognize Watteau's subject as an actual flutist despite being unable to identify him by name. The transverse flute was a relatively new instrument in the early years of the eighteenth century, gradually displacing in popularity the traditional *flûte à bec,* and the model played by Watteau's flutist is probably that produced by Bressan, a French manufacturer active at the beginning of the century.[3]

The study of the flute player in full face was used in preparation for the painting *Perfect Accord* (*L'Accord parfait*), known principally from an engraving by Báron in the *Recueil Jullienne* until its recent acquisition by the Los Angeles County Museum of Art.[4] Miramonde suggested that, in Watteau's painting, the amorous flutist was comically blundering through his romantic serenade, but in the present drawing the musician is clearly practicing his art with the utmost seriousness, and his fingering of the instrument is precise and impeccably accurate, as is evident by comparison with Bernard Picart's engraving illustrating proper technique in the 1707 edition of Jacques Hotteterre's popular manual *Principes de la flûte à bec, de la flûte traversière, et du hautbois.*[5]

The middle study of the flutist was etched in reverse by François Boucher for *Les Figures de différénts caractères* (no. 88), and the young boy—who modeled for Watteau on several occasions (see cat. no. 8)—was etched by Laurent Cars for the same publication (no. 232).[6]

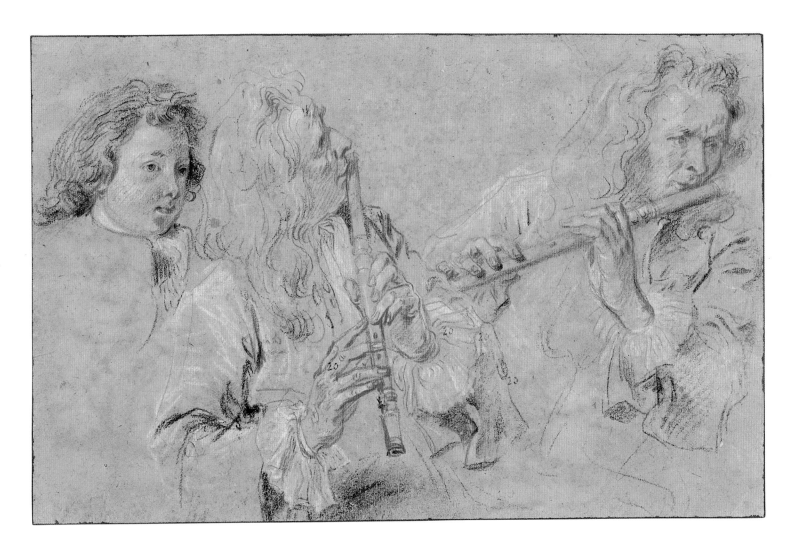

Notes

1. Watteau was also a friend of the composer Jean-Féry Rebel (1688–1747); his portrait of Rebel is in the Musée Magnin, Dijon.

2. It is likely that he attended the concert at Crozat's house held on September 30, 1720, which Rosalba Carriera mentions in her diary, although a well-known drawing by Watteau of three singers (Paris, Louvre; Rosenberg and Prat 1996, II, no. 668), often associated with the occasion, does not, in all probability, record that concert; see Dacier 1924, pp. 289–98.

3. Gétreau 1987, pp. 238–39; the author observes that, in another drawing by Watteau of a flutist playing a transverse flute (Cambridge, Fitzwilliam Museum; Rosenberg and Prat 1996, II, no. 577), the model seems to play an instrument manufactured by another producer of flutes, Ruppert.

4. Dacier and Vuaflart 1921–29, III, no. 23; the Los Angeles County Museum of Art purchased the painting in 1999.

5. Gétreau 1987, pp. 238–39.

6. It was exceptional for Jullienne to assign different engravers the task of reproducing sketches from a single sheet; in this case, it may be because both Boucher and Laurent Cars were employed by J.-F. Cars, Laurent's father, and therefore the drawing could be copied by both artists under the same roof.

36 Woman Reclining on a Chaise Longue

ca. 1718
Red and black chalks and stumping on cream paper
8 × 10⅛ in. (20.4 × 25.6 cm)
Private collection

Provenance Perhaps Jules-Robert Auguste (1789–1850), Paris; perhaps his sale, Paris, Hôtel Drouot, May 28–31, 1850, nos. 100–103 (the individual drawings within each lot are not described); Baron Louis-Auguste de Schwiter (1805–1889; Lugt 1768 at the lower left), of 1875; his sale, Paris, Hôtel Drouot, April 20–21, 1883, no. 164. Paris art market, around 1977; Galerie de Bayser, Paris; Wildenstein & Co., New York

Literature Goncourt 1875, p. 365; Parker and Mathey 1957, I, under no. 528; Rosenberg and Prat 1996, II, no. 583

Notes
1. The nude studies drawn in this manner are Rosenberg and Prat 1996, II, nos. 571, 578, 581, and 582.
2. Caylus, in Rosenberg 1984a, pp. 71–72.
3. Grasselli 1987a, p. 367, note 59, first made this observation. She further suggested the intriguing possibility that Tessin might even have been present, as part of Caylus's drawing party, when the nude studies were made. Tessin had taken drawing lessons from Jean Berain the Younger during his sojourn in Paris: see Colin B. Bailey in the present catalogue.

Like the *Young Woman Wearing a Chemise* (cat. no. 37), the present drawing is one of the intimate studies of the female nude sometimes thought to have been made by Watteau in private rooms rented for the purpose by the comte de Caylus. However, its handling and use of media are quite different from the manner of the next drawing, although it is likely that both studies—and the others with which they have been grouped—were made at the same time during a few modeling sessions. The present drawing is identical in manner to the two nude studies in the British Museum, London, which depict a partially nude model (almost certainly the same one throughout the series) draped in the same beribboned chemise and seated or reclining on a chaise longue; they are executed in soft, friable black chalk and greasy orange-red sanguine, and in all of them the red chalk is used exclusively to depict the woman's flesh; her clothing, the chaise longue, and any background details are drawn almost entirely in black.[1]

Woman Reclining on a Chaise Longue resurfaced just over twenty years ago, and is one of the frankest and most audacious of the series. The languorous sensuality of the model's pose and her candid, almost insolent, expression are no less startling than the bluntness of Watteau's technique. The abbreviated foreshortening of her left arm and powerful relief of her extended leg are astonishing examples of the artist's unconventional solutions to the problems of figure drawing. Caylus, in remembering his days of drawing from the model with Watteau, said that the artist "had no knowledge of anatomy and … was unable to comprehend or express [the nude form]; so much so that the complete rendering of an academy study was for him an exacting and consequently a disagreeable exercise. The female body, requiring less articulation, was somewhat easier for him."[2] Although judged inadequate by the academic standards of the time, *Woman Reclining on a Chaise Longue* seems, to modern eyes, one of the most vivid and erotic drawings of the female nude produced in the eighteenth century.

The drawing's sharp contrasts of black and red chalks are found in other types of drawings that date from around 1718, including *Studies of a Woman Wearing a Cap* (cat. no. 38) and *Woman in Black* (cat. no. 41). Although the present sheet was not among them, Count Tessin acquired four nudes from the series; as Tessin's second visit to Paris extended from September 1718 to March 1719, one can assume that the drawings were made just before or during this period.[3]

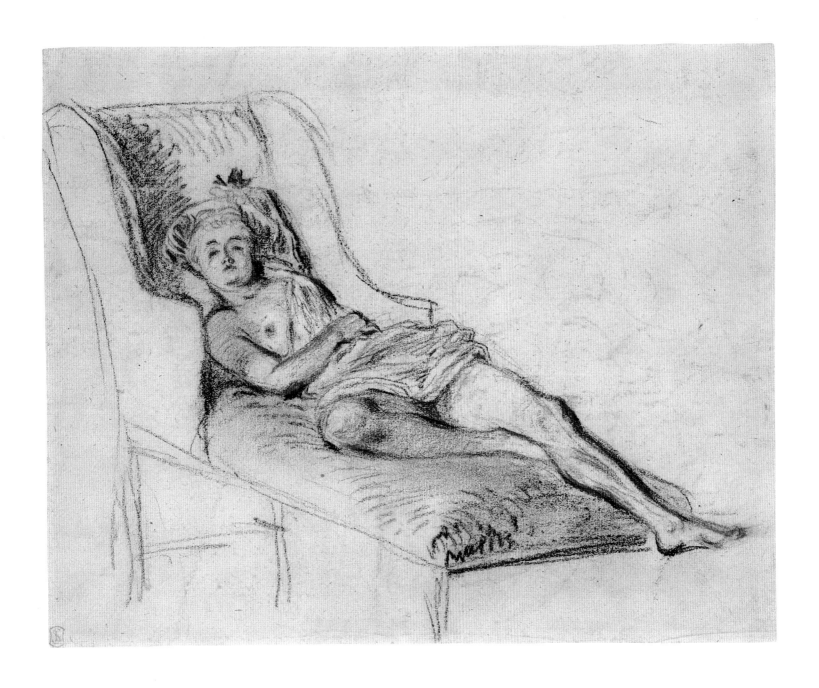

37 Young Woman Wearing a Chemise

ca. 1718
Red, black, and white chalks and stumping
on cream paper
6⅞ × 8⅛ in. (17.4 × 20.6 cm)

Thaw Collection; The Pierpont Morgan
Library, New York

Provenance John Postle Heseltine (1843–1929;
Lugt 1507 on the verso, at the upper right;
cat. 1900, no. 13; cat. 1913, no. 88, color
repr.); Adrien Fauchier-Magnan
(1873–1965), Paris; his sale, London,
Sotheby's, December 4, 1935, no. 67, repr.;
Siegfried Kramarsky, New York, in 1957;
Rosenberg and Stiebel, New York; Norton
Simon Foundation, Los Angeles

Exhibitions New York, Cleveland, Chicago,
and Ottawa 1975–76, no. 35; Washington,
Paris, and Berlin 1984–85, no. 68, repr.;
New York 1994–95, no. 24

Literature Engwall 1933, p. 7; Parker and
Mathey 1957, I, no. 527, repr.; Posner 1973,
pp. 26, 54, 61,101, note 61; Eidelberg 1978,
p. 19, note 40; Posner 1984, pp. 99, 283,
note 50; Rosenberg and Grasselli 1984,
pp. 59, 162, 164, 193; Börsch-Supan 1985,
no. 65, repr.; Grasselli 1985, p. 44; Roland
Michel 1985, p. 916; Grasselli 1987a, p. 368,
no. 277, fig. 453; Grasselli 1987b, p. 98,
fig. 7; Rosenberg and Prat 1996, II, no. 584

Notes
1. The other drawings are Rosenberg and
Prat 1996, II, nos. 578–83 and 585.
2. Caylus in Rosenberg 1984a, pp. 71–72.
3. Grasselli 1987b, p. 98.
4. Posner 1984, p. 99.
5. Eidelberg first made this observation in
Eidelberg 1978, p. 19, note 40; for
Vleughels's painting, see Hercenberg 1975,
no. 87.

Young Woman Wearing a Chemise is one of a group of eight intimate studies of naked or lightly draped women that has been associated with an anecdote recounted by Caylus in his life of Watteau.[1] Caylus reported that in his youth he rented rooms where he, Watteau, and their friend the amateur artist Nicolas Hénin would retire and draw undisturbed from the hired model.[2]

While several of these private studies were rapidly—even brutally—sketched in two chalks and obviously completed on the spot in a single brief session (see cat. no. 36), the present study is worked to a higher degree of finish in *trois crayons*. Sprawled on the floor with her chemise slipping unselfconsciously off her shoulder and riding up her thighs, the model artfully assumes a compact, spiraling pose to completely natural effect. Studying her from a height, Watteau created a figure of great plasticity and gave his composition a strong diagonal orientation that generates a remarkable sense of simultaneous dynamism and repose. Her figure is drawn principally in soft, crumbly black chalk, with red chalk confined largely to her face, hands, and toes, and white is used to highlight the sheen of her flesh and the seductive line of her shin. The extensive smudging of black and red chalks in the model's flesh, and sharp accents of color in her fingers, hair, and the bows on her sleeves, all heighten the effect of a drawing "permeated by light," a characteristic of the artist's later drawings.[3] Watteau responded with freshness and immediacy to his model, viewing her from an unusual perspective and foreshortening her figure in a way that defies convention but is, nevertheless, visually convincing. What he saw, and aimed to express, "is the voluptuousness of the female body as it surrenders to relaxation, curls or stretches, and turns with feline sensuality."[4]

The *Young Woman Wearing a Chemise* was not reproduced in *Les Figures de différents caractères* or introduced into any of Watteau's paintings, no doubt because of its erotic subject matter, but it did provide the source of inspiration for the figure of a nymph in the *Telemachus on the Island of Calypso* (private collection), a painting by Watteau's friend Nicolas Vleughels (1668–1737) that is dated 1722.[6]

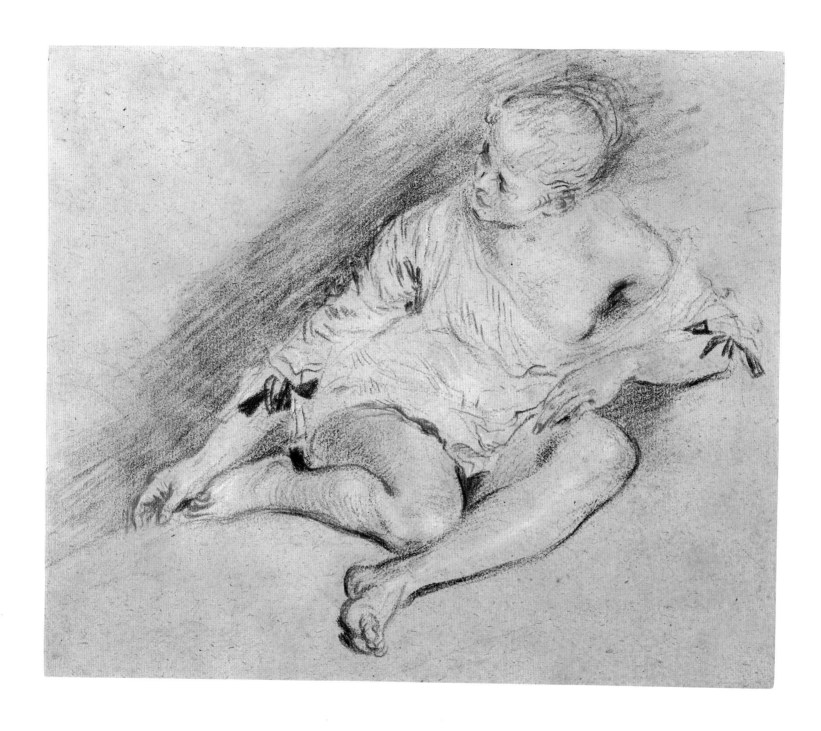

38 Studies of a Woman Wearing a Cap

ca. 1718
Black and red chalks, heightened with white, on paper
4¼ × 8⅛ in. (18.4 × 20.6 cm)
The Metropolitan Museum of Art, New York; Bequest of Theresa Kuhn Straus, in memory of her husband, Herbert B. Straus, 1978 (1978.12.3)

Provenance Antoine-Joseph Dezallier d'Argenville (1680–1765; paraph Lugt 2951 and no. *3273*, in brown ink, at the lower right); his sale, Paris, January 18–28, 1779, part of no. 391 (40 *livres* to Lenglier). Mrs. B.M. Ferrers and others sale, London, Sotheby's, May 13, 1931, no. 84, repr.; Mr. and Mrs. Herbert N. Straus, New York

Literature Goncourt 1875, under no. 762; Schéfer 1896, pp. 185–86, repr.; Parker and Mathey 1957, II, no. 597, repr.; Bean and Turčić 1986, no 332; Grasselli 1994b, p. 51; Labbé and Bicart-Sée 1996, p. 324, no. 3273, repr.; Rosenberg and Prat 1996, II, no. 603

Notes
1. The counterproof is illustrated in Rosenberg and Prat 1996, II, fig. 603a.

These two sketches of a model wearing different headdresses achieve a monumentality rarely found in Watteau's drawings of women. The broad, rather rough technique (especially in the drapery), heavy use of black chalk, and application of the stump to the blacks (most evident in the model's hair in the study on the left) link the drawing to some of Watteau's studies of a nude model (cat. no. 36) that can also be dated to around 1718.

Neither of the sketches was employed in any of Watteau's known paintings, but the figure in profile was engraved, in the original direction, by Pierre Filloeul for his *Livre de différents caractères de têtes, inventez par Watteaux* (pl. 12). A beautiful counterproof of the sheet, in a private collection, was pulled before the original drawing was trimmed and includes the top of the model's cap in the right-hand sketch; it also reproduces the horizontal crease that runs above the lower margin.[1] The handwritten inventory number and paraph in the lower right corner of the present sheet is the mark of the collector Dezallier d'Argenville, who also owned *Two Men Standing* (cat. no. 33).

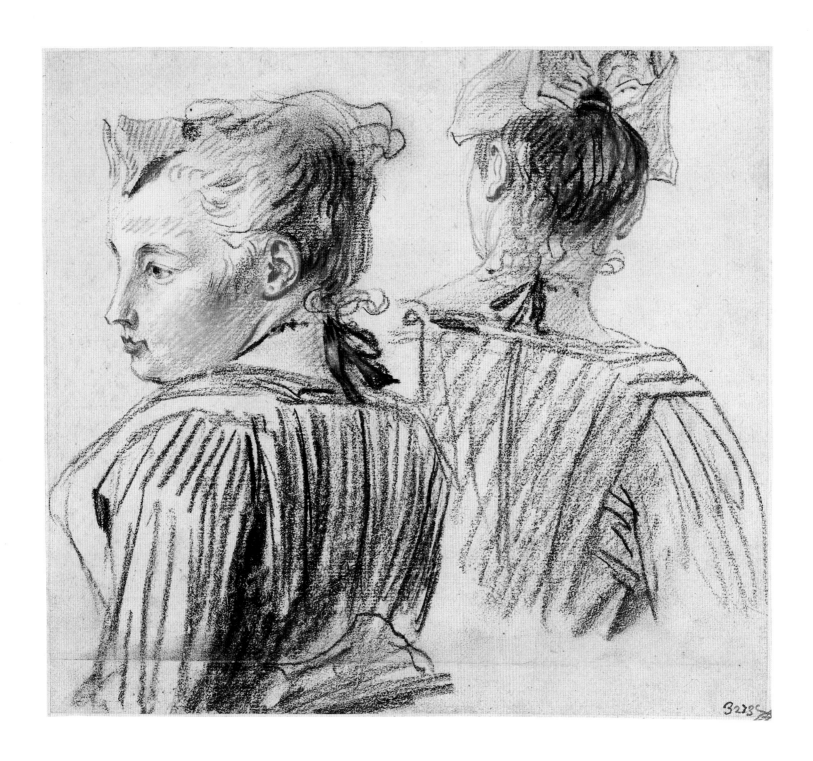

39 Young Man Wearing a High Hat

ca. 1718
Red and black chalks on cream paper
7½ × 6⅛ in. (19 × 15.5 cm)
Private collection

Provenance William Mayor, London (died in 1874; Lugt 2799 at the lower right); John Postle Heseltine (1843–1929); Dr. Tuffier; Penin de la Raudière, Paris, in 1957; Jean-Pierre Selz, Paris

Literature Goncourt 1875, pp. 27, 294, under no. 640; Fourcaud 1901, p. 341 and note 1; Parker 1931, p. 26, and note 4, p. 27; Parker and Mathey 1957, II, no. 736, repr.; Rosenberg and Grasselli 1984, p. 378, fig. 9; Grasselli 1987a, pp. 361–62, no. 251, fig. 443; Rosenberg and Prat 1996, II, no. 611

Notes
1. For the painting, see Rosenberg and Grasselli 1984, no. P53.
2. Rosenberg and Prat 1996, II, nos. 445, 489, and 491.
3. Rosenberg and Grasselli 1984, no. P62; for the dating of the drawings with graphite, see Grasselli 1987a, pp. 376–77.

This endearing sketch is a study for *The Shepherds* (*Les Bergers*; fig. 90), a painting generally dated to around 1718; in the picture, the wide-eyed young man in the conical cap gazes out from between the heads of a shepherdess and an old man playing bagpipes to watch a couple dancing.[1] There are several other studies for this painting, each using graphite in a similarly incisive manner.[2] Although Watteau had occasionally employed graphite in earlier drawings, he began to use it again in studies that date from around the time he was painting the second, more robust version of *The Embarkation to Cythera* (Berlin, Charlottenburg Palace) for Jullienne; that is, around 1718.[3]

With his squashy, cone-shaped bonnet, the boy could easily be a figure of ridicule, but Watteau invests him with empathy, portraying his shy curiosity with great tenderness. With the finest and most evanescent strokes of red and black chalks and graphite, Watteau vividly defines his figure's three-dimensional form, casting the boy's face and left shoulder in translucent shadows and brilliantly illuminating his cap and right shoulder. As he often does, Watteau makes cunning use of the empty page, here garnering it to suggest a wall over which the boy peers. It is the boy's left hand alone that emerges above it, the sanguine modeling of the fingers projecting forward from the black shadow of his shoulder. Although it is one of the drawing's most striking features, the hand was eliminated from the final painting.

The drawing was etched, in reverse, by Laurent Cars for *Les Figures de différénts caractères* (no. 262).

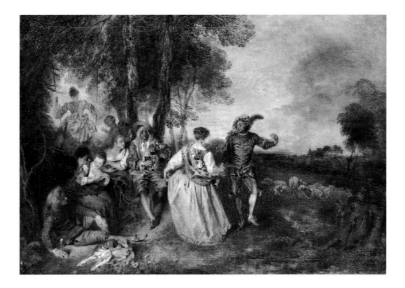

Figure 90
Antoine Watteau, *The Shepherds (Les Bergers),* ca. 1718. Oil on canvas, 22 × 31⅞ in. (56 × 81 cm). Stiftung Preußische Schlösser and Gärten Berlin-Brandenburg

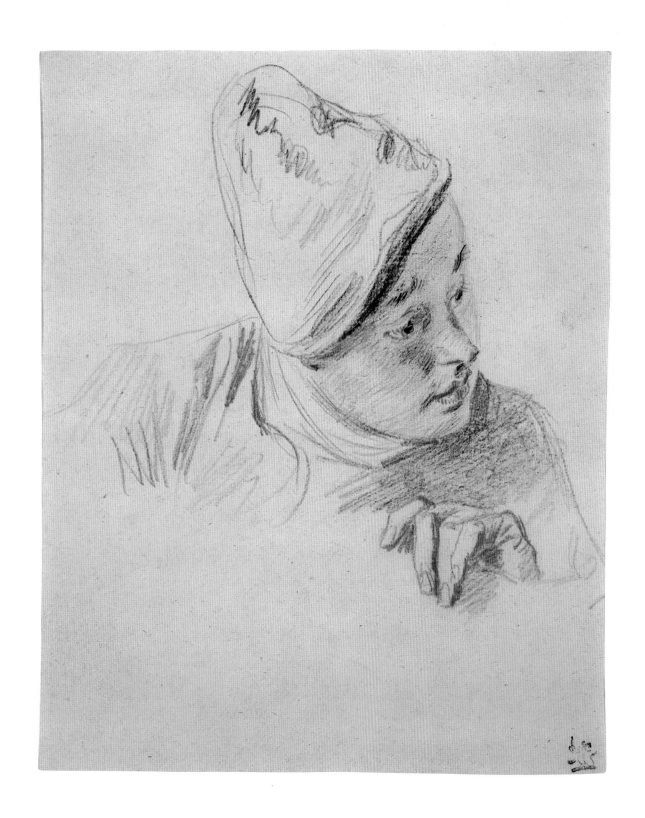

40 Head of a Man

ca. 1718–19
Red and black chalks on cream paper
5⅞ × 5⅛ in. (14.9 × 13.1 cm)
The Metropolitan Museum of Art, New York; Rogers Fund, 1937 (37.165.107)

Provenance Jules Niel (died around 1873), Paris; his daughter, Gabrielle Niel; Marquis de Biron (*ca.* 1860–1939); her sale, Paris, Galerie Georges Petit, June 9–11, 1914, no. 63, repr.

Exhibition Washington, Paris, and Berlin 1984–85, no. 110

Literature Parker and Mathey 1957, II, no. 726, repr.; Mathey 1959a, pp. 36, 76, note 77, repr.; Mathey 1959b, fig. 77; Huyghe 1968, repr. p. 6; Pouillon 1969, repr. p. [42]; Ferré 1972, I, p. 204, fig. 150; Eckardt 1973, under no. 11, repr.; Eidelberg 1977, p. 23; Posner 1984, pp. 208, 225, color pl. 49, p. 288, note 16; Roland Michel 1984a, pp. 140, 143, color pl. XXX; Rosenberg and Grasselli 1984, pp. 60, 364 fig. 8, p. 365; Börsch-Supan 1985, no. 120, repr.; Bean and Turčić 1986, no. 333; Grasselli 1987a, pp. 375–76, 384, note 14, no. 284, fig. 465; Grasselli 1994b, p. 51; Rosenberg and Prat 1996, II, no. 615

Notes
1. Rosenberg and Grasselli 1984, no. P49.
2. For a summary of the lengthy literature on Mezzetin, see Rosenberg and Grasselli 1984, no. P49.
3. Adhémar 1950, p. 100.
4. As Grasselli has written, "the guitar-playing actor, whose serenade falls on deaf ears, may well be considered a worshipper of sorts." Rosenberg and Grasselli 1984, no. D110.
5. Rosenberg and Prat 1996, II, no. 627.

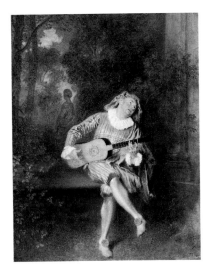

Figure 91
Antoine Watteau, *Mezzetin*, 1718–20. Oil on canvas, 21¾ × 17 in. (55.2 × 43.2 cm). The Metropolitan Museum of Art, New York; Munsey Fund, 1934

One of Watteau's most moving and expressive studies, this famous drawing provided the model for the head of the *commedia dell'arte* character Mezzetin in a painting of the same name (fig. 91), also in the Metropolitan Museum of Art, New York.[1] The drawing exudes such a vivid sense of life and (unusually for Watteau), such a resonant and bare display of its subject's emotional and psychological state, that for years scholars have attempted to identify the sitter with one of the contemporary actors—Angelo Costantini and Luigi Riccoboni among them—closely associated with the role.[2] However, Watteau's model posed for him on other occasions, and Adhémar was certainly right in asserting that the model represented is "one of his friends whose name we shall undoubtedly never know."[3]

Although Watteau did not generally make drawings with particular compositions in mind, the study for *Mezzetin* seems to be an exception. The unusual position of the model's head, his upturned glance and the particular way light falls across his face all suggest that Watteau had already laid out the composition of his painting and made the study in order to work out the final details of his subject's expression and pose; the faint red chalk lines around the head indicate the position of the large beret that the actor wears in the painting.

The quasi-religious aspect of the drawing has often been noted, due in part to the heavenward roll of his upturned eyes, so reminiscent of the expression of saints in Baroque altarpieces. Mezzetin's face expresses an aching but ecstatic longing for which the painting provides a context, the sentimental valet pouring out his heart in a serenade to an unseen woman.[4]

The painting has been dated almost unanimously to 1718–20. Watteau's combination of sooty black chalk, greasy orange-red sanguine, and stumping occurs in other drawings of this period, including some of the studies of female nudes (see cat. no. 36) and a portrait study of the two daughters of the dealer Pierre Sirois.[5] But the gentle fall of light on Mezzetin's Rubensian face, the nuanced modeling of his glowing flesh, the remarkable, foreshortened perspective of his features, and the sharp, dense accents on his parted lips and piercing eyes serve to render this portrait of Love's martyr exceptional in Watteau's œuvre, and an unsurpassed image of romantic aspiration and torment.

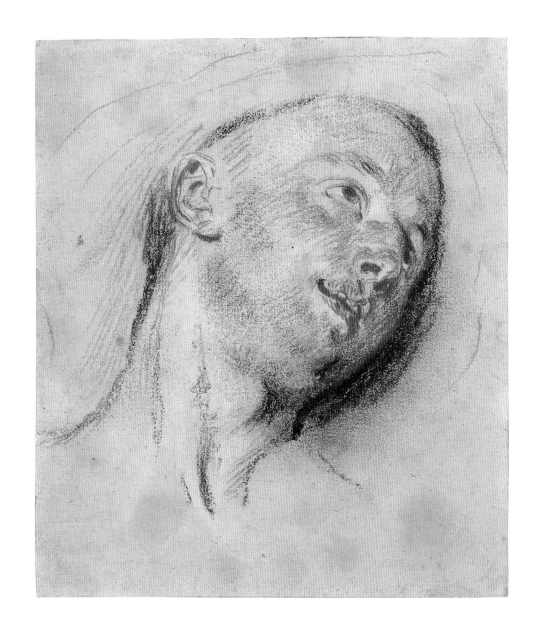

41 Woman in Black

ca. 1718–19
Black and red chalks and stumping on cream paper
7¾ × 7¹⁄₁₆ in. (19.7 × 17.9 cm)
Sterling and Francine Clark Art Institute, Williamstown, Massachusetts (1955.1831)

Provenance Sold after the death of Malbeste, draftsman–engraver, Paris, April 1, 1844, no. 118; perhaps Daniel Saint (1778–1847); perhaps his sale, Paris, Hôtel Drouot, May 4–7, 1846, part of no. 190; William Mayor, London (died in 1847); his sale, Paris, Hôtel Drouot, November 21–22, 1859, no. 158 (141 francs); Paul Barroilhet, Paris (1805–1871); his sale, Paris, Hôtel Drouot, April 2–3, 1860, no. 145, under the title *La Jeune Veuve* (100 francs); John Postle Heseltine (1843–1929; cat. 1917, no. 38, repr.); Colnaghi, London; Robert Sterling Clark (1877–1956), in 1919

Exhibition Washington, Paris, and Berlin 1984–85, no. 117

Literature Goncourt 1875, under no. 630; Mantz 1892, p. 114, no. 76; Bouvy 1921, p. 17 and note 1; Parker and Mathey 1957, II, no. 618, repr.; Haverkamp-Begemann, Lawder, and Talbot 1964, no. 52; Jean-Richard 1978, under no. 118; Rosenberg and Grasselli 1984, p. 202; Grasselli 1987a, p. 367, no. 262, fig. 452; Rosenberg and Prat 1996, II, no. 619

Notes
1. Rosenberg and Prat 1996, II, nos. 451, 567, 568, and 600.
2. Rosenberg and Prat 1996, II, nos. 578 and 581.
3. Rosenberg and Prat 1996, II, no. 600.

Watteau seems to have been captivated by the mysterious, slightly funereal image of a woman swathed in a black mantle, because he made at least four other drawings of the subject in addition to the present, monumental sheet in the Clark Art Institute.[1] This drawing is essentially a study of drapery and the effects created by light—both direct and reflected—shimmering off black satin. Watteau's interest in the translucent effects of shadows as they fall across the face, also found in *Young Man Wearing a High Hat* (cat. no. 39), is further explored here, where hints of color emanate from underneath the black chalk.

The combination of red and black chalks with stumping has analogies with some of the most refined of studies of female nudes, such as the British Museum sketches.[2] A seated, full-length study of the same model wearing the same black mantle, in the Musée Condé, Chantilly,[2] also bears a portrait drawing of Watteau's friend Nicolas Vleughels that is similar in handling to the portrait study for *Mezzetin* (cat. no. 40); those drawings, like the present sheet, all seem to date from around 1718–19.

The *Woman in Black* does not appear in any of Watteau's paintings, but it was etched in reverse by François Boucher for *Les Figures de différents caractères* (no. 252; see fig. 44, p. 45).

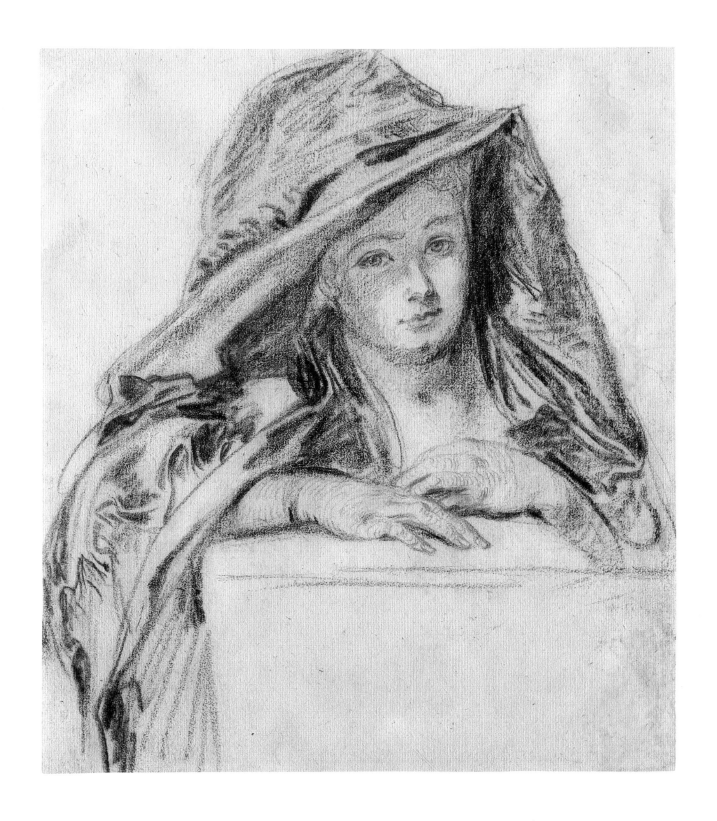

173

42 Standing Actor Spreading His Cape

ca. 1719–20

Two shades of red chalk on cream paper
6¾ × 5⅛ in. (17 × 13 cm)

The Minneapolis Institute of Arts; The John R. Van Derlip Fund (69.88)

Provenance Walter Schatzki, New York, before 1957; Mrs. O'Donnell Hoover, New York

Exhibitions Toronto, Ottawa, San Francisco, and New York 1972–73, no. 155; Washington, Paris, and Berlin 1984–85, no. 121

Literature Parker and Mathey 1957, II, no. 681, repr.; Eidelberg 1977, p. 34; Rosenberg and Grasselli 1984, pp. 56, 58, 116, 197, 201, 203, 442, fig. 8, p. 444; Börsch-Supan 1985, no. 117, repr.; Nochlin 1985, p. 72, repr.; Grasselli 1987a, pp. 384, notes 14 and 15, pp. 385, 387–89, 405, no. 293, fig. 478; Rosenberg and Prat 1996, II, no. 623

Notes

1. Rosenberg and Grasselli 1984, no. P71. Undoubtedly some of the figures in the painting are based—as was the artist's usual practise—on earlier sketches from his bound books of studies; see Rosenberg and Prat 1996, I, no. 219, and II, no. 647.
2. Rosenberg and Prat 1996, I, no. 179 (verso), and II, nos. 621, 622, and 552.
3. Rosenberg and Prat 1996, II, no. 636.
4. Rosenberg and Camesasca 1970, no. 197.
5. Rosenberg and Grasselli 1984, no. D121.

This elegant sketch of an actor flourishing his cape can be dated with some precision, since it served as a study for *The Italian Comedians* (*Les Comédiens italiens*; fig. 92), a painting made for the British physician Richard Mead during Watteau's year in England (1719–20).[1] While Watteau did not, as a rule, make studies with particular compositions in mind, the unusual ambition of *The Italian Comedians*, and its tightly interwoven composition, seems to have demanded a certain amount of specific preparation. In addition to figure studies, Watteau devoted four of his rare compositional studies to working out the picture's complex layout (fig. 7, p. 19).[2]

Standing Actor Spreading His Cape is a study for the amorous actor on the far left of the painting, who leans over to steal a kiss from a decidedly ambivalent woman. The drawing trails in its lower section—an area obscured in the painting by the figures of seated children; and the figure is dramatically lit from the ground in a way that anticipates the illumination by theatrical footlights in the final composition. The broad and confident handling of the simplified forms and the comparative abstraction of the draperies are reminiscent of another drawing of a man in a cape (Paris, private collection),[3] who reappears in *Peaceful Love* (*L'Amour paisible*; lost),[4] the second painting that Watteau made for Dr. Mead. It seems plausible, as Grasselli has suggested, that both drawings were actually executed in England.[5]

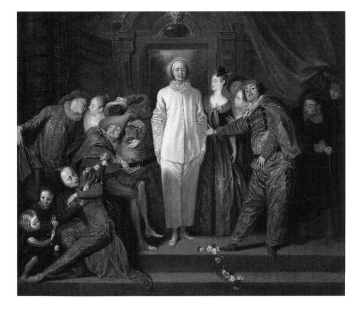

Figure 92
Antoine Watteau,
The Italian Comedians (*Les Comédiens italiens*),
ca. 1719–20.
Oil on canvas, 25⅛ × 30 in. (63.8 × 76.2 cm).
National Gallery of Art, Washington, D.C.; Samuel H. Kress Collection

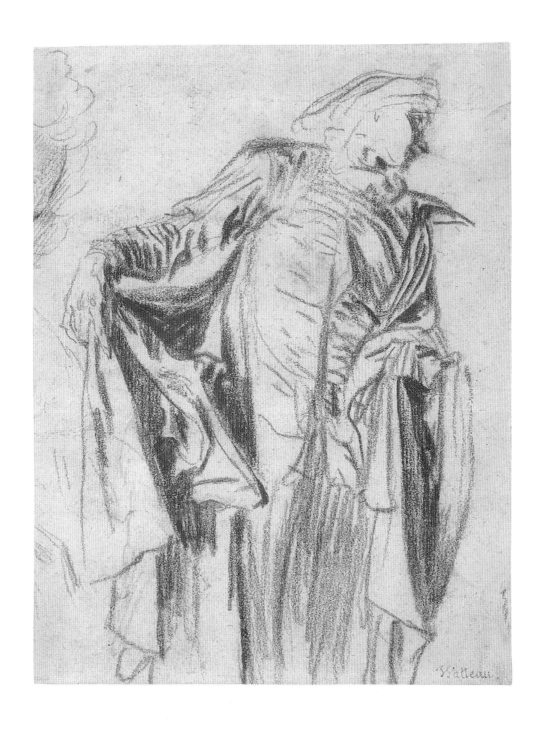

43 Head of a Man Wearing a Hat, with Hand Studies

ca. 1719–20
Black and red chalks on cream paper
6½ × 9⅜ in. (16.5 × 23.8 cm)
Private collection

Provenance Comtesse Martine Marie Pol de Béhague, Paris (1870–1939); her sale, London, Sotheby's, June 29, 1926, no. 123, repr.; Agnew, London; Louis Colville Gray Clark, London (1881–1960); Colnaghi, London; Sir David Eccles, London, in 1957; Jean Davray, Paris, in 1963; Harry A. Brooks, New York, in 1968; Knoedler, New York; Norton Simon Foundation, Los Angeles, from 1970; Artemis, London, in 1976–77 (cat. 13, repr.); Eugene Victor Thaw, New York; private collection

Exhibitions London 1948, no 33; London 1950, no. 110; London 1955, no. 232; London 1968, no. 767; Claremont and Sacramento 1976, no. 63; London 1976–77, no. 13; New York 1999a, no. 6

Literature Parker and Mathey 1957, II, no. 753, repr.; Posner 1984, p. 291, note 66; Roland Michel 1984a, pp. 89–90; Rosenberg and Grasselli 1984, pp. 174, 439; Rosenberg and Prat 1996, II, no. 640

Notes
1. Rosenberg and Prat 1996, I, no. 155 (verso) and II, no. 487, respectively.
2. Rosenberg and Grasselli 1984, no. P70.

Watteau's model appears in two other drawings by the artist—a portrait study in the Musée Jacquemart-André, Paris, and a sheet of studies in the Musée du Louvre, Paris, associated with the Berlin *Embarkation to Cythera*—both of which appear to date from 1718.[1] However, Watteau's sitter also served as the model for the principal actor in *French Comedians* (*Comédiens françois*; Metropolitan Museum of Art, New York), a painting that dates from very late in the artist's career, around 1719–20.[2] Although the drawing cannot be regarded as preparatory for the painting—the position of the model's head is entirely different—it, too, is a late work and may have been made at the time Watteau was undertaking *French Comedians*. The hand study on the right side of the sheet, while without a direct corollary in the painting, exhibits a certain theatrical flourish, which suggests that it, too, might have been a discarded idea for the same picture.

The smudgy application of black chalk in hair and hat, soft black shadows around the hand on the right, and very delicate touches of red chalk in the lightly accented face are characteristic of Watteau's atmospheric late style; even the model's introspective expression is typical of the artist's final, understated drawings. Remarkable, however, is the startling three-dimensionality of the almost spectral hand in orange-red chalk that reaches out from the left side of the page. It appears in none of Watteau's known paintings, finds no ready comparison in his drawings, and by its insistent, imploring gesture seems alien to his artistic sensibility. Could it be a late example of the artist copying from an unidentified Italian old master?

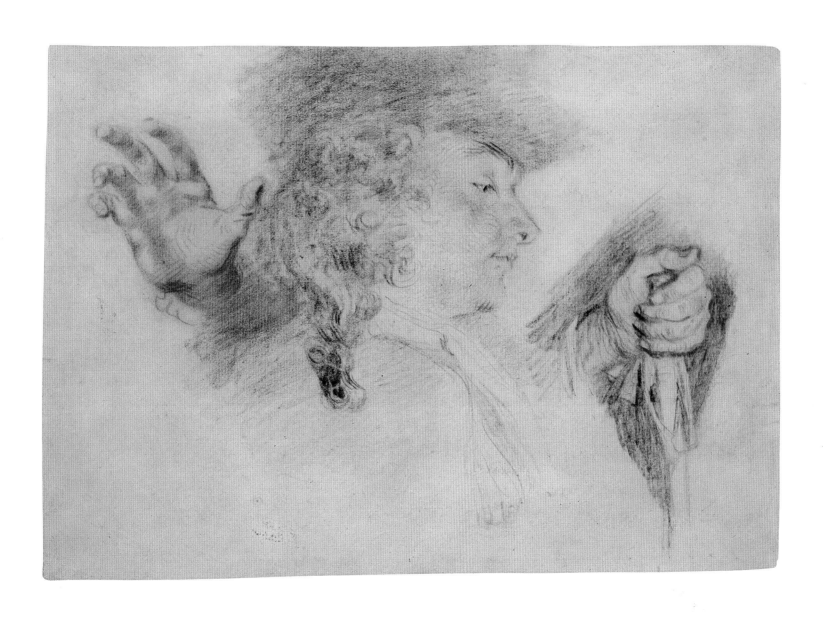

44a Three Studies of a Woman's Head and a Study of Hands (recto)
44b View of a House, a Cottage, and Two Figures (verso)

ca. 1719–20
Recto, red chalk and graphite with touches of black chalk and red wash on cream paper
Verso, red chalk on cream paper
7 × 6¼ in. (17.9 × 15.9 cm)
National Gallery of Art, Washington, D.C.; Samuel H. Kress Collection (1963.15.34a)

Provenance Perhaps Charles Gasc (born around 1850; appears to bear his mark, Lugt 544, at the lower left). Lugt Tabourier sale, Paris, Hôtel Drouot, June 20–22, 1898, no. 144, Richard S. Owen, Paris; Samuel Henry Kress (1863–1955), New York, in 1937

Exhibition Washington, Paris, and Berlin 1984–85, no. 36

Two of the three sketches on the recto of this sheet in Washington—the woman with crossed hands on the upper left, and the woman looking up on the lower right—were used as studies for figures on the right side of *The Dancing Couple* (*La Contredanse*; fig. 93).[1] The painting, which was rarely seen until its recent appearance at public auction, has often been dated to around 1715–16, but, on closer examination, it is clear that it is a later painting, executed around the time of Watteau's trip to London, that is, 1719–20.[2] In its large figures, pastel palate, and manner of evoking the shimmer of silk skirts with dense white highlights, *La Contredanse* can be compared to *La Promenade* (Bryn Mawr, private collection), a painting that was engraved by Philippe Mercier and shares a preparatory study with *The Italian Comedians*, and may, like the latter picture, have been made in London.[3]

The restrained mood of the three sketches—probably of a single model—the understated handling of the chalks, and the use of a more complex mix of media, including graphite and sanguine wash, suggest a comparable date for the drawings. Grasselli has observed that another, less carefully articulated but full-figure study for the woman with her hands crossed is in the Ecole des Beaux-Arts, Paris[4]; she further notes that Watteau probably made the Washington studies while *La Contredanse* was already in progress, to fix the finer details of the model's pose and expression.

The red-chalk landscape with a house, a cottage, and two figures on the verso of the sheet was discovered only in 1980 when it was removed from its old mount. It is of particular interest because it is one of the comparatively small number of landscape drawings securely attributed to Watteau to have come down to us; like the present study, several of these are on the reverse of other drawings.[5] The Washington landscape was etched by François Boucher for *Les Figures de différents caractères* (no. 195), and comparison with the print (fig. 94) makes evident that only slightly more than half the original drawing survives: the sheet was cut some years after Watteau's death, presumably to improve the *mise-en-page* of the recto. Interestingly, the sheet proves that Watteau did not mount all of his studies in bound books, since the recto was available to him when he composed *La Contredanse* and the verso was still visible more than five years after his death when Boucher reproduced it.

Of the more than a dozen "pure" landscapes included in *Les Figures de différents caractères* (all of them etched by Boucher), the

Figure 93. Antoine Watteau, *The Dancing Couple* (*La Contredanse*), *ca.* 1719–20. Oil on canvas, 17¾ × 21¾ in. (45.1 × 55.3 cm). Private collection

Literature Goncourt 1875, under no. 572;
Parker and Mathey 1957, II, no. 781, repr.;
Eisler 1977, pp. 300–01; Jean-Richard 1978,
under no. 101, repr.; Roland Michel 1984a,
pp. 87–88, 177, 253, note 33; Rosenberg and
Grasselli 1984, pp. 59–60, 71, 148, 176, 196,
353, fig. 7 (detail); Börsch-Supan 1985,
no. 84, repr.; Grasselli 1987a, pp. 240,
note 10, p. 410, note 55, pp. 427–28,
no. 257, fig. 519 (recto) and 520 (verso);
Grasselli 1987b, pp. 99–100, fig. 10 (recto)
and 12 (verso); Roland Michel 1987b,
p. 119, note 2; Opperman n.d., p. 50;
Rosenberg and Prat 1996, II, no. 620

Notes
1. Rosenberg and Camesasca 1970, no. 131.
2. It appeared for sale at Sotheby's, New
York, May 21, 1998, lot 125; it went unsold.
3. See Grasselli 1987a, pp. 391–96.
4. Rosenberg and Grasselli 1984, under D36;
the drawing is Rosenberg and Prat 1996, II,
no. 481. It is worth observing that the Ecole
des Beaux-Arts sheet also contains a study for
the figure of Harlequin in *The Italian
Comedians*, a painting securely datable to
Watteau's trip to England.
5. Other landscape studies on the reverse of
figure drawings are Rosenberg and Prat
1996, I, nos. 18, 28, 135, 136, 138, and II,
no. 575.
6. Lost landscapes etched for *Les Figures de
différents caractères* are Rosenberg and Prat
1996, III, nos. G1, G6, G29, G34, G37, G59,
G66, G90, G93, G98, G100 and G105.
7. Grasselli 1987b, pp. 99–101.

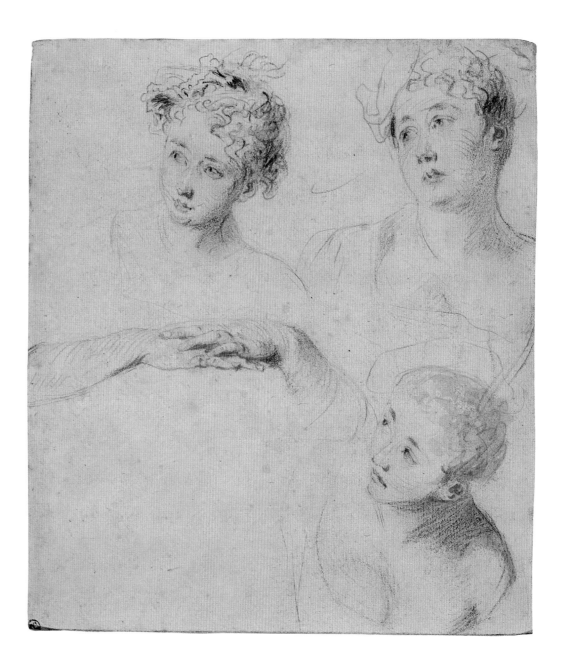

Washington study is the only one to have survived in the original, albeit truncated,
form.[6] It is difficult to date since there are so few landscape drawings to provide
comparisons, and most of these are unconnected to paintings. The landscape need not
have been drawn at the same time as the sketches of women on the reverse, of course,
and Rosenberg and Prat believe that it is from an unspecified earlier date. It may depict

Figure 94. François Boucher, after Watteau, *Landscape.* From *Les Figures de différents caractères* (no. 195), *ca.* 1726–28. Engraving, 6¾ × 11¾ in. (17.1 × 29.9 cm). Musée de Louvre, Paris

a view of Les Porcherons, a district on the edge of Paris situated near Crozat's *hôtel*, where Watteau once lived, though the dates of his residence are uncertain. The soft, atmospheric handling of red chalk in the Washington study suggests analogies to Watteau's late figure drawings, as Grasselli has argued[7]; however, in the absence of any securely datable landscape studies from nature, a date for the present sketch can only be offered tentatively.

45 Five Studies of a Dog

ca. 1720
Red and black chalks on cream paper
7 × 11¼ in. (17.8 × 28.5 cm)
Inscribed in red chalk, lower right: *Watteaux*

Collection Andrea Woodner and Dian
Woodner, New York (WD-504)

Provenance Jean-Pierre-Antoine Tassaert
(1727–1788; Lugt 2388 on the verso, with an
inscription in brown ink: *I n° 7/ Tassaert*).
Wolf Bürgi. Berne (his mark, not cited by
Lugt, on the verso). Ian Woodner, New
York (1903–1990)

Exhibition New York 1990a, no. 98

Literature Rosenberg and Prat 1996, II,
no. 666

Notes
1. The drawing with three studies of a dog is
in the Musée Cognacq-Jay, Paris; Rosenberg
and Prat 1996, II, no. 598. *The Hunt
Meeting* is in Rosenberg and Camesasca 1970,
no. 207.
2. See Huyghe and Adhémar 1950, no. 198,
and Ingamells 1989, no. P416. The idea that
The Hunt Meeting was painted as a gift to
celebrate the wedding of Jean de Jullienne
on July 22, 1720, was first proposed by
Alfassa 1910; it is supported by a letter dated
September 3, 1720, that purports to be from
Watteau to Jullienne in which the painting is
discussed. The letter is one of three
purporting to be by Watteau that were
transcribed by Charles de Vèze and published
in the *Archives de l'art français* in 1857. The
letters, which are lost and have never been
reproduced in facsimile, were greeted with
scepticism at the time of their publication
and have subsequently been regarded with
doubt. Until the originals are recovered it is
impossible to know if they were written by
Watteau or are forgeries.
3. Recently, Roland Michel (1998) has
questioned whether the Woodner sheet
really dates from so near the end of
Watteau's life; to our eyes, however,
Rosenberg and Prat's dating to 1720 seems
convincing.

Watteau's few surviving studies of animals reveal him to have been as keen and sympathetic an observer of animal behavior as of human nature. The five studies of a dog on the present sheet were not precisely transposed into any of Watteau's surviving paintings, but they are handled similarly to a sheet of three red-chalk studies of a different dog that was employed in *The Hunt Meeting* (*Rendez-vous de chasse*; London, Wallace Collection),[1] a large painting that has generally been dated near the end of the artist's career, and might have found its inspiration in British sporting art encountered by Watteau on his visit to England in 1719–20.[2] Several dogs of different breeds appear in *The Hunt Meeting*, and a black hound on the left of the painting seems to be based on the same model studied in the Woodner drawing; it seems probable that the present sketches are unused studies for the painting.[3]

The drawing is styled in Watteau's final manner: lightly and rapidly sketched in a richly pictorial blend of sooty black and brick-red chalks, several of the artfully arranged studies are so delicate as to appear almost phantom. They nevertheless project a powerful sense of life, and the dog who looks out of the sheet with hollow eyes is possessed of a haunting presence not easily forgotten.

46 Study of the Head of a Young Shepherd in Profile

ca. 1727–28

Red, black, and white chalks on cream paper
10 × 7 in. (25.5 × 17.7 cm)

Private collection

Provenance J.F. Gigoux (Lugt 1164); Monaco, Christie's, June 30, 1995, no. 92; Thomas Agnew & Sons, London

Notes

1. See Ananoff 1976, I, no. 46 (called *Femmes à la fontaine*).

2. A drawing in red and black chalks in the Musée des Beaux-Arts, Orléans, inscribed with Boucher's name, is the only known copy of one of Bloemaert's drawings that can be given to Boucher with certainty; Bloemaert's sketch is in the Hermitage, Saint Petersburg. See Slatkin 1976, pp. 248–49, pl. 2; and Schreiber Jacoby 1986, p. 251, no. II.C.1. Boucher also published a suite of twelve etchings after drawings by Bloemaert that was announced in the *Mercure de France* in June 1735, but may have been made some years earlier; see Jean-Richard 1978, nos. 176–86.

3. The availability of Bloemaert's drawings in Rome has been suggested by Laing in Laing, Rosenberg, and Marandel 1986, p. 113; see the copies of Bloemaert's sketches by Pierre Subleyras in the Louvre (inv. 34912, 34912 bis) as examples.

This unpublished sheet bears studies for the head and arm of a seated shepherd in *The Fountain*, (Louisville, Speed Art Museum)[1] and can be dated to the period around 1727–28, when the young Boucher became something of a specialist in rural genre paintings in the Dutch taste, in which peasant figures styled on the manner of Bloemaert were set into vaguely Italianate landscapes.

The Fountain was probably painted just before Boucher's departure for Italy or perhaps shortly after he had arrived there—the trip having been financed with money Boucher had earned etching Watteau's drawings for Jullienne. As the painting dates from the aftermath of Boucher's labors on *Les Figures de différents caractères*, it is possible that, in choosing to paint peasant scenes, Boucher might have been consciously turning his back on the rarified elegance of Watteau, the artist to whom he had devoted much of the previous few years. *The Fountain* instead takes as its model the earthier sensibility of Abraham Bloemaert, the Dutch Mannerist whose remarkably naturalistic studies of peasants and farm animals Boucher is known to have copied as well.[2] Certainly the eager face and strong limbs of the shepherd in the present drawing mirror those found in any number of sketches of rural youths by Bloemaert that circulated among Boucher's fellow students in Rome.[3] Nevertheless, when Boucher came to draw in the style of Bloemaert—even in his outright copies of Bloemaert's works—he did so in Watteau's medium. Such studies, including the present *Shepherd*, are executed in the two- or three-color chalk technique that he had developed when copying Watteau, and not in the pen, ink, and brown washes, or simple red chalk, in which Bloemaert worked almost exclusively. In the present drawing, Boucher analyzed the naked musculature of the boy's arm with the training of an academician, and was much more restrained and conventional in his integration of different colored chalks than Watteau ever was. The drawing is extroverted in handling and expression in a way that would have been alien to Watteau's more delicate and ambiguous sensibility.

47 Landscape with Figures

ca. 1730–33

Red chalk on vellum

12 × 19⅜ in. (30.5 × 49.3 cm)

The J. Paul Getty Museum, Los Angeles
(83.GB.200)

Provenance Earl Spencer, Althorp (Lugt 1530
at the bottom right); Maurice Fenaille;
Eugene Victor Thaw, New York

Literature Schreiber Jacoby 1986, p. 299,
no. III, E.6; Goldner and Hendrix 1992,
no. 58

Notes

1. Some of these early landscapes by Boucher
are themselves copies after Campagnola; see
Schreiber Jacoby 1979, pp. 261–72; Schreiber
Jacoby 1986, pp. 164–85 and no. III.E.3.
2. See Schreiber Jacoby 1986, pp. 299–300;
for Boucher's *Italian Fêtes* tapestries, see E.A.
Standen, *European Post-Medieval Tapestries and
Related Hangings in The Metropolitan Museum
of Art,* II, 1985, pp. 507–32.
3. Formerly in the collection of Jean Bloch.
4. See Schreiber Jacoby 1987, pp. 259–79;
also see Colin B. Bailey's essay in this book.

Almost all of Boucher's known landscape drawings from the early part of his career display his debt to those of Watteau. Of course, Boucher was deeply familiar with Watteau's style as a landscape draftsman, since he had been given the responsibility of etching all of the landscape drawings—a dozen in all—that were included in *Les Figures de différents caractères*. Like the present *Landscape with Figures*, which is by far the largest and most impressive of the group, most of Boucher's early landscapes are in red chalk alone and succeed in integrating aspects both of Watteau's copies after Campagnola and of his *plein-air* landscape sketches.[1] The winding road, country church with a towering steeple, and thatch-roofed *fabrique* that are prominent in the Getty drawing can all be found in Watteau's outdoor studies made in Les Porcherons (indeed, the cottage at the center of the drawing is very close to the one in cat. no. 44b). Yet the decorative massing of trees, with the undulating rise and fall of the land, as well as the rhythmic application of discrete strokes of red chalk to build up the composition are all indebted to Watteau's copies of Venetian landscapes, such as the *Landscape* from San Francisco (cat. no. 15). Of course, Boucher's distinctive handwriting is evident throughout the Getty drawing: his sawtoothed manner of evoking foliage is entirely different from Watteau's open gestural looping.

Beverly Schreiber Jacoby has observed that motifs from the *Landscape with Figures* reappear in the Beauvais tapestries *The Girls with Grapes* and *The Hunters*, two hangings in Boucher's series *Italian Fêtes* that were almost certainly designed by 1736.[2] A lost counterproof of the drawing, today known from an old photograph, could have aided the artist in determining how his design would look when it was reversed in the weaving.[3] However, it seems most unlikely that the original drawing would have been made specifically as a study for tapestries. Its large-scale, meticulous finish, and unusual and costly vellum support all suggest that it was made as an independent work of art—an early (and unexpected) example of the autonomous drawing that would become fashionable by mid-century.[4]

185

48a Seated Boy, and Studies of His Head and Hands (recto)
48b Seated Boy (verso)

early 1730s

Recto, two shades of red chalk and white heightening with border in pen and black ink, on brown laid paper

Verso, red and white chalks, with border in pen and black ink, on brown laid paper

13⅞ × 10⅝ in. (35 × 26.9 cm)

Recto, inscribed in an unknown hand, lower left, in pen and black ink, *L. Chardin*, over *F. Boucher* in graphite

National Gallery of Canada, Ottawa; purchased, 1983 (28217)

Provenance Tan Bunzl-De Rothschild, London, 1983

Exhibitions Vancouver, Ottawa, and Washington 1988–89, no. 53; New York 1999b

Literature Ananoff 1976, I, p. 233, no. 89, fig. 374; Schreiber Jacoby 1986, III.B.2

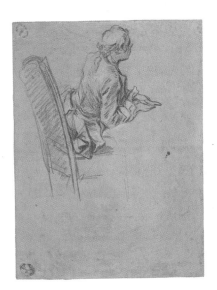

The four sketches on the recto and verso of this sheet all relate to the figure of a young boy in Boucher's *Of Three Things, Which Will You Do?* (*De trois choses en ferez-vous une?*; Saint-Jean-Cap-Ferrat, Musée Ephrussi de Rothschild).[1] The title surely referred to a sexually suggestive game, the meaning of which has been lost. In the painting, a boy—whose pose was first sketched in the present drawing—takes a young woman by the hand and gestures with his finger as he counts off the mysterious "three things." The recto of the drawing shows the boy in the pose he would assume in the painting, with a detailed study of his hands holding the hand of his beloved, and a more worked-up sketch of his head. The verso bears a rejected study of the boy seated in a chair and viewed from behind and at a distance.[2]

The style of both the painting and the drawing place them securely in the early 1730s, in the year following Boucher's return to Paris after his two-year study trip to Rome. Boucher was now a masterly draftsman: he had complete control of his chalks, and with the lightest and most rapid touches he sketched the boy's face, conveyed the torsion of his body, and evoked the flickering of light and shadow across his silk tunic. Like Watteau, he would rework shadowed areas in darker red chalk and add accents with the sharpened tip of his moistened chalk. Unlike Watteau, who drew from the live model for his own pleasure, Boucher was an academician who almost never posed a model without a particular composition in mind. Despite their apparent spontaneity, each of the Ottawa sketches was conceived and adjusted with an eye to its final destination, and it was Boucher's particular gift to be able to imbue his drawings with a freshness belying his many calculations.

Another drawing showing the torso and right arm of the same model in an open-necked blouse is in the Fogg Art Museum, Harvard: it is on the same paper stock, executed in the same red and white chalks, and was probably drawn in the same modeling session as these Ottawa sketches.[3] The Fogg drawing served as a study for *The Egg Merchant* (Hartford, Wadsworth Athenaeum), a painting of identical dimensions and format as *De trois choses en ferez-vous une?* and of a compatibly suggestive subject matter.[4] It seems plausible that, as the drawings were made simultaneously, the paintings might have been conceived as pendants.[5]

Notes

1. See Ananoff 1976, I, no. 88 bis.
2. The pose of the boy in the sketch on the verso, in particular, evokes images of Chardin's paintings of schoolboys spinning tops and building houses of cards, and no doubt led to the erroneous inscription of his name on the lower left of the recto. Boucher's drawing preceded Chardin's first genre paintings by at least a year or two; see Rosenberg 1979, pp. 187–91, nos. 71 and 75.
3. See Schreiber Jacoby 1986, no. III.B.2.
4. See Ananoff 1976, I, no. 90.
5. Alastair Laing, in Laing, Rosenberg, and Marandel 1986, p. 139, rejects the notion that the two paintings were intended as a pair, despite the fact that were paired in the late nineteenth century (admittedly, the two pictures had separate histories before they were united in 1874).

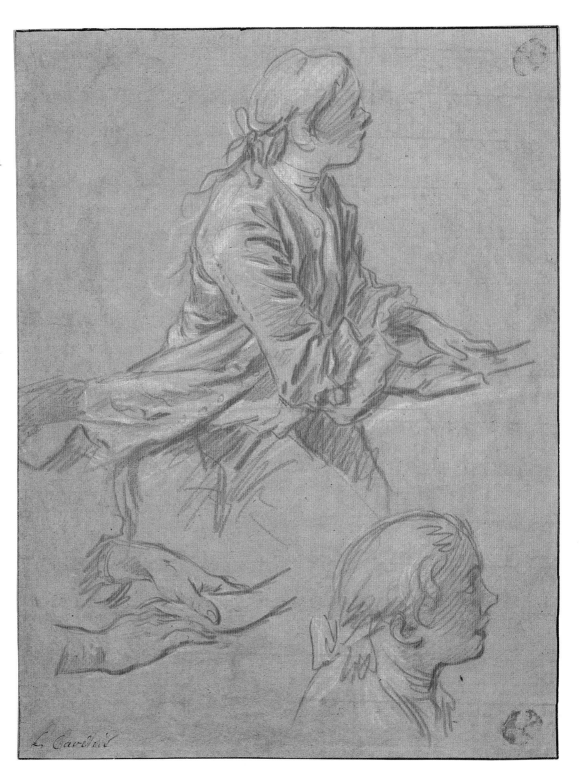

49 Study for "La Belle Cuisinière"

ca. 1734
Red and white chalks on buff paper
14¼ × 7½ in. (36.2 × 19.2 cm)
Berger Collection at The Denver Art
Museum (TL-17339)

Provenance G. Huquier; his sale, July 1, 1771,
lot 43 (bought by Larocet for 6 *livres*); Le
Pelletier collection, Paris; New York,
Christie's, January 30, 1997, lot 150

Exhibition Aspen 1998

Literature Michel 1906, p. 63, under no.
1135; Cailleux 1964, under no. 2; Ananoff
1976, I, no. 74/75, fig. 335; Jean-Richard
1978, under no 205; Burollet 1980, p 45;
Laing, Rosenberg, and Marandel 1986,
p. 148, under no. 21.

Notes

1. In addition to *La Belle Cuisinière*, there is
La Belle Villageoise, the original of which is
lost; at least two autograph replicas are
known, one in the Norton Simon Museum,
Pasadena (Ananoff 1976, no. 78), the other
with P. & D. Colnaghi, London; and *The
Kitchen Maid and the Young Boy* in the
collection of Dr. Feray, Sainte-Adresse
(Laing, Rosenberg, and Marandel 1986,
no. 28).

2. Laing, Rosenberg, and Marandel 1986,
no. 21.

3. See Laing, Rosenberg, and Marandel
1986, p. 145; also Jean-Richard 1978,
no. 205.

4. See Laing, Rosenberg, and Marandel
1986, p. 147; also Jean-Richard 1978,
no. 1589.

5. For example, *The Water Urn* (dated 1733)
and *The Washerwoman* in the
Nationalmuseum, Stockholm; see Rosenberg
1979, nos. 55 and 56.

6. Boucher owned Kalf's *Interior of a Cottage*
in the Musée du Louvre, Paris (inv. 1411);
see Burollet 1980, p. 45.

7. Burollet 1980, p. 43.

8. See Laing, Rosenberg, and Marandel
1986, p. 148; also Jean-Richard 1978,
no. 1520.

9. Bjurström 1982, no. 836; for the painting,
see Laing, Rosenberg, and Marandel 1986,
under no. 27, fig. 119.

In the early 1730s, shortly after returning to Paris from Rome, Boucher made a trio of mildly erotic kitchen scenes in the Dutch taste.[1] This drawing is a study for the standing figure of a young cook in the small panel painting *La Belle Cuisinière* (*The Pretty Cook;* Paris, Musée Cognacq-Jay), to whom an ardent boy on bended knee confides his passion.[2] The painting almost certainly dates from between 1732 and 1734, as an advertisement for Pierre Aveline's engraving that appeared in the April 1735 edition of the *Mercure de France* stated that the painting had been recently acquired by an Englishman and taken to London.[3] Another peasant interior by Boucher, *La Belle Villageoise* (*The Pretty Village Girl*), was engraved by Pierre Soubeyran and announced in the *Mercure* in June 1738 as the pendant to *La Belle Cuisinière*.[4] Charming and accomplished though they are, Boucher would quickly abandon such humble scenes, leaving the field open for the newest master of the genre, Chardin.[5]

No specific source for Boucher's painting has been found, but the beautiful still-life elements—the copper pots, wooden barrel, and vegetables—are reminiscent of pictures by Willem Kalf, one of whose still-life paintings Boucher is known to have owned.[6] The painting's moralizing symbols, such as the predatory cat, also have precedents in seventeenth-century Dutch painting; indeed, Boucher's decision to depict eggs in the kitchenmaid's apron—one of which has fallen to the ground and broken, representing her virginity and presaging its loss—may have been inspired by the popular engraving *The Broken Egg*, made after a painting by Frans van Mieris the Elder.[7] Boucher's figures are very much his own, of course, but they find a generic source in the drawings of peasants and farm workers by Abraham Bloemaert, whose figure studies the artist copied and etched. The present drawing—one of the most beautiful from this period of Boucher's career—derives its immediacy from the artist's direct study of the model; Boucher soon re-employed it for the plate *The Radish Seller* (*Des radix des raves*) in the print series *Cries of Paris* (*Cris de Paris*) engraved by S.-F. Ravenet and published in May 1737.[8] The same girl seems to have posed for the smiling *Young Peasant Girl* in Stockholm, a drawing of comparable size and technique that served as a preliminary sketch for the *Return from the Market* (Norfolk, Virginia, Chrysler Museum), a painting also datable to around 1732–35.[9]

As is usually the case with Boucher's studies for paintings, the artist has carefully mapped out the precise way the figure will fit into his painted composition, and indicates its relation to the larger setting—in this case, by including the disembodied hand of the pretty cook's kneeling suitor. It is principally in technique and mood—the strengthening of accents and shadows with a moistened chalk, for example, and the delicate reticence of the model's pose, with its suggestion of withdrawal—that memories of Watteau are kindled in Boucher's rustic kitchen.

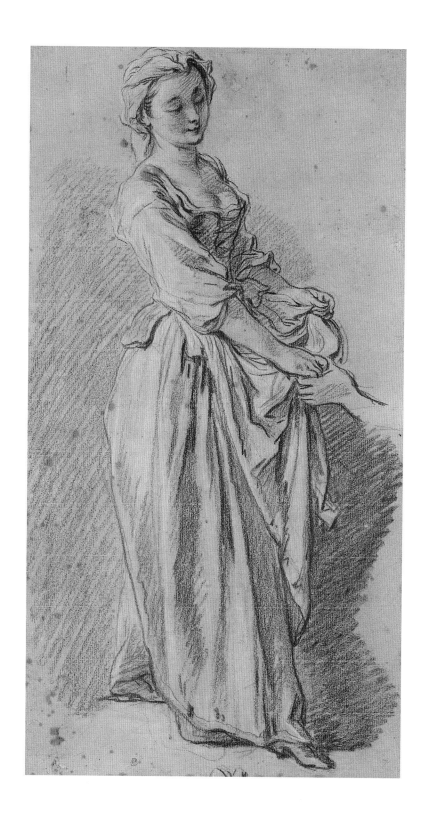

50 Reclining Male Figure

ca. 1735

Red, black, and white chalks on blue paper
11 × 17⅜ in. (27.9 × 44.1 cm)

Inscribed *Veateaut* in brown ink: *Bernard Vaillant*

The J. Paul Getty Museum, Los Angeles
(83.GB.359)

Provenance Art market, Geneva

Literature Schreiber Jacoby 1986, p. 284, no. III.B.26; Schreiber Jacoby 1987, pp. 263, 265, fig 7; Goldner and Hendrix 1992, no. 60

Notes
1. See E.A. Standen, *European Post-Medieval Tapestries and Related Hangings in The Metropolitan Museum of Art*, II, 1985, pp. 507–15.
2. A drawing of *Two Girls Begging* that was also made as a study for *The Charletan and the Peep Show* is also on blue paper. See Bjurström 1982, no. 847; and Schreiber Jacoby 1986, no. III.B.10.
3. See Schreiber Jacoby 1986, p. 284; for Watteau's painting, see Rosenberg and Grasselli 1984, no. 51.
4. Brunel 1986, p. 171.

The elegant, reclining form of a man playing a guitar was made in preparation for the tapestry *The Charletan and the Peep Show*, one of the hangings in the set of *Italian Fêtes* that was first woven at Beauvais in 1736.[1] He appears in reverse in the woven composition, outstretched across a grassy hillock on the right side of the tapestry; a musical manuscript opened before him, he accompanies a singing couple on his guitar. The great swathe of tumbling, rose-colored drapery on which he rests in the drawing gracefully mirrors his raised head while also suggesting the incline of the hillside on which he would appear in the finished tapestry. Boucher often worked in *trois crayons*, but the present sheet is a rare instance where he employed the technique on blue paper.[2]

Beverly Schreiber Jacoby first observed that the pose of Boucher's guitarist is a variant of the figure of the seated jester with a guitar in the lower right-hand corner of Watteau's famous *fête galante, The Pleasures of the Dance* (*Plaisirs du bal*; London, Dulwich Picture Gallery).[3] In fact, a number of figures to be found in the eight scenes of the *Italian Fêtes* are virtual pastiches of characters from Watteau, and, indeed, the mood and spirit of the whole series owes much to Watteau's example. Full of dancing couples, serenading musicians, and picnicking lovers in overgrown gardens filled with sculpture, the *Italian Fêtes* represent Boucher's first mature foray into pastoral painting and, as Georges Brunel has observed, Boucher arrived at the pastoral by way of the closely related genre of the *fête galante*.[4] In many ways, Boucher's first tapestry series—with poetic young men, like this guitarist, and women in ruffs and silks and fancy dress—is Watteau's genre writ large, but with a more down-to-earth sensuality and jocular animation about it.

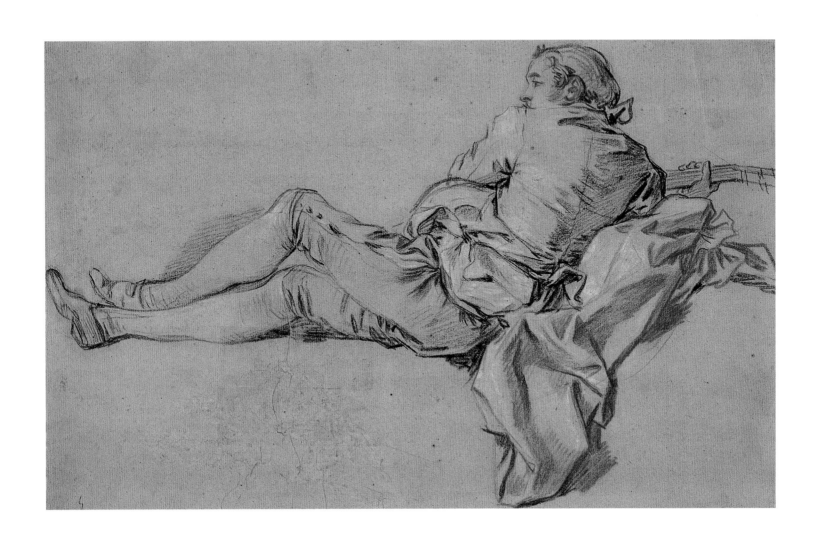

51 Study of a Female Nude

ca. 1737

Red chalk, with traces of white heightening, on buff paper

12 × 16⅝ in. (30.5 × 42.2 cm)

Private collection, Montreal and Toronto

Provenance Anthony Freire Merreco, London; sale, Christie's, London, July 8, 1975, no. 82, repr. p. 26

Exhibitions Ottawa 1976, no. 55; New York 1987, no. 18

Literature Ananoff 1976, I, p. 367, no. 251/53; Bjurström 1982, under no. 850, note 1

Notes

1. Basan's engraving is reproduced in Ananoff 1976, I, under no. 251, fig. 1a; the composition study in black and white chalks on blue paper came to Stockholm by way of Count Tessin and is reproduced and discussed in Bjurström 1982, no. 850.

2. For a more complete discussion of Françoise de Mailly, duchesse de Mazarin, and the decoration of her *hôtel particulier*, see D.C. Gluckman and J. Patrice Marandel, *François Boucher Rediscovered: The Conservation of Three Eighteenth-Century Works from the Permanent Collection*, Los Angeles County Museum of Art, 1997.

3. See Wintermute 1987, no. 19.

Watteau approached the drawing of the female nude as he did every subject of his art: with curiosity, candor, and sensitivity, but without preconceptions or reliance on familiar formulae. His women are beautiful, but natural and lacking self-consciousness; each is an individual who projects her own character. Boucher presents an altogether different case. As an Academy-trained history painter, he usually conceived of the nudes he drew as being in the service of a story from ancient history, mythology, or the Bible. Although he regularly made preparatory studies from the live model, especially in the early years of his career, Boucher tempered naturalistic observation by the imperative, implicit in the *grand genre*, for idealization. We never forget that Watteau's models are contemporary Parisiennes who have undressed, but who will put on their clothes again once the modeling session is at an end. Boucher, on the other hand, was "Ovid's Painter," and Venus requires no clothes.

Study of a Female Nude is a preparatory drawing for the central figure in *Venus Intoxicating Cupid with Nectar*, a lost painting known from Basan's engraving and from a compositional study by Boucher in the Nationalmuseum, Stockholm.[1] The Stockholm sheet—one of four designs for a suite of overdoors commissioned in 1737 by the duchesse de Mazarin for her *hôtel* on the rue de Varenne—accurately but schematically lays out the whole composition. Boucher would have turned to the present study as a guide to gesture and expression when painting the figure of Venus.[2] Like the young woman in Watteau's *Remedy* (cat. no. 24), whose pose she virtually mirrors, Boucher's Venus is supple and yielding, but her contours are firmly outlined and her flesh only lightly modeled, thereby emphasizing a greater quality of abstraction. Undoubtedly sketched from life, the drawing nonetheless represents the idealized vision of feminine beauty and sensuality deemed appropriate to grand-manner history painting; Boucher's great gift was to infuse such fabrications with a convincing sense of authenticity, as well as obvious charm.

On the verso of the drawing is another, very slight sketch of the figure in identical pose but with a putto; a beautiful counterproof of the recto was formerly in the collection of David Daniels, New York.[3]

193

52 Study of a Valet with a Coffee Pot

1739
Red and black chalks and touches of graphite, heightened with white chalk, on buff laid paper
13⅝ × 7⅝ in. (34.6 × 19.5 cm)

The Art Institute of Chicago; Gift of the Joseph and Helen Regenstein Foundation (1959.183)

Provenance Norblin de la Gourdaine; Baronne de Connaitré; Baronne de Ruble; Madame de Witte; Marquis de Bryas; Cailleux, Paris; Charles E. Slatkin, New York

Exhibitions New York 1963, no. 47; Washington and Chicago 1973–74, no. 36; Chicago 1976, no. 39; New York 1980, no. 46

Literature Goncourt 1880, I, p. 199; Michel 1906, no. 1279; Cailleux 1964, under no. 17; Vallery-Radot 1964, pl. 54; Carlson 1966, p. 158, pl. 21; Slatkin 1967, p. 63; McCullagh 1981, p. 125, fig. 109; Laing, Rosenberg, and Marandel 1986, pp. 181–82, fig. 132

Notes

1. For *The Breakfast* see Laing, Rosenberg, and Marandel 1986, no. 33; as to whether it is a breakfast scene or a luncheon is not entirely clear: does the clock on the wall read 8:00 a.m. or 2:00 p.m.? We have opted to follow Laing's reading of it as a breakfast scene. The silver utensil held by the servant has often been incorrectly identified as a chocolate pot; it is in fact a high-spouted coffee pot.
2. See, for example, Lancret's *Cup of Chocolate* of 1742 in the National Gallery, London; Holmes 1991, no. 18.
3. For de Troy's painting, see Conisbee 1981, p. 156, pl. 11.

Boucher painted only a few genre scenes set in elegant, contemporary interiors, but they are among his most delightful creations. *Study of a Valet with a Coffee Pot* is a study for the most celebrated of these, *The Breakfast* (*Le Déjeuner*; Paris, Louvre), which is signed and dated 1739, and depicts two stylishly dressed young women, their children in attendance, taking morning coffee in a fashionable Rococo salon filled with up-to-date furnishings, fabrics, and *objets de vertue*.[1] *The Breakfast* is Boucher's most successful essay in the new category of the *tableau de mode*, a genre established in the 1720s by Jean-François de Troy and soon after taken up by Lancret.[2] De Troy's aristocratic scenes of salon sociability, such as the well-known *A Reading from Molière* (1728; London, private collection), are far grander than the more intimate glimpse into the domestic rituals of the *bourgeoisie* found in Boucher's *Breakfast*, but both artists describe the material circumstances of their subjects' surroundings in minute detail and with comparably high finish.[3] Although de Troy became the most committed and accomplished practitioner of the genre, the origin of the *tableau de mode* can be traced to Watteau's great *Shopsign* (fig. 2, p. 14).

The care with which Boucher undertook his painting is evident in the justly admired study of the valet in Chicago. In the painting, the valet appears in the background and the pot he holds rests on a crumpled cloth; he is hidden from the waist down by the figure of the seated woman feeding a child. Nevertheless, Boucher studied the figure in full-length, working it to a high degree of finish. Over the lightest underdrawing of graphite, with which he laid down the outlines of the body, Boucher worked up the figure and face of the valet in sanguine—as well as the coffee pot and the chimneypiece he stands beside—reserving black chalk principally for the servant's hair. He then went back over the red chalk drawing, as Watteau so often did, adding white highlights that define the volumes and angular folds of the apron and sleeve; he retouched the eyes, eyebrows, buttonholes, and buckles with accents in black; a few rapid strokes of black chalk complete the mantlepiece at right. The sweet, reticent expression on the young man's face and his graceful pose recall many of Watteau's studies, but the vigorous plasticity of his form is entirely characteristic of Boucher's more extrovert drawing style. The boy is conceived with an eye to his placement and role in the larger composition, and Boucher surrounds him with props and a rudimentary setting, such as one never finds in Watteau's purposeless sketches.

53 A Seated Chinese Girl in Profile

ca. 1739–42

Red, black, and white chalks with brown wash on buff paper

9¾ × 8⅝ in. (24.8 × 21.8 cm)

Signed *f Boucher*

Berger Collection at The Denver Art Museum (TL-18050)

Provenance London, Christie's, July 1, 1997, no. 135

Exhibition Aspen 1998

Notes

1. La Muette, a crown property and former hunting lodge, situated on the edge of the Bois de Boulogne, Paris, was the residence from 1705 to 1716 of Fleuriau d'Armenonville, Minister of the Treasury; it was probably not more than a few years after he had moved in that he commissioned *chinoiserie* grotesques from Claude III Audran, who presumably handed over much of the work to his assistant, Watteau. For the most recent discussion of Watteau's work at La Muette, see Eidelberg and Gopin 1997, pp. 19–46.

2. The rediscovered fragment depicts *Viosseu, Chinese Musician* and appeared at auction at Sotheby's New York, January 11, 1996, lot 151; the painting is now in a private collection in New York. Eidelberg and Gopin 1997, p. 24, reject the attribution of the painting to Watteau, and consider it an anonymous copy; I regard it as entirely characteristic of Watteau's hand. Boucher's prints after Watteau's paintings at La Muette can be found in Jean-Richard 1978, nos. 164–75.

3. Laing, Rosenberg, and Marandel 1986, p. 205, fig. 46.

4. E. and J. de Goncourt 1881, I, p. 244, quoted in Laing, Rosenberg, and Marandel 1986, p. 202. The series of prints can be found in Jean-Richard 1978, nos. 12–20 (*Figures chinoises* by Boucher); 198–202 (*Cinq sujets chinois* by F.-A. Aveline); 1082–88 (*Suite de figures chinoises* by J.-P.-L. Houel); 1125–33 (*Scènes de la vie chinoise* by G. Huquier the Elder); 1164–70 (*Chinoiseries* by J.-G. Huquier); 1208–15 (*Figures chinoises* by J. Ingram).

The taste in early eighteenth-century France for things oriental was fed by the regular importation of Chinese silks and porcelains from the East, but the concomitant vogue for *chinoiserie*—imaginative recreations of the Celestial Empire by European painters and craftsmen—was given its principal impetus by Watteau, whose "Chinese" decorations for the Château de la Muette achieved widespread fame during his lifetime.[1] The decorative scheme was destroyed sometime in the eighteenth century—only one fragment of it, recently rediscovered, is known to have survived—but thirty vignettes painted by Watteau for La Muette's wainscotting were engraved for the *Recueil Jullienne*, twelve of them by Boucher.[2] The prints were not published until 1731, but Boucher almost certainly etched the plates in the mid-1720s, when he produced his copies after Watteau.

Boucher seems to have begun creating original *chinoiseries* in the late 1730s, the approximate date we assign to the present, previously unpublished drawing. In 1740 he designed a *chinoiserie* trade card for Gersaint's famous shop, *"A la Pagode,"* from which he bought oriental *objets* for his own collection.[3] He turned out paintings, drawings, tapestry designs, and stage sets, as well as designs for at least six suites of "Chinese" prints, producing works in such number as to prompt the Goncourt brothers to observe in 1881 that Boucher had tried to "make China into one of the regions of Rococo."[4]

Boucher's most noteworthy venture into *chinoiserie* are the ravishing oil sketches he made as designs for his third tapestry series for Beauvais, *The Chinese Hangings* (*La Tenture chinoise*).[5] Boucher's designs feature bustling, carnival-like scenes with a picturesque profusion of clowns, musicians, jugglers, dancers, fishermen, hunters, Asian princes, and Mandarin priests disporting under parasols and pagodas in vaguely exotic landscapes. They are French *fêtes champêtres* in Chinese clothing, or, as Hugh Honour characterized them, "oriental pastorals."[6] The present drawing of a young woman in Chinese dress—perhaps playing a musical instrument, hence her unexplained gesture—is not reproduced exactly in any of Boucher's known paintings or prints.[7]

The delicate, dry mixing of three chalks in *A Seated Chinese Girl* continues Watteau's legacy, and a new, softer application of the crayons gives the drawing a gentle, atmospheric quality. And yet the girl's posture of rather stiff dignity and the distinctly sharp folds of her voluminous drapery exemplify the subtle departures from his usual style that Boucher brought to his *chinoiseries*. Of course, Boucher's *chinoiseries* are not ethnographic studies: the model for the *Seated Chinese Girl* is obviously European. Nevertheless, as Alastair Laing has observed, Boucher did try to create a style that conveys a feeling of oriental exoticism; in a drawing like the *Seated Chinese Girl*, that desire translated into sharper, spikier strokes of chalk and less fluency and curvaciousness of form than is found in any other genre of his work. With both the Watteau of La Muette and the Watteau of the Persian drawings (cat. nos. 12, 13) as his model, Boucher imbued his daydreaming girl in Chinese fancy dress with a more personal, yet strangely compelling, fantasy of Cathay.

5. Ananoff 1976, I, pp. 338–50, nos. 224–33;
see also Laing, Rosenberg and Marandel
1986, nos. 41–44; and Sutton 1982, pp.
231–33. Ten sketches survive (Besançon,
Musée des Beaux-Arts), eight of which were
exhibited in the Salon of 1742. Only one
complete set of the tapestries is known, in
Palazzo Reale, Turin.

6. Quoted in Brunel 1986, p. 169.

7. The figure does, however, appear, with
slight variations, in five works of the period:
The Feast of the Emperor of China and *The
Chinese Dance* (two of the oil sketches for
The Chinese Hangings [Ananoff 1976, I,
nos 224 and 227]); Huquier's print *The
Chimes*; Aveline's engraving *The Chinese
Concert* (Jean-Richard 1978, nos. 1125 and
201, respectively); and *Tea "à la Chinoise"*
(1742; Little Durnford Manor, Wiltshire,
Trustees of the Earl of Chichester), an
overdoor painted *en camaïeu bleu* on a gray
ground (Laing, Rosenberg, and Marandel
1986, under nos. 41–44, p. 205, fig. 146). It
is the seated woman holding out cups of tea
for her two children in the *Tea "à la
Chinoise"* who most closely conforms to the
present drawing, although her figure is in
reverse.

54 *Woman with Two Children*

ca. 1740
Black and red chalks on cream laid paper
lined
9⅜ × 6⅝ in. (23.7 × 16.9 cm)
Cooper-Hewitt, National Design Museum,
Smithsonian Institution; purchased, Friends
of the Museum Fund 1938–66–6
(1938–57–908)

Provenance De Grab sale, October 25, 1875,
no. 251/25pl (according to inscription on
verso); J.J. Peoli (1825–1893; Lugt 2020)

Exhibitions Toronto, Ottawa, San Francisco,
and New York 1972–73, no. 25

Notes
1. After the important study by Rey 1931,
recent studies of Chantereau include
Rosenberg and Schnapper 1970; Bjurström
1971; Bjurström 1982, nos. 897–906.
2. Two drawings recently acquired by Jeffrey
Horvitz, which are on deposit at the Fogg
Art Museum, Cambridge, Massachusetts, for
example, and a splendid sheet of *Two Young
Peasants Wearing Hats*, now in a private
collection, Germany (see Thomas Le Claire
Kunsthandel, *Master Drawings 1500–1900*,
VIII, 1992, no. 31, entry by E. Williams).
3. See Bjurström 1971 for a corpus of twenty
drawings that he had identified.
4. The drawing was first attributed to
Chantereau by Rosenberg 1972, no. 25.

Previously regarded as little more than a minor dependent of Watteau, Chardin, and Pater (who may have been his teacher), Jérôme-François Chantereau can now claim a corpus of well over forty drawings—several of them attributed only in the last decade.[1] On the strength of this graphic œuvre, he is revealed as an observant *petit maitre*, more charming than profound, perhaps, but with a distinctive style.[2] Without academic training and working outside the artistic mainstream, he developed a technique that was largely indebted to Watteau: Chantereau seems to have worked almost exclusively in *trois crayons*, with the occasional addition of pastel or touches of wash; he was at ease mixing and mingling his colors; favored the use of a sooty black chalk, especially for the shadows; and regularly resorted to stumping to create moody, atmospheric effects.

Virtually all of his surviving drawings treat everyday subjects—scenes of military and peasant life, sketches of barnyard animals, even kitchen still lifes—and a number are complete, multifigural compositions. His figure sketches appear to have been drawn from life, on the spot and not from professional models.[3] His drawings of military encampments are strikingly reminiscent of Watteau's, and stress the heaviness of time weighing upon the bored recruits. Chantereau's peasant studies inevitably recall Watteau as well, in particular the Savoyard drawings (see cat. no. 14). *Woman with Two Children* is a characteristic example[4]: the forms are quickly and somewhat crudely sketched in—note the anatomically bizarre feet—with nervous, sharply accented strokes of chalk. Interior modeling was added with broad swathes of softly smudged color; large areas of untouched paper are commandeered with considerable sophistication to imitate the effect of sunlight on the woman's apron and skirt and the swaddled baby in her arms. Chantereau's young mother is prettier and more picturesquely presented than any of Watteau's unidealized Savoyards, and his figures announce the arrival of Fragonard and Hubert Robert rather than evoking memories of the Le Nain brothers. Yet Chantereau's young mother is observed sympathetically and without condescension by an artist insightful enough to appreciate the originality of Watteau's approach.

55 Mascarade

ca. 1705–10
Pen and brown ink with touches of black
ink on cream paper
6¼ × 7⅞ in. (15.7 × 20 cm)
Museum of Fine Arts, Boston; Bequest of
Forsyth Wickes, 1965 (65.2572)

Provenance Paignon Dijonval, Paris, by 1810,
no. 3149 (?); Georges Haumont by 1935

Exhibitions Charlottenburg 1935, no. 381;
Paris 1948, no. 111

Literature Rosenberg 1972, p. 163; Roland
Michel 1987, pp. 22–23, fig. 14; Munger and
Zafran 1992, no. 63; Roland Michel in Clark
1998, p. 55, fig. 5

Notes
1. Roland Michel 1989, p. 164, under no.
62.
2. For example, the figure group is patched
in on Gillot's pen drawing *A Rocky Grotto* in
the National Gallery of Canada, Ottawa; see
Johnson 1988, pp. 158–59, no. 49.
3. Populus 1930, p. 156, no. 242.
4. Gillot's pendant drawing is lost and the
composition known only through Caylus's
print. Munger and Zafran 1992, no. 63; also
see Populus 1930, no. 242.

Mascarade is one of the most beautiful sheets executed in what Marianne Roland Michel has described as Claude Gillot's "*style nerveux*"[1]: scratchy, closely interwoven penwork in brown ink; touches of black ink overlaid to emphasize a face or gesture and vary the tonal effects; and lightly applied parallel lines across the entire background, which create an atmospheric screen that sets off the foreground figures. The closeness of the energetic pen strokes and the varying density with which they are applied create form, suggest shadows, and evoke a quality of flickering light throughout the drawings, obviating the need for washes. Gillot's unforgiving medium allows for no mistakes: the only way to correct an error was to redraw the motif on a patch that could be pasted over the offending area. This Gillot has done with the second head from the left; and similar patches can be found on several other pen drawings by Gillot, in which they are so well integrated as to be virtually undetectable.[2]

Mascarade was etched by the comte de Caylus—who gave the drawing its title—as one of a suite of prints called *Scènes humoristiques* that reproduced musical, pastoral, and *fête* subjects by Gillot.[3] *Mascarade* may have been intended as the pendant to *Ecole de jeunesse*, which shows children in an outdoor classroom receiving instruction from their schoolmistress (the humor lying, presumably, in the contrast of the seriousness of working children with the frivolity of a band of adults making merry).[4]

No reliable chronology for Gillot's drawings has been established, and it is impossible to know if the artist drew *Mascarade* while Watteau was working in his studio. The fluency of Gillot's draftsmanship and the cut of the women's dresses both seem to corroborate a dating of around 1705–10, the very years during which the two artists were in close contact. Although Gillot's characters wear masks and exotic fancy dress—principally Turkish—his fashionable costume ball offers obvious parallels to the *fêtes galantes* that would soon become Watteau's subject matter. The revelers, several of whom display the insouciance of actors from the *commedia dell'arte*, dance and flirt in an overgrown garden, removed from the realm of everyday experience and inhabiting a world of pleasure. They face the viewer like actors on a stage, confined to the shallow space that Gillot preferred, their games accompanied by a quartet of difficult-to-detect musicians. Watteau would have found in Gillot's drawing little inspiration for the more profound poetry to which he aspired, but the humor and vivacity conveyed by its web of wiry pen lines could hardly have failed to impress him.

56 The Feast of Pan

ca. 1707–08

Red chalk over pencil on cream paper in three sections

L: 5¹⁵⁄₁₆ × 3¹⁵⁄₁₆ in.; M: 6⁷⁄₁₆ × 6½ in.;
R: 5⅞ × 3⅞ in. (L: 15 × 10.1 cm;
M: 17.1 × 16.6 cm; R: 14.5 × 9.8 cm)

Yale University Art Gallery, New Haven;
Everett V. Meeks, B.A. 1901, Fund
(1958.9.5a)

Provenance Edmond and Jules de Goncourt
(Lugt 1089; sale, Paris, February 15–17, 1897,
no. 105); Hector Brame, Paris

Exhibitions Paris 1879, no. 467; Los Angeles
1961, no. 8

Literature Munhall 1962, pp. 22–35, figs. 1,
8, and 9; Haverkamp-Begemann and Logan
1970, I, no. 51; Ettesvold 1980, p. 63;
Launay 1991, no. 112; Raux 1995, no. 20;
Stein 1997, p. 75

Notes

1. Caylus, in Rosenberg 1984a, p. 59;
translated in Ironside 1948, p. 14.
2. The definitive study of the present
drawing and the series of *Bacchanals* is
Munhall 1962, pp. 22–35; also see Populus
1930, no. 4.
3. The drawing for *The Feast of Diana* was
sold at Christie's, London, July 2, 1991, lot
154, and is now in a European private
collection; *The Feast of Faunus* was recently
bequeathed by Agnes Mongan to the Fogg
Art Museum at Harvard University,
Cambridge. Another drawing of *The Feast of
Pan* by Gillot is in the Musée des Beaux-
Arts, Lille (see Raux 1995, no. 20) and is
sometimes described as a first study for
Gillot's print, preceding the revised Yale
sheet; like Perrin Stein (see Stein 1997,
p. 75), I do not believe the Lille drawing was
preparatory to the Yale sheet or Gillot's
etching, but was perhaps an earlier, unrelated
drawing of the same subject. Finally, there
once existed four variants of the *Bacchanals*
series, in pen heightened with white,
recorded in D'Argenville's sale, Paris, January
18–28, 1779, lot 395.
4. A painted version of *The Feast of Bacchus* is
in the museum at Langres; I have never seen
the painting, but Munhall rejected it as a
copy after the etching; Munhall 1962, p. 27.
5. The counterproof for *The Feast of Faunus*

According to Caylus, when Watteau entered Gillot's shop the older artist had a reputation "as a painter of bacchanals, of other fanciful or even historical subjects."[1] Not surprisingly, several of Watteau's earliest paintings were of Bacchic subjects, as was *Children Imitating a Triumphal Procession* (cat. no. 1), one of his earliest surviving drawings and presumably made under Gillot's tutelage. Gillot's own *Feast of Pan* was drawn in preparation for a print of the same title that is one of a series of four etchings of *Bacchanals* by the artist published in the first decade of the eighteenth century. As such, it is an example of the sort of work Gillot was producing when he and Watteau met.[2]

Gillot's drawing depicts a pagan celebration to Pan, the god of Nature. Before a stone altar carved from a natural grotto, naked and loosely draped nymphs and satyrs joyously dance to the music of pipes and tambourines, worshiping beneath a bust of the horned deity; to the right, an old, bearded priest leads a procession of infant satyrs who drag a sacrificial goat in his wake. Except for modest adjustments in a few details, the drawing corresponds exactly to the etching. The three other prints in the suite also represent bacchanalian tributes to the gods Diana, Faunus, and Bacchus. Gillot's preparatory drawings for *The Feast of Diana* and *The Feast of Faunus* are known, each the same size as the Yale sheet and, like it, executed in red chalk over graphite underdrawing; only the drawing for *The Feast of Bacchus* has disappeared without trace.[3]

As the inscription—*inventé, peint, et gravé par C. Gillot*—indicates, the four prints were etched by the artist himself, and painted versions of the compositions once existed, though none is known today.[4] Gillot's etchings are the same size and in the same direction as the original drawings, and he may have employed counterproofs to assist him in transferring his images to the plate; one of these appeared recently at auction.[5] More interesting, as Edgar Munhall observed in his analysis of the present drawing, is "Gillot's consistently accurate adaptation of his nervous line into the print medium."[6] The scratchy strokes of the figures—with their attenuated forms and sharp little faces—the tight squiggles of foliage, and the screen of parallel lines that unifies the background are translated with fidelity by the etcher's needle. *The Feast of Pan* is the only study for the *Bacchanals* that is drawn on three pieces of paper joined together, and the only one with an elevated central section. As this section conforms to the height of the other drawings, it seems possible that Gillot was experimenting with a format for the series that he decided to abandon. He may have made a mistake, or changed his mind while composing the drawing and salvaged the sheet by "patching" in the new section.

The iconography of Gillot's image can be traced to august, classicizing sources in the art of the previous century, such as the *Bacchanals* that Poussin painted for Cardinal Richelieu and Cornu's copy of the Borghese Vase for Versailles, which were celebrated

appeared at Sotheby's London, April 5, 1995, lot 149, miscatalogued as *The Triumph of Cupid* by Charles-Nicolas Cochin; 17.5 × 36 cm, red chalk counterproof.

6. Munhall 1962, p. 27.

7. As Munhall first observed, Munhall 1962, pp. 29–30.

8. Sophie Raux first suggested Brebiette as a source for Gillot's *Bacchanals*; Raux 1995, under no. 20, pp. 90–91.

9. For Watteau's *Feast of Pan*, see Rosenberg and Camesasca 1970, no. 9; see also Roland Michel 1984a, p. 212, fig. 209.

examples of the revival of bacchanalian subjects after the antique.[7] But Gillot may also have looked to *petits maîtres* such as Pierre Brebiette (1598?–ca.1650), a draftsman and printmaker who specialized in small, racy, and humorous bacchanals.[8] To a far greater degree than Brebiette, Gillot domesticated his mythic revels by expunging from them any threat of pagan brutality, emphasizing harmony and sensuality over erotic frenzy. The world of pagan antiquity occupied only a small corner of Watteau's imagination, but Gillot's vision of it as an unfettered site of langorous pleasure was to make a lasting impression: Watteau transformed his own version of *The Feast of Pan* (Los Angeles, Armand Hammer Foundation) into an Arcadian landscape in which the actors of the *commedia dell'arte* assume all the mythological roles, with Pierrot as the god Pan. In that small canvas one finds the origins of the *fête galante*.[9]

57 "Arlequin esprit follet": The Comedian's Repast

ca. 1704–18

Pen and black and red ink, and brush and red wash, on tan laid paper

6½ × 8¼ in. (15.7 × 21.2 cm)

The Art Institute of Chicago; Restricted gift of Dr. and Mrs. William D. Shorey (1986.408)

Provenance François Renaud (Lugt 1042, Supplement); Henri Michel-Lévy, his sale, Paris, May 12–13, 1919, lot 90; Léon Michel-Lévy, his sale, Paris, June 17–18, 1925, lot 65; comte Ch. de Noailles; Springell collection, sale, Sotheby's, London, June 30, 1986, lot. 71

Exhibitions London 1945, no. 24; London 1950, no. 34, pl. VI; Bristol 1956, no. 32; London 1968, no. 286; New York 1991, no. 19

Literature Dacier 1926, p. 288; Populus 1930, pp. 91f.; Poley 1938, no. 137; Boucher and Jaccottet 1952, pl. 7, p. 175; Méjanès 1987, p. 56

Notes

1. For a history of the fairs in the first part of the eighteenth century, see Méjanès 1987, p. 56, and Isherwood 1981, pp. 24–47.
2. Dieckmann 1962, pp. 207–08.
3. Populus 1930, pp. 26–27.
4. The self-portrait is known from an engraving by J. Aubert; it is reproduced in Rosenberg and Grasselli 1984, p. 37; on Gillot as a stage designer, see Populus 1930, p. 37; on Gillot as author of *Polichinelle Grand Turc*, see Populus 1930, p. 25.
5. Populus 1930, pp. 91–92, no. 17.
6. Populus 1930, pp. 91–92, no. 17.
7. Engraved in reverse by Huquier; see Méjanès 1987, no. 72.
8. Populus 1930, p. 27.

The manic energy of a pantomime performance by the *commedia dell'arte* was never more vibrantly recreated than in Gillot's ink and wash drawings. Between 1697 and 1716, when the Italian players were banned from working in Paris by royal decree, the troupes performed their standard repertory at the popular fairs held on the outskirts of the city.[1] Gillot was among the first to recognize the novelty of illustrating them, and he seems to have regularly attended productions at the Foire Saint-Germain (in summer) and the Foire Saint-Laurent (in the autumn).[2] A number of Gillot's drawings have been shown to be accurate transcriptions of scenes from known plays in the *commedia dell'arte* repertoire, some of them probably sketched *sur le motif*. When not drawing an actual performance, Gillot seems to have relied on sketches made from marionettes.[3] The care he took to preserve a record of these fair productions should come as little surprise, since Gillot closely identified with the *commedia dell'arte*: he wears Pierrot's ruff in his self-portrait, and was himself a stage designer and the author of the play *Polichinelle Grand Turc*.[4]

Although Gillot's drawing presents characters and a setting somewhat at variance to the manuscript of the play, it depicts a scene from Act II of *Arlequin esprit follet*, an anonymous comedy first produced in Paris in 1670.[5] In the drawing, Scaramouche, Mezzetin, and Punchinello have been hoisted up from the banqueting table on mechanical chairs as the wily Harlequin ignites an explosive pastry beneath them. Gillot laid out the basic forms of his composition in a light sanguine wash, then went back over the sheet, applying shadows and summary modeling in a darker brownish-red wash; finally, he outlined his forms and picked out details in pen and black ink. His weightless figures, with their pinched faces and long limbs that taper to a point, are drawn with a typically nervous stroke. The result is a richly worked study made in a dazzling rush of quicksilver spontaneity; in its effervescence, technical mastery, and ribald humor it presages the great series of Punchinello drawings by the elder and younger Tiepolo.

The composition was etched by the artist himself, in the same direction, as one of four *Scènes comiques du théâtre italien*, and the inscription on the print—*Gillot pinx. et Sculp.*—suggests that there was once a painted version as well.[6] Gillot also made another, differently composed drawing of the same scene that includes, among other variations, the additional figures of Pierrot and an unknown woman.[7] It is impossible to date either drawing accurately, but Populus believed that Gillot sketched most of his scenes from the *commedia dell'arte* between 1704 and 1718.[8]

The rude humor and outrageous antics preserved in Gillot's drawings of the *commedia dell'arte* seem, in general, to have been less the product of his own invention than of the company's playwrights and players. Such drawings are illustrations of performances, and depend on the play to supply the characters, *mise-en-scène* and bracing humor that Gillot

transcribed with such virtuosity. Watteau's depictions of the *commedia dell'arte* were never so literal, and can rarely be identified with any particular plot: in Watteau's paintings, the characters play offstage, in a more subtle and profound theatre of the imagination. Nevertheless, it was Gillot who first opened the door that led Watteau into this new world.

58 Head of a Young Girl, and Studies of Her Hands and of Her Right Foot

1682

Red, black, and white chalks, with touches of yellow and pink pastel, on beige paper
16 × 22 in. (36.7 × 26.5 cm)

The Metropolitan Museum of Art, New York; Sperling Fund, 1980 (1980.321)

Provenance Kathryn Bache Miller; sale, London, Christie's, April 15, 1980, no. 171, repr.; Yvonne Tan Bunzl, London

Literature Bean 1983, pp. 17–18, pl. 21; Bean and Turčić 1986, no. 140; Hilaire and Ramade 1993, under no. 131, fig. 3

Notes

1. Stuffmann 1964, pp. 56–58, no. 20. The enormous canvas was ordered by the Carmelites of Toulouse for the Chapel of Notre-Dame du Mont Carmel, an annex of the Church of the Grands Carme; seized in the Revolution, it is today in the Musée des Augustins, Toulouse. See Hilaire and Ramade 1993, pp. 366–67, no. 131.

2. Wethey 1969, I, no. 87.

3. For the Stockholm drawings, see Bjurström 1976, nos. 441 and 458, respectively. For the study in a private collection, see Hilaire and Ramade 1993, p. 366, under no. 131.

4. Dezallier d'Argenville, IV, 1762, p. 194; translated in Rosenberg 1972, p. 170, under no. 68.

Charles de La Fosse's sheet of studies for the head, hands, and right foot of the young Virgin Mary was made in preparation for *The Presentation of the Virgin in the Temple*, signed and dated 1682, the Parisian artist's first provincial commission.[1] The grand canvas depicts the young Mary climbing the steps of the temple towards the High Priest Zacharias, who awaits her at the top with his hand extended; her elderly father, Joachim, and mother, Anne, follow behind her and help the girl mount the stairs. It is natural that La Fosse, a passionate enthusiast of Italian painting, would have turned for inspiration to Titian's celebrated rendition of the subject now in the Accademia in Venice, a painting that he had ample opportunity to study during his three-year residence in Venice.[2] La Fosse adopted the Renaissance master's long, frieze-like composition, but his young Virgin is more hesitant than Titian's self-possessed child: she casts her gaze downward and brings her left hand modestly to her chest, seemingly humbled by an awareness of her grave responsibility.

The painting almost exactly repeats the head and left hand of the Virgin as they were worked out in La Fosse's drawing, while her right hand and foot differ somewhat from the artist's earlier conception. A full compositional drawing, in reverse to the painting and with numerous variations, is in the Nationalmuseum, Stockholm, as is a study in colored chalks of the head of the same girl, but with her hair drawn back and without a veil; in addition, another sketch related to the entire composition is in a private collection in Paris.[3] In the Metropolitan sheet, we see La Fosse working from a posed model, outlining her head in red chalk. Her face is sensitively modeled with broadly applied white-chalk highlights, while her eyelashes and nostril are strengthened in black, and her jaw, neck, and lips are touched with pink pastel. Her blonde hair is recreated with alternate strokes of black chalk and yellow pastel. A veil, which partially covers one of the hand studies, is almost sculptural in its thick folds and must have been the last motif to have been added to the sheet. The hand and foot studies are strongly outlined in red chalk and modeled in red and white chalks, as was standard academic practice. Dezallier d'Argenville (1762) remarked on "the intelligent use of highlights, a great fire" in La Fosse's drawings, but also noted "a heavy touch, weighty draperies, rather short figures," which, the connoisseur observed, "are a sure sign of [La Fosse's] hand."[4]

La Fosse's figure studies, like those on the present sheet, were drawn with an eye to their subsequent translation into painted compositions, and he used his chalks like paint: red for flesh, black for hair, white for the effects of reflected light, with touches of colored pastel to heighten the sense of realism; La Fosse would never divorce color from its naturalistic function or use it with the expressive freedom that Watteau would eventually achieve.

207

59 Study of a Reclining Man

ca. 1720s
Red, black, and white chalks on cream paper
6⅞ × 8¼ in. (20.2 × 17 cm)

Private collection

Provenance Sale, Berne, Gutekunst and
Klipskin, October 5–6, 1950, lot 149, repr.;
Matthiesen Gallery, London, until 1952; Mr.
and Mrs. Eliot Hodgkin, London

Exhibitions London 1968, no. 400; London
1987, no. 110

Literature Cailleux 1964, pp. i–iii, repr. fig. 4;
Preston 1985, pp. 40–47; Holmes 1991,
p. 88; Rosenberg and Prat 1996, III, R69

Notes
1. On the portrait, see Rosenberg and
Camesasca 1970, no. 118.
2. An inscription on Bernard Lépicié's
engraving of the painting, published in 1734,
makes clear its allegorical intentions:

The small page of elegant, controlled sketches in red and black chalks heightened with white is clearly a characteristic work by Nicolas Lancret, apparently dating from the 1720s. It would appear to be an original study drawn from a live model; yet it replicates precisely the figure of Antoine de La Roque—even in the positions of the hands in the detail studies and the fall of his drapery—as he appears in Watteau's celebrated painting (fig. 95). Thus, while the exact status of this modest drawing remains something of a mystery, it serves to raise interesting questions about the authorship of a seemingly well-documented painting.

In the portrait, the soldier-turned-writer is depicted in an Arcadian setting with nymphs frolicking in the background.[1] The painting is staged in the manner of a scene from the *opéra comique*, a natural allusion to the sitter, who wrote two libretti for the opera after his leg was shattered at the Battle of Malplaquet (1709). La Roque gestures toward the raised leg; on the ground behind him is his discarded armor—a reference to his former career as soldier—and a lyre, flute, book, and manuscript that each attest to his present occupation. A month before Watteau's death, La Roque took over publication of the influential *Mercure*, soon to be renamed the *Mercure de France*.[2]

The present author, among others, has previously observed that Lancret appears to have been responsible for painting the merry band of Muses and fauns in the background of the portrait, but examination of the exhibited drawing leads one to ask whether Lancret may not have been responsible for the portrait in its entirety. No drawings by Watteau for the painting are known,[3] while two by Lancret have been associated with it: the present sheet, and a newly attributed study of a female nude in Besançon (see fig 59, pp. 62–63). And whereas the painting finds no easy parallel in Watteau's oeuvre, it is directly comparable in handling and type to a series of richly colored and vaguely allegorizing portraits in park settings that are among Lancret's finest works.[4]

Bernard Lépicié's engraving after the painting, published in 1734, argues against the reattribution of the portrait to Lancret. It is inscribed *Watteau pinxit* and was published while both La Roque and his

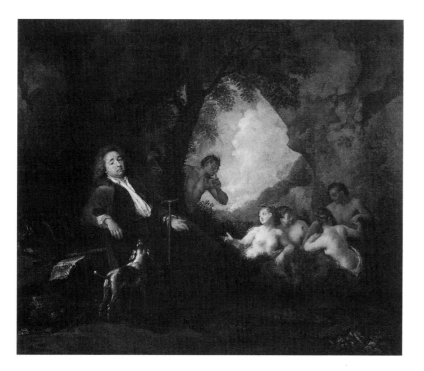

Figure 95. Antoine Watteau, *Antoine de La Roque*, ca. 1718. Oil on canvas, 18⅛ × 21½ in. (46 × 54.6 cm). Fuji Art Museum Collection, Tokyo

"Victim of the god Mars; now the Muses
occupy his heart and mind.

He fought for glory; now he writes for it."
For a brief life of La Roque, and a discussion
of Lépicié's print, see Dacier and Vuaflart
1921–29, III, no. 269.

3. Wintermute 1990, p. 152; Holmes 1991,
p. 88; Grasselli, in Rosenberg and Grasselli
1984, p. 191, was the first to recognize
Lancret's involvement in the execution of
the painting. Rosenberg and Prat 1996, II,
no. 412, associate a drawing of a faun by
Watteau in a French private collection with
the painting, but the connection is tenuous
by their own admission.

4. Among these are the so-called *Bourbon-
Conti Family* in the Krannert Art Museum,
Champaign; the so-called *Luxembourg Family*
in the Virginia Museum of Fine Arts,
Richmond; and the *Portrait of the Actor
Grandval* in the Indianapolis Museum of Art.

5. Wildenstein 1924, no. 442, fig. 106;
Wildenstein 1924, no. 446, fig. 109; the
latter, *Halte de chasseurs*, was sold at
Christie's, New York, October 21, 1997,
lot 59.

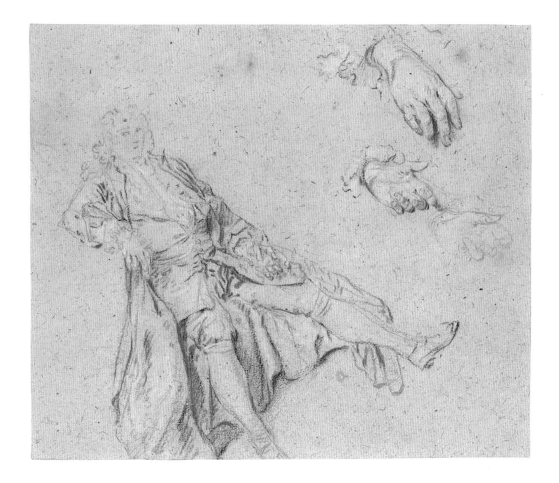

friend Lancret were alive (it is inexplicable that either would have allowed the painting
to be given to the wrong author). On closer inspection of the present drawing we see
that the face is schematic, and not the same as that of the sitter in the portrait: could it
be that Lancret, inspired by Watteau's painting, posed an anonymous model in the same
position as La Roque some years after the portrait was finished? Figures in roughly
similar poses can be found in two of Lancret's later hunting compositions.[5]

60 Three Studies of a Turbaned Black Man

ca. 1720

Black and red chalk, with stumping, heightened with white chalk, on pale brownish-gray laid paper

6¹⁵⁄₁₆ × 11⅛ in. (17.6 × 28.3 cm)

The Art Institute of Chicago; Restricted gift of the Joseph and Helen Regenstein Foundation (1987.58)

Provenance Sale, Sotheby's, New York, January 16, 1985, lot 95

Exhibitions New York and Fort Worth 1991–92, no. 33; New York 1991, no. 21

Literature Wintermute 1992, p. 191; Riopelle 1992, p. 331, fig. 65; Grasselli and McCullagh 1994, p. 170

Notes

1. See Wildenstein 1924, no. 546, fig. 131. Margaret Morgan Grasselli first recognized the Chicago drawing as the work of Lancret and provided the attribution when it came up for sale at Sotheby's in 1985. Grasselli also pointed out its relationship to the former Wildenstein painting, and noted that a drawing of the same model, standing full-length and seen from two angles, was in the Hermitage (sale, Leipzig, Boerner, April 29, 1931, lot 145); another related drawing has reappeared and was sold at Sotheby's, London, July 3, 1996, lot 109.

2. The suggestion that the Chicago drawing or its replica might have been made for commercial reasons was offered by Grasselli and Suzanne Folds McCullagh in Grasselli and McCullagh 1994, p. 170.

3. Grasselli and McCullagh 1994, p. 170, fig. 1.

4. The pair of drawings were with Patrick Perrin, Paris; see his catalogue *Dessins anciens de Le Sueur à Carpeaux*, Paris, 1989, no. 15.

When Lancret embarked on the present page of studies—one of the finest he produced—he could hardly have avoided thinking of Watteau's great *Three Studies of the Head of a Young Negro* (fig. 25, p. 33) The sketches seem to have begun as preparations for the head of a black servant who appears in Lancret's *The Negro and the Kitchenmaid* (whereabouts unknown), a painting formerly with Wildenstein, Paris[1]; however, the delicacy with which the drawing was worked up, the rich mixing of three chalks, and the subtle and effective use of stumping suggest that Lancret finished it with an eye to its potential value as an independent work of art.[2] In a departure from Watteau's practice, Lancret produced an exact, apparently autograph replica of the sheet in *trois crayons* (Berlin, Staatliche Museen, Kupferstichkabinett),[3] and a pair of individual copies of the left and center studies in red chalk alone (private collection)[4]: clearly, the artist recognized a ready market for his images.

As Watteau had done before him, Lancret presents his young model's head from three directions, but whereas Watteau arranged his studies to spiral down the sheet with a rhythmical power, Lancret spread his sketches horizontally across the page with less sensitivity to their spacial relationships. Despite possessing a gravity rarely encountered in Lancret's works, the faces in the present drawing lack the poignant realism that make Watteau's studies of his black model so memorable. Lancret does not caricature his model—the faces are drawn with the greatest sympathy—but he renders them with a doll-like sweetness. Nor does Lancret attempt the highly sophisticated mingling of chalks found in Watteau's drawing, to evoke the model's flesh. In Lancret's drawing, the flesh is reproduced almost entirely in red chalk, as was customary, regardless of the model's race; as Mary Tavener Holmes observed, Lancret relies almost entirely on the model's features to indicate his ethnicity. Nevertheless, the drawing's soft and crumbly modeling, warm coloration, and keen sense of decorative detail—observe the red and black striping in the turban—make this sheet one of Lancret's finest achievements. With *Three Studies of a Turbaned Black Man,* Lancret comes as close as he ever would to achieving the sonorous poetry of his master.

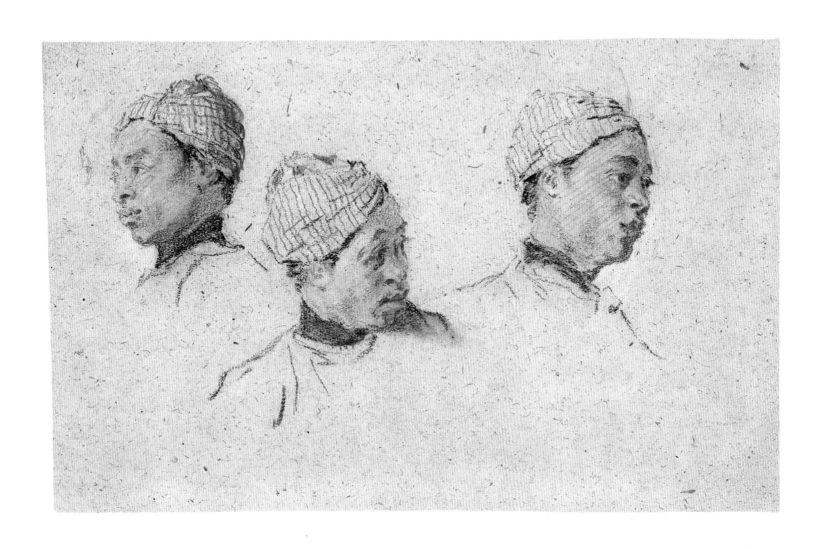

61 Seated Figure and Standing Figure

ca. 1725

Red, black, and white chalks on buff paper
7¼ × 11⅝ in. (18.3 × 29.5 cm)

National Gallery of Art, Washington, D.C.;
Gift of Myron A. Hofer in memory of his
mother, Jane Arms Hofer, 1944 (1944.9.1)

Provenance Edmond and Jules de Goncourt,
Paris; Goncourt sale, Hôtel Drouot, Paris,
February 15, 1897, lot 146; Frédéric Villot

Exhibitions Paris 1860, no. 280; New York
1959, no. 63; New York and Fort Worth
1991–92, no. 27

Literature Goncourt 1881, I, pp. 99–100;
Launay 1991, no. 158; Grasselli and
McCullogh 1994, p. 170

Notes

1. For other drawings see Bjurström 1982,
no. 1010; Munger and Zafran 1992, no. 68;
Ingamells 1989, p. 236.
2. See Eric Zafran's discussion of the
costume in Munger and Zafran 1992, no. 68.
3. For Watteau's drawings of women in
Polish costume, see Rosenberg and Prat
1996, I, nos. 44 and 76; for *The Dreamer*, see
Rosenberg and Grasselli 1984, no. P26; for
lost works of women in "Polish" costume,
see Dacier and Vuaflart 1921–29, III,
no. 145, and Rosenberg and Camesasca
1970, no. 166.
4. See Hughes 1981, pp. 7–14; Holmes 1985,
chapter 3, note 21.
5. Sale, Paris, November 21, 1774, lot 132;
see Rosenberg and Grasselli 1984, p. 305.
6. Versions of *The Beautiful Greek* include
those in the Art Institute of Chicago (inv.
c36415); the Wallace Collection, London
(P450); and the collection of the douairière
duchesse de Mouchy, Paris. Versions of *The
Amorous Turk* include those in the Blaffer
Foundation, Museum of Fine Arts, Houston;
and the collection of the douairière duchesse
de Mouchy, Paris.
7. Gillot's manuscript is in the Bibliothèque
Nationale (B.N. Fr. Manus. 9312 no. 1306);
the association between Gillot's play and
Lancret's paintings was first made in Populus
1930, p. 25.
8. The Fitzwilliam Museum painting (acc.

This sheet is one of at least a dozen known drawings by Lancret depicting a model in the same fur-trimmed red gown and matching toque; other sheets are found in the museums in Stockholm, Boston, and Berlin, on the art market in New York, and in several private collections.[1] All are drawn in a rich blend of *trois crayons* with a pronounced use of white heightening. The subject is sometimes referred to as "*une Polonaise*" because the costume the model wears is a type derived from a Polish dress with split sleeves (the *kontuoik*) that had been introduced into France in the first years of the eighteenth century.[2] Watteau drew and painted sitters in similar dress on several occasions, the best-known example of which—the painting *The Dreamer* (*La Rêveuse*) in the Art Institute of Chicago—was attributed to Lancret for much of the nineteenth century.[3]

There is no reason to think that Lancret's drawing represents an actual foreign sitter. Presumably, Lancret supplied the fur-trimmed gown and the other elaborate costumes in which he dressed his regular models, as Watteau is known to have done. The "Polish" outfit is in keeping with a general taste for the "exotic" that was pronounced in Parisian artistic and literary circles in the 1710s and 1720s. One of Watteau's finest series of portrait drawings had been inspired by the visit to Paris of a Persian Embassy in 1715 (cat. nos. 12, 13), and the arrival of the Ottoman ambassador to France in 1721—which coincided with the publication of Montesquieu's *Lettres persanes*—was commemorated with a special issue of the *Mercure de France*.[4] The contemporary fashion for *turqueries* may have inspired the present drawing, despite the Polish derivation of the model's costume: most Parisians would have made little distinction among foreign cultures, and Lancret employed his drawings of "*une Polonaise*" to serve as studies for paintings of *The Beautiful Greek* (*La Belle Grecque*), while Watteau's *The Dreamer* was regularly misidentified as "*une jeune femme Turque*" in eighteenth-century sales catalogues.[5]

Several painted versions of *The Beautiful Greek* are known, most of them single-figure costume studies that were usually intended to pair with versions of Lancret's *Amorous Turk* (*Le Turc amoureux*).[6] These paintings probably found their narrative source in the popular theatre of the fairgrounds, possibly in *Polichinelle Grand Turc*, a play thought to have been written by the painter Claude Gillot, in whose studio both Watteau and Lancret had apprenticed.[7] In Gillot's comedy, Punchinello throws a Turkish costume ball at which he appears dressed "*en grande Turque*" and frees a "*charmante Brunette*" from the seraglio.

The sketch of "the beautiful Greek" seated on the right side of the Washington drawing was employed as a study for two paintings in which her Turkish lover is absent: *Music Party in a Landscape* (Cambridge, Fitzwilliam Museum) and *The Dance Before the Fountain* (Potsdam, City Castle); the figure on the left was not used in any of Lancret's

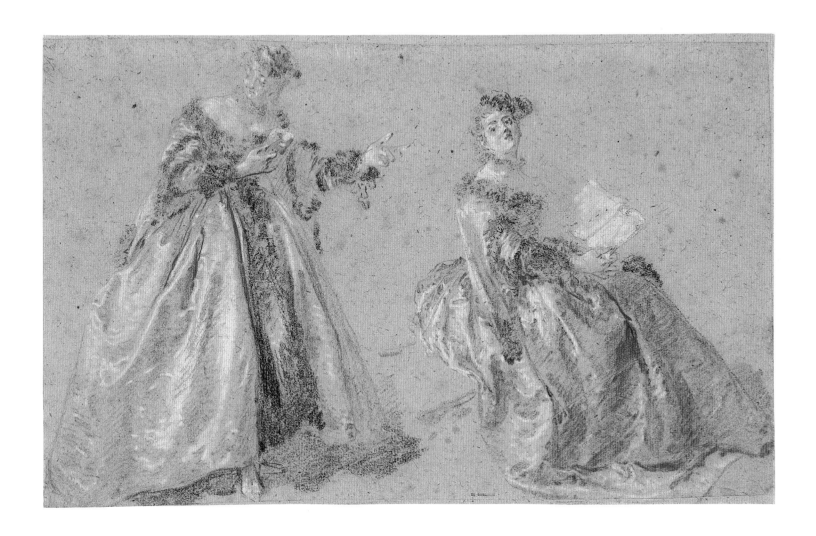

no. 329) is not published in Wildenstein 1924; the Potsdam painting is published in Wildenstein 1924, no. 149, fig. 47.
9. Grasselli and McCullagh 1994, p. 170, wonder if the Washington drawing might be an example of a finished, autograph replica after Lancret's working studies.

known paintings.[8] Like Watteau, Lancret was entranced by the theater, costume, and the exotic, and in drawings such as the present sheet—and *Three Studies of a Turbaned Black Man* (cat. no. 60)—he appealed to current fashion. The drawing is so richly textured and colored, so elaborately worked up, and finished with such suavity that one can only assume that Lancret recognized its potential value as an independent work of art.[9] A natural popularizer, Lancret succeeded in transforming Watteau's empathetic studies of foreign worlds into an irresistible fantasy of the Orient.

62 The Guitar Player

ca. 1725–30

Red chalk touched with a darker shade of red chalk, on cream laid paper, laid down on cardboard

9⅜ × 4⅝ in. (23.8 × 11.7 cm)

National Gallery of Canada, Ottawa; purchased, 1951 (6048)

Literature Roland Michel 1987a, pp. 184–85, repr. p. 184

Notes

1. Audran's etching is reproduced in Rosenberg and Prat 1996, III, no. G74; a copy of the lost drawing is published by Rosenberg and Prat 1996, III, no. R159.

The Ottawa *Guitar Player* is one of many single-figure studies of musicians, actors, and comedians in fancy dress made by Lancret in the 1720s, soon after Watteau's death, when the master's manner and subject matter still had a powerful hold over his imagination. It is comparable to figures by Watteau such as *Pierrot Playing a Guitar*, a lost drawing known through J. Audran's etching in *Les Figures de différents caractères* (no. 187) and a fine old copy in a French private collection.[1] Not only is Lancret's handling of red chalk similar, if heavier and more angular, to that found in many of Watteau's drawings from around 1710–14, but the guitar player's closely contained, rigidly upright pose and slightly anxious expression find parallels in such images as the previously mentioned *Pierrot*. A unique aspect of Lancret's work in the 1720s, however, is the unsual proportions he gives to many of his figures: long and attenuated, with wide hips and a tiny head, as found in the *Guitar Player*. Typical of Lancret's manner in this period is the lightly sketched face and the dense accenting in areas of the drapery, effected by heavy reworking in these parts, sometimes—as here—with a darker-red crayon.

Although he does not appear in any of Lancret's known paintings, *The Guitar Player* must have been stockpiled with many other studies for possible use in his *fêtes galantes* or theater scenes.

63 Studies of an Actor

ca. 1739

Black, red, and white chalks on gray laid paper, affixed to laid paper mount
10⅜ × 8½ in. (26.4 × 21.7 cm)

The Fine Arts Museums of San Francisco, Achenbach Foundation for Graphic Arts; purchase, Georges de Batz Collection (1967.17.4)

Provenance Jacques Mathey, Paris; de Batz Collection

Exhibitions New York and Forth Worth 1991–92, no. 37

Literature Hattis 1977, no. 71; Claverie 1980, p. 150

Notes

1. Hattis 1977, p. 110.
2. Brunabois Montador 1739, p. 187.
3. The original portrait of Grandval, which was exhibited in the Salon of 1742, is lost and known through an engraving by J.-P. Le Bas; see Wildenstein 1924, no. 591; an autograph replica of the painting, on a somewhat reduced scale, is in the Indianapolis Museum of Art, see Wildenstein 1924, no. 592, fig. 146.

The drawing is the study for a lost painting, known through a contemporary engraving by Nicolas-Gabriel Dupuis that illustrated the third scene of the third act of the play *Le Glorieux*, a comedy by Philippe Destouches first performed in 1732 at the Comédie Française.[1] Lancret's painting was exhibited, with a pendant depicting a scene from Destouches's *Philosophie Marie*, at the Salon of 1739. In his Salon critique, *Description raisonnée des tableaux exposés au Louvre, 1739. Lettre à Mme. la marquise de S.P.R.*, the Chevalier de Neufville de Brunabois Montador observed that every actor in Lancret's painting could be identified[2]; accordingly, the present drawing must be a study of Abraham-Alexis Quinault, called Quinault-Dufresne, the young leading man who was the successor at the Comédie Française to the celebrated Nicolas Racot de Grandval. Grandval, whose portrait would be painted by Lancret in 1742, appeared beside Quinault-Dufresne in *Le Glorieux*, where he played the role of Valère.[3]

This drawing wittily conveys the self-conscious stance, carefully arranged silhouette, and rhetorical gesture of the stage actor. While the black-and-white-chalk technique employed in the figure sketch is rarely found in Watteau's work, the detail studies of the actor's right hand in red and white chalks are certainly an inheritance from the artist. As the drawing was unquestionably made in preparation for the painting exhibited in 1739, it can be securely dated to around 1739, quite late in Lancret's career, when the influence of Watteau's art was waning.

64 Head of Omphale, Study for "Hercules and Omphale"

1724
Red and black chalk, heightened with white, on cream paper
9¼ × 6½ in. (23.4 × 16.5 cm)
University of California, Berkeley Art Museum; Gift of Mr. and Mrs. John Dillenberger in memory of her son, Christopher Karlin (1971.16)

Provenance Art market, London

Exhibitions Toronto, Ottawa, San Francisco, and New York 1972–73, no. 79

Literature The Art Quarterly, 1971, p. 374; Bordeaux 1984, no. D66

65 Hercules Seated, Study for "Hercules and Omphale"

1724
Black, red, and white chalks on light-brown paper
15¾ × 12⅝ in. (40 × 32 cm)
The Art Institute of Chicago; Promised gift of Dorothy Braude Edinburg to the Harry B. and Bessie K. Braude Memorial Collection (87.1998)

Provenance Max Hevesi, Vienna; sale, New York, Christie's, January 30, 1998, lot 237

Notes
1. Bordeaux 1984, no. P47, fig. 43.
2. The most thorough discussion of the painting, its history, and influence can be found in Bailey 1991, pp. 244–49, no. 23.
3. Lecomte 1604, II, 695; cited in Bailey 1991, p. 244 and note 1.
4. Paignon-Dijonval sale, Paris, 1810, no. 3249, cited in Bordeaux 1984, under no. D65; the British Museum drawing, Bordeaux 1984, no. D65.
5. Bailey 1991, p. 246. Although both Correggio and Parmigianino sometimes worked in chalks, neither employed the seductive three-chalk technique found in

More than any artist of his generation—or, indeed, any painter until the emergence of François Boucher—François Lemoyne must be credited with freeing history painting from the stranglehold of archaicizing classicism that had inhibited its development since the time of Le Brun. La Fosse had certainly begun the shift toward a more sensual and urbane manner, but it was Lemoyne who created a new type of history painting that might be termed "gallant mythology." In an era when the crown was almost bankrupt and official commissions had all but dried up, Lemoyne achieved success with collectors by introducing the eroticism and elegance of Watteau's *fêtes galantes* into "*le grand genre*." Lemoyne's most important and adventurous works date from the 1720s, and none was more influential than *Hercules and Omphale* (fig. 96).[1]

Painted by Lemoyne between May and July 1724 for his patron François Berger while the two men were traveling together in Rome, the painting met with immediate acclaim, was exhibited in the Salon of 1725, and was soon reproduced in at least two contemporary engravings and countless copies and pastiches.[2] The story of Hercules and Omphale was told by Apollodorus and Ovid, but known in France through Lecomte's *Mythologie* (1604), a copy of which was recorded as being in Lemoyne's library.[3] Having violated the sacred rites of hospitality by slaying a guest in his own home, Hercules was obliged to atone for his crime by consenting to sell himself into slavery for a year and giving the money paid for his enslavement to the family of his victim. He was purchased by Omphale, queen of Lydia, whom he was obliged to serve sexually. So subjugated was Hercules to the queen's demands that rumor reached Greece that he had taken to wearing female clothing and would spin and weave in the company of her attendants.

In Lemoyne's masterpiece, Hercules is seated in a rocky landscape with a distaff in his left hand and spindle in his right, a great piece of gold-embroidered silk wrapped around his right leg and concealing his genitals. Omphale, wearing the lion's skin that Hercules has discarded and holding his club provocatively under her arm, looms over the emasculated hero with her arm thrown over his shoulder. A winged cupid, who offers Hercules a bowl of sweets, looks at us with amusement. The wry humor of Lemoyne's comedy *en travestie* is conveyed even in the artist's magnificent *trois crayons* studies for the principal characters: in the Berkeley drawing (cat. no. 64), Omphale gazes at her lover with a look of omnivorous sexual privilege, while Hercules glances back from the page of Chicago's *académie* (cat. no. 65) in nervous supplication.

In addition to these two sheets, two other drawings for the painting are known: a lost drawing of the entire composition in black and white chalks on blue paper, last recorded in the sale of the Paignon-Dijonval collection in 1810; and a glorious *trois crayons* study of the torso of Omphale in the British Museum, London.[4] In the latter drawing, Omphale's face is only summarily indicated, and the Berkeley study would have been

Lemoyne's drawing, and Veronese used it only rarely.

6. Caylus in Lépicié 1752, II, p. 99; Bailey first associated Caylus's remark with Lemoyne's Hercules (1991, p. 246).

7. Dacier and Vuaflart 1921–29, I, pp. 42, 54, 160, and 172; on Watteau and Lemoyne's shared collectors, see Bordeaux 1984, p. 40.

8. For *The Hunting Breakfast*, see Bordeaux 1984, no. P38, fig. 34; for *The Hunt Meeting*, see Ingamells 1989, no. P416.

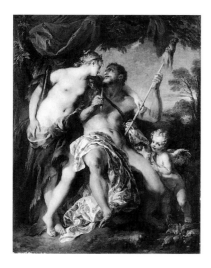

Figure 96. François Lemoyne, *Hercules and Omphale*, 1724. Oil on canvas, 72½ × 58¾ in. (184 × 149 cm). Musée du Louvre, Paris

necessary to fix her subtle expression and the precise turn of her head; presumably no such additional drawing would have been required for Hercules, since the Chicago sheet offers the complete figure. The precedents of Correggio, Parmigianino, and Veronese are invariably cited in discussions of the sinuous figure of Omphale, and with good reason: the three artists were among Lemoyne's favorites, and he had been studying their paintings *in situ* at the time he was working on his canvas. The blonde Omphale of the painting does bear some resemblance to Parmigianino's *Madonna of the Long Neck* (Florence, Uffizi), as Colin Bailey has observed, but the raven-haired model of Lemoyne's drawing is another matter; in his *trois crayons* study, Lemoyne was obviously working in a manner closer to that of Watteau.[5]

The study of the nude Hercules—drawn on a darker shade of tan paper than the studies for Omphale to emphasize the ruddier color of his frame—was only recently discovered and has not previously been published. It, too, employs the subtle blend of chalks found in the drawings of Watteau and, by extension, Rubens. The impact of Michelangelo's ceiling decorations on Lemoyne's work, cited by Caylus (1752), can certainly be felt in the muscular figure of Hercules, which recalls the *ignudi* of the Sistine Chapel in its dramatic foreshortening.[6] Lemoyne's drawing is a masterly exercise in the academic rendering of the nude male form, in which every part of the body is articulated clearly and with coherence. Even the shadow that Omphale will cast over Hercules's head and shoulders in the painting has been calculated and included. Watteau's studies of the male nude could never be classified as *académies*, in the strict sense of the term, and offer little real sense of the structure or mechanics of the human body. Yet a comparison of Lemoyne's Hercules with any of Watteau's male nudes demonstrates a similar engagement with the figure, a naturalistic grasp of its form which elevates the rendering of it above the level of ideal abstraction common to most *académies*, and a sensuous appreciation of flesh and skin, as is especially apparent in the flickering white highlights of Lemoyne's drawing.

Lemoyne and Watteau certainly knew each other (they were present at several of the same sessions of the Academy), but the extent of their relationship was not remarked upon by contemporaries who knew their best work. Their works were acquired by a number of the same collectors.[7] Lemoyne made the occasional gallant genre piece, and painted a fine *Hunting Breakfast* (1723; São Paolo, Museu de Arte) only three or four years after Watteau's *Hunt Meeting* (London, Wallace Collection), with which it bears a certain affinity.[8] However, Lemoyne's enduring accomplishment was infusing history painting with the spirit of the *fête galante*; it would be his principal influence on his pupils, Boucher and Natoire, and his legacy to French painting.

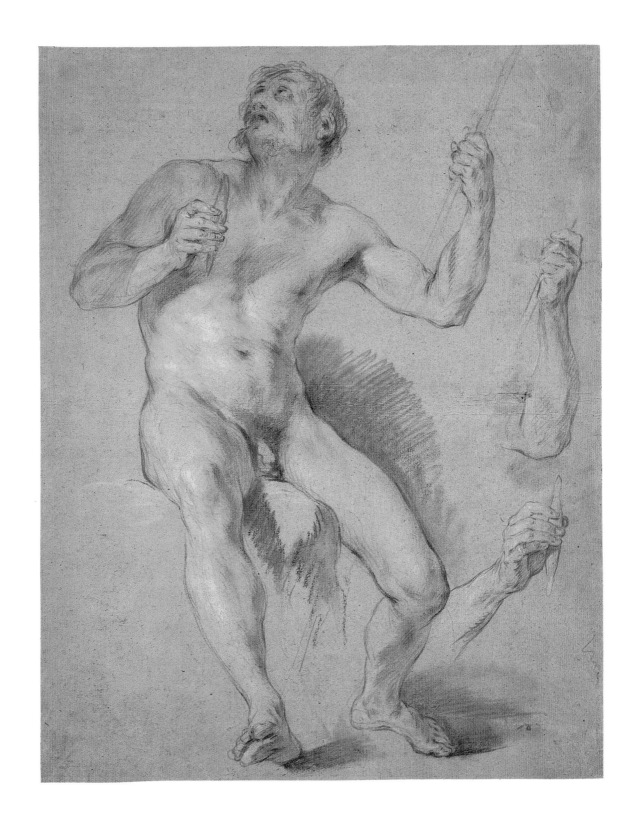

66 Study of a Nude Woman

ca. 1720–25
Red and black chalks, with touches of white chalk, on beige antique laid paper
16⅝ × 11 in. (42.2 × 27.8 cm)
Fogg Art Museum, Harvard University Art Museums, Cambridge, Mass.; Gift of Charles E. Dunlap (1954.115)

Provenance Gift of Charles E. Dunlap, 1954

Literature Bordeaux 1984, no. D81; Stuffman 1986, pp. 101–02, fig. 76a; Méjanès in Clark 1998, p. 184, fig. 3

Notes
1. The drawing was correctly attributed to Lemoyne by Marianne Roland Michel, Margaret Morgan Grasselli, and Jean-Luc Bordeaux.
2. Bordeaux identified two other female nudes drawn in comparable technique, see Bordeaux 1984, nos. D80 and 82; since the publication of his book others have resurfaced, including a study for a woman in *The Continence of Scipio* (1727; Nancy, Musée des Beaux-Arts), which was with Annamaria Edelstein Master Drawings, London, in 1993; and a study for the figure of Diana in *Diana and Callisto* (Cambridge, Mass., Horvitz Collection) first published in Bailey 1991, p. 255, fig. 3. Bordeaux wonders whether the Fogg nude could have been a first idea for one of the nymphs in *The Rape of Europa* (1725; Moscow, Pushkin Museum), although it bears no particular resemblance to any figure in that painting; Bordeaux 1984, under no. 81.
3. Bordeaux noted that lot 139 in the Boileau sale (March 4, 1782) included two studies by Lemoyne, one of which was "*une académie de femme nue, vue par le dos … aux trois-crayons.*" Bordeaux 1984, under no. D81.

This standing female nude was attributed to Watteau until the late 1970s, when it was returned to Lemoyne on stylistic grounds.[1] Although images of women in lost profile, seen from behind, appear often in works by Watteau—and the drawing is executed in the *trois crayons* technique with which Watteau is most closely identified—it displays a different handling than is found in Watteau's authentic nude studies. The chalks are more tentatively applied, with delicate cross-hatching, and less robustly integrated; the outlines and contours of the figure are hesitant and rather nervous, sometimes doubled with a number of slight changes of mind; the hair is drawn in broad, simple chalk marks. Furthermore, the model's body—rendered with great naturalism—is heavier, more lumbering and graceless than one would expect to find in a drawing by Watteau, and her pose—animated, walking, with arms raised in an inexplicable gesture—must certainly have been assumed with a particular composition in mind. The Fogg drawing is surely a study for a painting by Lemoyne that has yet to be identified.[2]

All of these characteristics are typically found in the softly modeled figure studies of Lemoyne, whose feminine ideal exerted a profound influence on Boucher, Natoire, and J.-M.-B. Pierre, among the artists of the next generation. Acknowledging the difficulty of dating such drawings, Jean-Luc Bordeaux has tentatively placed it around 1720–25.[3]

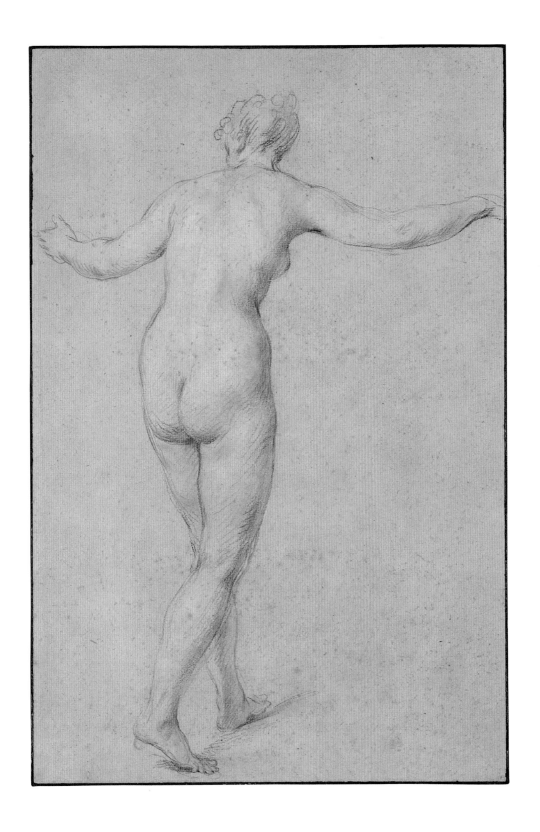

223

67 Veiled Turkish Woman

1738
Red and black chalks on white paper
8⅛ × 5⅛ in. (20.8 × 13.1 cm)

Inscribed in red chalk (autograph)
femme/Turque/dans le rues/Julliet 1738

The Pierpont Morgan Library, New York
(1989.50)

Provenance J.P. Heseltine (Lugt 1507); Walter
Hugelshofer; Janoz Scholz

Exhibitions Washington et al. 1967–68,
no. 65, repr.; Notre Dame 1980, no. 127

Literature Trivas 1936, no. 38; Hugelshofer
1969, no. 69, repr.; Boppe 1989, pp. 68,
285, no. 52, repr.; Scholz 1990, pp. 254–56,
fig. 1; de Herdt 1992, p. 58, no. 23

Notes
1. For a summary of Liotard's career, see de
Herdt 1992, pp. 5–25, and "Chronology,"
pp. 308–09.
2. They are all catalogued in de Herdt 1992,
pp. 276–92.
3. Preston 1995, p. 334.
4. Scholtz 1990, p. 256.
5. Despite their obvious differences in
subject matter, the two artists' techniques are
so similar that drawings by Liotard are
sometimes attributed to Portail, and *vice versa*;
other drawings have yet to receive a
satisfactory attribution, such as *Femme au
manchon*, de Herdt 1992, no. 87 (where it is
given to Liotard): when the drawing was in
the Goncourt collection, the brothers first
catalogued it as "Portail," then altered the
attribution to: *Liotard/10 contre épreuve/
Femme au manchon*; when the 1992 exhibition
was reviewed, Alastair Laing in *The
Burlington Magazine* (134, 1992, p. 751)
simply rejected the attribution of the sheet to
Liotard, while H. Preston in *Master Drawings*
(1995, p. 336) asked "if perhaps the early
description of it as an offset by Portail is, in
fact, correct?"
6. Dacier and Vuaflart 1921–29, III, no. 32;
de Herdt 1992, p. 10 and note 7.

Jean-Etienne Liotard had already achieved a measure of success as a portraitist, printmaker, and miniaturist when he left Paris in 1735 to travel and study in Italy. In Rome, he was invited by William Ponsonby, later 2nd Earl of Bessborough, to tour Malta, the Greek Islands, and Constantinople; arriving in Constantinople in June 1738, Liotard remained there for the next four years.[1] Approximately seventy-five drawings have survived from his sojourn in the Ottoman Empire, most of them seductive figure and costume designs *à deux crayons*, such as the present, exquisite *Veiled Turkish Woman*.[2] Like many of the studies, its subject and date are identified by an inscription in the artist's own hand, this one declaring that he sketched the Turkish woman in the streets in July of 1738, one month after his arrival. Among the local inhabitants, Liotard found a number of Frankish (or non-Muslim) women who were willing to pose unveiled, and he also drew other Western European residents dressed in local costumes.[3] Because of strict laws of the Quran, few Muslim women appear to have modeled for him, making the present drawing exceptional. By reducing color to a minimum, Liotard cunningly directs attention on the small opening of exposed pink skin between the top of the Turkish woman's veil and the bottom of her hat, drawing the viewer to the bold engagement of her lovely, rather feline, eyes.

Liotard's informal life study evokes memories of drawings by Watteau: not only his studies of "exotic" types, but the sketches of beautiful, unattainable women made for use in the *fêtes galantes* as well. Although Liotard's drawing displays the small head and attenuated body that is typical of Rococo proportions, the *Veiled Turkish Woman* is not a theatrical *turquerie* in the style of Lancret's *Seated Figure and Standing Figure* (cat. no. 61); rather, Liotard approached his subject with the candor and respectful curiosity that one associates with Watteau's Persian studies. His love for the Middle East and its people was sincere and lifelong, and he transformed himself into a veritable native who was thoroughly familiar with the language, art, and culture of the region.[4] In the drawings that record his experiences there, Liotard created an artistic universe as silent and poetic as Watteau's own.

Liotard's drawings are appealing for their subtle blending of softly colored chalks and their meticulous, miniaturist handling, so reminiscent of the drawings of Jacques-André Portail, another draftsman of the same generation who was greatly influenced by Watteau's example.[5] In the case of Liotard, this novel adaptation of Watteau's technique grew out of a close acquaintance with the master's work: he had early been engaged to engrave *The Sick Cat* (*Le Chat malade*) for the *Recueil Jullienne* (announced in 1731), and at his death in 1789 his posessions included "a portfolio of drawings by Watteau" as well as several paintings by the artist.[6]

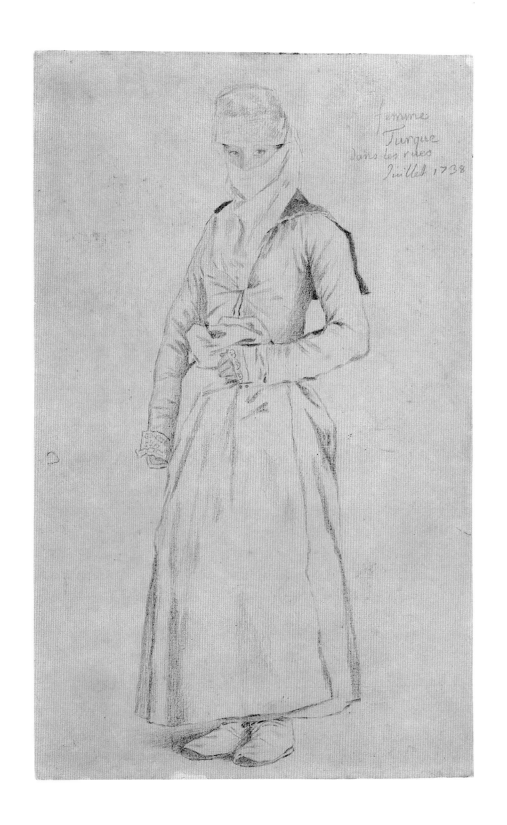

femme
Turque
dans les rues
Juillet 1738

68 Study of a Young Shepherd Holding a Songbook

ca. 1746
Red, black, and white chalks on beige paper
9¾ × 14½ in. (24.8 × 36.8 cm)
Private collection, New York

Exhibitions Hamburg 1989, no. 34; New York 1989, no. 6

Notes
1. See Duclaux 1977, pp. 61–64 and no. 4, respectively.
2. Williams 1989, no. 6.
3. Duclaux 1977, p. 43.
4. "*Deux tableaux, de 4 pieds et demi sur 3 pieds de haut, dans la Chambre des Bains de la Reine. Les sujets sont tirés des eglogues de M. de Fontenelle. Le premier represente "Un concert de musique champêtre": on voit une jeune bergère jouant de la guithare, un berger lui tenant un livre de musique, plusiers instruments sont auprès d'une fontaine rustique, et dans le lointain, des troupeaux gardes par des pastres.*" Engerand, *Inventaire des tableaux commandés et achetés par la direction des Bâtiments du Roi (1709–1792)*, Paris 1900, I, pp. 311ff.; cited by Williams 1989, no. 6.

It was from his teacher François Lemoyne that Charles-Joseph Natoire inherited a talent for enlivening official history painting with the elegance and charm of the *fête galante*. Mythological compositions lent themselves most easily to a spirit of graceful eroticism, as is found in Natoire's masterpiece, the cycle of overdoor decorations that recount the *Story of Psyche*, painted for the *salon ovale de la princesse* of the Hôtel de Soubise between 1736 and 1739 (*in situ*); yet even Natoire's stern religious compositions could be relieved by the introduction of almost balletic physical grace, as is evident in *Christ Chasing the Merchants from the Temple*, commissioned in 1727 by the Cardinal de Polignac (Paris, Saint-Medard).[1] It was on the rare occasions when the artist took up contemporary decorative subjects unencumbered by the requirements of historical narrative that he could explore most freely the possibilities of the *fête galante* and its successor, the *pastorale*.

Eunice Williams first recognized that the present drawing was likely made as a study for one of a pair of overdoor paintings commissioned from Natoire in 1746 for the queen's bathroom at Versailles; these pendants, which remained in place until 1854, when they were transferred to the Château de Saint-Cloud, were destroyed in the fire that gutted the château in 1871.[2] No prints record their appearance and a description of one of the paintings in the *livret* of the Salon of 1747, where it was exhibited, is terse, identifying it simply as *Musique pastorale et champêtre* (no. 35).[3] However, documents for payment of the royal commission have survived, and they provide fuller descriptions of both pictures.[4]

It indeed seems likely that the lively *trois crayons* study represents the young shepherd who holds the musical score for a female companion as she plays the guitar. Except for an emphasis on the painting's rusticity—the subject comes from Fontenelle's Eclogues— the royal inventory could almost be describing a picture by Watteau. However, it was precisely the replacement of worldly Parisians flirting in a park by innocent shepherds wooing in contemporary Arcady that marked the evolution from Watteau's *fête galante* to the *pastorale*, which Boucher was to make his special province.

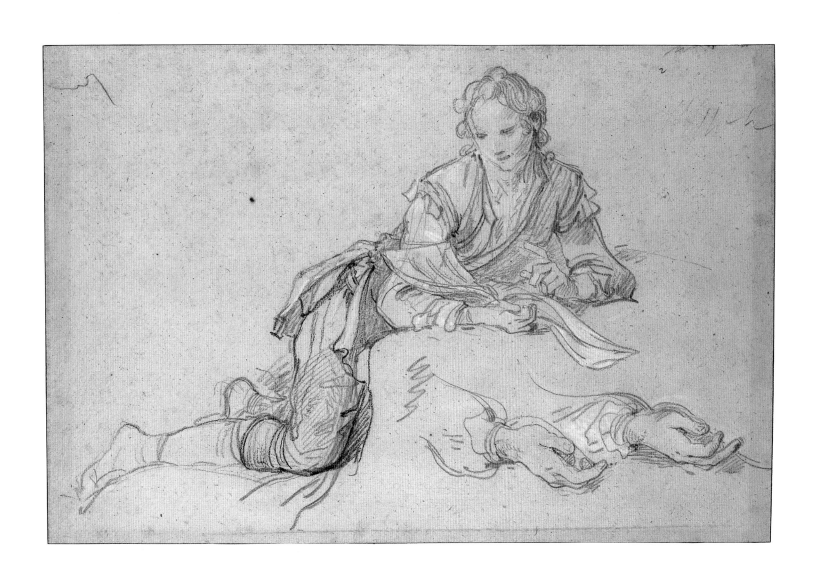

227

69 After the Hunt

ca. 1725

Pen and black ink, brush and white gouache on brown-gray paper, mounted on cardboard, framing lines in pen and black ink

7½ × 9⅝ in. (18.7 × 24.4 cm)

Signed on bottom left: *J.B.* [entwined] *Oudry*

Cooper-Hewitt, National Design Museum, Smithsonian Institution; purchased, Friends of the Museum Fund 1938–66–3 (1938–66–3)

Provenance Unidentified collector's mark at upper right (Lugt 337a or 341b); Sarah Cooper-Hewitt; bought at the Erskine Hewitt sale, New York, October 18–22, 1938, no. 562

Exhibition Toronto, Ottawa, San Francisco, and New York 1972–73, no. 100

Literature Opperman 1977, no. D981; *Apollo*, 1973, p. 194, fig. B.

Notes

1. Opperman 1977, I, p. 6, note 3.
2. Opperman 1977, I, p. 71.
3. Opperman 1977, I, p. 135, cites the abbé Gougenot's *Vie de Monsieur Oudry*, p. 380; for the drawings acquired by Tessin, see Bjurström 1982, nos. 1079–84.
4. See Opperman 1977, I, pp. 49–50; the *Histoire naturelle* was published in 15 volumes between 1749 and 1767, and Opperman quotes Buffon's article "Chien," vol. V, pp. 185–86.

Jean-Baptiste Oudry and Watteau were almost exact contemporaries and probably knew each other; certainly, they had friends and mentors in common: Oudry and Gillot were well acquainted and collaborated on at least one theatrical production, the ballet *Les Eléments* (1721), which had sets painted by Oudry and Antoine Dieu and costumes by Gillot.[1] Claude III Audran also knew Oudry, and the two are said to have collaborated on arabesque decorations for the Château de Reveillon in 1731.[2] Nevertheless, Oudry's artistic personality was very different from that of Watteau, and their works—both paintings and drawings—reveal few obvious parallels. Both artists held their own drawings in high regard, however, and parted with few during their lifetime, Oudry apparently considering his an estate the sale of which would support his entire family after his death. As with Watteau, one of the only collectors whom he allowed to have his drawings was the persistent Count Tessin.[3]

It is not clear whether *After the Hunt* was made as a composition study for a painting—no related canvas is known—or as an independent work of art. Drawn with a brush, gray wash, white gouache, and the almost undiluted India ink that was Oudry's favored medium until the late 1720s, it is remarkable for its vivid effects of light and shadow; indeed, the contrast between the brightly lit background and the darkened foreground is especially striking and effective. As was typical of Oudry's method as a draftsman, the drawing has a tightly organized and carefully meditated composition that is as complete as a painting, and it employs the rich range of pictorial effects that one would normally expect to find in a painting. Much of the pleasure of the sheet is found in the tension between the elegant naturalism with which the two hunting dogs are observed and the Rococo artifice of the setting in which they are placed. Like Watteau's rare sheet of animal sketches, *Five Studies of a Dog* (cat. no. 45), from about five years earlier, Oudry's drawing invests its animal subjects with particular characters, almost human sensibilities and intelligence that make them seem other than wholly animal. Although identifying sentimental qualities in animals is a commonplace of our own times, it was unusual in the early eighteenth century and found no philosophical expression until Buffon began to publish his *Histoire naturelle* in 1749.[4] The lifelike alertness and amusingly quizzical expressions of the dogs in *After the Hunt* demonstrate why Oudry was universally considered the most original and talented animal painter of the day.

70 *The Game of Hot Cockles*

1728
Black chalk, with white heightening, on faded blue paper
11¼ × 17 in. (28.5 × 43.2 cm)
Signed and dated in pen and brown ink on lower right: *J.B. Oudry 1728*
The Snite Museum of Art, University of Notre Dame; Gift of Mr. John D. Reilly, Class of 1963 (96.70.13)

Provenance Possibly Paignon Dijonval collection, cat. 1810, no. 3235; Boussac Collection; Cailleux, Paris; purchased in Paris in 1987

Exhibition New York 1983, no. 19

Literature Bjurström 1982, note 3, under no. 1084; Spiro *et al.* 1993, no. 24

Notes
1. For the most thorough discussion of Oudry's designs for Beauvais, see Opperman 1969, pp. 49–71.
2. In addition to the three drawings discussed above, Opperman (1969, pp. 56, fig. 5, and 58, fig. 6), links two other sheets in Stockholm to the series, but not entirely convincingly.
3. *La main chaude*—literally, "the hot hand"—was played by boys and girls together: a player chosen by lot had to kneel with his face buried in the lap of a non-participant called "the confessor," and open his hand behind his back. As the other players struck his hand in turn, he had to identify who hit him; if he guessed correctly, he was replaced in the "confessional" by the person he had identified. More than four decades later Fragonard would famously depict the subject in a painting now in the National Gallery of Art, Washington, D.C., see Rosenberg 1988, pp. 348–49, no. 165.
4. Bjurström 1982, no. 1084; like Opperman, Bjurström cites a counterproof of the Stockholm drawing, which is in the Ashmolean Museum, Oxford.
5. Locquin 1906, p. 109; cited by Opperman 1969, p. 59, note 26.
6. See Opperman 1977, nos. P95–P102, for the list of subjects in the final tapestry set.
7. See Opperman 1977, II, no. 554; the drawing was on the London art market in

Although he had no formal training as a tapestry designer, Oudry was named official painter to the Beauvais Manufactory in 1726; his task was to renovate the factory's outdated models. Over the next eight years he undertook to provide new models for four tapestry series, including *Country Amusements* (*Amusements champêtres*), a set of eight pieces completed in 1732, and apparently woven by the manufactory four times before the cartoons were exiled to the Aubusson factory in 1761. The *Country Amusements* were designed to replace *Children's Games* (*Jeux d'enfants*), one of the oldest sets then woven at the factory; Oudry updated the designs according to the new fashion for *fêtes*, both *champêtre* and *galante*, by replacing the children's games of Damoiselet's antiquated set with contemporary adult play.[1]

The Game of Hot Cockles (*Le Jeu de la main chaude*) is one of three known preparatory drawings for the set and its date of 1728 coincides with the year in which Oudry began work on the designs.[2] The drawing depicts three adult couples in an overgrown park playing an all but forgotten children's game.[3] Taking advantage of his strength as an *animalier*, Oudry added a barking dog and three prominently placed sheep in the mix. Another complete compositional study of the subject—signed and dated 1728, and with significant variations—was executed in black and white chalks on blue paper.[4] Since the artist was required to submit all of his preliminary designs to the manufactory for approval, we can assume that one of the drawings represents an initial, rejected idea[5]; unfortunately, as the subject was not included in the final tapestry set, it is impossible to determine which of the studies for *Le Jeu de la main chaude*—the Reilly sheet or the drawing in Stockholm—came first.[6] A third study for the set is in a private collection, and was employed as a design for two hangings, *Le Jeu de pied de bœuf* and *Le Jeu de Colin-Maillard*.[7]

In *Country Amusements*, Oudry consciously took on Watteau's genre.[8] Oudry's manner of drawing bears no relation to Watteau's style, nor does his more decorative, picturesque vision. Rather, it was Oudry's stroke of inspiration to realize how ideally suited *fêtes galantes*—with their lush garden settings—would be for large, decorative wall coverings. With only a few modifications, the small-scale compositions of Watteau and Lancret could be successfully inflated to mural size. The delicate shades of expression, of psychological and emotional nuance that are at the heart of Watteau's art were sacrificed in the process, but they were never to be faithfully replicated in any medium, even by Watteau's closest followers. As is evident in the Reilly drawing, Oudry seized on the playful comedy, erotic badinage and delight in nature that are inherent in the genre, creating, as Opperman recognized, "perhaps the earliest large-scale French Rococo decorations of pastoral subjects, well in advance of those by Boucher."[9] In fact, after Oudry was appointed director of the Beauvais manufactory in 1734, he turned over

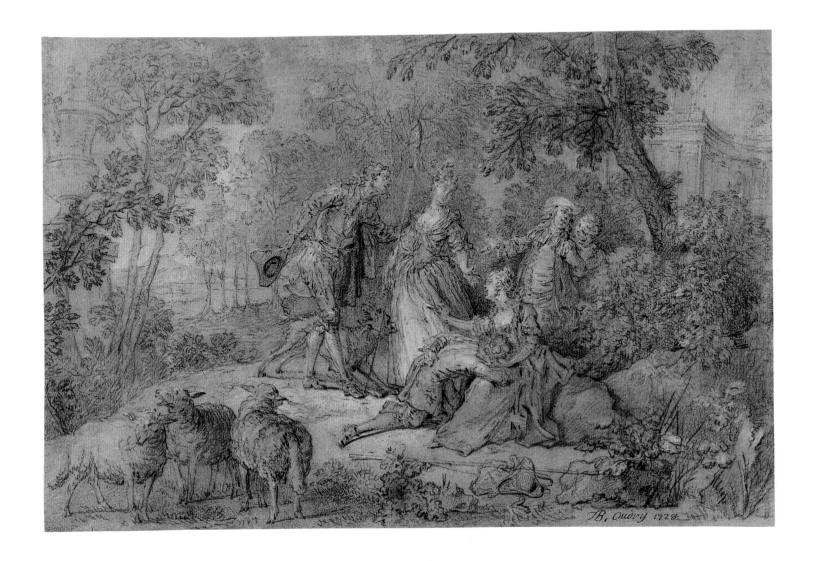

1998, see Spink & Leger, *Master Drawings,
17th to 20th Century*, 1998, no. 4.
8. Opperman 1983, no. 2.
9. Opperman 1977, I, pp. 87–88.
10. Opperman 1969, pp. 50–51.

most of the design projects to Boucher, who produced six sets of cartoons—including the *Italian Fêtes*—for what would prove the most financially and artistically successful series of tapestries in the history of the factory (see cat. no. 50).[10] But it was Oudry's *Country Amusements* that had expanded and modernized the repertory, opening the way for the extension of gallant imagery into a woven medium.

71 Three Studies of Standing Women, Seen from the Back

ca. 1721
Red and black chalks on three pieces of
cream paper, mounted on board
5¾ × 7⅞ in. (14.6 × 20 cm)
Indianapolis Museum of Art; The Clowes
Fund Collection (C10084)

Provenance Probably Groult Collection, Paris;
Andrew H. Noah, Akron (Ohio); Dr.
George Henry Clowes (1877–1958),
Indianapolis; property of the Clowes Fund,
Indianapolis, after 1958

Exhibitions Indianapolis 1955, no. 49;
Bloomington 1963, no. 13

Literature Grasselli 1987a, II, pp. 428–29, III,
fig. 522; Rosenberg and Prat 1996, III, R197

Notes
1. Rosenberg and Prat 1996, II, no. 548.
2. Rosenberg and Grasselli 1984, no. P51.
3. Rosenberg and Prat 1996, II, no. 527.
4. Dacier and Vuaflart 1921–29, III, no. 268.
5. Grasselli 1987a, pp. 428–29.

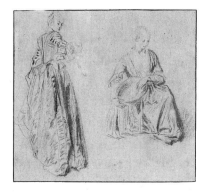

Figure 97. Antoine Watteau, *Two Studies of
Women, One Standing, One Holding a Bowl*,
ca. 1717. Red chalk with graphite, 5 × 5½ in.
(12.8 × 13.9 cm). Private collection

This composite sheet of three drawings mounted side by side is of special interest because it is a rare example of Jean-Baptiste Pater directly copying the drawings of his master, Watteau. The sketch on the left replicates a small red-chalk study by Watteau that is now in the Fitzwilliam Museum, Cambridge[1]; Watteau's drawing—which was etched by J.-C. François when it was in the collection of Dezallier d'Argenville—was employed as a study for a woman on the far left of the painting *Pleasures of the Dance* (*Les Plaisirs du bal*; London, Dulwich Picture Gallery).[2] Pater's central drawing copies a standing woman who appears on the left side of Watteau's *Two Studies of Women, One Standing, One Holding a Bowl*, a drawing in a private collection (fig. 97)[3]: Watteau's figure was drawn in red chalk and graphite, a medium he favored in his later drawings, and it served as a study for the lost canvas *Peaceful Love* (*L'Amour paisible*; fig. 52, p. 55), which Watteau painted in England for Dr. Richard Mead[4]; she was etched by François Boucher for the second volume of *Les Figures de différents caractères* (no. 332). Both of Watteau's drawings and the two paintings with which they are associated seem to date from 1717 or later. The sketch on the right is Pater's rendering of a lost drawing by the master that does not reappear in any of Watteau's known paintings, but which was twice etched in the eighteenth century, by N.-B. Lépicié for the second volume of *Les Figures de différents caractères* (no. 342) and by the comte de Caylus for his *Suite de figures inventées par Watteau*

It is not possible to date Pater's copies with any precision, but it is reasonable to speculate that they might have been made at the end of Watteau's life, when—reproaching himself for having mistreated his former pupil—the dying artist spent his final month training his younger compatriot. Although all three of the sketches that Pater copied were later engraved, his copies are oriented in the same direction as Watteau's drawings, a fact that suggests he was working from Watteau's closely guarded originals. In addition, the central sketch incorporates black chalk—a medium Pater rarely used—in a manner that follows Watteau's use of graphite in his drawing. Red chalk is applied in the copies in ways quite characteristic of Pater's easily identifiable hand, but the sketches are more restrained than was usual for Pater, and they resist many of his most easily recognizable stylistic and morphological idiosyncrasies, suggesting that they could have been made under Watteau's supervision.[5] Pater's copies reveal how inept he was at conveying the structure of a figure beneath its draperies—a skill at which Watteau excelled—and how difficult and unnatural it was for him to work in any medium other than red chalk. Nevertheless, the Indianapolis drawings do transmit an appreciation of the rich surface patterning found in Watteau's rendering of silks and satins, and they show Pater valiantly struggling to attain for his figures the quality of grace so evident in Watteau's ethereal women.

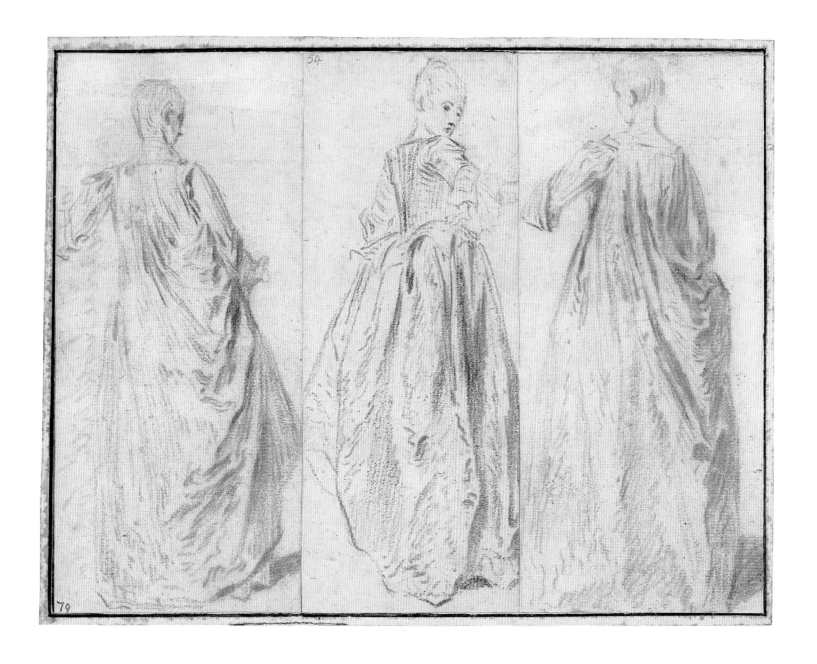

The numbers 79 and 54 that are inscribed in black chalk on two of the sketches indicate that the sheets came from the so-called "Groult Album" of more than five hundred drawings—the majority of them by Pater, though also including sketches by Watteau and Claude III Audran—that was in the collection of Camille Groult (1837–1908) and his descendants until its dispersal at auction in Paris on December 19, 1941.

72 Seated Soldier

ca. 1725–30
Red chalk on tan paper
7½ × 4⅞ in. (19.1 × 12.5 cm)
Thaw Collection; The Pierpont Morgan Library, New York (Thaw 1.32)

Provenance Helene C. Seiferheld Gallery, Inc., New York

Exhibitions New York, Cleveland, Chicago, and Ottawa 1975–76, no. 32; New York 1994–95, p. 258 (illus. as Watteau)

Literature Grasselli 1985, p. 44; Rosenberg and Prat 1996, III, no. R406

Notes
1. Submitted to the Academy on December 31, 1728; see Ingersoll-Smouse 1928, no. 397, fig. 108; the author catalogues seventy-two military compositions, nos. 397–469, although one of these—*Visite au camp*, no. 418, fig. 128—was certainly painted by Nicolas Lancret.
2. The Thaw sheet was first reattributed to Pater in Hattis 1977, p. 143; however, the owner of the drawing had earlier recognized its close connection to published studies of soldiers by Pater; see Denison 1975, no. 32. In addition to the Thaw sheet, there are soldier studies by Pater in the Fine Arts Museums of San Francisco; the Pierpont Morgan Library, New York; the British Museum, London; the Musée du Louvre, Paris; and a private collection (sold Christie's, New York, January 9, 1991, lot 50).
3. Karl Parker first identified the *Marching Soldier* as by Pater in Parker 1933, pp. 25–27; Margaret Morgan Grasselli recognized that the *Sleeping Soldier* was also by Pater in Grasselli 1975, pp. 91–92.
4. A painting by Pater formerly in the collection of the princesse de Faucigny-Lucinge, Paris, Ingersoll-Smouse 1928, no. 402, fig. 110; an engraving of the painting, by Baudouin, was published in 1762 under the title *Tentes de vivandières du quartier général*.

Like Watteau, Pater was a native of Valenciennes and he would have had many opportunities in his youth to study the soldiers garrisoned in the town during the later years of the War of the Spanish Succession. Indeed, it is possible that as a boy Pater first came to know Watteau when the older artist returned home for a brief visit in 1709–10, a period during which Watteau himself made a number of paintings and drawings of military subjects (see cat. no. 4). Pater followed his master's example in becoming a specialist in paintings of military themes, in 1728 submitting to the Academy *Soldiers Celebrating* (Paris, Louvre) as his *morçeau de reception*. Ingersoll-Smouse recorded more than seventy essays in the genre, many of them extant.[1]

As Watteau himself had done, Pater would have found it necessary to assemble a repertoire of figure studies of soldiers in various poses for eventual use in his bivouac scenes and *Marches de troupes*. Not surprisingly, Pater's sketches of soldiers adhere to the models established by Watteau, and depict their subjects far from the heat of battle, most often resting or sleeping, occasionally daydreaming. In the present drawing, a seated soldier, just back from a march, pauses to rest heavily against his musket. Although the drawing was attributed to Watteau until 1977—when Phyllis Hattis recognized it as the work of Pater—it is typical of Pater's mature style: the soft, loose, and squiggly strokes, the sharp and rapidly applied accents that serve to indicate shadows, the relative flatness of form, and the wide-eyed, snub-nosed face of the model are entirely characteristic of the two dozen of so drawings of soldiers by Pater that that have thus far been identified.[2] Two of Pater's best-known sketches are the *Marching Soldier* and the *Sleeping Soldier* in the Louvre—attributed to Watteau until 1933 and 1975, respectively[3]—and both served as studies for *Tentes de vivandières du quartier général* (whereabouts unknown).[4] Curiously, it has gone unremarked that this sheet was also used as a study for the same painting, employed as the model for the seated soldier resting in the lower left-hand corner.

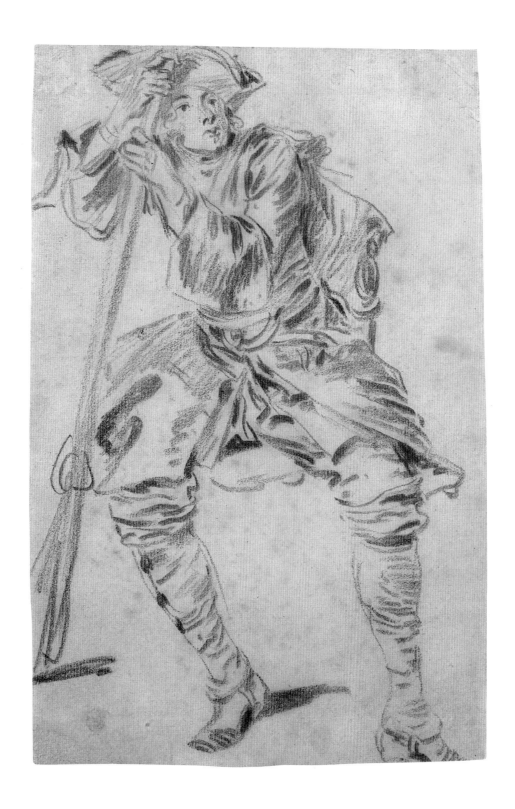

73 Studies of a Seated Lady and a Maid Pouring from a Jug

ca. 1730

Red chalk on tan paper

7½ × 8¼ in. (19 × 21 cm)

Sheet is numbered 67 in brown ink, top left-hand corner (recto)

Collection Kate de Rothschild and Yvonne Tan Bunzl, London

Provenance Groult collection, Paris; Groult sale, 1941, lot 55

Exhibitions Paris 1951, no. 102; New York 1989, no. 20

Notes

1. It has been suggested that this seated lady and her maid servant might have been a study for figures in a *fête galante* by Pater called *Repos dans un parc*, formerly in the collection of the Earl of Pembroke, and now in the Saint Louis Art Museum (Ingersoll-Smouse 1928, no. 53, fig. 209). In the painting, the woman holds a glass while her servant, dressed in blackamoor costume, is pouring wine into it from a jug; although the figures in the painting bear certain similarities to those in the present drawing, the differences in pose and costume are considerable and argue against the association.

2. Among the other examples of sheets by Pater bearing studies of two female figures are those in Rotterdam (Rosenberg and Prat 1996, III, no. R728) and Paris (Louvre, inv. 27546).

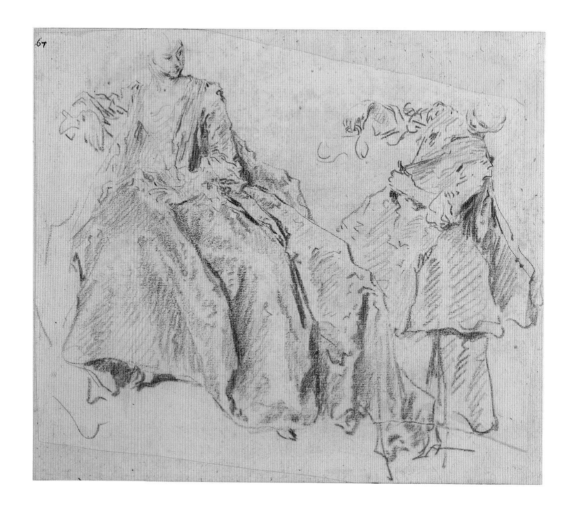

Pater shared Watteau's fascination with the billowing silk drapery of women's gowns, though he recreated it with less delicacy than did his master. Whereas Watteau almost always rendered it in tiny folds, Pater worked it into voluminous swathes that are broadly chalked with dense shadowing in the heavy folds; it is one of the charms, not failings, of his opulent vision of feminine fashion that his gowns take on a life and form of their own, becoming grand carapaces little effected by the shape or pose of the body beneath.

Most of Pater's drawings are small, single-figure sketches that were obviously taken out of sketchbooks and cut from larger pages. Although it, too, has been cut, the present drawing is one of the relatively few sheets to survive bearing two figures, in some sort of physical and psychological relationship to each other.[1] Their poses create an almost musical counterpoint in Pater's figure studies.[2]

74 Young Man Playing a Flute

ca. 1730
Red chalk heightened with white chalks on cream paper
5⅞ × 6⅞ in. (14.8 × 17.4 cm)

Inscribed, lower right: *139*

Private collection, Cleveland

Provenance Probably Groult collection, Paris; private collection, Paris

Exhibition New York 1984, no. 30

Notes
1. See Ingersoll-Smouse 1928, no. 18, fig. 11.
2. For example, the red-chalk sketch *Seated Flutist* by Pater in the Museum of Fine Arts, Boston (inv. 15.1267); see Rosenberg and Prat 1996, III, no. R81.

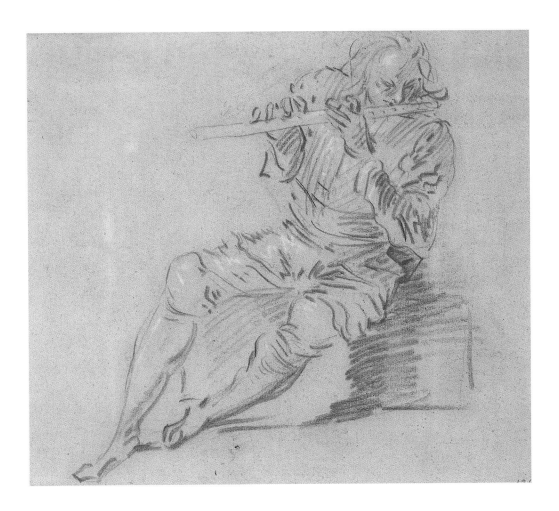

This exceptionally fresh and vivid sketch was used as a study for the seated flutist in the lower left-hand corner of the painting *Concert champêtre* in the British Royal Collection.[1] A number of studies of flute players by Pater have survived, and they owe an obvious debt to Watteau's drawings of similarly engaged musicians (see cat. no. 35).[2] The present sketch displays Pater's typical stylistic traits: the figure is evoked in rapid notations of sharp, discontinuous, and squiggly strokes of red chalk that create a lively, decoratively patterned surface that flattens form and conveys little sense of underlying structure or the figure's anatomy. Unlike Watteau, who took great pains to re-create accurately the precise fingering employed by the flutists he drew, Pater makes no effort to anatomize the process of music-making and renders his model's sausage-like fingers schematically. He does, however, capture with force and economy a quality of intense concentration in the musician's face, and he shapes his figure into a pleasing silhouette.

75 A Music Party

1738
Red and black chalks on cream paper
12¾ × 10 in. (32.4 × 25.3 cm)

Verso inscribed in brown ink: *Collection C Jusky (?) Peintre*

The J. Paul Getty Museum, Los Angeles (88.GB.60)

Provenance Baron A.-F. De Silvestre, his sale, Paris, December 4–6, 1851, no. 270; comte H. de La Beraudière, his sale, Paris, April 16–17, 1883, no. 232; Richard Lion, his sale, Paris, April 3, 1886, no. 117; H.H.A. Josse, his sale, Paris, May 28–29, 1894, no. 33; private collection, England; sale, Christie's, London, December 9, 1986, lot 152; art market, London

Literature Goldner and Hendrix 1992, no. 67; Salmon 1996, p. 88 and no. 29

Notes
1. Salmon 1996, no. 27. The drawing, called *Assemblée dans le parc*, was sold at auction in Paris, Hôtel Drouot, March 9, 1988, lot 42. For the payment to Portail for the drawing on December 17, 1738, see Salmon 1996, p. 9.
2. Two replicas of the Getty drawing are known, though, to judge from photographs, both appear to be copies by another hand; one, formerly in the collection of the vicountess Harcourt, was sold in Paris, Hôtel Drouot, April 3, 1886, lot 117; the other, formerly in the Bourgarel Collection, is reproduced in *Revue de l'art ancien et moderne*, February 1960.

Jacques-André Portail's career as a draftsman is poorly understood, and a reliable chronology of his drawings has yet to be established. However, a record of payment that serves to date a drawing in a private collection in Paris may also cast light on the origins of the present work. In 1738, the same year that Portail was appointed *dessinateur du roy* by Philibert d'Orry, he received payment of 112 *livres* for a drawing depicting a party in the garden of Orry's residence, a commission with which Xavier Salmon has recently associated a sheet in a French private collection.[1] As it is loosely drawn in black and red chalks and appears unfinished, the Paris sketch might be a first draft for the drawing—presumably more finished and now lost—that was finally delivered to the powerful minister of culture. For our purposes, the sketch is interesting because it includes a pair of young women holding a songbook who also appear in a more elaborately worked form at the center of the present sheet. Although this *Music Party*—surely modeled from life—is large and sensitively observed, it has the appearance of a preliminary study for one of the meticulously finished genre drawings for which Portail is renowned. It seems likely that both the present sheet and the Paris sketch were made preparatory to the lost drawing of Orry's garden party and therefore should be dated to 1738.

Musical gatherings were among Portail's favorite subjects, and *A Music Party* reveals the effects of Watteau's influence in its pervasive atmosphere of quiet absorption and in the intense concentration on the face of each participant as he makes music, follows the score, or simply listens. Red and black chalks were Portail's typical medium, used with a miniaturist's precision in his delicately polished genre and still-life compositions, but more freely and boldly handled here and in other figure studies. He generally drew with a sanguine crayon of distinctive, rosy-pink hue, and separated his red and black chalks into isolated zones of color with little integration, characteristics that distinguish his technique from that of Watteau and make his drawings easily recognizable. In fact, it is to drawings by other legatees of Watteau—notably Carmontelle and Lancret—that *A Music Party* bears the most obvious stylistic affinities.[2]

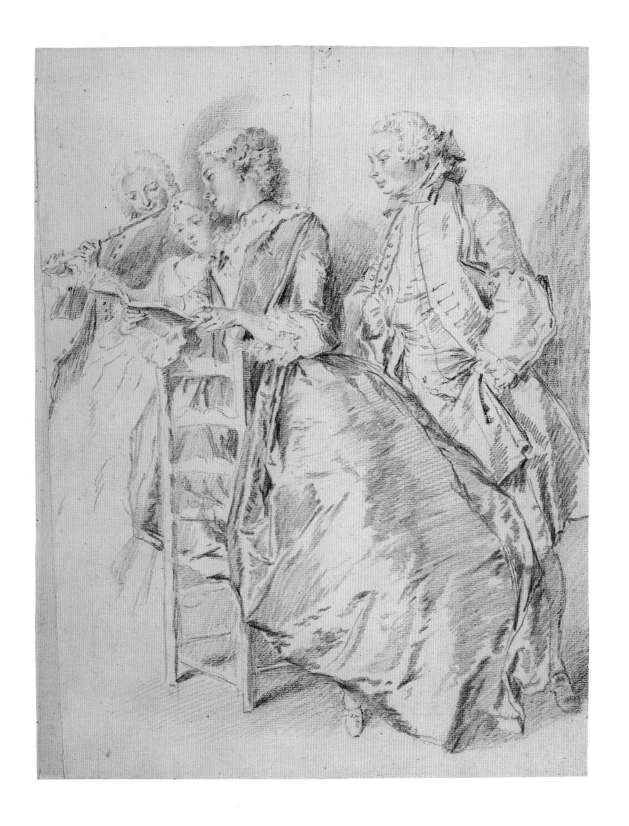

239

76 Old Man with a Basket of Fruit and Vegetables

ca. 1740

Black and red chalks with touches of
graphite on buff laid paper, laid down on
cream laid paper

16¾ × 12¼ in. (42.5 × 31 cm)

Inscribed on lower left: "*Par Portail*"

The Art Institute of Chicago; Gift of David
Adler Fund (1972.26)

Provenance Given by Mr. William H. Schab,
New York, in 1972; David Adler Fund

Exhibition Chicago 1976, no. 36

Literature Salmon 1996, no. 43; Salmon in
Clark 1998, p. 204, fig. 3

Notes

1. The drawing, called *Le Philosophe*, was
sold at auction at Sotheby's, London, June
30 1986, lot 165; it is published in Salmon
1996, no. 47. Two other drawings in a
comparable chalk technique but of a
different old man are also in private
collections. One is in a private collection,
Paris, see Salmon 1996, no. 44; the other,
called *Le Chasseur*, is in the collection of
Jeffrey Horvitz, on loan to the Fogg Art
Museum at Harvard University, Cambridge
(sold, Sotheby's, London, June 30, 1986, lot
164), see Salmon 1996, no. 46, and Salmon
in Clark 1998, no. 4.

2. See Salmon 1996, nos. 49 and 48,
respectively.

Portail followed Watteau in making a series of unsentimental studies of *figures populaires*, which included this solemn and dignified *Old Man with a Basket of Fruit and Vegetables* in Chicago; another drawing of the same model, without his walking stick and the accompanying still life, is in a private collection in Paris.[1] Portail, who never knew Watteau, was nevertheless an observant student of his drawings, and was inspired to undertake his own drawings of elderly pilgrims by life studies such as Watteau's *Old Savoyard* (cat. no. 14); Portail's two known drawings of standing Savoyards (one in the Musée Condé, Chantilly, the other in a private collection, Paris) are so close in spirit to Watteau's models that, until recently, they were attributed to him.[2]

If Portail's weathered old man possesses something of the gravity and interior life of Watteau's heroic Savoyards, the manner in which he is drawn has little relationship to Watteau's audacious style. Portail developed his own distinctive and essentially decorative chalk technique, which shares with that of Watteau only a preference for red and black crayon. Where Watteau enlivened his sheets with dense and rapidly applied accents of colored chalk, Portail subordinated every stroke to a finely controlled web of hatching. His minute touches created an even and delicately modulated surface that glows with a soft radiance, and imbues both the still life and the figure of the old man with a quality of stately quietude.

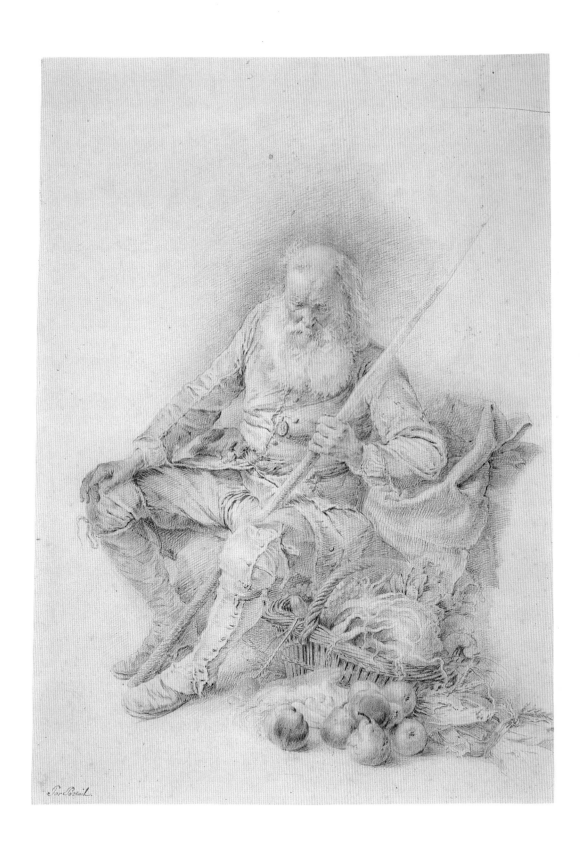

Par Portail.

241

77 Young Man Sharpening His Pencil

ca. 1740
Black and red chalks, and graphite on cream paper
10⅛ × 8¼ in. (25.2 × 20.9 cm.)
Collection Mr. and Mrs. Russell B. Aitken, New York

Provenance Didier Aaron, New York, until 1998

Notes
1. See Rosenberg 1979, no. 76.

An autonomous work of art that was made to be framed and exhibited, this previously unpublished drawing is one of Portail's loveliest genre scenes. The artist achieved a remarkably stylized pictorial effect by draining the composition of all color, except for the barest hints of sanguine in the young draftsman's face and hands and the carved frame of his chair, and laying bare the complex network of tiny, precise hatchings that ornament and enliven the surface of the sheet. The figure is drawn with a miniaturist's precision, achieving an appearance reminiscent of Liotard's manner but without the Swiss artist's dependence on stumping. In Portail's drawings everything, including the deep folds of the boy's coat, is subordinated to an evenness of handling that equalizes spatial values and eliminates any strong accent. Cool, northern light bathes the scene, creating atmosphere, and permeating it with a sense of time stilled.

Parallels to Portail's world of poetic silence can be found in Watteau's art, but a closer comparison may be with the quiet domesticity of Chardin's universe. Like Chardin, Portail was a specialist in still life, and both artists treated the human figure as if it were an element of still-life composition. As in Chardin's genre paintings, the characters in Portail's drawings usually engage in some sort of absorbing occupation or activity: making music, embroidering, reading, or, as here, sharpening a stick of chalk in a *porte-crayon* in preparation for drawing. Given their similar artistic sensibilities, it comes as no surprise that in the present composition Portail took up a traditional subject, with deep roots in seventeenth-century Dutch painting, one that Chardin also found sympathetic. Chardin's famous painting *The Young Draftsman* (Paris, Louvre) had been exhibited to great success at the Salon of 1738, the first Salon that Portail would have seen after his arrival in Paris from Nantes.[1] In the silent, interior world of Chardin's art, Portail found an influence on his development to rival that of Watteau, as well as an endorsement of his own creative vision.

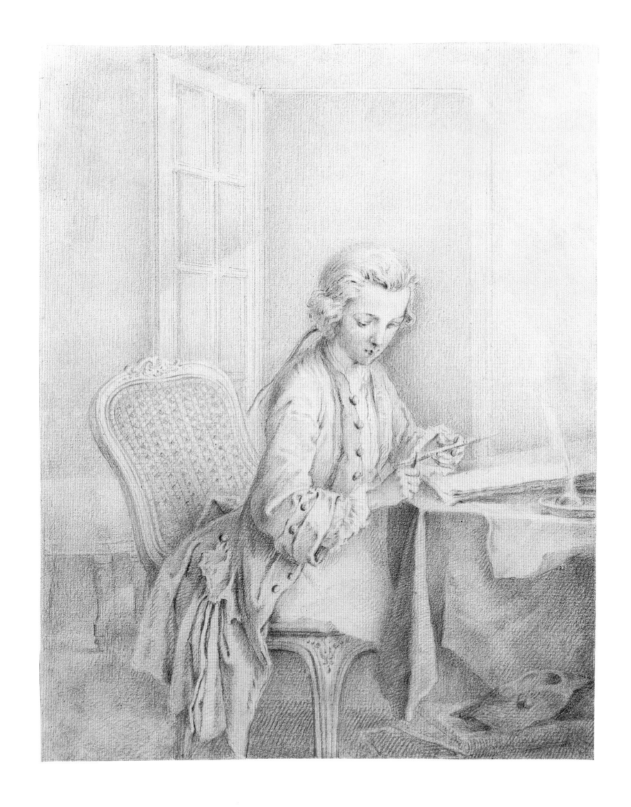

243

78 Fête Galante in a Park

ca. 1725

Red chalk on cream paper

6⅝ × 10¾ in (16.8 × 27.3 cm.)

Private collection

Provenance E. Dervaux

Exhibitions Lille 1889, no. 399 (as Watteau);
New York 1992, no. 29

Literature Rosenberg and Prat 1996, I,
pp. xxv, fig. 8

Notes

1. Orlandi 1753, p. 415; Eidelberg 1970,
pp. 39–70.

2. See Eidelberg 1981, p. 36; a rare figure
study, presumably made from life and in *trois
crayons*, is in Stockholm, see Bjurström 1982,
no. 1133.

3. The Louvre drawing, which is also
executed in red chalk, was inscribed in the
eighteenth century with Quillard's name; see
Duclaux 1987, no. 152.

4. Eidelberg 1981, p. 33.

5. Rosenberg and Prat 1996, II, no. 599.

Despite his having been one of Watteau's most dedicated imitators, Pierre-Antoine Quillard remains something of a mystery and no clear account of his relationship with Watteau exists. His first biographer, Père Orlandi (1753), described him as a "disciple" of Watteau who followed in the older artist's manner, and recent attempts to situate the ten-year-old Quillard as a collaborator in Watteau's "studio" are not entirely persuasive.[1] As Martin Eidelberg has argued, it would appear that Quillard certainly had access to some of Watteau's early, Gillotesque drawings, which he copied; furthermore, Quillard seems to have worked only rarely in *trois crayons* and his drawings reflect the impact of Watteau's youthful red-chalk manner rather than the master's more complex mature techniques.[2]

Too little is known about Quillard's career and too few of his works have been identified to allow for a coherent reconstruction of his development as either a painter or draftsman. We can presume that the stiff, somewhat awkward sheets at Chatsworth that copy motifs from Watteau's sketches are early works, while the fluent, energetic style of the *Fête galante* in the Louvre (fig. 33, p. 38) represents his mature style.[3] The latter sheet—a touchstone for reconstructing the artist's oeuvre—offers the closest stylistic comparison for the present *Fête Galante in a Park*, the most ambitious and accomplished drawing by the artist known today.

Like most of Quillard's known drawings, the *Fête Galante in a Park* represents a complete *tableau*; in this, it reflects the artist's experience of Watteau's paintings rather than his drawings.[4] Although it is possible that Quillard was familiar with Watteau's rare compositional studies, his sheet is worked up to a level of finish never found in comparable sketches by Watteau, such as *Study for "The Pleasures of Love"* (*Les Plaisirs d'amour*; fig. 36, p. 40).[5] No painting by Quillard related to his drawing has come to light, and it is impossible to say whether the sheet was made as a preparatory study for a painted composition, or as an independent work of art. The three couples who talk, stroll, and flirt beside a garden fountain in the drawing display the artist's predilection for long, attenuated bodies in graceful attitudes, and tiny faces with slanted eyes and sharp noses. The figure groups, which are arranged in a sinuous, unfurling movement across the sheet, are linked to each other by broad, parallel hatchings that indicate an undulating lawn; a similarly decisive hatching is found in the landscape of the Louvre drawing. In fact, the graphic style of *Fête Galante in a Park* is characterized throughout by the use of long, elegant strokes of red chalk that give the drawing a slow and seductive rhythm that is well suited to its subject matter.

The drawing is steeped in Watteau's sensibility, and it is hardly surprising that in the nineteenth century it was attributed to the older master. One can assume that, by this point in his career, Quillard no longer copied motifs from Watteau outright, but the

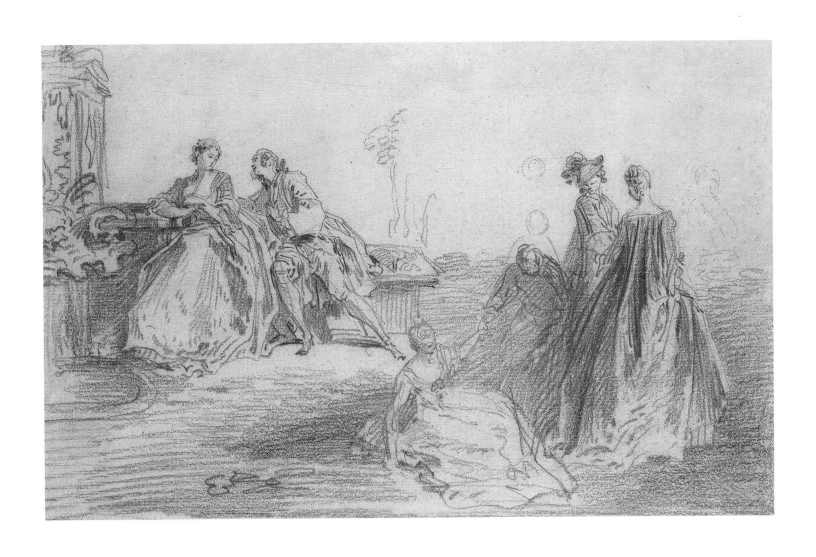

6. Rosenberg and Grasselli 1984, no. P60.

7. Rosenberg and Grasselli 1984, no. P61.

8. Such as the red-chalk studies of a standing woman seen from behind in Stockholm; see Rosenberg and Prat 1996, II, no. 398.

9. The suggestion is made in New York 1992, no. 29; for *The Conversation*, see Rosenberg and Grasselli 1984, no. P23.

10. See Fahy 1973, pp. 284–96, no. 30. My thanks to Colin Bailey for drawing to my attention the similar poses in Quillard's drawing and de Troy's *Declaration of Love*.

figure groups, nevertheless, find counterparts in Watteau's works: the standing couple on the right is similar, though in reverse, to figures in the foreground of Watteau's painting *The Enchanted Isle* (Switzerland, private collection),[6] and the man helping his companion up from the ground is a variation on a famous motif in *The Embarkation to Cythera* (fig. 1, p. 9).[7] In both attitude and handling, the standing woman seen from behind evokes memories of similar images in Watteau's own drawings.[8] It should be noted, however, that the seated couple on the left, who have been likened to a couple in *The Conversation* (fig. 16, p. 28),[9] finds an even closer parallel in the imploring cavalier and his lady companion from Jean-François de Troy's *tableau de mode*, *The Declaration of Love* (New York, Wrightsman Collection).[10] In fact, while remaining deeply indebted to the example of Watteau, Quillard's drawing differs from its prototypes in one significant way. His lovers do not wear theatrical or fancy dress; rather, they are attired in fashionable and expensive clothing of around 1725, the presumed date of the drawing and the year that de Troy exhibited his first "paintings of fashion"—including *The Declaration of Love*—at the Salon. De Troy's genre scenes take place in the contemporary interiors of a Parisian *hôtel particulier*; Quillard's drawing is still set in Cythera, but the *beau monde* has invaded its timeless landscape. No less than de Troy's celebrated series of cabinet pictures, Quillard's drawing indicates a turning point in the development of Watteau's genre.

Artists' Biographies

François Boucher (1703–1770)

The son of a master painter in the Académie de Saint-Luc, Boucher probably received his initial training in his father's shop, before spending a brief apprenticeship with the talented history painter François Lemoyne, whose pearly, painterly manner is apparent in much of the artist's early work. Having won the Prix de Rome in August 1723 with *Evilmerodach Releasing Jehoiachim from Prison* (whereabouts unknown), Boucher was now set on the course of study offered by the Academy to promising history painters. Unfortunately, however, owing to administrative mismanagement, there was no room for him at the French Academy in Rome and he was obliged to delay his visit. Boucher's artistic education continued in Paris, not Rome, and on the margins of academic pedagogy: he was employed to make designs for thesis plates to be engraved by Jean-François Cars and his assistants, and between 1724 and 1728 contributed more than one hundred etchings after Watteau's paintings and drawings for Jullienne's *Figures de différents caractères* and the *Recueil Jullienne*. Not only did the exposure to Watteau's figures and landscape leave an indelible mark on Boucher's emerging style, but the generous fee paid by Jullienne—Mariette reported that Boucher earned 20 *livres* a day—enabled the young artist to save enough money to visit Rome at his own expense: in April 1728 he would leave Paris for a two-year stay. While in Rome he was lodged "in a little hole of a room," through the generosity of the director of the French Academy, Nicolas Vleughels, Watteau's friend, with whom he had once shared lodgings.

Back in France by the summer of 1731, Boucher rapidly ascended the Academy's hierarchy—associate member, November 1731; full member, January 1734 (with *Rinaldo and Armida*, Paris, Louvre); assistant professor, July 1735; full professor, July 1737. He began to receive important decorative commissions from middle-class, aristocratic, and royal patrons alike, the most important of which—seven overdoors for the hôtel de Soubise; four grisaille ceiling decorations for Queen Maria-Leczinska's bedchamber at Versailles; two hunting scenes for the king's *petites appartements* (*The Leopard Hunt*, 1736; *The Crocodile Hunt*, 1739, both Amiens, Musée de Picardie)—confirmed his authority as the most fluent and inventive of the new generation of history painters. During the 1740s, Boucher's ascendancy over the visual culture of his times would be consolidated through his designs for tapestries (he worked for the Beauvais manufactory from 1736), as well as for the stage (sets and costumes for performances both at the Foire Saint-Laurent and the Opéra). With Madame de Pompadour's installation as *maitresse en titre* in 1745, demand for his work at royal residences increased; it was for Pompadour that in 1752–53 he produced his masterpieces *The Rising of the Sun* and *The Setting of the Sun* (London, Wallace Collection), mythological decorations for the Château de Bellevue from which a single set of Gobelins tapestries was woven.

Named *premier peintre du roi* in August 1765, Boucher continued to produce at a prodigious rate—his early biographers claimed that he worked twelve hours a day—and a thriving studio was established, in which both his son-in-law, Jean-Baptiste Deshays, and his most gifted pupil, Jean-Honoré Fragonard, were trained. Despite growing critical aversion to his idyllic pastorals and effortlessly conceived mythologies—"The man has everything, except Truth" (Diderot)—Boucher's late work, particularly the set

of mythological decorative commissions in 1768 for Bergeret de Frouville (Kimbell Art Museum and J. Paul Getty Museum) display an acuity and inventiveness without parallel in the work of any of his contemporaries.

Jérôme-François Chantereau (?1710—1757)

Next to nothing is known of the life or career of Jérôme-François Chantereau, a member of the Académie de Saint-Luc who was also active as a picture dealer in Paris. While he achieved a certain measure of success as a painter—he executed five works for Christian VII, King of Denmark, and a number of his paintings were engraved—he gained notoriety after killing the restorer and fellow picture dealer Joseph-Ferdinand Godefroy in 1741 (the result of a duel). Around forty drawings by him have been identified—nearly one-quarter of which were acquired by Count Tessin during his second sojourn in Paris (1739–42)—and from these emerge an artist who depicted the everyday life of peasants and soldiers with sympathy and directness: a tender and reticent personality, quite at odds with the violence associated with him.

Claude Gillot (1673—1722)

Gillot was initially trained by his father, an embroiderer and painter of ornaments, before being sent to Paris to become an apprentice in the studio of the history painter Jean-Baptiste Corneille (1649–1695), with whom he may have spent five years. Gillot specialized in decorative or ornamental work and showed a taste for grotesqueries and bacchanals inspired by Jacques Callot and contemporary designers such as Jean Berain II. More original, however, was Gillot's interest in subjects drawn from the *commedia dell'arte* and—since this troupe was banished from France in 1697—from the popular fair theaters that appropriated its repertory. His idiosyncratic vignettes are drawn with a refinement and virtuosity conspicuously lacking in the stiff and somewhat mannered appearance of his paintings—few of which

survive—and it is his innovative graphic work that most influenced the young Watteau, who entered Gillot's studio around 1705 and may have remained with him for as long as four years.

Watteau not only absorbed Gillot's fascination with fairground and theatrical subject matter, he also imitated the older artist's manner of drawing in red chalk. Watteau's early sheets in this medium, with their elongated figures, balletic postures, and rapidly executed physiognomies, have often been attributed to Gillot. One of Watteau's earliest paintings, *Harlequin Emperor in the Moon* (Nantes, Musée des Beaux-Arts) is based on a composition by Gillot, who in turn had been inspired by a performance of the play from which the scene is taken at the Foire Saint Laurent in September 1707.

The pupil soon outshone the master and Watteau's early biographers are in agreement that Gillot encouraged Watteau to move on and join the workshop of Claude III Audran since he "regarded this imitator with a jealous eye." Although Gillot was made an associate member of the Academy in 1710, and like Watteau had to be urged on more than one occasion to produce his *morceau de reception*—which he delivered in April 1715 (*Christ at the Time He was about to be Nailed to the Cross*, Corréze, Eglise de Noailles)—he seems to have abandoned painting toward the end of his career and to have devoted himself to book illustration and ornamental design. In the year before his death he was commissioned to produce costume designs for the ballet by the young Louis XV. Despite his prolific and varied output—and his essential contribution to the creation of the *fête galante* (Lancret had also briefly been his pupil)—Gillot died in poverty in Paris in May 1722.

Charles de La Fosse (1636—1716)

Charles Lebrun's most talented pupil, La Fosse was the son of a goldsmith who first trained with the engraver François Chauveau. He studied in Italy between 1658 and 1663 at the Crown's expense, settling for three years in Venice. His early

familiarity with the work of Titian and Veronese set him apart from the gifted practitioners who would later assume prominence in the Academy and is indicative of an affinity that would later predispose him to the young Watteau. Upon his return to Paris he was employed to paint frescoes for the marriage chapel of the church of Saint-Eustache and under Lebrun's patronage collaborated on royal *chantiers* at the Louvre and the Tuileries. He also contributed decorations to Versailles: the lunettes and chimneypieces for the Salon de Diane and the ceiling of the Salon d'Apollon.

In June 1673 La Fosse was received at the Academy with his *Rape of Proserpina* (Paris, Ecole des Beaux-Arts), initially painted for the duc de Richelieu, whose collection of paintings by Rubens would inspire in La Fosse a veneration for the Flemish master. La Fosse continued to work at Versailles; for the king's bedchamber in the newly built Trianon de Marbre, he contributed three overdoors, including *Clytie Changed into a Sunflower (in situ)*, his masterpiece. Following an invitation to London in 1689 to decorate the residence of Ralph, Duke of Montagu (former British ambassador to France), La Fosse was lured back to Paris in 1692 with the prospect of decorating the recently completed dome of the church of the Hôpital des Invalides. Work on the project slowed considerably and was ultimately shared among several academicians, with La Fosse receiving the decoration of the cupola and four pendentives representing the Evangelists. La Fosse would be employed with this same *équipe*—which comprised Jean-Baptiste Jouvenet, Louis and Bon de Boullougne, and Antoine Coypel—on the decoration of the royal palaces of Marly (1699) and Meudon (1700-02). Although, as Mansart's protégé, he had initially been given the entire commission to decorate the Chapel at Versailles, the architect's death in 1708 ensured that this project would also be shared among the senior history painters of the Academy.

Although the office of *premier peintre* eluded him, La Fosse was appointed director of the Academy in April 1699, rector in 1702, and Chancellor in 1715, a year before his death. He continued to undertake monumental commissions well into old age and between 1704 and 1707 was employed on the vault of the Grande Galerie of Pierre Crozat's town house in the rue de Richelieu; his decoration for Crozat's country house at Montmorency dates to around 1710. In 1711 he undertook four monumental religious paintings for the choir of the Cathedral of Nôtre-Dame de Paris; only two were finished in 1715, and it is noteworthy that until quite recently preparatory drawings for one of them, *The Adoration of the Magi*, were attributed to Watteau himself.

The most "baroque" of French seventeenth-century history painters despite an impeccable classical education, La Fosse introduced a robust, painterly figural style indebted to Rubens, Van Dyck, Correggio, and the Venetians, which was particularly suited to the demands of mural decoration. His abbreviated handling and warm coloring represent an alternative aspect of the *style Louis XIV*, fully in place by 1690, that helps explain the Academy's receptivity to colorists such as Watteau, Lemoyne, and Boucher. As a resident of Crozat's Parisian town house from 1708 until his death, La Fosse was also well placed to assist Watteau, and may well have been involved in the commission for a series of oval decorations painted by Watteau for Crozat's dining room; Caylus for one, claimed that Watteau's mythologies were based on the elder artist's designs.

Nicolas Lancret (1690–1743)

Like his friend and fellow student Lemoyne, Lancret was the son of a coachman. After first training with an anonymous drawing master and an engraver in 1707, he entered the studio of Pierre Dulin (1669–1748), a mediocre history painter. We know that Lancret also attended life class at the Royal Academy, because in October 1708 he was expelled from that institution—along with Lemoyne—for insulting other students (both were readmitted three months later). In August 1711 he competed, unsuccessfully, for the Prix de

Rome—Lemoyne was the recipient—and shortly thereafter entered Gillot's studio, where he studied for about two years and where he probably made the acquaintance of Watteau, who had left the studio several years before.

Although trained initially as a history painter, Lancret's passage through Gillot's studio and contact with Watteau changed the direction of his art: in February 1718 he became an associate member of the Academy upon the presentation of several works "*sur un genre particulier*"; in March 1719 he was received as a full member as a "painter of fêtes galantes" —the corporation thus acknowledging his indebtedness to the artist for whom this category had been created.

Lancret initially made a name for himself as "a pupil of the late M. Gillot and an emulator of the late M. Watteau" (*Mercure de France*, June 1723), exhibiting *fêtes galantes* in the Exposition de le Jeunesse in June 1722 and 1723. At the Salon of 1725 Lancret also showed portraits and hunting scenes, suggestive of the larger repertory of subjects that he would develop in the two decades following Watteau's death. Initially he seems to have sought to establish himself as a painter of contemporary history: his sketches of the *Lit de Justice at the Majority of Louis XV* and *The Conferring of the Order of the Saint Esprit* (both 1723, Paris, Louvre), while remaining in his possession, did attract a royal commission showing an unfortunate mishap that befell the carriage of the queen's future ladies-in-waiting en route to Fontainebleau (*The Accident at Montereau*, whereabouts unknown).

It was, however, as a genre painter in the tradition of the *fête galante* and the *tableau de mode* that Lancret gained both fame and a large clientele (his patrons included several of Watteau's earliest champions). His ability to incorporate genre subjects into the allegorical framework that remained a staple of decorative commissions ensured a continuing demand for his work during the 1730s. His principal patron was the king, whose apartments in various royal residences were decorated by Lancret—most notably the *Déjeuner au jambon*, 1735 (Chantilly, Musée Condé), painted for the private dining room at Versailles and the *Leopard Hunt*, 1736 (Amiens, Musée de Picardie), part of the series of exotic hunts for the Galerie des petits appartements du Roi at Versailles, on which the young Boucher also participated.

François Lemoyne (1688–1737)

Four years younger than Watteau—and a fellow student of Lancret's at the Academy—François Lemoyne imbued French history painting with a luminosity, gracefulness, and "naturalism" that in many ways mirror the innovations of the *fête galante* (but on a "higher" register). The son of a postilion in royal service, Lemoyne received an exemplary academic training in the studio of Louis Galloche, with whom he was apprenticed between 1701 and 1712. Awarded the Prix de Rome in August 1711, Lemoyne was prevented from taking up his scholarship by the Academy's impecuniousness. He thus remained in Paris and five years later was made an associate member of the Academy; in July 1718 he became a full member with the Lebrun-inspired *Hercules Slaying Cacus* (Paris, Ecole des Beaux-Arts).

The recipient, initially, of poorly paid religious commissions, Lemoyne was only able to work on the large-scale mythologies for which his talents were uniquely suited after meeting the enlightened art lover and tax collector François Berger. Berger paid the artist a monthly stipend; invited him to Italy at his expense (they visited Bologna, Venice, Rome, Naples, and Modena between November 1723 and July 1724); and commissioned a set of four history paintings, including *Hercules and Omphale*, 1724 (Paris, Louvre), and *The Bather*, 1724 (Dallas, private collection), which introduced a new sensuousness and fluency into the Academy's highest canon. When these paintings, along with six other works, were shown at the Salon of 1725, Lemoyne's primacy as a history painter was immediately acknowledged and commissions from the Crown (initially for altarpieces, it is true) followed in regular succession.

Lemoyne shared first prize with Jean-François de Troy at the *concours* of 1727 (*The Continence of Scipio*; Nancy, Musée des Beaux-Arts) and in 1729 was commissioned to paint a heroic chimneypiece for the Salon de la Paix at Versailles, representing *Louis XV Giving Peace to Europe* (*in situ*). In November 1732 Lemoyne finally began to work in earnest on the ceiling decoration of the Salon d'Hercule at Versailles—his first design dates as early as 1728—and for the next four years he would be engaged upon this monumental mythology depicting Hercules's ascension to Olympus and his marriage to Hebe before the assembled deities of antiquity. Unveiled to Louis XV in September 1736, this epic ceiling decoration, comprising some 142 figures of more than life size, won for Lemoyne the position of *premier peintre du roi*, an honor he jealously coveted.

Yet the cost to his physical and mental well-being had been enormous, and Lemoyne—always unstable—now seems to have suffered a nervous breakdown. Although he continued to work on Berger's last commission, *Time Saving Truth from Falsehood and Envy* (London, Wallace Collection) and produced preparatory drawings for a large history painting commissioned by the King of Spain (*The Defeat of Porus*, drawings in Stockholm, Nationalmuseum, and New York, Metropolitan Museum of Art), his delusional state steadily worsened and he committed suicide on June 4, 1737, by stabbing himself nine times with his sword.

Jean-Etienne Liotard (1702—1789)

Jean-Etienne Liotard was born to French Protestants who had left France for Geneva after the Revocation of the Edict of Nantes. Liotard's initial studies were as a miniaturist; after training with the miniature painter Daniel Gardelle, he was sent to Paris to continue his apprenticeship with Jean-Baptiste Massé (1670–1767), who was engaged on the project to engrave Lebrun's decorations at Versailles. When his three-year contract with Massé came to an end, Liotard established himself as a reasonably successful portraitist and engraver. In

September 1731 he engraved Watteau's *Sick Cat* (*Le Chat malade*) for the *Recueil Jullienne*; among his possessions at the time of his death would be found a portfolio of drawings by Watteau.

Despite encouragement from *premier peintre* François Lemoyne, Liotard seems not to have participated in the competition for the Prix de Rome (although he had painted *David and the High Priest Abimelech* in preparation for the *concours* of 1734); he would furthermore have had difficulties in entering the Academy on account of his religion. Thus he willingly accepted the invitation of the vicomte de Puisieux, French ambassador to the Kingdom of the Two Sicilies, to accompany him and his entourage to Naples. From there, Liotard journeyed to Rome, arriving in time for Easter 1736; and meeting William Ponsonby, later 2nd Earl of Bessborough, who invited him aboard his yacht *Clifton* for a tour of Malta, the Greek Islands, and Constantinople. The artist remained in Constantinople for four years, from 1738 to 1742; on his return to Europe, he continued an itinerant career as a portraitist working in oil, pastels, and black and red chalks. Taken up by a cosmopolitan array of ambassadors, grand tourists, and heads of state, he worked at the Hapsburg court between 1743 and 1745; was presented to Louis XV and commissioned to paint a portrait of the king and his five daughters in 1749; and also traveled to Venice, London, Amsterdam, and Geneva to fulfill requests for portraits. After 1742, when he returned from the Levant, he acquired the habit of wearing Turkish dress and grew a long beard (such eccentricities contribute to his fame). Despite Liotard's successes both in France and abroad, the Academy refused to admit him as a member, and he was obliged to exhibit at the Académie de Saint-Luc in 1751 and 1752.

Charles-Joseph Natoire (1700–1777)

Born in Nîmes and first taught by his father, the architect and sculptor Florent Natoire (*ca.* 1667–1751), Charles Natoire came to Paris at the age of seventeen to study with Louis

Galloche. Soon thereafter he entered the studio of François Lemoyne, becoming his most devoted pupil. An outstanding student, Natoire won the Prix de Rome in August 1721, left for Italy two years later (and so was not among the team of artists engaged by Jullienne to copy Watteau's drawings for *Les Figures de différents caractères*), and remained in Rome for the next seven years.

Natoire was made an associate member of the Academy in September 1730. After his return to Paris, the demand for his large-scale decorations was so great that it took him more than four years to produce his reception piece, *Venus Requesting Vulcan to Make Arms* (Montpellier, Musée Fabre). Like Boucher, Natoire was commissioned to provide designs for tapestry cartoons for the Beauvais manufactory (*Don Quixote* series, 1735–43); he contributed four paintings for the Château de Marly in 1743; and between 1736 and 1739 he completed his masterpiece, the series of decorative panels illustrating the story of Psyche for Boffrand's Salon ovale de Princesse at the hôtel de Soubise, Paris (*in situ*).

Working again with Boffrand, Natoire participated in the illusionistic decoration of the Chapelle des Enfants-Trouvés (1746–50), where his ceiling and wall paintings were surrounded by architectural *trompe l'oeil* settings by the Brunetti brothers. The splendor of this ensemble won for Natoire the appointment of director of the French Academy in Rome, a post he took up in May 1751 and held for the next twenty-four years and which effectively signaled the end of his career. While Natoire proved a sympathetic and encouraging teacher (both Jean-Honoré Fragonard and Hubert Robert benefited from his *plein air* sessions in the Campagna), he was less successful as an administrator. Removed from the directorship in August 1775, he retired to Castello Gandolfo, where he died two years later.

Jean-Baptiste Oudry (1686—1755)

Two years younger than Watteau, Jean-Baptiste Oudry was born in Paris to the painter and picture dealer Jacques Oudry (*ca.* 1661–1720) and received his apprenticeship as the pupil of Nicolas de Largillierre, whose assistant he became. Trained as a portraitist, Oudry experimented early in his career with still-life painting, landscapes, and even scenes from the *commedia dell'arte* inspired by Gillot (rather than Watteau). Made an associate member of the Academy in June 1717, he submitted his reception piece, *Abundance with Her Attributes* (Château de Versailles), in February 1719. Oudry was received as a history painter, but the liveliness of the brilliantly painted fruits and vegetables in the foreground of this conventional allegory indicated the future direction of his career.

In the 1720s Oudry established himself as the preeminent painter of hunting scenes and animal portraits, successfully challenging Desportes's monopoly on these genres and gradually supplanting him as Louis XV's preferred chronicler of the hunt. Thanks to the support of Louis Fagon, *intendant des finances* in 1726, Oudry was appointed painter to the royal tapestry works at Beauvais (then director in 1734); the opportunity to provide cartoons for various series marked a decisive change of direction in his art.

Oudry became adept at panoramic, multifigured compositions in which nature and fantasy were successfully combined, and his capacity to produce monumental canvases in which the documentary and picturesque were seamlessly blended served him well in the commission for *The Royal Hunts of Louis XV* (1733), a series of nine tapestries twice woven at the Gobelins. With the return of the Salon in 1737, Oudry also produced easel paintings for a Parisian and international clientele. Such works had to satisfy in their capacity to move spectators as well as to convince by their powers of illusion; in this regard *Bitch Hound Nursing her Pups*, 1752 (Paris, Musée de la Chasse), purchased by the baron d'Holbach and later praised by Diderot, stands as a masterpiece of dramatic and sentimental genre painting.

A still-life painter of unparalleled finesse and delicacy (the *trompe l'oeil* series of irregular *Stag Antlers* painted between

1741 and 1752 are meditative excursions into the art of illusion), Oudry also experimented in *plein air* landscape drawing at Arcueil, where he captured the abandoned parks and gardens with admirable directness. Appointed professor of the Academy in 1743 and inspector of all the works at the Gobelins in 1748, Oudry exercised considerable influence on the academic pedagogy, while remaining attached throughout his career to the lowly genres of animal painting and still life.

Jean-Baptiste Pater (1695–1736)

Like Watteau a native of Valenciennes, Pater—the son of a sculptor—was initially trained in the shop of a local painter Jean-Baptiste Guidé (died 1711), a member of the Guild of Saint Luke. It is not known whether he met Watteau on the latter's return home in 1709–10, but Gersaint records that Pater's father urged the boy to follow his compatriot back to Paris and study with him there. A brief apprenticeship with Watteau followed, resulting in dismissal, and Pater returned to Valenciennes between 1715 and 1718, when his efforts to practice independently of the guild led to the inevitable legal complications. Back in Paris by 1718, Pater worked for the dealers Sirois and Gersaint, producing *fêtes galantes* in Watteau's manner. In his last months, the dying Watteau sought reconciliation with his former pupil and invited him to Nogent-sur-Marne, where he resumed the twenty-six-year old's instruction. Pater later admitted to Gersaint that "he owed all he knew to that short period of time."

Unrepentantly derivative and eager to fulfill the demand for *fêtes galantes* left by Watteau's early death, Pater devoted his career to producing genre paintings in Watteau's style that were also indebted to the seventeenth-century Flemish artist David Teniers the Younger. Admitted to the Academy as an associate member in July 1725, he was commissioned to paint a military subject for his reception, which he submitted on New Year's Eve 1728 (*Soldiers Celebrating*, Paris, Louvre). Although he, too, later received a commission for the Galerie des petits appartements du Roi at Versailles, Pater worked primarily for the Parisian market, producing a vast array of Watteau-inspired genre scenes as well as a number of copies after Watteau's most popular compositions, including *Gersaint's Shopsign* (Berlin, Charlottenburg Palace) and *The Pleasures of the Dance* (London, Dulwich Picture Gallery).

Jacques-André Portail (1695–1759)

The son of an architect born in Brest but active in Nantes after 1719, Portail was trained by his father, for whom he initially worked. While he also gained experience in Nantes as a portraitist and religious painter, in 1738 he was invited by Philibert d'Orry to join the Ministry of Fine Arts as *dessinateur du Roy*; two years later he was appointed curator of both the king's paintings and the royal collection of maps, and granted lodgings at Versailles. From 1742 until 1759, Portail would also be responsible for the installation of the Salon, a post that passed after his death to Jean-Baptiste-Siméon Chardin. In addition to his administrative duties, Portail was commissioned to produce perspectival views of the grounds and buildings at Versailles, for which he was handsomely paid. In September 1746, in recognition of his service as *tapissier* of the Salon, the Academy admitted him on the same day to both associate and full membership as a "painter of flower and fruits" (most of his still lifes have since disappeared).

Portail's fame today rests less upon his architectural views or paintings of flowers and fruits than on his numerous figure studies, often in black and red chalks and of varying degrees of finish, that recall Watteau in their delicacy and subtle admixture of chalks. His finished drawings, often displayed mounted and framed, found favor with such highly placed collectors as Madame de Pompadour and the Marquis de Marigny.

Pierre-Antoine Quillard (?1704–1733)

The son of a cabinet maker, Quillard displayed a precocious

talent that was apparently recognized by the young Louis XV, who awarded the artist an annual pension of 200 *livres*. Competing unsuccessfully for the Prix de Rome in August 1723—the recipient was the twenty-year-old François Boucher—Quillard made a second attempt the following year when the prize was awarded to Carle Van Loo. Thwarted in his efforts to pursue the training of a history painter in Rome under the Academy's aegis, Quillard left Paris for Lisbon in 1726 to accompany the Swiss naturalist Charles-Fréderik Merveilleux, who had been commissioned to write a natural history of Portugal: Merveilleux hired the artist to provide the engravings for his book. In Lisbon, Quillard's talents were recognized by King John V, who appointed him court painter in 1727. During the next six years Quillard was active in all aspects of artistic life, producing *fêtes galantes* and portraits in the emerging Rococo style, as well as painting large altarpieces, state portraits, and ceiling decorations (the last perished during the Lisbon earthquake of 1755).

Although his early red-chalk drawings are indebted both in style and content to Watteau, it has as yet been impossible conclusively to establish that the younger artist was employed as an assistant in Watteau's studio—if Watteau had a studio—or that he collaborated on certain canvases. That motifs from Watteau's paintings reappear in Quillard's red-chalk drawings is undeniable, however, even if the relationship between the two artists is still to be fully defined.

Antoine Watteau (1684–1721)

Born in the Flemish city of Valenciennes in October 1684, Antoine Watteau was the second of four sons of Jean-Philippe Watteau, a roofer, and his wife, Michèle Lardenois. Around the age of ten, Watteau entered into formal artistic training as an apprentice to a local artist, possibly the forgotten religious painter Jacques-Albert Gérin. Aspiring to improve his technique, he was brought to Paris in 1702,

probably by a scene painter from Valenciennes. He supported himself for a few years by making copies of religious paintings for a dealer on the Pont Notre-Dame. Eventually tiring of production-line work, he parted company with his employer, shortly thereafter making the acquaintance of Claude Gillot, an artist recognized for his innovative repertory of theater scenes. As Gillot's pupil, Watteau emulated the artist's manner of painting, but eventually began to develop his own style.

For unknown reasons, Watteau left Gillot and entered the workshop of Claude III Audran (1658–1740), a prominent decorative painter and designer who headed a team of guilders, sculptors, and painters who ornamented the interiors of private and royal residences. Audran was also Painter in Ordinary to the king and curator of the Luxembourg Palace. At the time, the Luxembourg Palace housed Rubens's Marie de Médicis cycle of paintings, motifs from which Watteau would repeatedly copy in his drawings.

On August 31, 1709, Watteau was awarded second prize in the Prix de Rome competition for his submission *Abigail Who Brings Food to David* (whereabouts unknown). Disheartened by the paltry salary he earned at Audran's workshop, Watteau decided to leave Paris and return to Valenciennes. In order to finance his trip home, Watteau sold *Return from the Campaign* (*Retour de campagne*; whereabouts unknown)—his sole possession—to the dealer Pierre Sirois at the price of 60 *livres*.

Once home, Watteau had many opportunities to paint the soldiers of Valenciennes, a garrison town during the later years of the War of Spanish Succession (1701–13). On commission for Sirois, he produced *The Bivouac* (*Camp Volant*; Moscow, Pushkin Museum), for which he charged his patron 200 *livres*. Sirois showed his two Watteau paintings to other dealers and collectors, thereby increasing the artist's exposure, and Watteau was able to return to Paris with a growing market for his art.

On July 30, 1712, Watteau was received as an associate

member of the Academy. He competed once again for the Prix de Rome, but this time the Academicians were so taken by the originality and accomplishment of his submissions—one of them was identified as the *commedia dell'arte* scene *Jealousy* (*Les Jaloux*; whereabouts unknown)—that Watteau was invited to become a full member of the Academy. On August 28, 1717, five years after his provisional admission and after repeated admonitions, he submitted his *morçeau de reception*, *The Embarkation to Cythera* (*Le Pèlerinage à l'isle de Cithère*; Paris, Louvre).

At an unknown date, Watteau met Pierre Crozat, a wealthy banker who commissioned from the artist a series of four paintings for his dining room representing the seasons. The access Watteau had to Crozat's extensive collection of old master drawings—including works by Jacopo Bassano, Peter Paul Rubens, and Anthony Van Dyck—had a tremendous impact on the artist and, at least briefly, he took up residence in his patron's mansion. Watteau desired his independence, however, and eventually left the home of Crozat. In a succession of moves, Watteau lived with the painter Nicolas Vleughels, an older painter of Flemish origin.

By 1719 Watteau was well established in Paris and recognized as the creator of the new genre known as *fêtes galantes*, and the first biography of Watteau was published in Orlandi's *Abécédario pittorico*. Despite his success in Paris, Watteau decided to depart for London, where he found ample work from English connoisseurs. In 1720 he produced *Peaceful Love* (*L'Amour paisible*; whereabouts unknown) and *The Italian Comedians* (*Comédiens italiens*; Washington, D.C., National Gallery of Art) for Dr. Richard Mead, an art collector and a doctor who specialized in infectious diseases. Watteau, suffering the effects of tuberculosis, is believed to have sought consultation with him.

Troubled by his deteriorating health and isolated by his inability to speak English, Watteau left England almost a year after he arrived. On his return to France, he took up residence with the dealer Edme-François Gersaint, for whom he painted the celebrated *Gersaint's Shopsign* (*L'Enseigne de Gersaint*; Berlin, Charlottenburg Palace). After living for about six months with Gersaint, the ailing artist moved to Nogent-sur-Marne, near Vincennes. Shortly before his death, Watteau was determined to reconcile with Jean-Baptiste Pater, whom years earlier he had accepted as a student and then dismissed; in his final month, Watteau devoted himself to instructing the young painter.

Selected Bibliography

Adhémar 1977
Hélène Adhémar, "Watteau, les romans et l'imagerie de son temps," *Gazette des Beaux-Arts*, November 1977, pp. 165–72

Alfassa 1910
Paul Alfassa, "L'Enseigne de Gersaint," *Bulletin de la Société de l'histoire de l'art français*, 1910, pp. 1–47, 126–72

Almanach Royal
Almanach Royal, 91 vols., Paris 1700–1792

Alpers 1991
Svetlana Alpers, "Roger de Piles and the History of Art," in *Kunst und Kunsttheorie, 1400–1900*, Wiesbaden 1991, pp. 175–88

Ananoff 1966
Alexandre Ananoff, "Watteau face à tous ses imitateurs," *Connaissance des Arts*, 174, August 1966, pp. 14–21

Ananoff 1976
Alexandre Ananoff, *François Boucher*, 2 vols., Lausanne and Paris 1976

Argui-Bruley, Labbé, and Bicart-Sée 1987
Françoise Argui-Bruley, Jacqueline Labbé, and Lise Bicart-Sée, *La Collection Saint-Morys au Cabinet des dessins du Musée du Louvre*, 2 vols., Paris 1987

Bacou 1967
Roseline Bacou, *Le Cabinet d'un grand amateur P.J. Mariette, 1694–1774: Dessins du XVᵉ siècle au XVIIIᵉ siècle*, exhib. cat., Paris, Musée du Louvre, 1967

Bailey 1987
Colin B. Bailey, "Conventions of the Eighteenth-Century *Cabinet de Tableaux*: Blondel d'Azincourt's *La Première Idée de la curiosité*," *Art Bulletin*, 119, no. 3, September 1987, pp. 431–47

Bailey 1991
Colin B. Bailey, *The Loves of the Gods: Mythological Painting from Watteau to David*, exhib. cat., Paris, Réunion des Musées Nationaux; Philadelphia, Philadelphia Museum of Art; Fort Worth, Kimbell Art Museum; 1991

Bailey 1997
Colin B. Bailey, *On Paper* [review of Rosenberg and Prat 1996], 1, no. 5, May–June 1997, pp. 45–48

Ballot de Savot n.d.
Ballot de Savot, *Eloge de Lancret, peintre du Roi ..., accompagné de diverses notes sur Lancret, de pièces inédites et du catalogue de ses tableaux et de ses estampes*, edited and assembled by J.J. Guiffrey, Paris n.d.

Bastide 1993
Jean-François de Bastide, *La Petite Maison* [1758], Paris 1993

Baticle 1985
Jeannine Baticle, "Le Chanoine Haranger, ami de Watteau," *Revue de l'Art*, 69, 1985, pp. 55–68

Bean 1983
Jacob Bean, "Four More Drawings by Charles de La Fosse," *Master Drawings*, 21, no. 1, 1983, pp. 17–20, pls. 20–23

Bean and Turčić 1986
Jacob Bean and Lawrence Turčić, *15th–18th Century French Drawings in The Metropolitan Museum of Art*, New York 1986

Bjurström 1959
Per Bjurström, *Les Illustrations de Boucher pour Molière*, Uppsala Universitet, 1959

Bjurström 1967
Per Bjurström, "Carl Gustaf Tessin As a Collector of Drawings," *Contributions to the History and Theory of Art*, Uppsala 1967, pp. 99–120

Bjurström 1971
Per Bjurström, "F-J Chantereau dessinateur," *Revue de l'art*, 14, 1971, pp. 80–85

Bjurström 1976
Per Bjurström, *French Drawings, Sixteenth and Seventeenth Centuries: Drawings in Swedish Collections*, Stockholm 1976

Bjurström 1979
Per Bjurström, "Two More Drawings by Watteau," *Stockholm National Museum Bulletin*, 3, 1979, pp. 141–48

Bjurström 1982
Per Bjurström, *French Drawings, Eighteenth Century: Drawings in Swedish Public Collections*, Stockholm 1982

Blunt 1934
Anthony Blunt, "Watteau and His Contemporaries," *The Burlington Magazine*, 69, no. 404, November 1934, pp. 230–31

Blunt 1947
Cyril Blunt, "A Note on Watteau's Usage of Drawings," *Connoisseur*, 119, June 1947, pp. 98–99

Blunt and Croft-Murray 1957
Cyril Blunt and E. Croft-Murray, *Venetian Drawings of the XVII and XVIII Centuries in the Collection of Her Majesty The Queen at Windsor Castle*, London 1957

Boerlin-Brodbeck 1987
Yvonne Boerlin-Brodbeck, "La Figure assise dans un paysage," in *Antoine Watteau (1684–1721): Le peintre, son temps et sa légende*, ed. François Moureau and Margaret Morgan Grasselli, Geneva 1987, pp. 163–71

Boilly 1852–53
Jules Boilly, "Mémoire de Greuze contre sa femme," *Archives de l'Art Français*, 2, 1852–53, pp. 153–72

Boppe 1989
Auguste Boppe, *Les Peintres du Bosphore au XVIIIe siècle*, Paris 1989

Bordeaux 1984
Jean-Luc Bordeaux, *François Le Moyne and His Generation, 1688–1737*, Neuilly-sur-Seine 1984

Borowitz 1982
Helen Borowitz, "The Watteau and Chardin of Marcel Proust," *Bulletin of the Cleveland Museum of Art*, January 1982, pp. 18–35

Börsch-Supan 1985
Helmut Börsch-Supan, *Watteau, 1684–1721: Führer zur Austellung im Schloss Charlottenburg*, exhib. cat., Berlin, Schloss Charlottenburg 1985

Boucher and Jaccottet 1952
F. Boucher and P. Jaccottet, *Le Dessin français au XVIIIe siècle*, Lausanne 1952

Bourgeois 1905
L'abbé C. Bourgeois, *Recherches historiques sur Damery*, Châlons-sur-Marne 1905

Bouvy 1921
Eugène Bouvy, "Fêtes vénitiennes," *Etudes italiennes*, 2, April–June 1921, pp. 1–18, 65–82

Brème 1997
Dominique Brème, *François de Troy, 1645–1730*, Paris 1997

Brinckmann 1943
A.E. Brinckmann, *J.A. Watteau*, Vienna 1943

Brookner 1985
Anita Brookner, "Review: *Antoine Watteau, 1684–1721*," *The Burlington Magazine*, 127, no. 983, February 1985, pp. 116–117

Bruand 1950
Yves Bruand, "Un grand collectionneur, marchand et graveur du XVIIIᵉ siècle: Gabriel Huquier (1695–1772)," *Gazette des Beaux-Arts*, ser. 6, 37a, 1950, pp. 99–114

Brunabois Montador 1739
Chevalier de Neufville de Brunabois Montador, *Description raisonnée des tableaux exposés au Louvre, 1739: Lettre à Mme la Marquise de S.P.R.*, Bibliothèque national, Paris, Collection Deloynes

Brunel 1986
Georges Brunel, *Boucher*, London 1986

Burollet 1980
Burollet, *Musée Cognacq-Jay: Peintures et dessins*, Paris 1980

Cafritz 1988
R.C. Cafritz, *Places of Delight: The Pastoral Landscape*, exhib. cat., Washington, D.C., The Phillips Collection, 1988

Cailleux 1957
Jean Cailleux, "Personnages de Watteau dans l'œuvre de Lajoüe," *Bulletin de la Société de l'histoire de l'art de France*, 1957, pp. 101–11

Cailleux 1959
Jean Cailleux, "Four Studies of Soldiers by Watteau: An Essay on the Chronology of Military Subjects," *The Burlington Magazine*, 101, no. 679, supplement, September–October 1959, pp. i–v

Cailleux 1961
Jean Cailleux, "Decorations by Antoine Watteau for the Hôtel de Nointel," *The Burlington Magazine*, 103, no. 696, supplement, no. 7, March 1961, pp. i–v

Cailleux 1962
Jean Cailleux, "A Rediscovered Painting by Watteau: *La Partie Quarrée. L'Art du Dix-huitième Siècle*," *The Burlington Magazine*, 104, no. 709, supplement, no. 10, April 1962, pp. i–v

Cailleux 1964
Jean Cailleux, "Invalides, Huntsmen, and Squires," *The Burlington Magazine*, 106, no. 731, supplement, February 1964, pp. i–iii

Cailleux 1967
Jean Cailleux, "Newly Identified Drawings by Watteau," *The Burlington Magazine*, 104, no. 767, February 1967, pp. 56–63

Cailleux 1972
Jean Cailleux, "*Watteau and His Times* at the Hermitage," *The Burlington Magazine*, 114, no. 835, October 1972, pp. 733–34

Cailleux 1975
Jean Cailleux, "A Strange Monument and Other Watteau Studies," *The Burlington Magazine*, 107, no. 865, April 1975, pp. 246–49

Camesasca and Rosenberg 1982
Ettore Camesasca and Pierre Rosenberg, *Tout l'œuvre peint de Watteau*, Paris 1982

Canaday 1966
John Canaday, "Watteau's Forbidden World," *Horizon*, 8, no. 3, 1966, pp. 60–79

Carlson 1966
Victor Carlson, "Three Drawings by François Boucher," *Master Drawings*, 4, no. 2, 1966

Carlson and Ittmann 1984
Victor I. Carlson and John W. Ittmann, *Regency to Empire: French Printmaking, 1715–1814*, exhib. cat., Baltimore Museum of Art, 1984

Caylus 1732
Anne-Claude-Philippe de Tubières, comte de Caylus, *Discours sur les desseins*, Paris 1732, reprinted in *Revue Universelle des Arts*, 9, 1859, pp. 317–23

Caylus [1748]
Anne-Claude-Philippe de Tubières, comte de Caylus, "La vie d'Antoine Wateau, peintre de figures et de paysages, sujets galants et modernes, lue à l'Académie le 3 février 1748" [1748], in Pierre Rosenberg, *Vies anciennes de Watteau*, Paris 1984, pp. 53–91

Cellier 1867
L. Cellier, *Antoine Watteau, son enfance, ses contemporains*, Valenciennes 1867

Clark 1996
Alvin Clark, "Agnes Mongan's Flourishing Legacy: A New La Fosse for the Fogg in Honor of Her 90th Birthday," *Drawing*, 17, nos. 4–6, November 1995–March 1996

Clark 1998
Alvin L. Clark, Jr., ed., *Mystery and Elegance: Two Centuries of French Drawings from the Collection of Jeffrey E. Horvitz*, exhib. cat., Cambridge, Harvard University Art Museums, 1998

Claverie 1980
Françoise Claverie, *Les Arts du Théâtre de Watteau à Fragonard*, exhib. cat., Bordeaux, Galerie des Beaux-Arts, 1980

Cocke 1984
Richard Cocke, *Veronese's Drawings with a Catalogue Raisonné*, New York 1984

Conisbee 1981
Philip Conisbee, *Painting in Eighteenth-Century France*, London 1981

Conisbee 1985a
Philip Conisbee, "Book Review of *François Le Moyne and His Generation* by Jean-Luc Bordeaux," *The Burlington Magazine*, 127, no. 993, December 1985, pp. 908–09

Conisbee 1985b
Philip Conisbee, "Interpreting Watteau's Century," *Art History*, 8, September 1985, pp. 359–66

Cooper 1963
Douglas Cooper, *Great Private Collections*, New York 1963

Copley-Sargent 1950
Copley-Sargent, "Full Swing in the London Season," *Art News*, 49, 1950, p. 42

Cormack 1970
Malcolm Cormack, *The Drawings of Watteau*, London, New York, Sydney, and Toronto 1970

Courajod 1872
Louis Courajod, "Documents sur la vente du Cabinet de Mariette," *Nouvelles Archives de l'Art Français*, 1872, pp. 346–70

Coutts 1994
Howard Coutts, "Watteau's Use of a Veronese Drawing in Crozat's Collection," *The Watteau Society Bulletin*, 3, 1994, pp. 21–24

Crow 1985a
Thomas E. Crow, "Codes of Silence: Historical Interpretation and the Art of Watteau," *Representations*, 12, Fall 1985, pp. 2–14

Crow 1985b
Thomas E. Crow, *Painters and Public Life in Eighteenth-Century Paris*, New Haven and London, 1985

Cuzin 1981
Jean-Pierre Cuzin, "Deux dessins du British Museum: Watteau, ou plutôt La Fosse," *La Revue du Louvre et des Musées de France*, 1, 1981, pp. 19–21

Dacier 1924
Emile Dacier, "Une légende: Watteau et le concert Crozat du 30 Septembre 1720," *Bulletin de la Société de l'Histoire de l'Art français*, 1924, pp. 353–55

Dacier 1926
Emile Dacier, "Les Scènes et figures théâtrales de Gillot," *La Revue de l'Art*, 49, no. 276, May 1926, pp. 280–94

Dacier and Vuaflart 1921–29
Emile Dacier and Albert Vuaflart, *Jean de Jullienne et les graveurs de Watteau au XVIIIe siècle*, 4 vols., Paris 1921–29

Daniels 1976
Jeffrey Daniels, *Sebastiano Ricci*, London 1976

Denison 1975
Cara Doufour Denison, *Drawings from the Collection of Mr. and Mrs Eugene Thaw*, New York 1975

Denison 1993
Cara Doufour Denison, *French Master Drawings from the Pierpont Morgan Library*, exhib. cat., Paris, Musée du Louvre; New York, Pierpont Morgan Library; 1993

Denison et al. 1994
Cara Dufour Denison et al., *The Thaw Collection: Master Drawings and New Acquisitions*, exhib. cat., New York, Pierpont Morgan Library, 1994

De Piles 1699
Roger de Piles, *Abrégé de la vie des peintres, avec des réflexions sur leurs ouvrages, et un traité du peintre parfait, de la connoissance des desseins, de l'utilité des estampes*, Paris 1699

Deshairs 1913
L. Deshairs, "Les Arabesques de Watteau" (Mélanges offerts à M. Henri Lemonnier), *Archives de l'Art Français*, 7, 1913, pp. 287–300

Dezallier d'Argenville 1727
Antoine-Joseph Dezallier d'Argenville, "Lettre sur le choix et l'arrangement d'un Cabinet curieux, écrite par M. Dezallier d'Argenville, Secrétaire du Roy en la Grande Chancellerie, à M. de Fougeroux, Tresorier-Payeur des Rentes de l'Hôtel de Ville," *Mercure de France*, June 1727, pp. 1295–1330

Dezallier d'Argenville [1745]
Antoine-Joseph Dezallier d'Argenville, "Autre *Abrége de la vie d'Antoine Watteau*," *Abrége de la vie des plus fameux peintres* [Paris 1745], in Pierre Rosenberg, *Vies anciennes de Watteau*, Paris 1984, pp. 46–52

Dezallier d'Argenville 1762
Antoine-Joseph Dezallier d'Argenville, *Abrégé de la vie plus fameux peintres* [Paris 1762], 4 vols., Geneva 1972

Diderot Salons 1957–67
Denis Diderot, *Salons*, ed. Jean Seznec and Jean Adhémar, 4 vols., Oxford 1957–67

Dieckmann 1962
M.H. Dieckmann, "Claude Gillot interprète de la Commedia dell'Arte," *Cahiers de l'Association internationale des Etudes françaises*, 196, 1962, pp. 207–08

Dimier 1928
Louis Dimier, ed., *Les peintres français du XVIIIième siècle: Histoire des vies et catalogue des œuvres*, Paris and Brussels 1928

Duclaux 1977
Lise Duclaux, "Natoire Dessinateur," in *Charles Joseph-Natoire*, exhib. cat., Troyes, Musée des Beaux-Arts, 1977

Duclaux 1987
Lise Duclaux in *Dessins français du XVIIIe siècle de Watteau à Lemoyne*, exhib. cat., Paris, Musée du Louvre, 1987

Eckardt 1973
Dorette Eckardt, *Antoine Watteau*, Berlin 1973, reprinted 1975

Edwards 1966
Hugh Edwards, "Two Drawings by Antoine Watteau," *Museum Studies, The Art Institute of Chicago*, 1, 1966, pp. 8–14

Eidelberg 1966
Martin Eidelberg, "A Cycle of Four Seasons by the Young Watteau," *Art Quarterly*, 19, nos. 3–4, 1966, pp. 269–76

Eidelberg 1967
Martin Eidelberg, "Watteau's Use of Landscape Drawings," *Master Drawings*, 5, no. 2, 1967, pp. 173–82

Eidelberg 1970
Martin Eidelberg, "P.A. Quillard, an Assistant to Watteau," *The Art Quarterly*, 33, no. 1, 1970, pp. 39–70

Eidelberg 1973
Martin Eidelberg, "Watteau and Gillot: A Point of Contact," *The Burlington Magazine*, 115, no. 841, April 1973, pp. 232–39

Eidelberg 1974
Martin Eidelberg, "Watteau and Gillot: An Additional Point of Contact," *The Burlington Magazine*, 117, no. 858, September 1974, pp. 538–39

Eidelberg 1977
Martin Eidelberg, *Watteau's Drawings: Their Use and Significance*, Ph.D. diss., Princeton University 1965, New York and London 1977

Eidelberg 1981
Martin Eidelberg, "Quillard As a Draughtsman," *Master Drawings*, 19, no. 1, 1981, pp. 27–39

Eidelberg 1984
Martin Eidelberg, "Gabriel Huquier: Friend or Foe of Watteau?" *The Print Collector's Newsletter*, 15, no. 5, November–December 1984, pp. 157–65

Eidelberg 1986
Martin Eidelberg, "Review of *Antoine Watteau (1684–1721)*," *Master Drawings*, 22–24, no. 1, 1986, pp. 102–06

Eidelberg 1987
Martin Eidelberg, "Watteau in the Atelier of Gillot," in *Antoine Watteau, (1684–1721): Le peintre, son temps et sa légende*, ed. François Moureau and Margaret Morgan Grasselli, Geneva 1987, pp. 45–47

Eidelberg 1995
Martin Eidelberg, "Watteau's Italian Reveries," *Gazette des Beaux-Arts*, ser. 6, 126, October 1995, pp. 111–38

Eidelberg 1997a
Martin Eidelberg, "An Album of Drawings from Rubens' Studio," *Master Drawings*, 35, no. 3, Fall 1997, pp. 234–66

Eidelberg 1997b
Martin Eidelberg, "'Dieu invenit, Watteau pinxit.' Un nouvel éclairage sur un anciènne relation," *Revue de l'Art*, 115, 1997, pp. 25–29

Eidelberg and Gopin 1997
Martin Eidelberg and Seth A. Gopin, "Watteau's Chinoiseries at La Muette," *Gazette des Beaux-Arts*, ser. 6, 130, 1997, pp. 19–46

Eidelberg and Rowlands 1994
Martin Eidelberg and Eliot W. Rowlands, "The Dispersal of the Last Duke of Mantua's Paintings," *Gazette des Beaux-Arts*, 122, 1994

Eisler 1966
Colin Eisler, "Two Immortalized Landscapes: Watteau and the *Recueil Jullienne*," *Bulletin of The Metropolitan Museum of Art*, 25, 1965–66, pp. 165–76

Eisler 1977
Colin Eisler, *Paintings from the Samuel Kress Collection: European Schools Excluding Italian*, London 1977

Engerard 1900
Fernand Engerard, *Inventaire des Tableaux, commandés et achetés par la Direction des Batiments du Roi (1709–1792)*, Paris 1900

Engwall 1933
Gustaf Engwall, "Antoine Watteau," *Old Master Drawings*, 8, no. 29, June 1933, p. 7

Eswarin 1979
Rudy Eswarin, "Terminology of *Verre Eglomisé*," *Journal of Glass Studies*, 21, 1979, pp. 98–101

Ettesvold 1980
Paul Ettesvold, "De Watteau à Watteau de Lille: dessins français du XVIIIième siècle. La donation Suzanne et Henri Baderou au musée de Rouen," *Etudes de la Revue du Louvre et des Musées de France*, 1, 1980, pp. 62–66

Fahy 1973
Everett Fahy, *The Wrightsman Collection, Volume 5, Paintings and Drawings*, Greenwich 1973

Fourcaud 1901
Louis de Fourcaud, "L'invention sentimentale, l'effort technique et les pratiques de composition et d'exécution de Watteau," Part of a series of articles published between 1901 and 1905, *Revue de l'Art ancien et moderne*, 10, no. 56, November 1901, pp. 236–349

Fourcaud 1909
Louis de Fourcaud, "Antoine Watteau, peintre d'arabesques," *Revue de l'Art ancien et moderne*, 24, no. 142, January 1909, pp. 49–59 and 143; February 1909, pp. 129–40

Frasier 1973
A. Ian Fraser, *A Catalogue of the Clowes Collection*, Indianapolis 1973

Fumaroli 1996
Marc Fumaroli, "Une amité paradoxale: Antoine Watteau et le conte de Caylus (1712–1719)," *Revue de l'Art*, no. 114, 1996, pp. 34–47

Garnier 1989
Nicole Garnier, *Antoine Coypel, 1661–1722*, Paris 1989

Garnier 1996
Nicole Garnier, "Les Portraits de Watteau," in *Watteau et son cercle dans les collections de l'Institut de France*, exhib. cat., Chantilly, Musée Condé, 1996

Gersaint [1744]
Edme-François Gersaint, "Abrégé de la vie d'Antoine Watteau," in *Catalogue raisonné des diverses curiosités du Cabinet de Feu M. Quentin de Lorangère*, 2 March 1744, in Pierre Rosenberg, *Vies anciennes de Watteau*, Paris 1984, pp. 29–44

Gersaint [1747]
Edme-François Gersaint, *Catalogue raisonné de bijoux, porcelaines, bronzes … de M. Angran Vicomte de Fonspertuis* [Paris 1747], in Pierre Rosenberg, *Vies anciennes de Watteau*, Paris 1984, pp. 42–44

Gétreau 1987
Florence Gétreau, "Watteau et la musique: réalités et interprétations," in *Antoine Watteau (1684–1721): Le peintre, son temps et sa légende*, ed. François Moureau and Margaret Morgan Grasselli, Geneva 1987, pp. 235–46

Gillet 1921
L. Gillet, *Un grand maître du XVIIIième siècle, Watteau*, Paris 1921

Giltaij 1992
Jeroen Giltaij, *Chefs-d'oeuvre de la peinture français des musées néerlandais, XVIIᵉ-XVIIIᵉ siècles*, exhib. cat., Dijon, Musée des Beaux-Arts, 1992

Goldner and Hendrix 1988
George Goldner and Lee Hendrix, *European Drawings I: Catalogue of the Collections*, Malibu, J. Paul Getty Museum 1988

Goldner and Hendrix 1992
George Goldner and Lee Hendrix, *European Drawings II: Catalogue of the Collections*, Malibu, J. Paul Getty Museum 1992

Goncourt 1875
Edmond de Goncourt, *Catalogue raisonné de l'oeuvre peint, dessiné et gravé d'Antoine Watteau*, Paris 1875

Goncourt 1880
Edmond and Jules de Goncourt, *L'Art du dix-huitième siècle*, Paris 1880

Goncourt 1881
Edmond de Goncourt, *La maison d'un artiste*, 2 vols., Paris 1881

Gosset 1914
Pol Gosset, "L'ex-libris de M. de Damery," *Nouvelle Revue de Champagne et de Brie*, January–February 1914, pp. 4–11

Gougenot 1748
Anonymous [L'abbé Louis Gougenot], *Lettre sur la peinture, sculpture, et architecture à M.****, s.l. 1748

Grasselli 1981
Margaret Morgan Grasselli, "Review of *Watteau Drawings in the British Museum*," *Master Drawings*, 19, no. 3, Autumn 1981, pp. 310–12

Grasselli 1985
Margaret Morgan Grasselli, "News," *Watteau Society Bulletin*, 2, 1985, pp. 40–45

Grasselli 1986
Margaret Morgan Grasselli, "Eleven New Drawings by Nicolas Lancret," *Master Drawings*, 23–24, no. 3, Autumn 1986, pp. 377–89

Grasselli 1987a
Margaret Morgan Grasselli, *The Drawings of Antoine Watteau: Stylistic Development and Problems of Chronology*, Ph.D. diss., Harvard University 1987

Grasselli 1987b
Margaret Morgan Grasselli, "Watteau's Use of the *Trois-crayons* Technique," in Konrad Oberhuber *et al.*, *Drawings Defined*, ed. Walter Strauss and Tracie Felker, New York 1987, pp. 181–94

Grasselli 1987c
Margaret Morgan Grasselli, "New Observations on Some Watteau Drawings," in *Antoine Watteau (1684–1721): Le peintre, son temps et sa légende*, ed. François Moureau and Margaret Morgan Grasselli, Paris and Geneva 1987, pp. 95–101

Grasselli 1993
Margaret Morgan Grasselli, "Eighteen Drawings by Antoine Watteau: A Chronological Study," *Master Drawings*, 31, no. 2, Summer 1993, pp. 103–27

Grasselli 1994a
Margaret Morgan Grasselli, "A Curious Link Between Watteau and La Fosse," *The Watteau Society Bulletin*, 3, 1994, pp. 9–13

Grasselli 1994b
Margaret Morgan Grasselli, "USA News," *Watteau Society Bulletin*, 3, 1994, pp. 51–60

Grasselli and McCullagh 1994
Margaret Morgan Grasselli and Suzanne Folds McCullagh, "Review of *Nicolas Lancret, 1690–1743*," *Master Drawings*, 32, no. 2, Summer 1994, pp. 168–71

Grate 1994
Pontus Grate, *French Paintings, II: Eighteenth Century*, Stockholm 1994

Griffiths 1994
Antony Griffiths, "Print Collecting in Rome, Paris, and London in the Early Eighteenth Century," in *Print Collecting in the Sixteenth and Eighteenth Century Europe*, Harvard University Art Museums Bulletin, 2, no. 3, Spring 1994, pp. 37–58

Grimm 1877–82
Friedrich Melchior Freiherr von Grimm, *Correspondance littéraire*, 16 vols., Paris 1877–82

Grouchy 1894
Emmanuel Henri Grouchy, *Everhard Jabach, collectionneur parisien*, Paris 1894

Guiffrey 1874–75
J.J. Guiffrey, "Documents sur Pierre Mignard et sur sa famille (1660–1696)," *Nouvelles Archives de l'Art Français*, 1874–75, pp. 1–128

Guiffrey 1877
J.J. Guiffrey, "Testament et inventaire des biens, tableaux, dessins, planches de cuivre, bijoux, etc., de Claudine Bouzonnet Stella, rédigés et écrits par elle-même. 1693–1697," and "Avis de parents. Procès-verbal de suicide et inventaire des biens de François Le Moyne, premier peintre du Roi," *Nouvelles Archives de l'Art Français*, 1877, pp. 1–117, 184–218

Guth 1957
Paul Guth, "Toute la vérité sur le verre 'églomise,'" *Connaissance des arts*, 66, August 1957, pp. 28–33

Haskell 1987
Francis Haskell, *The Painful Birth of the Art Book*, New York 1987

Hattis 1977
Phyllis Hattis, *Four Centuries of French Drawings*, San Francisco 1977

Haverkamp-Begemann, Lawder, and Talbot 1964
Egbert Haverkamp-Begemann, E. Lawder, and C.W. Talbot, *Drawings from the Clark Institute*, 2 vols., New Haven and London 1964

Haverkamp-Begemann and Logan 1970
Egbert Haverkamp-Begemann and A.M. Logan, *European Drawings and Watercolors in the Yale University Art Gallery, 1500–1900*, 2 vols., New Haven and London 1970

Hebert 1766
M. Hebert, *Dictionnaire pittoresque et historique* [Paris 1766], 2 vols., Geneva 1972

Held 1963
Julius Held, "The Early Appreciation of Drawings," *Latin American Art, and the Baroque Period in Europe, Studies in Western Art, Acts of the Twentieth International Congress of the History of Art*, III, Princeton 1963, pp. 72–95

Held 1980
Julius Held, *The Oil Sketches of Peter Paul Rubens: A Critical Catalogue*, 2 vols., Princeton 1980

Hercenberg 1975
Bernard Hercenberg, *Nicolas Vleughels: Peintre et directeur de l'Académie de France à Rome, 1668–1737*, Paris 1975

de Herdt 1992
Anne de Herdt, *Dessins de Liotard*, exhib. cat., Paris, Musée du Louvre, 1992

Herluison 1873
Henri Herluison, *Actes d'état civil d'artistes français, peintres, graveurs, architectes, etc.*, extraits des registres de l'Hôtel de ville de Paris, détruits dans l'incendie du 24 mai 1871, reprinted Geneva 1972

Hérold 1931
Jacques Hérold, *Gravure en manière de crayon. Jean-Charles François (1717–1769), catalogue de l'œuvre gravé*, Paris 1931

Hilaire and Ramade 1993
Michael Hilaire and Patrick Ramade, *Century of Splendor*, exhib. cat., Montreal, Montreal Museum of Fine Arts, 1993

Hind 1923
A.M. Hind, *A Catalogue of Rembrandt's Etchings*, London 1923

Holmes 1991
Mary Taverner Holmes, *Nicolas Lancret, 1690–1743*, exhib. cat., New York, Frick Collection; Fort Worth, Kimbell Art Museum, 1991

Holt 1957
Elizabeth Basye Gilmore Holt, *A Documentary History of Art, II: Michelangelo and the Mannerists. The Baroque and the Eighteenth Century*, Garden City and New York 1957

Hope 1963
Henry R. Hope, *Northern European Painting: The Clowes Fund Collection*, exhib. cat., Bloomington, Indiana University, Museum of Art, 1963

Hugelshofer 1969
Walter Hugelshofer, *Schweizer Zeichnungen von Niklaus Manuel bis Alberto Giacometti*, Bern 1969

Hughes 1981
Peter Hughes, *Eighteenth-Century France and the East*, London 1981

Hulton 1980
Paul Hulton, *Watteau Drawings in the British Museum*, exhib. cat., London, British Museum, 1980

Huyghe 1968
René Huyghe, *L'Univers de Watteau*, Paris 1968, reprinted Paris 1984

Huyghe and Adhémar 1950
René Huyghe and Hélène Adhémar, *Watteau, sa vie, son œuvre*, Paris 1950

Ingamells 1989
John Ingamells, *The Wallace Collection: Catalogue of Pictures, vol. 3, French Before 1815*, London 1989

Ingersoll-Smouse 1928
Florence Ingersoll-Smouse, *Pater*, Paris 1928

Isherwood 1981
Robert M. Isherwood, "Entertainment in the Parisian Fairs in the Eighteenth Century," *Journal of Modern History*, 53, March 1981, pp. 24–47

Isherwood 1986
Robert M. Isherwood, *Farce and Fantasy: Popular Entertainment in 18th Century Paris*, New York 1986

James 1997
Carlo James, "The History of Preservation of Works of Art on Paper," in *Old Master Prints and Drawings: A Guide to Preservation and Conservation*, Amsterdam 1997, p. 138

Jean-Richard 1978
Pierrette Jean-Richard, *L'Œuvre gravé de François Boucher dans la Collection Edmond de Rothschild*, Paris 1978

Joachim 1974a
Harold Joachim, *The Helen Regenstein Collection of European Drawings*, Chicago 1974

Joachim 1974b
Harold Joachim, "A Group of Drawings by Nicolas Lancret," in *Liber Amicorum Karel G. Boon*, ed. D. de Hoop Scheffer, C. van Hasselt, and C. White, Amsterdam 1974, pp. 102–109

Joachim 1976
Harold Joachim, "Trois siècles de portraits dessinés à l'Art Institute of Chicago," *L'Œil*, 255, October 1976, pp. 2–9

Joannides 1994
Marianne Joannides, *A Loan Exhibition of Master Drawings from The DePass Collection*, exhib. cat., London, Phillips; Truro, Royal Cornwall Museum, 1994

Johnson 1988
W. McAllister Johnson, *Master Drawings from the National Gallery of Canada*, Ottawa, 1988

Jombert 1755
Charles Antoine Jombert, *Méthode pour apprendre le dessin* [Paris 1755], reprinted Geneva 1973

Jullienne 1726
Jean de Jullienne, "Abrégé de la vie d'Antoine Watteau, peintre du roy en son Académie royale de peinture et de sculpture," Preface to *Les Figures de différents caractères* [1726], in Pierre Rosenberg, *Vies anciennes de Watteau*, Paris 1984, pp. 11–17

Kennedy and Thackray 1991
Gillian Kennedy and Anne Thackray, *French Drawings, XVI–XIX Centuries*, exhib. cat., London, Courtauld Institute Galleries, 1991

Labbé and Bicart-Sée 1987
Jacqueline Labbé, and Lise Bicart-Sée, "Antoine-Joseph Dezallier d'Argenville As a Collector of Drawings," *Master Drawings*, 25, no. 3, 1987

Labbé and Bicart-Sée 1996
Jacqueline Labbé, and Lise Bicart-Sée, *La Collection de dessins d'Antoine-Joseph Dezallier d'Argenville reconstituée d'après son Abrégé de la vie des plus fameux peintres, édition de 1762*, Paris 1996

Laing, Rosenberg, and Marandel 1986
Alastair Laing, Pierre Rosenberg, and J. Patrice Marandel, *François Boucher, 1703–1770*, exhib. cat., New York, Metropolitan Museum of Art, 1986

Laroque [1721]
Antoine Laroque, "Les Beaux-Arts [notice nécrologique de Watteau]," *Mercure de France*, August 1721, in Pierre Rosenberg, *Vies anciennes de Watteau*, Paris 1984, pp. 5–7

Launay 1991
Elisabeth Launay, *Les Frères Goncourt, collectionneurs de dessins*, Paris 1991

Le Brun 1776
Jean Baptiste Pierre Le Brun, *Almanach historique et raisonné des architectes, peintres, sculpteurs, graveurs, et ciseleurs, Année 1776* [1776], Geneva 1972 (reprinted with Le Brun 1777]

Le Brun 1777
Jean Baptiste Pierre Le Brun, *Almanach historique et raisonné des architectes, peintres, sculpteurs, graveurs, et ciseleurs, Année 1777* [1777], Geneva 1972 (reprinted with Le Brun 1776)

Le Camus de Mézières 1780
Nicolas Le Camus de Mézières, *Le Génie de l'architecture, ou L'Analogie de cet art avec nos sensations*, Paris 1780

Leporini 1935
Heinrich Leporini, "Watteau and His Circle," *The Burlington Magazine*, 66, no. 384, March 1935, pp. 137–38

Lépicié 1752
Bernard Lépicié, *Vie des premiers-peintres du roi, depuis M. Lebrun jusqu'a présent*, 2 vols., Paris 1952

Levey 1961
Michael Levey, "The Real Theme of Watteau's Embarkation of Cythera," *The Burlington Magazine*, 103, no. 698, May 1961, pp. 180–85

Levey 1964
Michael Levey, "A Watteau Rediscovered: *Le Printemps* for Crozat," *The Burlington Magazine*, 106, no. 731, February 1964, pp. 53–58

Lieudé de Sepmanville 1747
Cyprien Antoine de Lieudé de Sepmanville, *Réflexions nouvelles d'un amateur des beaux-arts*, Paris 1747

Locquin 1949
Jean Locquin, "Contribution a l'étude des sources d'inspiration d'Antoine Watteau," *Bulletin de la Societe de l'Histoire de l'Art français*, 1949, pp. 49–52

Lugt 1921
Frits Lugt, *Les Marques de collections de dessins & d'estampes*, Amsterdam 1921.

Lundberg 1957
Gunnar W. Lundberg, *Roslin: liv och verk*, [Malmö 1957]

Mannlich 1989–93
Johann Christian von Mannlich, *Histoire de ma vie*, 2 vols., Trier 1989–93

Mantz 1892
Paul Mantz, *Antoine Watteau*, Paris 1892

Mariette 1741
Pierre-Jean Mariette, *Description sommaire des desseins des grands maistres du cabinet de feu M. Crozat*, Paris 1741

Mariette 1851–53
Pierre-Jean Mariette, *Abécédario de P.-J. Mariette et autres notes inédites de cet amateur sur les arts et les artistes*, 6 vols., ed. Ph. de Chennevières and Anatole de Montaiglon, Paris 1851–53, reprinted Paris 1966

Marois 1984
Dominique Le Marois, "Les montages de dessins au XVIIIᵉ siècle. L'exemple de Mariette," *Bulletin de la Société de l'Histoire de l'Art français, 1982*, 1984, pp. 87–96

Marsy 1746
François Marie de Marsy, *Dictionnaire abrégé de peinture et d'architecture* [Paris 1746], 2 vols., Geneva 1972

Mathey 1936
Jacques Mathey, "Quelques confusions entre les dessins de Watteau et ceux de son école," *Revue de l'Art*, July 1936, pp. 3–18

Mathey 1937
Jacques Mathey, "Watteau, Boucher et le modèle," *L'Art et les Artistes*, 34, no. 181, November 1937, pp. 37–40

Mathey 1938
Jacques Mathey, "Aspects divers de Watteau dessinateur dans la collection Groult," *L'Amour de l'Art*, December 1938, pp. 371–76

Mathey 1939
Jacques Mathey, "A propos d'un catalogue des dessins de Watteau: Nouvelles identifications," *Bulletin de la Société de l'Histoire de l'Art français 1938*, 1939, pp. 158–65

Mathey 1940
Jacques Mathey, "Remarques sur la chronologie des peintures et dessins d'Antoine Watteau," *Bulletin de la Société de l'Histoire de l'Art français, 1939*, 1940, pp. 150–60

Mathey 1948a
Jacques Mathey, "Quelques peintures de Gillot et Watteau," *Bulletin de la Société de l'Histoire de l'Art français, 1945–1946*, 1948, pp. 46–50

Mathey 1948b
Jacques Mathey, "Deux dessins de J.B. Pater," *Gazette des Beaux-Arts*, ser. 6, 2, 1948, pp. 133–35

Mathey 1955
Jacques Mathey, "Lancret, élève de Gillot et la *Querelle des carrosses*," *Gazette des Beaux-Arts*, ser. 6, March 1955, pp. 175–78

Mathey 1959a
Jacques Mathey, "Le rôle décisif des dessins dans l'œuvre de Watteau," *Connaissance des Arts*, 86, April 1959, pp. 40–49

Mathey 1959b
Jacques Mathey, *Antoine Watteau: Peintures réapparues, inconnues ou négligées par les historiens*, Paris 1959

Mathey 1960
Jacques Mathey, "Drawings by Watteau and Gillot," *The Burlington Magazine*, 102, August 1960, pp. 354–59

Mathey 1967
Jacques Mathey, "*La Comédienne*: An Unpublished Watteau," *Connoisseur*, 165, no. 664, June 1967, pp. 90–93

McClellan 1996
Andrew McClellan, "Watteau's Dealer: Gersaint and the Marketing of Art in Eighteenth-Century Paris," *The Art Bulletin*, 78, no. 3, September 1996, pp. 439–53

McCullagh 1992
Suzanne Folds McCullagh, "Eighteenth-Century French Cabinet Drawings," in *Drawing: Masters and Methods. Raphael to Redon*, London 1992, pp. 89–102

Méjanès 1987
Jean-François Méjanès in *Dessins français du XVIIIᵉ siècle du Watteau à Lemoyne*, exhib. cat., Paris, Musée du Louvre, 1987

Michel 1906
André Michel, *François Boucher: Catalogue raisonné de l'œuvre peint et dessiné*, Paris 1906

Michel 1986
Christian Michel, "Lettres addressées par Charles-Nicolas Cochin fils à Jean-Baptiste Descamps, 1757–1790," *Archives de l'Art Français*, XXVIII, 1986, pp. 9–98

Mirimonde 1961
Albert Pomme de Mirimonde, "Les sujets musicaux chez Antoine Watteau," *Gazette des Beaux-Arts*, ser. 6, 58, November 1961, pp. 249–88

Mirot 1924
Léon Mirot, *Roger de Piles, peintre, amateur, critique, membre de l'Académie de peinture (1635–1709)*, Paris 1924

Monbeig-Goguel 1987
Catherine Monbeig-Goguel, "Le dessin encadré," *Revue de l'Art*, 76, 1987, pp. 25–31

Monbeig-Goguel 1988
Catherine Monbeig-Goguel, "Taste and Trade: The Retouched Drawings in the Everard Jabach Collection at the Louvre," *The Burlington Magazine*, 130, November 1988, pp. 821–35

Mongan 1965
Agnes Mongan, "Three Views of a Drummer by Antoine Watteau," *Fogg Art Museum: Acquisitions 1964*, 1965, pp. 42–48

Mongan 1966
Agnes Mongan, "A Watteau Drawing After Rubens," *Fogg Art Museum: Acquisitions 1965*, 1966, pp. 161–64

Montaiglon 1875–92
Anatole de Montaiglon, *Procès-verbaux de l'Académie Royal de Peinture et de Sculpture, 1648–1793*, 10 vols., Paris 1875–92

Montaiglon and Chennevières 1860
Anatole de Montaiglon and Ph. de Chennevières, eds., "Abécédario de P.-J. Mariette et autres notes inédites de cet amateur sur les arts et les artistes," *Archives de l'Art français*, vol. 4, 1860

Morgan 1975
Margaret P. Morgan, "Autour de Watteau: Nouvelles attributions à Pater et à Quillard," *La Revue du Louvre et des Musées de France*, no. 2, 1975

Moselius 1950
C.D. Moselius, "La Collection Cronstedt," *Claude III Audran, Dessins du National museum de Stockholm*, exhib. cat., Paris 1950, pp. x–xx.

Moureau 1987a
François Moureau, "Watteau in His Time," in *Antoine Watteau (1684–1721): Le peintre, son temps et sa légende*, ed. François Moureau and Margaret Morgan Grasselli, Paris and Geneva 1987, pp. 469–506

Moureau 1987b
François Moureau, "Theater Costumes in the Work of Watteau," in *Antoine Watteau (1684–1721): Le peintre, son temps et sa légende*, ed. François Moureau and Margaret Morgan Grasselli, Paris and Geneva 1987, pp. 507–26

Moureau 1987c
François Moureau, "Watteau libertin?" in *Antoine Watteau (1684–1721): Le peintre, son temps et sa légende*, ed. François Moureau and Margaret Morgan Grasselli, Paris and Geneva 1987, pp. 17–22

Moureau 1988
François Moureau, "L'Italie d'Antoine Watteau ou le rêve de l'artiste," *Dix-Huitième Siècle*, 20, 1988, pp. 449–57

Munger and Zafran 1992
Jeffrey Munger and Eric Zafran *The Forsyth Wickes Collection in the Museum of Fine Arts Boston*, Boston 1992

Munhall 1962
Edgar Munhall, "Claude Gillot's *Feast of Pan*," *Yale University Art Gallery Bulletin*, 27 April 1962, pp. 22–35

Munhall 1968
Edgar Munhall, "Savoyards in French Eighteenth-Century Art," *Apollo*, 87, no. 72, February 1968, pp. 86–94

Munhall 1976
Edgar Munhall, *Jean-Baptiste Greuze, 1725–1805*, exhib. cat., Hartford, Wadsworth Athaeneum, 1976

Munhall 1992a
Edgar Munhall, "Notes on Watteau's *Portal of Valenciennes*," *The Burlington Magazine*, 134, no. 1066, January 1992, pp. 4–11

Munhall 1992b
Edgar Munhall, *Little Notes Concerning Watteau's "Portal of Valenciennes,"* New York 1992

Müntz 1884
Eugène Müntz, "Lettres inédites de P.-J. Mariette," *Courrier de l'Art*, 4th year, 1884, pp. 176–77, 188–89, 211, 322–23, 333–35, 346–47, 370–71, 392–94, 406–07, 488–89

Müntz 1890
Eugène Müntz, *Les Archives des arts: Recueil de documents inédits ou peu connus*, Paris 1890

Nemilova 1964a
Inna S. Nemilova, *Watteau et ses œuvres à L'Ermitage*, Leningrad 1964 [in Russian, with a summary of the text in French, pp. 156–59]

Nemilova 1964b
Inna S. Nemilova, "Essais sur l'œuvre de Jean-Antoine Watteau, I: Détermination de la date de l'exécution de la peinture *Le Savoyard*, conservée au musée de l'Ermitage, et le problème de la périodicité de ce genre de peinture pour Watteau," *Trudy gosudarstvennogo Ermitaza*, 7, 1964, pp. 85–98 [in Russian]

Nemilova 1970
Inna S. Nemilova, "La Peinture de Watteau, 'Les acteurs de la Comédie Français' et le problème des portraits dans l'œuvre de l'Artiste," *Zapadnoevropeïkoie Iskousstvo*, 1970, pp. 145–58 [in Russian]

Nochlin 1985
Linda Nochlin, "Watteau: Some Questions of Interpretation," *Art in America*, January 1985, pp. 68–87

Nordenfalk 1979
Carl Nordenfalk, "The Stockholm Watteaus and Their Secret," *Nationalmuseum Bulletin*, 4, 1979, pp. 105–39

Nordenfalk 1987
Carl Nordenfalk, "L'An 1715," in *Antoine Watteau (1684–1721): Le peintre, son temps et sa légende*, edd. François Moureau and Margaret Morgan Grasselli, Paris and Geneva 1987

Opperman 1969
Hal Opperman, "Observations on the Tapestry Designs of J.B. Oudry for Beauvais (1726–1736), *Allen Memorial Art Museum Bulletin* 26 (1969), pp. 49–71

Opperman 1977
Hal Opperman, *Jean-Baptiste Oudry*, 2 vols., New York and London 1977

Opperman 1983
Hal Opperman, *J.B. Oudry*, exhib. cat., Fort Worth, Kimbell Art Museum, 1983

Opperman 1985
Hal Opperman, "Watteau in Retrospect," *The Burlington Magazine*, 127, no. 993, December 1985, pp. 913–15

Opperman 1988
Hal Opperman, "Review of *Watteau (1684–1721)*, Washington, Paris, and Berlin, 1984–85," *Art Bulletin*, 70, no. 2, June 1988, pp. 354–59

Opperman n.d.
Hal Opperman, "The Countenance of Watteau," unpublished article manuscript, n.d.

Orlandi 1719
Père P.-A. Orlandi, *Abécédario pittorico*, Bologna 1719

Orlandi 1753
Père P.-A. Orlandi, *Abécédario pittorico*, Venice 1753

Parker 1930
K.T. Parker, "The Drawings of Antoine Watteau in the British Museum," *Old Master Drawings*, 5, no. 7, June 1930, pp. 2–28

Parker 1931
K.T. Parker, *The Drawings of Antoine Watteau*, London 1931

Parker 1932
K.T. Parker, "Nicolas Lancret, Lady Assisted at Her Toilet by Two Maids; Study of a Tree," *Old Master Drawings*, March 1932, pp. 64–65

Parker 1933
K.T. Parker, "Jean-Baptiste Pater, A Soldier Marching to the Right," *Old Master Drawings*, September 1933

Parker and Mathey 1957
K.T. Parker and Jacques Mathey, *Antoine Watteau: Catalogue complet de son œuvre dessiné*, 2 vols., Paris 1957

Parmentier-Lallement 1996
Nicole Parmentier-Lallement, "Michel II Corneille," *The Dictionary of Art*, VII, London 1996, pp. 863–64

Poley 1938
Heinz-Joachim Poley, *Claude Gillot, Leben und Werk, 1673–1722*, Würzburg 1938

Pomian 1979
Krzysztof Pomian, "Marchands, connaisseurs, curieux à Paris au XVIIIᵉ siècle," *Revue de l'Art*, 43, 1979, pp. 23–36

Populus 1930
Bernard Populus, *Claude Gillot (1673–1722): Catalogue de l'œuvre gravé*, Paris 1930

Posner 1972
Donald Posner, "Watteau's Reclining Nude and the Remedy Theme," *The Art Bulletin*, 54, no. 4, December 1972, pp. 383–89

Posner 1973
Donald Posner, *A Lady at Her Toilet*, London 1973

Posner 1975
Donald Posner, "An Aspect of Watteau 'peintre de la realite,'" in *Etudes d'art français offertes à Charles Sterling*, Paris 1975, pp. 279–86

Posner 1984
Donald Posner, *Antoine Watteau*, London 1984

Pouillon 1969
C. Pouillion, *Watteau*, Paris 1969

Pradel 1692
Abraham du Pradel [Nicolas de Blégny], *Le Livre Commode des Adresses de Paris pour 1692*, 2 vols., ed. Edouard Fournier, Paris 1878

Preston 1985
H. Preston, "Facets of French Art: An English Private Collection," *Apollo*, January 1985, pp. 40–47

Propeck 1988
Lina Propeck, *L'An V. Dessins des grands maîtres*, exhib. cat., Paris, Musée du Louvre, 1988

Puttfarken 1985
Thomas Puttfarken, *Roger de Piles' Theory of Art*, New Haven 1985

Puyvelde-Lasalle 1943
Ghislaine Puyvelde-Lasalle, *Watteau et Rubens*, Brussels and Paris 1943

Rand 1997
Richard Rand, *Intimate Encounters: Love and Domesticity in Eighteenth-Century France*, exhib. cat., Hanover, Hood Museum of Art, Dartmouth College; Toledo, Toledo Museum of Art; Houston, Museum of Fine Arts; 1997

Ratouis de Limay 1907
Paul Ratouis de Limay, *Un amateur orléanais au XVIIIᵉ siècle, Aignan-Thomas Desfriches (1715–1800), sa vie, son œuvre, ses collections, sa correspondance*, Paris 1907

Raux 1995
Sophie Raux, *Catalogue des dessins français du XVIIIième siècle de Claude Gillot à Hubert Robert*, Lille, Palais des Beaux-Arts, 1995

Rey 1931
Robert Rey, *Quelques satellites de Watteau*, Paris 1931

Riopelle 1992
Christopher Riopelle, "Exhibition Review: Nicolas Lancret," *The Burlington Magazine*, May 1992, pp. 330–32

Rogers 1778
Charles Rogers, *A Collection of Prints in Imitation of Drawings, to which are Annexed Lives of Their Authors with Explanatory and Critical Notes*, 2 vols., London 1778

Roland Michel 1984a
Marianne Roland Michel, *Watteau: An Artist of the Eighteenth Century*, London 1984 [German edition 1984]

Roland Michel 1984b
Marianne Roland Michel, *Lajoüe et l'art Rocaille*, Paris 1984

Roland Michel 1985
Marianne Roland Michel, "Watteau: After the Exhibitions," *The Burlington Magazine*, 127, December 1985, pp. 915–17

Roland Michel 1986
Marianne Roland Michel, "Watteau and England," in *The Rococo in England: A Symposium*, Victoria and Albert Museum, 1984, London 1986, pp. 46–59

Roland Michel 1987a
Marianne Roland Michel, *Le dessin français au XVIIIᵉ siècle*, Fribourg 1987

Roland Michel 1987b
Marianne Roland Michel, "Watteau et les *Figures de differents caracteres*," in *Antoine Watteau (1684–1721): Le peintre, son temps et sa légende*, ed. François Moureau and Margaret Morgan Grasselli, Paris and Geneva 1987, pp. 117–27

Rosenberg 1970
Pierre Rosenberg, "Watteau and Oppenort," *The Burlington Magazine*, 112, March 1970, pp. 169–70

Rosenberg 1972
Pierre Rosenberg, *French Master Drawings of the Seventeenth and Eighteenth Centuries in North American Collections*, exhib. cat., Toronto, Art Gallery of Ontario; Ottawa, National Gallery of Canada; San Francisco, California Palace Legion of Honor; New York, New York Cultural Center; 1972

Rosenberg 1973
Pierre Rosenberg, "A propos de Nicolas Vleughels," *Pantheon*, 31, no. 2, 1973, pp. 143–53

Rosenberg 1979a
Pierre Rosenberg, "Dieu As a Draughtsman," *Master Drawings*, 17, no. 2, 1979, pp. 161–69

Rosenberg 1979b
Pierre Rosenberg, *Chardin, 1699–1779*, exhib. cat., The Cleveland Museum of Art in association with Indiana University Press, 1979

Rosenberg 1984a
Pierre Rosenberg, *Vies anciennes de Watteau*, Paris 1984

Rosenberg 1984b
Pierre Rosenberg, "Review of Per Bjurström's *Drawings in Swedish Public Collections, VI: French Drawings of the 18th Century*," *Master Drawings*, 22, no. 1, Spring 1984, pp. 64–70

Rosenberg 1985
Pierre Rosenberg, "Watteau dessinateur," *Revue de l'Art*, 69, 1985, pp. 47–54

Rosenberg 1988
Pierre Rosenberg, *Fragonard*, exhib. cat., Paris, Galeries Nationales du Grand Palais, 1988

Rosenberg 1990
Pierre Rosenberg, *Masterful Studies: Three Centuries of French Drawings from the Prat Collection*, exhib. cat., New York, National Academy of Design; Fort Worth, Kimbell Art Museum; Ottawa, National Gallery of Canada; 1990

Rosenberg 1991
Pierre Rosenberg, "Des dessins de Watteau," in *Japan and Europe in Art History*, Tokyo 1991

Rosenberg and Camesasca 1970
Pierre Rosenberg and Ettore Camesasca, *Tout l'oeuvre peint de Watteau*, Paris 1970, reprinted Paris 1982, English edition 1971 with a preface by John Sunderland

Rosenberg and Grasselli 1984
Pierre Rosenberg and Margaret Morgan Grasselli, *Watteau (1684–1721)*, exhib. cat., Washington, D.C., National Gallery of Art; Paris, Galeries Nationales du Grand Palais; Berlin, Schloss Charlottenburg; 1984

Rosenberg and Prat 1996
Pierre Rosenberg and Louis-Antoine Prat, *Antoine Watteau, 1684–1721: Catalogue raisonné des dessins*, 3 vols., Milan 1996

Rosenberg and Schnapper 1970
Pierre Rosenberg and Antoine Schnapper, *Bibliothèque municipal de Rouen, Choix de dessins anciens*, exhib. cat., Rouen 1970

Rowlands 1996
Eliot Rowlands, *Italian Paintings, 1300–1800, in the Nelson-Atkins Museum*, Kansas City, 1996

Rubin 1968–69
Enid Rubin, "On the Possible Re-dating of Caylus' Biography of Watteau," *Marsayas*, 14, 1968–69, pp. 59–66

Sahut 1977
Marie-Catherine Sahut, *Carle Vanloo, premier peintre du Roi, 1705–1765*, exhib. cat., Nice, Musée des Beaux-Arts Jules Chéret, 1977

Salmon 1995
Xavier Salmon, *Versailles: Les Chasses exotiques de Louis XV*, exhib. cat., Amiens, Musée de Picardie; Versailles, Musée National des Châteaux de Versailles et de Trianon; 1995

Salmon 1996
Xavier Salmon, "Jacques-André Portail 1695–1759," *Cahiers du dessin français*, no. 10, Paris 1996

Schéfer 1896
Gaston Schéfer, "Les portraits dans l'œuvre de Watteau," *Gazette des Beaux-Arts*, 79, September 1896, pp. 177–89

Schnapper 1988
Antoine Schnapper, *Le Géant, la licorne et la tulipe, collections et collectionneurs dans la France du XVIIᵉ siècle*, Paris 1988

Schnapper 1994
Antoine Schnapper, *Curieux du grand siècle. Collections et collectionneurs dans la France du XVIIᵉ siècle*, Paris 1994

Schreiber Jacoby 1979
Beverly Schreiber Jacoby, "A Landscape Drawing by François Boucher after Domenico Campagnola," *Master Drawings*, 17, 1979, pp. 261–72

Schreiber Jacoby 1986
Beverly Schreiber Jacoby, *François Boucher's Early Development As a Draughtsman, 1720–1734*, New York and London 1986

Schreiber Jacoby 1987
Beverly Schreiber Jacoby, "Watteau and Gabburri," in *Antoine Watteau (1684–1721): Le peintre, son temps et sa légende*, ed. François Moureau and Margaret Morgan Grasselli, Paris and Geneva 1987

Scholz 1990
Janos Scholz, "Letters to Felice," *Master Drawings*, 28, no. 3, Autumn 1990

Séailles 1923
Gabriel Séailles, *Les Grands Hommes de France*, Paris 1923

Sérullaz 1981
Maurice Sérullaz, "Deux dessins de Watteau," *Revue du Louvre*, 31, no. 1, 1981, pp. 29–32

Slatkin 1967
Regina Shoolman Slatkin, "Review of *L'œuvre dessiné de Boucher* by A. Ananoff," *Master Drawings*, 5, no. 1, pp. 54–66, pls. 44–49

Slatkin 1972
Regina Shoolman Slatkin, "Some Boucher Drawings and Related Prints," *Master Drawings*, 10, no. 3, 1972, pp. 264–83

Spiro et al. 1993
Stephen Spiro et al., *Master Drawings: The Wisdom Reilly Collection*, Notre Dame, The Snite Museum of Art, The University of Notre Dame, 1993

Steadman and Osborn 1976
David W. Steadman and Carol Osborne, *18th-Century Drawings from California Collections*, exhib. cat., Claremont, Montgomery Art Gallery, Pomona College; Sacramento, E.B. Crocker Art Gallery; 1976

Stein 1996
Perrin Stein, "Boucher's Chinoiseries: Some New Sources," *The Burlington Magazine*, 138, September 1996, pp. 598–604

Stuffmann 1964
Margaret Stuffmann, "Charles de La Fosse et sa position dans la peinture française à la fin du XVIIIième siècle," *Gazette des Beaux-Arts*, ser. 6, 64, July 1964, pp. 1–121

Stuffmann 1968
Margaret Stuffmann, "Les tableaux de la collection de Pierre Crozat: Historique et destinée d'un ensemble célèbre établis en partant d'un inventaire après décès inédit de 30 mai 1740," *Gazette des Beaux-Arts*, ser. 6, no. 72, July–September 1968, pp. 11–144

Stuffman 1982
Margaret Stuffman, *Einschiffung nach Cythera, L'isle de Cythère*, exhib. cat., Frankfurt, Städtische Galerie in Städelsches Kunstinstitut, 1982

Stuffmann 1985
Margaret Stuffmann, "Review of the Exhibition *Watteau (1684–1721)*, Washington, D.C., Paris, and Berlin, 1984–85," *Kunstchronik*, March 3, 1985, pp. 77–98

Stuffmann 1986
Margaret Stuffmann, *Französische Zeichnungen im Städelschen Kunstinstitute, 1550 bis 1800*, exhib. cat., Frankfurt am Main, Stadtische Galerie im Städelschen Kunstinstitute, 1986

Sutton 1959
Denys Sutton, "Drawings of Antoine Watteau," *The Burlington Magazine*, 101, January 1959, pp. 28–31

Sutton 1985
Denys Sutton, "Antoine Watteau—Enigmatic Ironist," *Apollo*, 121, no. 277, March 1985, pp. 146–56

Tessin [1762]
Ulla Tessin, "Antoine Watteau," *Portraits des hommes illustres, avec un abrégé historique de leurs vies*, II, 1762, in Pierre Rosenberg, *Vies anciennes de Watteau*, Paris 1984, pp. 96–98

Thornton 1965
Peter Thornton, *Baroque and Rococo Silks*, London 1965

Tomlinson 1987
Robert Tomlinson, "Fête galante et/ou foraine? Watteau et le théâtre," in *Antoine Watteau (1684–1721): Le peintre, son temps et sa légende*, ed. François Moureau and Margaret Morgan Grasselli, Paris and Geneva 1987, pp. 203–11

Trivas 1936
Numa S. Trivas, *Jean-Etienne Liotard, Peintures, pastels et dessins, manuscrit*, Geneva 1936

Vaillat and Ratouis de Limay 1923
Léandre Vaillat and Paul Ratouis de Limay, *J.-B. Perronneau (1715–1783), sa vie et son œuvre*, Paris 1923

De Vallee 1939
Hélène De Vallée, "Sources de l'art de Watteau: Claude Simpol," *Prométhée*, April 1939, pp. 67–74

Vallery-Radot 1964
J. Vallery-Radot, *French Drawings from the Fifteenth Century Through Géricault*, New York 1964

Voss 1953
Hermann Voss, "François Boucher's Early Development," *The Burlington Magazine*, 95, March 1953, pp. 81–93

Voss 1954
Hermann Voss, "François Boucher's Early Development – Addenda," *The Burlington Magazine*, 96, July 1954, pp. 206–10

Walpole 1771
Horace Walpole, *Anecdotes of Painting in England ...*, IV, Strawberry Hill 1771

Watelet and Levesque 1792
Claude-Henri Watelet and Pierre-Charles Lévesque, *Dictionnaire des arts de peinture, sculpture et gravure*, 5 vols., Paris 1792

Watteau Society Bulletin 1984
"News," *The Watteau Society Bulletin*, 1, 1984, pp. 31–45

Webb 1994
Peter Webb, "Watteau's Place in the History of Erotic Art," *Watteau Society Bulletin*, 3, 1994, pp. 15–20

Wedmore 1894
Sir Frederick Wedmore, "My Few Things," Part II, *Art Journal*, 14 March 1894

Weigert 1950
R.A. Weigert, "Claude III Audran et son milieu," *Claude III Audran, Dessins du Naturalmuseum de Stockholm*, exhib. cat., Paris, 1950, pp. 27–31

Weigert and Hernmarck 1964
Roger-Armand Weigert and Carl Hernmarck, ed., *Les Relations artistiques entre la France et la Suède, 1693–1718: Nicodème Tessin le jeune et Daniel Cronström correspondance (extraits)*, Stockholm 1964

Wildenstein 1924
Georges Wildenstein, *Lancret*, Paris 1924

Wille 1857
Johann Georg Wille, *Mémoires et journal de J.-G. Wille, graveur du Roi*, 2 vols., Paris 1857

Williams 1989
Eunice Williams, *Master Drawings, 1700–1890*, exhib. cat., New York, 1989

Wintermute 1987
Alan Wintermute, *François Boucher: His Circle and Influence*, New York 1987

Wintermute 1990
Alan Wintermute, ed., *Claude to Corot: The Development of Landscape Painting in France*, New York, Colnaghi USA, 1990

Wintermute 1992
Alan Wintermute, "One of the Great Sponges: The Art of Nicolas Lancret," *Apollo*, March 1992, pp. 190–91

Wintermute 1993
Alan Wintermute, in *Master Paintings 1400–1800*, exhib. cat., London and New York, Colnaghi, 1993

Zafran 1998
Eric Zafran, *French Painting in the Museum of Fine Arts, Boston*, I, *Artists Born Before 1790*, Boston 1998

Zolotov 1971
Youri Zolotov, *Antoine Watteau. Textes anciens*, Moscow 1971 [in Russian]

Zolotov et al. 1973
Youri Zolotov et al., *Antoine Watteau. Catalogues raisonnés des tableaux et des dessins dans les musées russes*, Leningrad 1973, reprinted Leningrad 1985

Exhibitions

Aspen 1998
Old Master Paintings and Drawings from Colorado Collections, Aspen Art Museum, 1998

Berkeley 1968
Master Drawings from California Collections, University of California Art Museum, 1968

Berlin 1985
Watteau, 1684–1721: Führer zur Austellung im Schloss Charlottenburg, Schloss Charlottenburg, 1985

Bloomington 1963
Northern European Painting: The Clowes Fund Collection, Indiana University Museum of Art, 1963

Bordeaux 1969
L'Art et la musique, Galérie des Beaux-Arts, 1969

Bristol 1956
French XVIIth-Century Drawings, City Art Gallery, 1956

Cambridge 1984
Drawings from the Collection of E.W. Hofer, Fogg Art Museum, Harvard University, 1987

Charlottenburg 1935
Exposition, venue unknown, 1935

Chicago 1976
Selected Works of 18th-Century French Art in the Collections of the Art Institute of Chicago, Art Institute of Chicago, 1976

Claremont and Sacramento 1976
18th-Century Drawings from California Collections, Montgomery Art Gallery, Pomona College, and E.B. Crocker Art Gallery, 1976

Frankfurt 1977
Französische Zeichnungen aus dem Art Institute of Chicago, Städtische Galerie in Städelsches Kunstinstitut, 1977

Frankfurt 1982
Einschiffung nach Cythera, L'ile de Cythère, Städtische Galerie in Städelsches Kunstinstitut, 1982

Hamburg 1989
Kunsthandel VI: Meisterzeichnungen 1500–1900, Thomas Le Claire Kunsthandel, 1989

Indianapolis 1955
European Old Master Drawings in Indiana Collections, John Herron Art Museum, 1955

Lille 1889
Watteau, venue unknown, 1889

London 1878
Twenty-six Drawings by Watteau, Property of Miss James, South Kensington Museum, Bethnal Green Branch, 1878

London 1945
The Age of Grace, Rowland, Browse and Delbanco, 1945

London 1948
Exhibition of Old Master Drawings, P. and D. Colnaghi, 1948

London 1950
French Masters of the 18th Century, Matthiesen Gallery, 1950

London 1954–55
European Masters of the Eighteenth Century, Royal Academy of Arts, 1954–55

London 1968
France in the Eighteenth Century, Royal Academy of Arts, 1968

London 1976–77
Title unknown, Artemis, 1976–77

London 1987
Eliot Hodgkin, 1905–1987: Painter and Collector, Hazlitt, Gooden and Fox, 1987

Los Angeles 1961
French Masters, Rococo to Romanticism, University of California Los Angeles Galleries, 1961

New York 1959
French Drawings from American Collections, Metropolitan Museum of Art, 1959

New York 1980
Seventeenth- and Eighteenth-Century French Drawings from the Robert Lehman Collection, Metropolitan Museum of Art, 1980

New York 1981
European Drawings, 1375–1825, Pierpont Morgan Library, 1981

New York 1983
18th-Century French Drawings in Association with Galérie Cailleux, Colnaghi USA, 1983

New York 1984
Old Master Drawings, Colnaghi USA, 1984

New York 1987
François Boucher: His Circle and Influence, Stair Sainty Matthiesen, 1987

New York 1988
Creative Copies: Interpretive Drawings from Michelangelo to Picasso, Drawing Center, 1988

New York 1989
Master Drawings 1700–1890, W.M. Brady, 1989

New York 1990a
Master Drawings from the Woodner Collection, Metropolitan Museum of Art, 1990

New York 1990b
Claude to Corot: The Development of Landscape Painting in France, Colnaghi USA, 1990

New York 1991
From Pontormo to Seurat: Drawings Recently Acquired by the Art Institute of Chicago, Frick Collection, 1991

New York 1992
Kunsthandel VIII: Master Drawings, 1500–1900, W.M. Brady, 1992

New York 1994–95
The Thaw Collection: Master Drawings and New Acquisitions, Pierpont Morgan Library, 1994–95

New York 1995–96
Fantasy and Reality: Drawings from the Sunny Crawford von Bulow Collection, Pierpont Morgan Library, 1995–96

New York 1999a
Eighteenth-Century French Drawings in New York Collections, Metropolitan Museum of Art, 1999

New York 1999b
French and English Drawings from the 18th and 19th Centuries from the National Gallery of Canada, The Frick Collection, 1999

New York, Cleveland, Chicago, and Ottawa 1975–76
Drawings from the Collection of Mr. and Mrs. Eugene V. Thaw, Pierpont Morgan Library, Cleveland Museum of Art, Art Institute of Chicago, and National Gallery of Canada, 1975–76

New York and Fort Worth 1991–92
Nicolas Lancret, 1690–1743, Frick Collection and Kimbell Art Museum, 1991–92

New York and Richmond 1985–86
Drawings from the Collection of Mr. and Mrs. Eugene Victor Thaw, Pierpont Morgan Library and Virginia Museum of Fine Arts, 1985–86

Notre Dame 1980
Janos Scholz, Musician and Collector, Snite Museum of Art, 1980

Ottawa 1976
European Drawings from Canadian Collections, National Gallery of Canada, 1976

Paris 1860
Tableaux et dessins de l'école française, principalement du XVIIIe siècle, tirés de collections d'amateurs, Salle Martinet, 26, boulevard des Italiens, 1860

Paris 1879
Exposition de dessins de maîtres anciens, Ecole des Beaux-Arts, 1879

Paris 1948
Danse et Divertissements, Galérie Charpentier, 1948

Paris 1951
Le Dessin français de Watteau a Prud'hon, Cailleux, 1951

Paris 1976
Dessins français de l'Art Institute of Chicago, Musée du Louvre, 1976

Paris 1987
Dessins français du XVIIIe siècle de Watteau à Lemoyne, Musée du Louvre, 1987

Paris and New York 1993–94
French Master Drawings from The Pierpont Morgan Library, Musée du Louvre and Pierpont Morgan Library, 1993–94

Providence 1975
Rubenism, Brown University Museum and Rhode Island School of Design Museum of Art, 1975

San Francisco 1985
Master Drawings from the Achenbach Foundation for Graphic Arts, San Francisco Fine Arts Museum, 1985

San Francisco 1989
Works of Art from the Collection of Mr. and Mrs. John Jay Ide, California Palace of the Legion of Honor, 1989

Tampa and Cambridge 1984
Master Drawings and Watercolors: The Hofer Collection, Tampa Museum and Fogg Art Museum, 1984

Toronto, Ottawa, San Francisco, and New York 1972–73
French Master Drawings of the Seventeenth and Eighteenth Centuries in North American Collections, Art Gallery of Ontario, National Gallery of Canada, California Palace of the Legion of Honor, and New York Cultural Center, 1972–73

Vancouver, Ottawa, and Washington 1988–89
Master Drawings from the National Gallery of Canada, Vancouver Art Gallery, National Gallery of Canada, and National Gallery of Art, 1988–89

Washington and Chicago 1973–74
François Boucher in North American Collections: 100 Drawings, National Gallery of Art and Art Institute of Chicago, 1973–74

Washington, Paris, and Berlin 1984–85
Watteau 1684–1721, National Gallery of Art, Grand Palais, and Schloss Charlottenburg, 1984–85

Washington et al. 1967–68
Swiss Drawings: Masterpieces of Five Centuries, National Gallery of Art et al., 1967–68

Index

Bold figures represent catalogue numbers;
figure numbers are in italics;
page numbers are in Roman script.

Picture Credits

Images are supplied by the owners of the works and are reproduced by their permission, with the following additional credits.

Figure 2 Photo Archives, Charlottenburg Palace, Berlin

Figure 8 Christie's Images

Figure 12 © The British Museum, London

Figure 19 Courtesy Lauros-Giraudon

Figure 20 © The British Museum, London

Figure 27 © The British Museum, London

Figure 31 © The Art Institute of Chicago, All Rights Reserved

Figure 32 © Foto Nationalmuseum, Stockholm

Figure 36 © The Art Institute of Chicago, All Rights Reserved

Figure 39 © Foto Nationalmuseum, Stockholm

Figure 40 © Foto Nationalmuseum, Stockholm

Figure 47 Photo by David Matthews, © President and Fellows of Harvard College, Harvard University

Figure 49 Photo by Laurent-Sully Jaulmes

Figure 63 © 1999 The Art Institute of Chicago, All Rights Reserved

Figure 68 Courtesy Chatsworth Settlement Trustees, Courtauld Institute of Art

Figure 82 Photographic Services, © President and Fellows of Harvard College, Harvard University

Figure 87 © Her Majesty Queen Elizabeth II

Figure 90 Photo Archives, Charlottenburg Palace, Berlin

Cat. 3 © 1998 Indianapolis Museum of Art

Cat. 9 © 1998 Board of Trustees, National Gallery of Art, Washington, D.C.

Cat. 38 © 1979 The Metropolitan Museum of Art

Cat. 40 © 1998 The Metropolitan Museum of Art

Cat. 44a and b © 1998 Board of Trustees, National Gallery of Art, Washington, D.C.

Cat. 58 © 1985 The Metropolitan Museum of Art

Cat. 61 © 1998 Board of Trustees, National Gallery of Art, Washington, D.C.

Cat. 71 © 1998 Indianapolis Museum of Art